THE ART OF PERSISTENCE

THE ART OF PERSISTENCE

Akamatsu Toshiko and the Visual Cultures of Transwar Japan

Charlotte Eubanks

University of Hawai'i Press
Honolulu

25 24 23 22 21 20 6 5 4 3 2 1

Library of Congress Cataloging-in-Publication Data

Names: Eubanks, Charlotte D. (Charlotte Diane), author.
Title: The art of persistence : Akamatsu Toshiko and the visual cultures of
transwar Japan / Charlotte Eubanks.
Description: Honolulu : University of Hawai'i Press, 2020. | Includes
bibliographical references and index.
Identifiers: LCCN 2019021695 | ISBN 9780824878283 (cloth)
Subjects: LCSH: Maruki, Toshi, 1912-2000. | Painters—Japan—Biography. |
Art—Political aspects—Japan—History—20th century. | Art and social
action—Japan—History—20th century. | Atomic bomb in art.
Classification: LCC ND1059.M312 E93 2019 | DDC 759.952—dc23
LC record available at https://lccn.loc.gov/2019021695

Sections of chapter 1 appeared previously as "Avant-Garde
in the South Seas: Akamatsu Toshiko's 'Micronesia Sketches,'"
in *Verge: Studies in Global Asias* 1:2 (Fall 2015).
Copyright © 2015 University of Minnesota Press.

Portions of chapter 6 appeared previously as "The Mirror of
Memory: Constructions of Hell in the Marukis' Nuclear Series,"
in *PMLA* 124:5 (October 2009). Copyright © 2009 Modern
Language Association. These sections are reprinted
by permission of the copyright holder,
the Modern Language Association of America.

Jacket art: Akamatsu Toshiko. *Jigazō: Kubi tsuri*
(Self-portrait: Suffocation). 1944. Oil on canvas. 53.0 cm x 45.5 cm.
Private collection.

Contents

Illustrations

Figures

Color Plates (following page 78)

Acknowledgments

This book has been a long time in the making and, like all such projects, has benefited enormously from the generosity and support of many people and institutions. I offer huge thanks to Maruki Hisako, who quite literally opened up the vaults and allowed me to examine her family's correspondence, take prints out of frames to see what might be written on the back, photocopy Akamatsu Toshiko's diaries, and review hundreds of artworks in person. Okamura Yukinori, curator of the Maruki Gallery for the Hiroshima Panels, has consistently gone above and beyond, providing me desk space at the gallery on several occasions and granting unlimited access to all the gallery's holdings. He has also shared his own research, including his many files of newspaper clippings and his history of Maruki Toshi (nee Akamatsu Toshiko) and Maruki Iri's early years and artistic careers through 1950. Hisako-san and Yukinori-san, your trust and your kindness have made this project possible. *Kokoro no soko kara kansha shiteimasu.* Thank you also to the many members of the gallery's Tomo no Kai, who have assisted me in so many ways over the last decade.

Libraries are the academic bread of life. The staff of the Gordon W. Prange Collection at the University of Maryland were fantastically helpful throughout this project. Eiko Sakaguchi provided expert tips about using the Database of Newspapers and Magazines Published during the Post-war Occupation Period from 1945 to 1949. Access to this database early in the archival research phase was instrumental to the formation of the entire project. Amy Wasserstrom oriented me to the Prange's extensive archives and assisted in numerous ways over my many site visits, offering suggestions at crucial junctures. Kana Jenkins has been expert at handling various image and duplication requests. Equally amazing was the staff of the Cotsen Children's Library at Princeton University. Andrea Immel, Annalee Pauls, and Mingjie Chen, in particular, facilitated several visits to the collection and assisted with permissions and image requests. I also offer sincere appreciation to the staff members of the National Diet Library and the Asian Reading Room at the Library of Congress, who were helpful in more ways than I can enumerate here. Thanks also to the people of Jingūji temple

in Matsumoto, the Saitama Peace Museum, Kunishige-san of the Zentsūji Public Library, the Katzen Art Museum at American University, the International Library of Children's Literature (Tokyo), the Tokyo Metropolitan Tama Library, the Sanko Library (Tokyo), the Center for International Children's Literature (Osaka), and Zenshōji temple in Chippubetsu.

While working on this book I received financial assistance from a number of institutions. The Penn State Department of Comparative Literature and Department of Asian Studies provided a crucial year of research leave in 2014–2015, during which time the Institute for Arts and Humanities gave me office space and a research stipend. The Penn State Karako Fund supported my initial research trip to the Maruki Gallery in 2009. The Japan–United States Friendship Commission and the Northeast Asia Council of the Association for Asian Studies financially assisted follow-up archival trips in the United States and Japan. Thank you for the Friends of the Princeton Library Cotsen Collection Research Grant, the Miller Center for Historical Studies Twentieth Century Japan Research Award, and the Northeast Asia Council Research in US Collections Grant. I also express appreciation to the Schoff Fund at the University Seminars at Columbia University for their help in publication. Material in this work was presented to the University Seminar: Modern East Asia.

Thank you to all those who offered insights, criticisms, and questions at the various presentations I have given on portions of this research. Attendees at the Association for Japanese Literary Studies (February 2018), the Feminist Art Project at the College Art Association (February 2016), the Association for Asian Studies (April 2015), the Cotsen Library Speakers Series (October 2014), the Asian Studies Conference Japan (June 2014), the Center for Historical Studies at the University of Maryland (April 2013), and the Modern Language Association National Conference (January 2014 and January 2019) all asked great questions and helped me to situate this research more precisely vis-à-vis developments in art history, Japanese studies, gender studies, and history. The participants of the "Indigeneity at Sea" roundtable at the Global Asias 4 conference and the attendees of the 2017 Summer Institute on Trans-Asian Indigeneity pushed me to think in much clearer and more textured terms about the stakes of persistence, particularly with respect to Oceanic and Indigenous Peoples. They were Tina Chen, Erin Suzuki, Dean Itsuji Saranillo, Yu-ting Huang, R. D. K. Herman, Pasang Yangjee Sherpa, Neal Keating, Lindsay Skog, Yu Luo, Budhaditya Das, Micah Morton, Christine Horn, Megumi Chibana, and Suchismita Das. Ann Sherif has been a particularly wonderful interlocutor,

and she deserves her own special shout-out! John Treat and Alan Tansman both read and provided feedback on various grant proposals related to this project; thank you!

Thanks to all the graduate students who shared CMLIT 508: Global Visual Cultures with me, helping me to think through questions of visual time, media sovereignty, and material criticism: Victoria Lupascu, Ivana Ancic, Aurélie Matheron, Camila Gutierrez-Fuentes, Derek Gideon, Irenae Aigbedion, Phoebe Salzman-Cohen, Rebekah Zwanzig, Shiqin Zhang, Deena Al Halabieh, Clayton McKee, and Xiaoran He. Discussions with Kendra McDuffie, Wei-Chih Wang, Jinny McGill, and Molly Appel have also been useful for thinking through aspects of Japanese media and trans-colonial visuality. Discussions with these bright young scholars helped me to find the through-line for the manuscript, the story I wanted to tell. Thank you, all!

My colleagues at Penn State have been amazing, and I feel lucky indeed to be a part of this collective of smart, energetic, and generous scholars. Special thanks to Rose Jolly for her crucial insights as I was working through the introduction to this book, and particularly for her probing questions concerning the relationship between persistence and structural violence. Reiko Tachibana and Haruko Iwami provided valuable assistance in deciphering some of Toshi's handwritten notes in Japanese, while Adrian Wanner and Elena Galinova helped unravel some of Toshi's Russian transcriptions.

The University of Minnesota Press and the Modern Language Association have kindly granted permission to reprint parts of this book originally printed in their publications. Some sections of chapter 1 appeared previously as "Avant-Garde in the South Seas: Akamatsu Toshiko's 'Micronesia Sketches,'" in *Verge: Studies in Global Asias*. Portions of chapter 6 were initially published as "The Mirror of Memory: Constructions of Hell in the Marukis' Nuclear Series," in *PMLA*.

A warm thanks to Stephanie Chun, Emma Ching, and the team at University of Hawai'i Press for deftly shepherding this book from manuscript to bound volume, and to the two anonymous press readers for their helpful criticisms, suggestions, and references.

Most important of all, I offer deep respect and gratitude to my family, Etta Habegger and Maren Eubanks, who have been with me every step, and every page, of the way. You have braved typhoons, sweated through Japanese summers, shared frustrations, and celebrated joys. I can never thank you enough. You have my heart and soul.

Conventions

An important note is in order concerning Toshi's name. Though she married Maruki Iri in 1941, she did not change her name. She was already well known by her birth name, Akamatsu Toshiko, and preferred to keep it. In 1956, however, Iri's mother Maruki Suma was murdered. Toshi had been extremely close to Suma and chose to change her name in Suma's memory. Thus there are several variants of her name, all well attested in museum records, publications, and newspaper coverage: Akamatsu Toshiko, Akamatsu Toshi, Maruki Toshiko, and Maruki Toshi. In previous English-language scholarship she is known almost exclusively by her married name (Maruki Toshi). But the name she called herself most often was simply Toshi. To avoid confusion, I have followed her lead and will refer to her as Toshi throughout this book. Bibliographical entries, however, will include the name she used at the time of publication.

Much of this book grows out of archival research, and many of the arguments I make in the pages to come depend upon close examinations of handwritten manuscripts and pre- (or sometimes post-) censorship galleys and proofs. Because Toshi frequently revised her manuscripts in the process of writing them, I have also indicated instances in which she has struck out words (~~like so~~). In instances where she has so thoroughly crossed through and scribbled over the words as to make them illegible, I note this in the translation. Material she has added, as indicated by the use of arrows, for instance, I translate in regular syntactical order.

Introduction

Akamatsu Toshiko, Microhistory, and the Art of Persistence in Transwar Japan

> You are from a civilized country. And you dropped the atomic bomb
> and toppled the fascists. Thank you. But you know nothing about art.
>
> —Akamatsu Toshiko, *E wa daredemo kakeru*

The scene is downtown Tokyo. The time, spring of 1947, early in the US-led occupation of Japan. Our artist, in her mid-thirties, has set up a sketch board, pencils, and paper atop the Sukiya Bridge in the heart of the popular shopping and entertainment district of Ginza. Competing with the so-called *pan-pan* girls (street prostitutes) for the attention of young GIs, she offers to make sketches of the men or of photographs of their loved ones, girlfriends, and wives far away. Though by no means well off, she earns enough income from her newspaper articles, illustrated vignettes, children's books, and magazine illustrations to pay the rent, feed herself and her husband Iri, buy art supplies, and rent exhibition space for her oil paintings. But she is saving money for a bigger goal: to establish a new arts organization, the Zen'ei Bijutsukai (Avant-garde arts group). The goal of the Zen'ei Bijutsukai, as Toshi conceptualized it, was "waking up people's hearts through the process of making art" (*geijutsu to tōjite, hirakareru ningen no kokoro no mezame*); the group aimed to bring artists of all stripes (surrealists, naturalists, abstract painters, sculptors, photographers, and so forth), as well as amateurs and beginners, together to focus on the vision of "self-realization" (*jikaku*) and the creation of "people's arts" (*minzoku geijutsu*).[1]

What the man atop Sukiya Bridge wants is likely a "silk scroll portrait," a hyperrealistic genre of painting, something like a personalized

pinup, marketed as exotica to American servicemen stationed in Japan.[2] What he got was a caricature (*fūshiga*), a genre in which Toshi was deeply skilled and freshly interested. A poor temple kid from rural Hokkaidō, she had put herself through art school in the early 1930s by doing caricatures for day-trippers at Ueno Park. And just the year before, she had completed a series of caricatures of Class A war criminals while attending the International Military Tribunal for the Far East as a stringer for the communist newspaper *Akahata*. In addition, she published several postwar articles on the value of the caricature as a means for producing and supporting a democratic society.[3] There was something about caricatures, Toshi believed, something about sketch work in general and about the practice of looking closely at people and drawing what you see, that fosters a sort of honest reciprocity, a social leveling.[4] Unsurprisingly, when Toshi showed the GI what she had drawn, the young man was at first disgusted, comparing her sketch unfavorably to a photograph-like work he kept in his wallet. Wadding up Toshi's drawing, he started to throw it off the bridge into the water below when Toshi stayed his hand with her joltingly frank evaluation of his poor aesthetic sense. She cracked a smile, and in the end, Toshi recalls, they shared a good laugh.

I use this vignette as an opening because it is explosive. The speaker, Akamatsu Toshiko, is much more well known in English scholarship as Maruki Toshi, an artist who, along with her husband and longtime collaborator Maruki Iri, brought to the world visceral, heart-rending, and unstinting visions of the atomic aftermath and its ruination of human bodies. She and Iri, perhaps more than any other artists, are *the* standardbearers of an avowedly antinuclear art. Yet, here, she *thanks* an American GI for "drop[ping] the bomb and toppl[ing] the fascists," placing herself in a position of supplication before going on the offensive with her quip, "but you know nothing about art." Her words challenge us to know *more* about art, about bombs, about fascism, and about claims to "civilization" in transwar Japan.

Toward a Microhistory of Transwar Visual Culture

In this book, I examine the relationship between art and politics in transwar Japan, exploring these via a microhistory of the artist, author, and activist Akamatsu Toshiko (also known as Maruki Toshi, 1912–2000). I treat Toshi's life as a case of what microhistorians call the "exceptional normal," scaling up from the details of her lived experience to address key issues in modern Japanese history and visual culture: empire, colonialism,

violence, and gender.[5] In this regard, my work bears the strong imprint of *Alltagsgeschichte*, the German school of the history of everyday life that concentrates on twentieth-century dictatorships, and especially on the relationship of common people to fascist violence. Microhistory proceeds by building up and out from specific details: one begins with an event and the meaning given that event by the actor herself, moving on to identify relevant contexts, first small and local, and then moving into ever wider circles, thereby addressing overarching cultural issues and underlying structural forces.

As with the Italian approach (*microstoria*), German and anglophone microhistories begin with the assumption of agency, the idea that individual people are not merely expressions of structural conditions (such as empire) but instead are conscious actors who make choices about how to conduct their day-to-day lives. I find this a useful—and hopeful— approach to history and to culture, because "instead of pointing out oppressive structures that cripple and kill people, microhistorians highlight how people build, maintain, erode, or eventually destroy structures," thus emphasizing both agency (ability to act in the moment) and responsibility (for the past and to the future).[6] Like so many other Japanese people of her era—teachers, farmers, students, businessmen, doctors, and so on—Toshi made a life that stretched across the meteoric rise and spectacular fall of the Japanese empire. And, like at least some of them, she pushed back against structures of violence. In that, she is normal. What is extraordinary about her is that she left rich and varied evidence of her activities: sketches, diaries, oil paintings, notes for speeches, books, journal articles by the hundreds, photographs, and the like. Thus her story is a compelling example of how individual human beings navigated the historical landscape of big events in the context of their own small everydays.

Because this is a microhistory, I begin in every instance with Toshi. But this book is not simply a biography of the artist. Though full of personal details and portions of her life story, the book's main concern lies with narrating a social history of art, using Toshi's experiences and actions to examine the visual culture of transwar Japan, understanding that visual culture not as an (anachronistically) foregone conclusion, but as the accretionary result of a series of small, everyday, highly personal decisions. At the same time, building on the insights of Michael Baxandall and T. J. Clark, I hold that the artist—however full of agency—is but one contributor to the creation of a work of art, that she is enmeshed in (constrained by, enabled by) a larger culture in which and for which she

produces.[7] That is, while we can trace, in many cases, what Toshi as artist was trying to do with or through a certain work of art, we need also to attend to what other cultural actors—publishers, censors, government officials, school teachers, children, parents, museum-goers, sponsors—would have been likely to see in it. This is what Baxandall[8] calls the "period eye," while Clark (like Toshi, strongly informed by Marxism) reminds us that works of art, too, can act as agents, particularly with respect to defining and manifesting class interests.[9]

Active for most of a century, Toshi was incredibly prolific. The archives of her copious writings and varied artistic output, ranging from oil nudes to children's book illustrations, while the subject of several important studies in Japanese,[10] have yet to be introduced in English scholarship outside of a handful of excellent dissertation chapters.[11] Anglophone historians have tended to pigeonhole Toshi, alongside her husband and sometime collaborator Maruki Iri, as an antinuclear artist, with little reference to the remainder of her work.[12] My research opens the conversation to a wider spectrum, considering her body of work, and her continuing commentary on it, as a prism through which to examine Japan's twentieth-century experience. I cover many of the major historical moments of modern Japanese history—colonization and empire, war, the nuclear bombing of Hiroshima, the International Military Tribunal of the Far East (IMTFE), prewar proletarianism and postwar protest culture—telling a story not only about the tumultuous life of a nation, but also about how one person sought to shift and shape that nation's visual culture and to craft for herself a life of which she could be (mostly) proud.

On Persistence

The overarching concern of this book, then, is to explore how one might attempt (might have attempted) to live a socially engaged life as an artist across the ages of empire, war, defeat, and protest politics. Situating Toshi in this complex temporal milieu allows us to think through, at a microhistorical and fine-grained level, the possibilities for art and politics in mid-twentieth-century transwar Japan.[13] As John Dower has noted, both in popular discourse as well as in academic writing, the overwhelming tendency when discussing wartime culpability has been to resort to a passive plural structure that places responsibility for the war onto the shoulders of politicians and military elite. The popular postwar mantra ran, in essence: "We were fooled!" (*Damasareta*).[14] This rhetorical habit of clinging to the passive voice continues to exacerbate Japan's foreign relations with its

erstwhile colonial possessions and military targets in East, South, and Southeast Asia.

One of the main reasons Toshi's story is so compelling, both personally and intellectually, is that she struggled to confront this plural passive, coming to acknowledge her wartime activity and its moral implications. *The Art of Persistence* thus provides an account of one woman's path toward claiming the war years in an active, first-personal voice. As such, this study offers a bridge between the growing body of scholarship concerning imperial Japan (which has tended to focus on institutions)[15] and scholarship focused on the production of postwar memory cultures.[16] The present study also builds on developments in Japanese studies considering the experience of imperialism and fascism. As Ethan Mark noted recently, postwar anglophone scholarship concerning Japanese fascism has entered a third wave.[17] Shifting away from early postwar attestations of a "warped" modernity,[18] and building on examinations of Japanese imperialism as a combination of top-down directives with bottom-up initiatives,[19] third-wave scholarship argues for the porosity of the metropole/colony dichotomy, largely by emphasizing questions of gender, first-person narrative, and popular culture in order to "unearth and probe specific causalities and responsibilities."[20]

Over the last quarter century, scholarship has moved away from binaries of complicity versus resistance, and we have begun to see the recognition of other, more complex agential positions, often gained through close examinations of subaltern and colonial positionalities.[21] Finally, my approach in *The Art of Persistence* is also inspired, in part, by scholars in the environmental humanities who have begun to think through the lens of resilience as a variety of agency (rather than, for instance, as mere survivance).[22] Resilience assumes a subject position located within a precarious community. To a certain extent, Toshi attempts to occupy this position, as when she adverts to her working-class origins, her place in gendered social hierarchies, and the like. But the fact is she was also a colonizer, albeit a reluctant one: she grew up as a Japanese citizen in colonial Hokkaidō and later visited the Japanese mandate in Micronesia.

I want to put some conceptual pressure on this cluster of notional categories: agency, complicity, resistance, and resilience.[23] More specifically, I want to mark out a position that might be called, simply, persistence. Located somewhere in the messy and muddled gray area between complicity and resistance, persistence shares certain qualities with resilience: a commitment to not disappearing, a fierce act of continuing to take

up space, quotidian survival as having its own resistant edge. Unlike resilience, however, persistence is not rooted so firmly in precarity. Persistent subjects may act from deeply compromised positions and enjoy the privilege of problematic associations with the classes and peoples in power.

Persistence occupies adjacent, proximate, or overlapping territory with that of the reluctant colonizer, but is somewhat more radicalized. The hallmark is not a potentially entirely private emotional position, of ethical discomfort and reluctant cooptation, but rather an emphatically public-facing position of cultural production. A refusal to be quiet. An insistence on continuing to look and to comment on what has been seen.

Similarly, persistence takes some cues from strategic essentialism, the pragmatic shuck and jive of staying just this side of the law, of staying alive, insofar as persistent subjects make use of cultural expectations, stereotypes, and assumptions to make room for themselves, and to do so in a manner that often seems, with the benefit of sanitized hindsight, to be unseemly: bigoted, opportunistic, racist. But persistence is edgier than strategic essentialism, more apt to push the bounds of what is legal or permissible, in part because persistent agents typically enjoy more stability, more social privilege than strategic essentialist actors: in short, they can get away with it.

One final characteristic of persistence is that it is in constant contention with structural violence.[24] While a study of persistence requires a microhistorical approach, in that persistence happens at the individual level, to tell a story of persistence is—at one and the same time—to tell a story concerning structural violence. One might be tempted to dismiss persistence merely as resistance in a minor key. And yet to do so would be to replicate the gendered and classed binaries which dismiss the physical labor of brown people as "natural" and the domestic labor of women as "invisible" because not "worth" seeing. Persistence is hard work. It is daily work. And it is at times dirty, disregarded, unpaid or underpaid, unsung, and unrewarded work. But it is work that matters because, through their persistence, people can "build, maintain, erode, or eventually destroy structures" of violence.[25]

Finally, there is nothing at all clean or simple about persistence, though there is a core principle at work: a fundamental, threshold condition for bearing witness, for persistently speaking and consistently documenting, is the complex act of staying alive and at some degree of liberty. The question of how far a persistent agent is willing to go in order to preserve her life and to ensure continued liberty of communication

(publication, exhibition, etc.) opens onto a tangled and complex terrain of moment-to-moment decision making and compromised compromises. This book tells the story of one such set of compromises and, through tracing Toshi's life and work, traces the contours of what it took to be a persistent agent in transwar Japan.

A Life in Order: A Brief Biographical Sketch of the Artist

The six chapters of this book, while they follow a roughly chronological order, do not follow a strictly linear path, meaning that at times there is temporal overlap or temporal gapping between any two adjacent chapters. Driven by argument rather than by temporality, then, this book assumes a certain amount of basic familiarity with Toshi's major life events, and so a brief biographical sketch of the artist is in order.[26]

Born to a settler-colonial family in 1912, Akamatsu Toshiko grew up the daughter of a Buddhist priest in rural Hokkaidō. In 1929 she won admission to a women's arts college (Joshi Bijutsu Senmon Gakkō, also known as Joshibi) in Tokyo, graduating from the Western painting division in March 1933. For four years after graduation, she worked as an art teacher in the public school system, but she quit her teaching post in March 1937 to serve as a governess for a diplomatic family stationed in Moscow for a year. Upon her return in April 1938, she used her savings to buy a small atelier in the Ikebukuro neighborhood of Tokyo, where she devoted herself full-time to art, earning her first solo exhibit in March 1939. Following a failed love affair, she traveled to the Japanese mandate in Micronesia (Pacific territories awarded to the Empire of Japan by the League of Nations following World War I), where she sketched and painted from January to May 1940. In the fall of 1940, she met and fell in love with fellow artist Maruki Iri, who had been born to a farming family outside of Hiroshima in 1901. Already married, Iri was a well-established ink brush painter and sometime surrealist poet.[27] They began to live together at Toshi's atelier.

In 1941, Toshi traveled to Moscow a second time, living there from January until June, during which time she worked as a nanny for a diplomatic family. Shortly after Toshi's return to Japan, Iri received a divorce and she and Iri married in July 1941. Toshi continued her work as an artist, supporting both herself and Iri, largely on the strength of South Seas–themed illustrations for children's books and popular magazines. Learning that some sort of high-powered bomb had decimated Hiroshima, Iri traveled to the city, where he was joined by Toshi, in

mid-August 1945. The couple spent one month tending to the surviving members of Iri's family before returning to Tokyo. Once again, Toshi supported herself as a full-time artist, now mining her experiences in Moscow to provide illustrations for newspapers, magazines, and children's books. She joined the Communist Party and attended the International Military Tribunal for the Far East, which she covered in the party newspaper *Akahata*.

With Toshi suffering from radiation sickness and malnutrition, she and Iri moved out of Tokyo to a remote mountain villa, where they began to paint images of the atomic bombing. In 1950, they exhibited their art in what was the first-ever display of the human suffering caused by the bombing. For the next several decades, Toshi and Iri continued to add to their nuclear paintings, touring them throughout Japan and all over the world. In 1967 they established the Maruki Gallery for the Hiroshima Panels in the mountains outside of Tokyo. In 1995, the couple was nominated for the Nobel Peace Prize. Iri passed away later that year, and Toshi died peacefully in 2000.

Organization and the Chapters to Come: Three Red Lines

This book is organized into three sections, each of which revolves around a different "red line," so to speak. The first of these is geographical in nature, referring to the equator (*sekidō,* "red path"). This section of the book tells the story of Japan's attempts to become a great maritime empire, with colonial holdings stretching beyond the equator to the southern Pacific. Chapter 1 draws on Toshi's memories and experiences of a childhood spent in colonial Hokkaidō (a forgotten—because so fully integrated—colony) and connects these with her accounts of her time in the Japanese mandate in Micronesia, which she turned into numerous sketches and travelogues for the popular press. In making this north-south linkage, I highlight the imbrication, at personal and microhistorical levels, of the "inner territories" (*naichi*) of Meiji-era Japan (1868–1912) and the "outer colonies" (*gaichi, shokuminchi*) of the Taishō and Shōwa periods (1912–1989), arguing that northern acquisitions served as a visible and visualized template for the colonization of southern territories. Continuing this investigation of colonial expansion, chapter 2 reads Toshi's private diaries kept during her time in Micronesia against the backdrop of a generally fascist aesthetics of the late 1930s and early 1940s. Identifying various tools of para-graphic framing, I trace the ways in which Toshi's art was turned into graphic war materiel as part of the

"culture for little countrymen" (*shōkokumin bunka*) movement, and I limn the methods by which she sought to create a "critical inside" to the total war experience.

Chapters 3 and 4 cohere around political concerns, specifically the "red" party lines of socialist and communist culture, tracing the rise and fall of proletarian art and politics and protest culture in general, first from the 1910s to the 1930s and again from the mid-1940s to the late 1950s. Chapter 3 uses Toshi's experiences in Russia, her contemporary accounts of them, her sketch work, and her Moscow-related exhibits as a microhistorical window opening onto alternate visions of the future offered by proletarian culture and the difficulties in displaying those visions publicly in fascist Japan. Attending to the gendered nature of Toshi's life as a nanny and governess in service to a diplomatic family (a "downstairs aesthetic"), I forward the argument that Toshi's artwork participates in and helps to envision what we might call an artistic Proletarian Eastern Time, a major feature of which was an extensive artistic slipstream between Russia and Asia. By "Proletarian Eastern Time" I mean to identify a sphere of socialist-inspired artistic production that spanned much of East Asia and that was in active contention with Parisian Modernism. Chapter 4 places Toshi's work into conversation with leftist visual aesthetics, arts-related writing, and self-consciously proletarian literary genres such as reportage and "wall stories" (*kabe shōsetsu*). I also provide an in-depth reading of her 1949 manifesto *Anyone Can Make Art* (*E wa dare demo kakeru*) as a politically committed vision to art as naked persistence.

The final two chapters deal with an informational "red line," suggesting the red ink of the censor (both during wartime and afterward under the occupation) and the critical culture of postwar ethical self-reflection (*hansei*), itself a major part of Japanese-language discourse from the 1950s to the 1990s. Chapter 5 employs Toshi's art and writings as a microhistorical lens turned, now, onto an examination of artistic wartime responsibility and the long, in fact still continuing, process of Japan's struggle to come to terms with the histories and realities of aggressive wartime activity. Through narrating Toshi's struggles to confront her past, I simultaneously explore the still-unfolding understandings of justice as meted out by the International Military Tribunal for the Far East (IMTFE) and as mitigated through Japanese media coverage of it in the late 1940s and early 1950s. Finally, in chapter 6, I examine Toshi's collaborative series of nuclear-themed artwork, cocreated with her husband Iri between 1948 and

1982 as an example of "direct action," a term first popularized in Japan by the Meiji-era anarchist Kōtoku Shūsui (1871–1911) and later lionized by experimental artists of the late 1950s and 1960s. Thus, I argue for a scholarly rapprochement between proletarian aesthetics and avant-garde art, which modern scholarship has needlessly bifurcated.

CHAPTER 1

From "Northern Gate" to "Southern Advance"

Envisioning the North-South Expansion of Colonial Japan

In March 1922, the students and faculty of Chippubetsu Elementary School, located in a rural area of northwestern Hokkaidō, celebrated the end of the academic year with an art exhibit keyed to the set theme "The Sun Lights up the Waves" (*nikkō shōha*). Two students from each grade level were chosen to display their art. One of the children so honored was a third grader named Akamatsu Toshiko. Toshi's piece was a watercolor rendition of a candy box whose design showed the rising sun shining on the ocean's surface. It referenced, as did the art contest as a whole, the imperial dream and ever-growing reality of Japanese expansion in the Pacific. Visually and materially, the composition suggests that maritime territories and islands were consumable commodities, ready to be gobbled up like so many sweet bonbons. In fact, the exhibit at Toshi's school came less than two months after the island of Yap was assumed into the Japanese protectorate in Micronesia, and the sugar in the boxed chocolates would have come, no doubt, from large-scale Japanese-run plantations in Okinawa, Tinian, Saipan, and Rota.[1]

Toshi and her classmates, however, did not need to imagine the far-off islands of the Pacific in order to envision a colonial Japan. The island of Hokkaidō was living proof of Japan's ability to "light up" the landscape through effective territorial expansion, a process of "imperial formation" that included the relocation of native populations, the transformation of the landscape from forest to cornfield and grassland to mining operation, the construction of an overland highway system, and the building of various forms of imperial architecture ranging from temples and schools to administrative buildings and shrines.[2] When Toshi left school that day to walk home, she traversed a landscape no less

colonial than the one her school's art contest asked her to compose and to celebrate.

In this chapter, I focus on the elaboration of a visual culture oriented toward the material formation of Japan as a colonial and imperial power. I begin with a brief exploration of the rhetoric and vision of Hokkaidō as a (forgotten because so successfully integrated) northern colony. I connect Toshi's memories and experiences of a childhood spent in colonial Hokkaidō, and the artwork she produced then, with her accounts of her short sojourn as a young adult in the South Seas protectorate and the many sketches and travelogues she created out of that experience. In making this north-south linkage, I highlight the imbrication, at personal and microhistorical levels, of the "inner territories" (naichi) of Meiji-era Japan (1868–1912) and the "outer colonies" (gaichi, shokuminchi) of the Taishō and Shōwa periods (1912–1989). When Toshi decided, as a young adult, to travel to the Japanese mandate in Micronesia, she was, in many ways, following in her grandfather's footsteps, undertaking a settler-colonial path familiar to her from the lives of her childhood friends and neighbors. Furthermore, she was responding to a visual culture that was saturated with appeals to envision the manifest destiny, as it were, of a Japanese southern advance, which would match and serve as a counterpoint to Japan's already successful attempts to expand, define, and secure its northern borders.

The Northern Push: From Ainu Mosir as "Northern Gate" to Hokkaidō as Inner Territory

As numerous historians have shown, Hokkaidō was modern Japan's first colony and an important "incubator" of imperial ideology and strategy.[3] Though the Tsugaru clan, based in northern Honshū, may have established trading outposts in the Ainu homelands (Ainu mosir, called Ezo by the Japanese) as early as the mid-1400s, the first formal Japanese structures did not appear until the early eighteenth century when the Tokugawa shogunate established an office for Ainu affairs near the southern tip of the island. Several Buddhist temples were also constructed in the area, attesting to permanent settlements, and over the course of the 1700s the Japanese population grew slowly, constructing branch temples as their settlements crept northward.[4] The pressure to lay claim to the northern territories rose rapidly in the late 1700s, when the shogunate became aware of Russian exploration in northeastern Ezo. The shogunate responded by fortifying Japanese trading posts, dispatching samurai from two northern

Honshū clans (the Tsugaru and the Nanbu), and beginning survey and cartography work. When Russian attention was drawn westward by Napoleon's advances, the Tokugawa regime stepped down its efforts at exploring and securing what was sometimes referred to as its territorial "northern gate" (*hokumon*).

The idea of northern expansion, however, did not fade for long. During the Boshin War of 1868 to 1869, pro-Tokugawa forces, facing a rout on the mainland, fled north to Ezo and attempted to establish an independent state under the leadership of Enomoto Takeaki (1836–1908). Though Enomoto convinced Britain and France to recognize his fledgling government, he was defeated by Meiji troops in May 1869. Enomoto was pardoned and went on to serve in a variety of high governmental posts, including minister of the navy. Nor were the rebels the only ones to have northern lands in their sights. As James Ketelaar has shown, "The Meiji political order included Ezo in its calculations literally from its very inception. Fourteen months *prior to* Enomoto's defeat, in the third month of 1868," the soon-to-be Meiji emperor "gave his approval to plans for the basic overall structure of his new government. At this same meeting he also approved of plans to extend this rule throughout Ezo."[5] With the defeat of Enomoto's forces, the Office of Colonization (Kaitakushi) was established in July 1869 and Ezo, now claimed under the new name of Hokkaidō, came into formal existence in August of that year.

Buddhist institutions took a leadership role in colonization of the northern island and in the imperial formation of former Ezo.[6] Throughout the prosecution of the Boshin War, the Meiji state was bankrolled largely by the Higashi Honganji temple, headquarters of one branch of True Pure Land Buddhism. Eager to disassociate itself from the crumbling Tokugawa shogunate, Higashi Honganji submitted a formal request to the Grand Council of State (Dajōkan) asking for permission to build roads into the interior of Hokkaidō, to organize and relocate agricultural colonists, and to carry out proselytization work. Thus, the True Pure Land school of Buddhism was in at the ground level of the Meiji state's colonial expansion into Hokkaidō, providing much of the financing, labor, and organizational infrastructure. Temple construction in Hokkaidō had crept along with somewhere between a dozen and a score new structures being built every half century, mostly near the southern tip of the island, from the 1500s through 1850. The years from 1850 to 1867 saw an uptick in construction, with 43 new temples, but with the agreement between the Meiji state and Higashi Honganji construction truly skyrocketed, with 26 temples built in 1867

and 1868 alone.[7] Not surprisingly, True Pure Land became the dominant sect on the island, a position they held throughout Toshi's childhood and still hold today. The official register of Buddhist temples in Hokkaidō from 1938 lists 2,224 places of worship (*an*, *dō*, and *ji*), some 1,938 of which were full temples (*ji*). The lion's share of these, some 573, are designated as affiliated with True Pure Land.

From 1868 until 1874, Higashi Honganji–affiliated priests and lay believers led construction and settlement on the island, assisted by forced Ainu labor and criminals shipped north to serve on road crews. The Meiji government took firmer control in 1874 and the Office of Colonization was given an official mandate to recruit former samurai to relocate to Hokkaidō as so-called farmer-warriors (*tondenhei*). Between 1874 and 1890, when recruiting was extended to commoners (*heimin*), the Office of Colonization relocated several thousand families of ex-samurai status to the fertile Kamikawa and Ishikawa river basins in the western and southern parts of Hokkaidō. As Michelle Mason has argued, the idea was to trade on the affiliation former samurai still had with their warrior heritage and to reorient that identity in the service of the Meiji state, encouraging them to invest themselves in an enterprise that would serve the nascent government (through territorial expansion and resource extraction), rather than allying themselves with enterprises (such as continued uprisings and revolts) that would threaten to topple it.[8] In 1882, when the Office of Colonization was abolished, the *tondenhei* were inducted into the Imperial Japanese Army and in 1903 were incorporated into the 7th Division, which saw action in the Russo-Japanese War of 1904–1905, in Manchuria in 1939, and in Guadalcanal in both 1942 and 1943.

In short, rather than conquering Hokkaidō with military force per se, for the most part the northern territories were carefully reconstructed as "Japanese spaces"[9] by means of cultivation (*kaitaku*), immigration (*ijū*), and what Ann Laura Stoler has theorized as "imperial formation." Imperial formation focuses on the notion of ruination, a move that is meant to shift "the emphasis from the optics of ruins to the ongoing nature of the imperial process" and to draw attention to the "deeply saturated, less spectacular forms in which colonialisms leave their mark."[10] Further, a focus on imperial formation attends to the ways in which "empire's ruins contour and carve through the psychic and material space in which people live and what compounded layers of imperial debris do to them."[11] The concept of imperial formation throws into sharp relief the colonial ruination that is occluded in the simple renaming of Ainu Mosir as Hokkaidō. In Toshi's

time, however, the imperial formations of highway, temple, and cornfield could still seem new and even natural, at least to a young girl situated firmly within the colonial structure.

The Akamatsu Family as Settler-Colonials

Toshi's paternal grandfather was born in 1855, the son of a Kagawa Prefecture (northern Shikoku) family that was hereditarily in charge of a True Pure Land temple. He did not get along with his stepmother and so, in a family rupture, left Kagawa for Hokkaidō, where he arrived on January 26, 1892, with the idea of founding a new, grander temple and a separate family line. The first major wave of *tondenhei* from Kagawa came about half a year later, and he quickly found himself living with a community of families from his native prefecture. Until 1896, he worked, alongside many other immigrants from Kagawa, "opening the land" (*kaitaku*) in the administrative area known as Horobetsu-gun, which lay along the southern coast of Hokkaidō.

In 1896, Toshi's grandfather began to reconnect to his religious vision. He moved north to Fukagawa, where he took over an informal Buddhist site (*an*) that had been established by the 17th abbot of Zenkakuji (another temple based in Kagawa) and licensed to provide basic services to *tondenhei* families in the area. After petitioning for and receiving official permission from the Hokkaidō Bureau, Toshi's grandfather took up duties as a preacher (*sekkyōshi*) on December 28, 1901. On August 12, 1902, however, the structure burned to the ground, and he relocated farther north to Chippubetsu, the name of which is an Ainu toponym (*chikkushibetsu*) meaning "river with a path." The Japanese town had been established in 1895, when two hundred *tondenhei* families, mostly from Kagawa, were settled in the area and the Ainu relocated. Here Toshi's grandfather finally founded his long-imagined new temple in a renovated elementary school building.

In 1903, after both of his sons had declared their disinclination to take up hereditary priesthood, Toshi's grandfather adopted a fourteen-year-old boy from Kagawa Prefecture, who traveled to Hokkaidō and joined the family as the soon-to-be husband of eldest daughter Taka. The temple was officially recognized by the Hokkaidō Bureau, listed under the name Zenshōji with Toshi's grandfather as its founder, on December 17, 1906. On March 12, 1909, Toshi's mother and father were married. Taka bore her husband six children, five of whom survived to adulthood. Her youngest surviving child was Toshi, born on February 11, 1912. In 1928 a

children's Buddhist education club was established, and by 1938 a full temple compound was in place with 230 families on its *danka* registry.[12]

Thus Toshi's natal situation positioned her squarely at the triple intersection of cultivation (*kaitaku*), immigration (*ijū*), and imperial formation. Toshi's memories of her childhood are, in fact, shot through with romanticized colonial rhetoric. "My grandfather's generation opened up the vast muddy plains and virgin forests where bears still lived," preparing them for cultivation and settlement, she wrote, and she recalled that her father "grew up as the younger sibling of a *tondenhei,* calmly listening to the grunts of bears and watching the foxes thread their way through the rows of corn."[13] Note that Toshi's language participates in the official myth that Hokkaidō was a *terra nullis,* an unpeopled, virgin land awaiting Japanese settlement and taming.

Though she never mentions displaced Ainu and so seems to have been blind to imperial formation as experienced by native populations, Toshi was not completely unaware of a gendered differential vis-à-vis experiences of colonization. She notes that she never remembers seeing her grandmother smile; rather, the old woman was "always reciting the *nenbutsu* [invocation of the Buddha Amida's mercy] with this painful look on her face."[14] And Toshi's mother's tragically early death in childbed speaks to the real toll that colonial life had on women. Toshi herself was eager to escape that life and her own childhood duties of escorting drunken villagers home, keeping them from passing out in snow banks on their way back from temple activities. By contrast, Toshi's father and grandfather were not just priests; they were, in many ways, petty colonial administrators. As an adult, her father, in addition to conducting funerary rites and other religious duties, used the temple as a study hall, gathering young villagers to work on their school lessons in the agricultural off-season. Nor did Toshi simply live in a temple; rather, she was born and raised in a colonial structure that was licensed by the state for the purpose of claiming land and making it Japanese. As James Ketelaar has observed, in Hokkaidō, temples were created "with the explicit purpose of perpetuating, expanding, indeed constituting the imperial will."[15]

Seeing with Imperial Eyes: The Farmer-Soldier and the Priest

Toshi's earliest surviving artworks attest to the ascendancy of colonial settler culture in Hokkaidō and point to the deep connections between Western-style art and the Japanese imperial project in the late nineteenth and early twentieth centuries. Aside from a few botanicals, only four of

Toshi's early pieces are extant. Not coincidentally, all are oil paintings and all are portraits: two of military figures and two of religious figures. During Toshi's childhood and young adulthood, the medium of oil painting and the genre of the portrait were deeply associated with Western forms and imperial objectives, and cultivating proficiency in creating and in viewing oil portraits was a matter of intense concern for the Japanese government.

In a recent study, Emiko Yamanashi has provided a useful four-stage summation of the history of oil painting in Japan, which, she contends, was "determined by Japan's shifting relations with the West."[16] The first stage took place in the middle decades of the eighteenth century, when painters in the Satake clan began creating works utilizing Western-style perspective. Basing their studies on books imported from Holland, many of these samurai men were associated with the Institute for Barbarian Studies (Bansho shirabesho), whose Department of Painting (Gagaku-kyoku) was initiated by the Edo government in 1856. In stage two, which began near the end of the Edo period in the 1860s, Japanese painters were able to study, not just from books, but also with Western artists, mostly Italians who were imported to Japan in association with the newly opened Technical Art School (Kōbu bijutsu gakkō). In stage three, the 1870s and 1880s, Japanese artists were able to travel to Europe to study in person. And in stage four, starting in the 1890s, the first generation of European-trained painters returned to Japan to start instructing their countrymen.

As Ellen Conant reminds us, the Meiji government's decision to sponsor training in Western visual arts "was not based on aesthetic values but on the premise that it provided skills essential for the country's industrialization and national security." Indeed, she continues, "the first minister of public works, Itō Hirobumi (1841–1909) . . . believed that knowledge of Western painting, sculpture, and architecture was integral to the erection and decoration of Western-style structures needed to house the new technologies and institutions being developed and implemented by the government, without recourse to foreign expertise."[17] In other words, when Toshi began to study Western-style perspective and drawing as an elementary school student in the 1920s in the settler colony of Hokkaidō, she was being trained by her school teachers, themselves governmental employees, in what were understood to be skills of ocular modernity connected with mapmaking, industrial development, national defense, international relations, and empire building.

Toshi's next stage of artistic training was to take her directly to the nexus of state-sponsored arts education. In March 1929 Toshi graduated from her local high school in Asahikawa, and in April of that year she matriculated at the Women's Arts College (Jōshi bijutsu senmon gakkō), where she had won admission to study in the four-year Western Arts Teachers' Training Course (Seiyō gakubu shihanka), on the strength of her portfolio of sketches and still lifes. The school was located in the tony Hongō neighborhood of Tokyo and its annual tuition was set at seventy-six yen, a steep price Toshi's family was ill-equipped to provide.[18] In fact, most of Toshi's schoolmates were of a much higher social class, and many were the daughters of prominent military or diplomatic families. Toshi supported herself by selling cheap caricatures on weekends at Tokyo's Ueno Park, but her main concern was to excel at oil painting and to find a way to continue in her academic course.

Though innovative arts and design movements, such as MAVO and proletarian art, flourished in 1920s and early 1930s Tokyo, Toshi's schooling hewed closely to a conservative regimen, the hallmark of which was the oil portrait. At the time, the oil portrait genre carried heavy political freight. Throughout the Meiji period, "as new heroes of Japanese history emerged . . . Western-style oil painting was deemed an effective medium with which to represent these historical figures," meaning that the specific medium of the oil portrait was marked, for Toshi and her peers, as the preferred one for depicting historical figures in a lifelike manner.[19] The girls at Toshi's school learned to see, and to paint, their diplomat and soldier fathers, brothers, and uncles as modern national heroes.

All four of Toshi's surviving portraits from this period date to around 1930. It is likely that she painted them in Hokkaidō after her first year of schooling, as a visual argument in support of her being allowed to return to complete her course. Her *Portrait of Akamatsu Seijun* (plate 1) and her *Portrait of Priest Nisei Atsura* (plate 2) attest to her success at mastering the national hero subgenre of modern Japanese oil painting, and they suggest the ways she interpreted this genre through the lens of her colonial experiences in Hokkaidō. Toshi poses her model Akamatsu Seijun, who was a paternal relative, in his full military regalia. His *tondenhei* uniform speaks to his lifetime of service to the empire as an agricultural settler responsible for cultivating and defending Japan's northern lands.[20] Seijun's medal bar bears three awards. The starburst silver medal on the blue and salmon-striped triangular fold ribbon is an Order of the Sacred Treasure Eighth Class Silver Award. The award was established by the Meiji emperor on

January 4, 1888, to recognize distinguished merit, whether civil or military, often accomplished over a period of time rather than through a single outstanding action. This was the most commonly awarded medal for enlisted men, and Seijun likely earned it in recognition for his lifetime of work as a *tondenhei*, "opening" the island to settlement. A second medal, on the blue- and purple-striped ribbon, recognizes that this man saw duty in the Russo-Japanese War of 1904–1905, certainly as part of the 7th Division of the Japanese Imperial Army. The famed Bear Division (Kuma heidan) participated in both the siege of Port Arthur (which stretched from August 1904 to January 1905) and the Battle of Mukden (prosecuted from February through March 1905). The third medal, with the two red stripes on a white background, is an Order of the Rising Sun Seventh Class Award, which was awarded to low-ranking officers in recognition of lengthy service.

While Toshi's portrait of the soldier clearly connects to Japanese imperial ambition, her portrait of the priest—who is her father, in fact—is no less political in nature. He, too, is posed in full regalia. His sumptuous robes, including the enormous rosary, drape over and envelop his body, which simply provides a physical structure for the display of rank and standing. Just as the soldier Seijun is posed at attention (his back straight, shoulders squared, chin lifted, and eyes straight forward), the priest, too, assumes a bodily position keyed to command structure: the high red chair (*kōza*) marks him out as senior officiant. Read against the historical backdrop of Buddhism's role in the settling, development, and imperial formation of Hokkaidō, the priest's ceremonial pose in the oil portrait redoubles his authority, marking him not only as a religious leader but also as a colonial figure and a governmental agent of colonization. In both portraits, Toshi composes figures from her own cultural history—indeed, from her own paternal line—in a heroic frame while showcasing her academic and technical abilities as well as her skill at portraying the human form. As W. J. T. Mitchell has argued, in a different context, "the whole language of aesthetic judgment . . . is already saturated with colonial discourse. This is not a fact to be lamented or overcome but to be understood."[21] The key thing to understand here is that Toshi's artistic training taught her the skills to see and to portray imperial subjects through imperial eyes.

Lessons Learned in the North and Extended to the South

If Toshi learned and practiced her lessons in the north before moving southward, so did the expanding empire of Japan as a whole. Michelle

Mason has argued that Hokkaidō provided early-twentieth-century power brokers in Japan with the basic blueprint for the acquisition of imperial Japan's other, later colonies. Indeed, multiple strategies the Meiji government employed in Hokkaidō resurfaced as successful policies in later expansionist interludes. In Hokkaidō, the Meiji government chose to resettle a disenfranchised and politically problematic population group (ex-samurai) in the new territory, and repeated waves of settlement were aimed at overpowering, either by massively outnumbering or by dispossessing, the local population. Villages were located adjacent to major sources of raw materials and natural resources, which villagers were tasked with exploiting. Settlers were recruited via an explicit message of imperial glory while native peoples (*dojin*) were depicted as backward, barbarian, and in need of civilizing influence, often through the implementation of Japanese-language education and the reformation of their landscapes via the imposition of modern infrastructure.[22] Finally, textbooks and other visual materials oriented to the Japanese public made use of scientific language, such as that of biology and cartography, to assert that the lands being settled belonged to a Japanese sphere, that they were a natural part of the ecosystem and the biosphere of that imperial (and imperious) nation. Thus, Mason concludes, "visions and policies toward Hokkaidō were constructed by and contributed to the discursive and material creation of the modern Japanese nation and empire. Hokkaidō was the incubator."[23]

Many of these strategies are hallmarks of colonial practice around the globe, which tends to rationalize territorial expansion as a benevolent civilizing gesture while simultaneously instrumentalizing the placement of colonial settlements and infrastructures so as to expedite the removal of natural resources. But these were strategies the Meiji state was experimenting with for the first time in a concerted and directed way in Hokkaidō. The successors to that experiment, in the later Meiji era as well as the Taishō (1912–1926) and Shōwa (1926–1989) periods, extended the lessons learned in Hokkaidō to an enormous geographic area, including the Ryūkyūs (1879, renamed Okinawa), the Kuril Islands (1895, Chishima), Taiwan (1895), the Sakhalins (1905, Karafuto), Korea (1910), Micronesia (1914, Nan'yō), and Manchuria (1931, Manshūkoku, Manchukuo), not to mention more ephemeral territorial holdings in mainland China, Siberia, French Indochina, the Dutch East Indies, and Malaya.

While one might suggest the limited applicability of the Hokkaidō model in its entirety to many of these territories, particularly ones that

were more heavily populated, the core structures of the northern expansion *were* repeated in Micronesia. First, as in Hokkaidō, the total native population was relatively low (though settlement was much denser, due to limited terrain). This allowed waves of Japanese immigrants to literally engulf the native peoples. The 1940 *General Survey of the South Sea Islands* (*Nan'yō guntō yōran*) notes that while only a few score Japanese lived in the islands as of 1914, Japanese immigration skyrocketed once the mandate was in place. By 1940, there were 77,257 registered Japanese (*hōjin*) in Micronesia, to only 51,723 native Islanders. Further, the vast majority of the "Japanese" were, in fact, Okinawans who had been relocated from their own territories; they were joined by about 2,000 other internal immigrants from the Japanese holdings in Korea, Taiwan, and Karafuto.[24] As in Hokkaidō, then, the Japanese government used the "opening" (*kaitaku*) of colonial lands to resettle a potentially acrimonious population (colonial subjects, in this case, rather than ex-samurai) to borderlands and to impress them into imperial service as resource extractors and as guardians of the home islands.[25]

Indeed, each annual issue of the *General Survey* devotes its opening pages to a series of photo spreads, providing visual evidence of deforestation, the relocation of native populations (for compulsory schooling and medical training, for instance), shrine construction (including shots of bowing natives), and the erection of shopping districts, temples, farms, and mines. One such photo spread, titled "Development Continues to Move Forward," notes that on islands in the Palau group, "our so-called 'colonies' (*shokuminchi*) are being established under the guidance of the South Seas Bureau (Nan'yōchō) and development (*kaitaku*) continues apace. We can see the settlers' hard work and the fruits of their labors. Soon, a new South Seas will be born!"[26]

Finally, as with Hokkaidō, Japanese holdings in the South Seas were rhetorically and visually framed in terms of border solidification and safeguarding against territorial expansion on the part of other imperial powers. Indeed, the "economic advance to the South" quickly turned into a "militarized advance to the South" in the early days of the Pacific War.[27] If Hokkaidō was the "northern gate" that could not be left ajar, the South Sea Islands were branded as Japan's "life line in the Pacific" (*umi no seimeisen*).[28] These geographies were understood to be linked. For instance, the 1938 edition of *The New Imperial Geography* (*Kōkoku shin chiri*), a junior high school textbook, begins with a precise account of Japan's location.

Our Position

Our country, Imperial Japan, lies at the eastern edge of the continent and is chiefly composed of the Japanese archipelago, which stretches across the northwest Pacific, and the Korean Peninsula, which serves as a bridge to the continent.

The Japanese archipelago is made up of three crescent-shaped island groupings, separated from the continent in the west by the Okhotsk Sea, the Japan Sea, the Yellow Sea, and the East China Sea. [In the north, the Japanese archipelago is] sandwiched between lands ruled by Soviet Russia and [in the south] it lies in close proximity to China. To the east, North America lies far across the Pacific Ocean. The Korean Peninsula is separated from Manchuria and Russia by the Yalu and Tumen Rivers. In the north, Karafuto is divided at 50 degrees north latitude and Shumshu Island, at the far northern end of the Chishima Island chain, faces Russian-controlled islands across the Chishima Strait. The southern border of Taiwan is marked by the Bashi Channel, with Luzon Island in the Philippines lying far to the south.

Thus, with the South Sea Islands—our lifeline in the Pacific—and Manchuria—our lifeline on the continent—our country is in a position to ensure its own development and to secure peace in Asia.

Previous to the Meiji Restoration our country consisted only of Hokkaidō, Honshū, Shikoku, and Kyushu—now termed the "inner lands" (naichi), but since the Meiji Restoration our territory has more than quadrupled in size with the advent of suzerainty in Karafuto and Taiwan, the annexation of Korea, our gains in the Kwantung Leased Territory, and our mandate in the South Sea Islands.[29]

Thus the imperial gaze sweeps from Karafuto in the north to the Micronesian islands in the south. If one of the most pressing concerns for the Meiji state had been to "clarify the boundaries of what was Japan and what was not,"[30] imperial-era geography textbooks, such as this one, typically echo and amplify that set of concerns in their prefatory remarks, which focus on describing Japan's "position" (ichi) both as a geographical matter and as a political and rhetorical one. Japan's position on a map is presented, simultaneously, as Japan's policy position, its position concerning domestic territories and international relations. In the push to identify borders, Hokkaidō's status as a colony is repressed and it is claimed as part of the traditional homelands (naichi) of the Japanese, with the "outer territories" (gaichi) constituting something of a

Lebensraum-like buffer, the outer edge of a temporal wave of coloniza-
tion, immigration, and imperial formation. As Vivian Blaxell has noted,
"Hokkaidō became Hokkaidō when Japan's imperial discourse and its
elaboration in the material realm tended to vigorously assimilate colo-
nized space and colonized subjects as Japanese (Hokkaidō, Okinawa,
Korea) or represented colonial spaces and subjects as becoming Japanese
(Taiwan and Micronesia)."[31]

Toshi and the Discourse of Southern Advance

In the fall of 1939, Toshi could not have been happier. Though surviving
more or less hand-to-mouth by selling caricatures of pleasure seekers at
Tokyo's Ueno Park, she was living the life of a free artist, having success-
fully escaped the stifling role of priest's daughter in the small-town frontier
of Hokkaidō for formal training in the Western arts of oil painting and
dessin (understood in Japan as a style of quick sketching from life). And she
was in love. In October of 1939, Toshi went to the movies with her lover,
avant-garde painter Yamamoto Naotake (1907–?) to see the documentary
film *Yap*. She recalls, "Lustrous men and women in straw skirts dancing.
Coconut palms in fruit, banana leaves rustling in the breeze. Before we
knew it, we both sighed, 'Ah! I'd love to go!'"[32]

Two months later, when Yamamoto jilted her for another woman, that
is exactly what Toshi did. She sold her art, packed her bags, and bought a
one-way steerage-class ticket on a boat departing Yokohama on January 19,
1940, bound for the island of Palau, which was the diplomatic and military
hub of Japan's imperial infrastructure in the Pacific, headed by the South
Seas Bureau (Nan'yōchō) in Koror. While traveling south, she began keep-
ing a sketchbook, opening with a detailed study of the deck, which was,
needless to say, not as grand as the staterooms advertised in NYK (Nippon
Yūsen Kaisha, the Japanese mail shipping line) promotional images that
typically framed the voyage as luxurious. Versed in popular maritime lit-
erature, both from domestic production and via translations of works by
Herman Melville and others, Toshi in her sketches is attentive to the tools
of maritime life, while also indulging in romantic fantasy. "Like Gauguin
who died in Tahiti," she writes, "I wanted to continue doing my art in the
South Seas. I wanted to die in the southern islands. . . . The whistle sounded
and I held the bouquet to my chest. 'Farewell, farewell.' The boat pulled out
of the harbor and I waved my hands until they hurt."[33] Modeling herself on
the likes of Paul Gauguin (1848–1903), Robert Louis Stevenson (1850–
1894), Pierre Loti (1850–1923), and Herman Melville (1819–1891), Toshi

turned a gaze at once colonial and romantic toward the redemptive land-scapes and open horizons of the southern ocean.

During her five months in Micronesia, Toshi completed 186 *dessin* in addition to several oil paintings and the few score of sketches that appear in her notebooks. The *dessin* was a powerful visual media in twentieth-century Japan, and Toshi was one of its masters. The *dessin* artist employed a simple tool (pen, pencil, or charcoal usually) to render a line drawing on paper. The sketch was meant to capture not only the visible physical details of a scene, but also movement, emotion, and the dynamics of light and shade. Writing in 1947, sketch artist Kawashima Ri'ichirō describes the practice of *dessin* as follows: "If you want to sketch something, it's not a matter of capturing the surface form of the object made available by the reflection of light. Say it's a chestnut; if you just reproduce the surface of the chestnut, that's not art. Cezanne, in drawing his chestnuts, got under the shell to the meat of the chestnut's life force. That's what you have to do, if you want to sketch properly."[34] Like many artists active in the early to mid-twentieth century in Japan, Kawashima supported himself, at least in part, by publishing journalistic accounts of, and *dessin* sketches from, his travels. Indeed, like Toshi, Kawashima was active in surveying Japan's newly acquired territories, as in his 1940 account of travels in China.[35] In terms of subject matter, *dessin* tends toward figures of women and natural landscapes, often conflating the two (woman *as* natural landscape). For newspapers and publishing companies eager to feed the reading public's appetite for firsthand accounts of Japan's ever-growing colonial geogra-phies, the *dessin* was a gold mine: the black-and-white line art reproduced easily, even on poor paper, and could be counted on to provide eye-catch-ing appeal for expansionist copy.

Though Toshi frames her Micronesian experiences as engendered by a broken-hearted yearning for the balm of artistic freedom, her sojourn in what Japanese called the "South Seas" (Nan'yō) was part and parcel of that nation's transwar imperial experience across the long twentieth cen-tury. Japanese occupation of islands in the South Pacific began in the 1870s as power brokers in the nascent Japanese navy sought to ignite a "South Seas fever" (*Nan'yō netsu*), encouraging ex-samurai, politicians, and entrepreneurs to imagine the Pacific variously as "a territory in which to gain personal achievements and fulfill a sense of adventure," an expanse supposedly "untouched by Western imperialists and thus the optimal and logical place for the new nation of Japan to acquire colonies," and as "a potential economic treasure house awaiting exploitation through trade

and development."[36] Navy minister Enomoto Takeaki (served 1881–1882)—the same Enomoto who had earlier fled to Ezo in an attempt to keep alive the rebellion against the Meiji government—even attempted to buy outright the Marianas Islands and Palau from the Spanish. When this was unsuccessful, he bankrolled various societies that "encouraged Japanese exploration and expansion into the South Seas," one result of which was the discovery and annexation in 1889 of a small, barren island later named Iwo Jima.[37]

If Enomoto's territorial ambitions began with a rebellious land grab in Ezo before turning south with an official ambit, Toshi followed a similar trajectory. While Toshi's trip to Micronesia was not sponsored by the military, the artwork she later published in Japanese newspapers and journals nevertheless replicated an Orientalist gaze and thereby helped to raise the temperature of Japan's colonial fever. As Faye Kleeman has noted, early visions[38] of southward expansion, "consisting primarily of private citizens migrating to specific places" to pursue "dreams of becoming rich or famous," in time grew into the full-blown "colonialism of the 1930s and 1940s [which], by contrast, featured a comprehensive state-directed expansion of Japanese territory aimed at creating an enlarged sphere of Japanese control."[39] The navy organized regular training cruises in the South Seas and ordered its cadets to keep a journal of their experiences to share with new recruits, while also allowing a select number of civilian journalists on board to create literary accounts of the voyages. By the 1930s, Japanese literary treatments of the South Seas were dominated by the near-propagandistic accounts of "military service literature" (*jūgun bungaku*), and the popular press was full of illustrated travel accounts.[40] Toshi would go on to use her Micronesian sketches in one of two ways, both typical of the period: either as a study for the later execution of an oil painting to be exhibited and (hopefully) sold, or as line art to be used to illustrate journalistic travelogues and documentary accounts of events of public interest. Thus, though Toshi did not receive funding from either the military or the government, she did anticipate making money by participating in a government-sanctioned and military-sponsored publishing boom.

Indeed, when she first arrived on Palau, Toshi relied heavily on the personal networks and industrial infrastructures of Japanese "imperial formation." The day after she disembarked from the *Kasagimaru*, she presented herself at the South Seas Bureau, an imposing example of political architecture that housed Japan's colonial offices. There she met Hijikata Hisakatsu (1900–1977), painter, sculptor, and long-term resident of the

islands. Hijikata, himself a Tokyo-trained sculptor, was an avid collector of Micronesian folklore, and in the weeks that followed he guided her on several expeditions to nearby settlements, where she filled her sketch book with renderings of exotic plants and idyllic villages both on the nearby island of Anguar, where she remained from February 25 to 29, and in rural areas of Palau, such as Melekeok, where she overnighted on March 6–7.

While based in Palau, Toshi also cultivated relationships with political figures such as Dōmoto Sadakazu (then serving as section chief for internal affairs at the South Seas Bureau) and Wada Kiyoharu (of the Tropical Botany Research Center), with cultural attachés and media specialists like Noguchi Masaaki (head of the South Seas Islands Cultural Society, Nan'yō guntō bunka kyōkai), and a Mr. Morita from the local newspaper. She frequently dined with industrialists including Nakamura Mutsuo (of Kimi Fisheries) and a Mr. Saeki (who was associated with fishery supplies and pearl cultivation efforts and was known for running something of an artists' salon from his house).

Indeed, Toshi spent many evenings dining at the Kohatsu Club, the official watering hole for the South Seas Development Company (Nan'yō kōhatsu kabushiki kaisha, NKKK), which liked to promote itself as "the Mantetsu of the South," borrowing some imperial glory from the successes of the South Manchuria Railway Company.[41] The NKKK was based in Saipan, maintained a branch office in Palau, and advertised heavily in trade magazines from the early 1900s onward, typically employing a company logo embedded in a rising sun that itself shone down on a tropical landscape.

In fact, Toshi was able to arrange for a solo exhibit of some of her South Seas artwork, which was on view at the Kohatsu Club from March 15 until March 18. Dōmoto Sadakazu issued official invitations, Hijikata Hisakatsu wrote the words of welcome, Morita from the newspaper ran off the copies, and Saeki threw them all an enormous banquet on the evening of Sunday, March 17, 1940. Hijikata described the party in his diary: "We talked, listened to the phonograph, and feasted on tomato juice soup, *ngduul,* chicken coquille, duck *aburi,* potatoes, carrots, kiwi, asparagus, eggs, and beer. Pineapple, pie, and coffee for dessert. . . . It was a night the likes of which Palau had never seen before."[42] The show was a great success: Toshi sold enough of her work to be able to afford, some months later, a second-class ticket back to Japan by way of Yap, where she made an extended sojourn.

Though Toshi was obviously social with a number of men who were hardwired into the colonial infrastructure and industrial resource exploitation of the islands, she barely mentions them in her own writings, and (aside

from Hijikata, who served initially as her guide to local culture and intro-
duced her to many of his Islander acquaintances) she almost never pictures
them or identifies them by name in her sketches. In fact, though she cleverly
and diligently cultivated their company, she seems to have maintained some-
thing of a canny emotional distance from many of them, with the exceptions
of Wada and Hijikata, for whom she does express real affection.

Toshi's visual art is telling. In a rare departure from her usual subject
matter—which otherwise is almost exclusively concerned with Islander bod-
ies, structures, and flora—Toshi made a series of four *dessin* of Saeki's salon
on April 13, 1940. The first in the series, labeled "At Saeki's Place" (Saeki-san
no tokoro), shows five Islander men pulling in a net and beaching a canoe,
apparently returning from a day of fishing. The second—"On Saeki's Veran-
dah: It's Called a *Sentopōriya*"—is a close-up of a potted flower. So even
while enjoying the company of powerful Japanese men, Toshi focuses her
first two sketches on Islander bodies, the details of local tools (canoes, nets),
and the local names for indigenous flowers, betraying her intensive interest
in Palauan culture. With her next two sketches, however, she moves inside.
The third sketch, "A Salon" (Aru saron), shows a man wearing glasses, re-
clining while he smokes in a Western-style parlor, complete with a round
table, tablecloth, floral centerpiece, floor rug, and four wooden chairs with
cushions (fig. 1.1). Toshi has lavished detailed attention on the chairs and
flowers, while leaving the man's face unfinished: his cheeks, chin, mouth,
and throat are missing, as is one shoulder. Her interest seems to center on
the material signifiers of "civilization"—everything that makes the scene
look like a Western parlor—while obscuring the particular Japanese incar-
nation of it. Toshi drew the same scene again from a slightly different angle
in a sketch labeled simply "Salon" (Saron). Instead of a profile, she composes
the smoking man from a full frontal position. Again, her pencil records the
details of the flowers, the clock, and the chair, while most of the man him-
self is missing, a blank between his mustache and his elbows.

This represents an absolute departure from Toshi's regular composi-
tional protocol. When drawing Islanders, she almost always begins her
sketch work with face, hair, and hands, and she often includes the names of
her subjects as part of the sketch, at times also noting their ages, relation-
ships to one another, bits of conversation, and the place name. Why has
Toshi inverted that practice here, in the presence of Japanese high society?
Was she wary of these men? Reluctant to identify them (and her reliance
on them)? Was she concerned at showing these men in such lavish, West-
ernized surroundings, the smell of coffee and the sound of jazz nearly

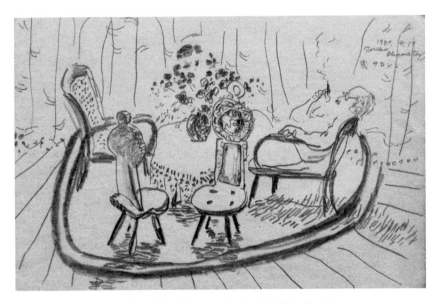

Fig. 1.1 Akamatsu Toshiko. *Salon* (Micronesia sketch #124). Pencil on paper.
26.0 x 19.0 cm. Private collection.

perceptible?[43] Was she bored of Japanese faces? Is her omission of their names and identities a sort of careful self-censorship? Or were they simply not the subjects she had come to sketch? Keeping in mind Kawashima's comments about the *dessin* as a visual discipline rooted in "getting under the shell . . . to the life force" of the subject, perhaps we can intuit that Toshi was aware of a certain interior life force with which she hesitated to make contact. Of course, answering questions of this sort and attempting to fill in belatedly the places left blank leads to conjecture. Fortunately, we can look elsewhere in her private notebooks for clues as to how Toshi felt about the Japanese presence (both on the individual and the imperial levels) in Micronesia, and from these gleanings we can begin to discern a regular pattern of omission, a practice of "self-redaction."[44]

Finding a Critical Inside: Toshi's Micronesia Sketches

Finding a critical *outside* during times of intensive ideological manipulation can be, when possible, both difficult and dangerous. From her childhood, Toshi, like all Japanese people of her generation and of the two generations before it, had been steeped in a visual and verbal rhetoric of Japanese exceptionalism and educated toward a belief in the inevitability of Japanese territorial expansion. In 1907, the Ministry of Education

established an official annual art exhibition (Monbusho bijutsu tenrankai, or Bunten for short), one indication of how deeply the government remained interested, and invested, in guiding arts and visual culture. Although the arts scene remained heterogeneous, and the year 1919 saw the first proletarian art exhibit in Japan, by 1922—the year the ten-year-old Toshi exhibited her "Sun Lights Up the Waves" assignment—the government was rounding up communists and socialists in Tokyo, an intimidation that intensified into persecution in March 1928 and again in April 1929, the month Toshi matriculated to arts college in the metropole. In June 1932 police interrogated 198 people associated with the Proletarian Arts Association (Proretaria bunka renmei taikai), less than a year before Toshi graduated college. In May 1937, the Imperial Navy sponsored the first display of "oceanic art" (*kaiyō bijutsu*) at the Mitsukoshi Department Store in Tokyo. That same year, the Japanese government added the Order of Culture (Bunka kunshō) to the roster of awards that civilians were eligible to receive from the emperor; in the inaugural year, nine individuals, no fewer than four of them painters, were recognized. In 1938, both the Imperial Army and the Imperial Navy began dispatching artists to the front lines as official correspondents. The same month Toshi and her lover went to see the documentary newsreel *Yap*, Toshi's oil painting of a Hokkaidō landscape (*Birch Forest, Shirakaba no hayashi*) hung at the First Holy War Art Exhibition as an example of the Nikakai group's new work.[45] As Alicia Volk has argued, the Nikakai (Second Section Society) had functioned as the "progressive wing" of Japan's national arts in the prewar period, serving as something of a foil to the more conservative First Section (Ikkakai) of the national salon and as a "regulatory valve" to adjust the pace with which Western aesthetic movements and forms entered the arts world in Japan.[46] That mediating space, the niche that Nikakai artists had carved out for themselves, was under close scrutiny.

In short, as Japanese political and geographical claims expanded, official toleration of ideological range and its visual expression contracted, a fact of life with which Toshi was intimately aware. During her time in the Japanese mandate in Micronesia, Toshi kept two notebooks that are filled with sketches, memos, vignettes, and diary entries. A close examination of these materials reveals that, unconventionally, Toshi intentionally cultivated a personal, open-ended approach to the Islanders she sketched, situating them as interlocutors, rather than positioning them (only) as colonial objects of desire. An analysis of these sketches, and of the occasional notes and diary entries she jotted down on, around, and between them, also

affords a glimpse into what I would call a growing "critical inside" to Toshi's perceptions of Micronesia and Japan's place in it.

An analysis of the first sketches Toshi composed upon arriving in Palau provides a sense of her working practices and the ways she cultivated relationships with her Islander subjects.[47] Shortly after disembarking at Koror on January 26, 1940, Toshi completed a series situated at one of the major sites of colonial and cultural transfer. The Catholic Church on Palau was established by Spanish Capuchins in 1891 and transferred to German leadership in 1907. While non-Japanese missionaries were allowed to stay in place through the 1920s, by the mid-1930s Japan had begun replacing all foreign missionaries with Japanese nationals as imperial policy in the South Seas grew increasingly secretive, presumably in order to enable the fortification of the islands, the deepening of harbors, and the emplacement of Japanese naval fleets. Though dependent on these colonial structures, Toshi largely ignores them in favor of intimate depictions of people and landscapes. Even in her most stereotypically colonialist sketch, that of the Catholic father reading to his parishioners, she allows a reciprocal gaze: while most of her subjects look at the text (perhaps of the Bible), two children peer steadfastly back at her, a breaking of the frame that the artist seems to have welcomed (fig. 1.2).[48]

Indeed, Toshi followed up on the visual exchange, sketching three of her subjects a second time, now posed on a breezeway with the church windows in the background, and she took the time to learn their names and included these as part of her sketch, a remarkable practice in a time when most Orientalist art tended to treat native peoples as nameless extensions of landscape (fig. 1.3). The youth Dorienko is recognizable as the curious boy from the previous sketch, Mis [sic] Deleo provides another profile along with a coy side glance, and Miss Kalisita becomes more than her bob haircut (just visible over her friend's shoulder in the church interior sketch), favoring the artist this time with a full frontal smile.

This process of cultivating visual exchange is a hallmark of Toshi's work, and she tends to provide transliterations for the names of the people she sketches, particularly if the composition is frontal and rendered in enough detail that the person is individually identifiable. As other early sketches attest, she was interested in family structures, naming practices, and in-group gestures of affection (fig. 1.4). In what appears to be a family portrait, Toshi sketches the mother Elaku, an unnamed daughter, and sons Habino, Elalulu, and Alubelto. "Alubelto" is likely a rendering of the name "Alberto" or "Albert," whose father might be the "Adam" who is named but

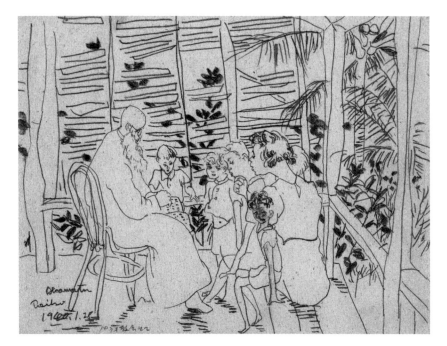

Fig. 1.2 Akamatsu Toshiko. *At the Palaun Church* (Micronesia sketch #25). January 28, 1940. Pencil on paper. 19.0 x 29.5 cm. Private collection.

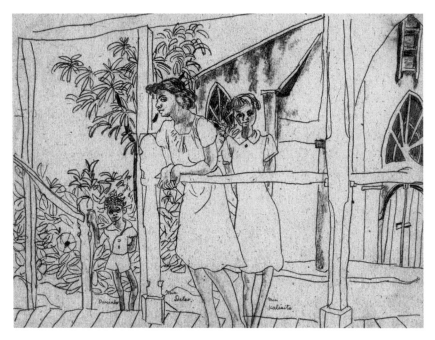

Fig. 1.3 Akamatsu Toshiko. *Dorienko, Mis Deleo, Miss Kalisita* (Micronesia sketch #28). Pencil on paper. 18.5 x 24.5 cm. Private collection. Though not dated, the sketch is almost certainly from January 28, 1940.

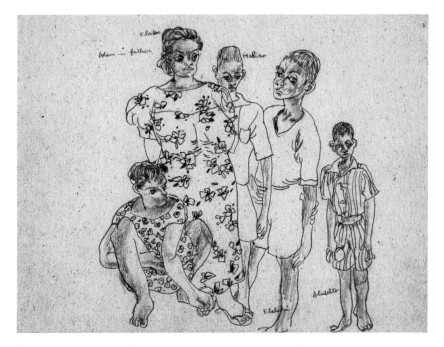

Fig. 1.4 Akamatsu Toshiko. *Adam Is Father. Elaku. Habino. Elalulu. Alubelto* (Micronesia sketch #33). Pencil on paper. 18.5 x 24.5 cm. Private collection. This sketch probably dates to January 28, 1940.

not pictured. Alubelto stands apart from the group, a subtle commentary on what may be a mixed-race status. In these early compositions, Toshi struggles with skin tone and facial feature, but her sketches are of real people rather than racial caricatures.

Toshi's notebooks include lists of vocabulary and useful phrases, which she learned in order to navigate basic social interactions with Islanders without having to rely solely on the colonial tongue of Japanese. Indeed, the first page of her Palauan notebook consists of a series of bilingual phrases.

Teiyangaran	What is this?
Teiyangaruke	Where is it?
Keburungattogoi	That was a silly thing to do.
Maruomoshiroiyattokoi	Interesting!

Teiyan	garan	kureru	Garan	kureru	teiyan
This	what	name/call	What	call/name	this

What is this?

Ankureru	Your name
Amoyotsufu	A cabbage-like tree. Blooms in April.
Garuke	What
Shinmu	Something you say when a tree has a lot of fruit on it.
Mugusei mokurotsuremu	Take that
Mu teiyanmokurotsuuremu	Take this
(Kumumowarotsuuretsuku	I am going to take this.
[not legible]	((I am staying at Irattakawo's house.))
(Bobaddo	I'm going to sleep)
(Meiwaiyu)
(Kamuruudo	One more time)

As later entries attest, vocabulary gathering was a regular practice for her, and as she traveled to different islands, she learned new words in new languages. Upon arriving in Yap, for example, she began composing a second list of key phrases.

Aan	What is it?
Arumurugaamu	Where are you going?
Kogobu	I'm here/it's arrived.
Arugon	Yes.
Daga	No.
Dabuguwan	That's not allowed.
Anigiri	That's OK.
Boadeigin	???????????
Tafoferu	Friends
Magaran	Hat
Shiyusurogu	My shoes
Kayamugaru	Thank you
Moi	Welcome
~~Gamaritan~~ Guwan	Bye
Chibiku flower	[Here Toshi has drawn a sketch of a flower]
Yomayoma	Ototōru [A shell; this had been Toshi's nickname on Palau.]
Munine	Coconut
Aanmunime	Reef

In addition to these phrase lists, the notebook also includes an early sketch (#36) of a carved figure with the names of anatomical features spelled out in the local language, along with the transliterations of the words for "Thank you," "Hello," "Yes, that's so," "What is this?," "Beautiful," "No," and "Ah." Though the sketch is not dated, its placement in the notebook indicates that she completed it before January 30, that is, within just a few days of her arrival in Palau.

In short, Toshi was learning to talk to Islanders in their native languages. With her basic stock of phrases, she could conduct simple conversations. "Hello. My name is Toshi. What is your name?" "Ah, that's beautiful." "What do you call this?" "Thank you." "Hey, that's not OK!" Furthermore, sporadic diary entries and notes scribbled on the back of some of her sketches suggest that Toshi often used the occasion of sketch work itself to cultivate relationships with Islanders (fig. 1.5). On February 11, not quite two weeks after her arrival, Toshi sat on the beach sketching crabs when a young Islander man walked up behind her to see what she was doing. His footsteps scared the crabs away, and he walked over to the water's edge to fetch her another. Toshi writes:

> As he squatted there I watched his back: he had bronzy brown skin and wore [illegible]-colored clothing, his long legs bent upward like upside down Vs [illegible]. Just as I was thinking it'd be interesting to draw him like that, he came trotting back, "Look! I caught you a crab. Draw it!" he said, and held it on his palm with his long fingers. It was a red crab.
>
> The crab tried to scamper off sideways, but, when trapped [in the young man's hands] it flattened its body and pulled in its legs.
>
> "Draw it." He held the crab so that I could see it as well as possible, pressing lightly on the crab's back with one of his fingers. Laughing in a moment of inspiration (an Islander holding a crab), I sketched the crab, sketched the hands, sketched the steepled legs and the back and the head and the eyes and nose, and, before long, I'd sketched the Islander who'd captured the crab.
>
> "All done!" I said, and he tossed the crab aside. He stared at the sketch. Realizing I'd drawn, not just the crab, but him, he looked a little puzzled.

The sketch and the supporting prose reveal some of the ways Toshi had found to connect—albeit not on entirely equal terms—with individual Islanders. Typically, she would seat herself prominently in a public place,

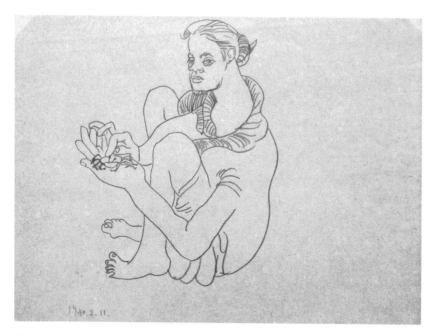

Fig. 1.5 Akamatsu Toshiko. *Untitled* (Micronesia sketch #51). February 11, 1940. Pencil on paper. 18.5 x 24.5 cm. Private collection.

take out her pencil and paper (or sometimes her palette, brush, and canvas), and begin to draw or paint. She would generally begin by composing frames of landscapes (plants, the horizon, the sea) or the exteriors of buildings (the Catholic church, a boathouse, a wharf, a large communal building called an *abai*), or particular tools (a canoe, for instance). If someone approached, curious, to look at her work, she would begin a conversation with them, exchanging names, pleasantries, and sometimes Golden Bat cigarettes. More often than not, she would end by sketching the people with whom she had been speaking.

In short, though enmeshed in its own colonial historicity, much of Toshi's sketch work resists an aesthetics of domination. In fact, some of her private notes concerning the Japanese colonial presence were scathing. On January 30, for instance, Toshi composed a sketch of two men. One is visible only in profile through a window, and the other is in the white pith hat and button-up collared shirt that functioned essentially as the colonial uniform. The sketch is labeled, *"Onbūrugau abai. Iremiderebai abai,"* the names of two of the local meeting houses, the high-gabled *abai* at which Islanders (generally men) would gather. While sketching the two men

inside, Toshi seems to have had a conversation with two Islander children outside, which she records, in part, on the reverse of the sketch.

1. From two kids. Mother was killed by a soldier and died. A fight broke out, with shouts and cries in their house, so were frightened and ran away. This happened in Koror on the main island.
2. Fight on Koror, main island. Firearms and an American war boat came. They took the firearms and -ed the Islander soldiers . . .
3.[49]

Though perhaps parts of the conversation were mimed, most likely Toshi's information was relayed partly through Hisakatsu, himself no great admirer of the Japanese colonial presence. Hisakatsu was fluent in several Micronesian languages and often accompanied Toshi during her first weeks in the islands. His own diary entry from January 28 indicates that Toshi was interested in the *abai* and that Hisakatsu had begun to introduce her to their architecture and cultural meaning, as well as to some of his Islander friends, who would have had some knowledge of Japanese. While Hisakatsu's presence and his contacts were no doubt useful in helping Toshi establish connections with Islanders, Toshi's gender also assisted. That is, in some instances (especially when speaking with women and children), she achieved some access and privileges that may not have been accorded to Japanese men, who may have been perceived as (and, indeed, often *were*) more threatening. In Toshi's memo, the identity of the soldiers (presumably Japanese) remains unspecified. Similarly, the final sentence of point two ends in ellipses, omitting the sentence-ending verb, while point three is left entirely blank, leaving the impression that the litany of wrongs listed here is incomplete, possibly an omission stemming from self-censorship.

Not quite a month later Toshi composed a series of sketches that included another critique of Japanese rule. The two sketches, dating to February 25, show an older and a younger man squatting by a canoe (sketch #52) and a young girl peeking out from behind the post of a boathouse (sketch #53). On the reverse of the second sketch, Toshi has included a lengthy note (fig. 1.6).

Palau
On my way to the Koror wharf. On the left-hand side is a boathouse built by the Islanders. Just as I passed by, the roofing was blown aside by a breeze and I could see two canoes inside. Red canoes stored there. I wondered if someday this beautiful building with its curving roof

and beautiful [illegible] would fall down and its pieces be used by thoughtless people for firewood. Looking [illegible] at the [scenes of] human sacrifice in each corner, I wondered [illegible] in their earliest incarnations. Comparing them to the [illegible] of Egypt and Greece, they seemed to hold little promise for [artistic] development. Anyway, those were the sorts of thoughts I was having. But after a while I could feel them exerting a strong, startling pull on me. Between the strange warping of light, the reds and yellows of refracted light from this southern sun, and the absolute fixity [of the carvings], it felt like [the carvings] wanted to pull people down under the earth—their veracity tugged at me. And to think that its fate is to be torn down soon. Next to it there's already a newly built shipyard and a hastily built boathouse with a galvanized zinc roof where they're building steamship after red-painted steamship. And the kids at the local Japanese school in their [illegible] clothes and [illegible] have the same fate as this boathouse. What is it that they're hiding away inside [their hearts] as they play there, atop the canoes?

1940.2

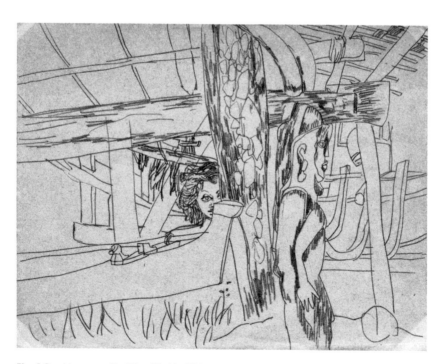

Fig. 1.6 Akamatsu Toshiko. *Untitled* (Micronesia sketch #53). February 25, 1940. Pencil on paper. 18.5 x 24.5 cm. Private collection.

Though not truncated, as in the earlier entry, the critique here still remains oblique, obscured by the faintly Orientalist and exoticizing prose that proceeds it. The beautiful architecture of the boathouse as Toshi describes it contains within it a certain savagery, and Toshi's vision of the carvings pulling viewers under the earth to serve as a human sacrifice plays on the age-old fears of cannibalistic natives. But exactly whose savagery is being hidden here? That of the young girl, playing amongst the canoes? Or of the two men fishing peacefully? No, if there is violence being hidden here, it has to do with the destruction of native architecture and its replacement with hastily built factories producing fleets of Japanese ships. Further, Toshi suggests that architectural destruction is linked, also, to the destruction of native children, primarily (if not exclusively) through the instrument of Japanese-language schooling.[50]

Toshi's perceptions of Japanese rule in Micronesia had clearly begun to sour. Speaking candidly many years after the fact, Hisakatsu recalls that by mid-March, Toshi was ready to get out of Koror. "She said, 'Anywhere is fine, just take me some place where there aren't any Japanese people!' So I invited young Wada Kiyoharu, a researcher at the Tropical Botany Research Center, and we headed to Kayangel. Toshiko's joy was unbounded, and before long she was fast friends with the Islander girls, and she went off with them and learned the songs and dances (the *matomaton*)."[51] Toshi, Wada, and Hisakatsu remained on Kayangel, a small island not quite a day's trip from Koror by steamboat, from March 20 through March 31.

The only other Japanese person with whom Toshi interacted during this time was the steamship captain who brought them to the island and who was responsible for the regular runs between Koror and Kayangel. Toshi's description of him is by far the most damning portrait in her diary, and it indicates something of her reasons for wanting to leave Koror. She spent the morning of March 29 sketching her friend Iratsutakatsu with her house and her chickens (fig. 1.7). Though the scene appears idyllic, Toshi's entry in her private notebook is anything but flattering. It reads, in part:

Just then the ship's captain from yesterday reached out and grabbed a short stick. Waving it around he started whacking randomly at the leaves of the *sakazuki* and walked in our direction.

"Good morning," I say.

He responds, "Ugh. So boring. I've done a circuit of the entire island. [illegible sentence] How about you—aren't you bored?"

"Me? Nope, not in the least. It's all so interesting."

He looked at me like he wasn't quite convinced, and then spoke to Iratsutakatsu.

"Oy! Oy! There's chickens everywhere. I bet you have no idea how many of them there are, right?"

"Sure, I know how many," Iratsukatsu replied.

"Nah. How many then? Thirty of them? Twenty maybe? Counting them is a pain, so I bet you've never done it," and, waving his short stick around again, he headed off in the direction of the palm grove. I wonder why the captain, normally so upbeat, finds this island so boring. Maybe it's because, for people like the captain, they actually want a tsunami to come now and again, or a wild beast to crash out [of the bushes]. ~~And so he waves his short stick around and, every now and again, strikes it across the buttocks of one of the island girls, and shouts at her and~~ So one day they head over to an island where they won't be bored, where not a single Japanese (*hōjin*) person is around, and they decide [illegible word] to take up with a woman. I don't find the captain awe-inspiring; I think he's beyond that, a sick creep (*fushigina hito da to omofu yorimo motto fushigi na arui wa kurutta yatsu da*).

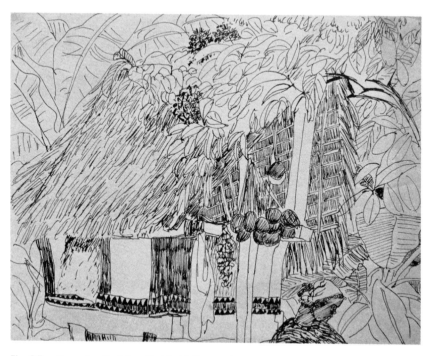

Fig. 1.7 Akamatsu Toshiko. *Untitled* (Micronesia sketch #98). March 29, 1940. Pen on paper. 18.5 x 24.5 cm. Private collection.

Though Toshi often lightly struck through passages in her diary, as she was searching for the right words or trying on different phrases, in this instance she has marked through a passage ("And so he waves his short stick around and, every now and again, strikes it across the buttocks of one of the island girls, and shouts at her and") heavily enough to render it almost illegible. This is clearly an instance in which she wrote too much and too directly, and she knew she had crossed the line of what was and what was not permissible to say in imperial Japan. Even in the (supposed) privacy of her own sketchbook, she felt the need to redact her words.

In his work on literary censorship in transwar Japan, Jonathan Abel has described the ways in which, almost from the point of its inception in 1868, the modern Japanese state began to develop "modern press laws regulating expression" in order to control both sedition or the disruption of public order (*annei chitsujo bōgai*) and obscenity or immorality (*fūzoku kairan*).[52] The laws, and the activities of official censors, reached a crescendo in the years between 1927 and 1936, during which time "more books were banned by censors and more passages were redacted by editors than in any other period before or after." This resulted, he suggests, in "the internalization of an explicit command to self-censor or at least self-redact."[53] Toshi's doubly crossed-out passage reflects this broader culture of thought control. Her depiction of a sadistic Japanese steamship captain satisfying his bloodlust by beating an Islander woman with a baton across her ass may have opened her to charges of both obscenity and sedition. Like her literary peers, Toshi had learned to anticipate the censor's work and to pre-emptively perform it, by redacting her own words (as in this instance), by cloaking her critiques in oblique language (as with the boathouse example), and by simply not allowing herself to write down certain thoughts (as with the eerily blank point #3). I would argue that these few examples, recovered through an attentive reading of her private notes, make up the traces of a "critical inside," a deep wariness Toshi had developed concerning the Japanese imperial formation of Micronesian people, places, and things.

Publishing the Critical Inside: Public Versions of Private Vision

Despite her misgivings (and the condemnation and ire underlying them), Toshi needed to support herself, to pay her way, and this she did by marketing both her visual art and her travel vignettes to popular Japanese magazines. Like many other Japanese artists of the period who had spent time abroad, Toshi turned to colonial reportage as a source of income. She

begins her first such publication, the July 1940 "Places in the South Seas," with an extended quote. The speaker, an unnamed "representative of the South Sea Islands Cultural Society" (no doubt Noguchi Masaaki), beseeches Toshi to counter all the popular misconceptions of the South Seas as cultureless islands populated by "wild beasts, poisonous snakes" and cannibals, and to use her publications to play up the wonderful culture and infrastructure that has been built up under the Japanese mandate: hotels, department stores, the Nan'yō Jinja (the island's central Shinto religious site), and so forth.[54] Toshi ventriloquizes herself agreeing, while noting that even as she found herself saying, "Sure, sure," her eyes were drawn instead to the bronze-skinned Islander women. "Where did they live? In what kind of house? What were they thinking, and what made them happy?" she wonders. She concludes the essay, "In the end, I fled the bursting-with-culture capital of the cultured South Seas for a remote island with no Japanese people (naichijin). No doubt I was spoken ill of: 'An artist comes all the way to the South Seas and all she's interested in are the Islanders!'"[55]

After returning to the Japanese main islands in late May of 1940, Toshi soon set about reworking some of her diary entries into publishable magazine articles. Aside from the one-page item cited above, her earliest effort appeared in August in the pages of Kaizō, a journal "at the center of the literary world" and thus "also a major focus of censorship."[56] Comparing her private notes to her published article allows a glimpse into the pressures and practices of censorship that impinged upon Toshi, as well as the creative mechanisms she used (including euphemism, obliqueness, writing between the lines, self-redaction, and self-censorship) to navigate them.

Toshi's initial diary entry is an amusing portrait of colonial failure.[57] Initially scheduled to depart Koror for Kayangel on March 19, the Japanese-built steamship (possibly one of the red-painted products of that hastily built shipyard she so despised in her private diary) had run into engine trouble and was not seaworthy again until late morning on the 20th. Though the crew and the captain (who will shortly wield his stick on Kayangel's flora, in the diary version) were able to get the ship running, Toshi describes a "strange vibration" and a "dull rattle" coming from the engine room before the engine "cut out completely" some miles from shore. Deciding to pass the time by working on her diary, she takes out her pencil and notebook, but just as soon as she starts writing, "the engine leapt to life. My pencil jumped up and down in rhythm with the surging engine and I could hardly shape a single letter." She continues:

After a while it just got aggravating. So I held the tip of my pencil against the paper and just let it move along freely and ended up with this jagged line of angular mountain shapes. Whenever the engine revved ridiculously, the pencil-mark mountains would take on wondrous proportions and then, when the engine idled down, they'd get smaller again. Looks just like a seismograph, I chuckled to myself. I repeated this experiment again and again and at some point I must have nodded off while examining my handiwork, waking only when the captain came to announce that we were approaching Garasumao. Cruising along the western coastline, we could see a reef off in the distance northward and, clearing this, the varied shapes of the main island's mountains on the right. As we sped along, the palms gave way to a coast of mangroves, pierced at one point by the reef, upon which a jetty had been heaped up and, at the very tip of this, a tiny palm-thatched embarkation hut scoured to a crusty white by the winds and waves. After the cargo of timber had been landed, the boat set off again. The Islander women who had gathered at the embarkation point stared silently at the departing boat, but when I flapped my hat at them, they waved their arms high in the air, laughing.

The engine chugged along, apparently back in good form now, and we sped along the green sea, puffing out white smoke as we went.

Today the sea gave us no fish for the line we'd run off of stern, but the journey itself was tranquil and cool.

Though the searing tropical sun casts a powerful light, just before it reaches your skin it meets with the cold breeze rising off the transparent green sea and all the heat dissipates, leaving only a fierce white light to batter the body.

Cruising through the light green seas, we came in sight of the white reef and now and again a large fish would dart past.

The shadow of the boat fell through the water and came to rest on the reef playing along in the water's depths, and along with it my shadow perched on the gunnel. Clearing the reef and entering the open seas, the boat began to rock gently and I swayed my body as if I myself were making the boat roll. This wonderful sense of well-being welled up within me and I raised my voice in song. One of the Islanders' story-songs. Some of the Islander women sprawled out on the deck joined me and we sang along in these preposterously loud voices, almost throwing the words back and forth. But no matter, for our high noon midsummer venue was little by little drowned out by the undulations of the sea.

Her diary entry ends at this point. The entire previous page of her notebook is, indeed, filled with the jerks and jolts of her pencil, the graphite lines of jagged peaks and dips attesting to the truly erratic state of the ship's engine.

The entry maps three interrelated terrains, with Toshi transcribing each through the medium of her seismographic pencil. One layer of her narrative comprises a description of the terrain: the shapes of the mountains, the coast of mangroves, and the jetty. The boat's mechanical troubles provide a second layer, curiously akin to the first, as Toshi's ironic pencil records the "ridiculous" sputtering of the engine and the resulting "jagged line of angular mountain shapes." Finally, Toshi's emotional responses to these two stimuli provides a third layer, as her inner terrain shifts from anger at the frustrating inability to write clearly, to bemusement at the involuntary wiggles of her pencil, to the joyous sharing of song. Given the narratives of Japanese cultural triumphalism—and indeed the League of Nations' logic in awarding the mandate to Japan as the representative of cultural enlightenment and civilization in the Pacific region—Toshi's sketch of her entry into Kayangel is amusingly deflationary. The Japanese craft (the *Chichibu-maru*), named after an industrial hub city just outside the major port of Yokohama in the home territories, smokes and belches its way to the jetty, so that the acquisitive, colonial gesture of mapping a new terrain is simultaneously also a mapping of Japanese mechanical and technical failure. The discord between these two provides a place for the eruption of artistic jouissance.

How did Toshi package this amusingly ironic, bitingly sarcastic view of Japanese prowess for the pages of *Kaizō*? Not surprisingly, the published piece is dominated by a logic of ventriloquism, the cunning work of an eraser, and some geographical sleight of hand.

X Month X Day

Though the searing tropical sun casts a powerful light, just before it reaches your skin it meets with the cold breeze rising off the transparent green sea and all the heat dissipates, leaving only a fierce white light to batter the body.

Cruising through the light green waters, we came in sight of the white reef. Now and again a large fish would dart past. The shadow of the boat fell through the water and came to rest on the reef, and along with it my shadow perched on the gunnel.

The engine purred along smoothly as the small boat sailed into the open waters.

The boat rocked gently and I could see the town of Koror rising above the horizon and then dipping below it again.

People who come to the South Seas think that it's all still savage down here. Just the other day some student or other showed up with all sorts of foodstuffs crammed into his pack, saying it would be a shame to run out of provisions while in the South Seas. "What are you on about?" I asked him. "Look there—paved roads, department stores, cafes, Japanese women flitting along—no reason to be homesick here!" As he was talking to me, fronds from a row of palm trees swayed back and forth, shading his helmet.

A flight of brilliant white steps led up to the high floor of the colonial offices with their red gates, catching the cool breezes. At the post office a young Japanese woman from the home islands tossed her permanent wave gently as she took care of the desk work.

The palms gave way to a grove of mango, and dark bluish shadows fell on the pure white clothes and the white helmets [of the colonial officers], whose white shoes click-clicked along. The South Seas and Koror: truly, these are cultured places.[58]

Obviously the scene Toshi pens is entirely different in this version and is little more than a panegyric to the clean, brisk efficiency of Japanese enculturation in the Pacific. Rather than belching its way toward a remote island, the steamship purrs its way into the main harbor at Koror, site of the South Seas Bureau. Though she lifts the topographic descriptions directly from her private journal (the fish darting by, the flora, the reef, the searing tropical sun), the boat she coasts in on is the very definition of shipshape, and the artist's personal, interior terrain has been completely effaced, rubbed out, along with the voices of the island women, in whose place we find the iconic white-clad figure of the colonial administrator, his homily on progress usurping the women's shouted song. Though the piece is titled an "illustrated diary" (e-nikki), this is not so much an act of self-writing as it is a feat of self-erasure in which the only vestige of the author is a shadow sunk on a reef.

This initial entry and its laudatory tone might also be understood, however, as buying Toshi a little room in which to navigate more freely in the three further entries included as part of the article.[59] The second "diary" entry describes Toshi's interactions with an Islander woman she is sketching while Hisakatsu looks on. In this piece, Toshi laments the erosion of Islander women's agency. "Before the economic power of the *naichi*

reached the island, women also had a large degree of mobility in terms of land ownership. Now, though, the land has been converted for copra production for the *naichi* and has been turned over to the men for cultivation, and so the women have grown quieter and quieter."[60] While Toshi had been unable to see the ruination visited upon Hokkaidō through the cultivation (*kaitaku*) of its landscape and the displacement of its native peoples, her time in Micronesia has taught her to see through imperial eyes, in both senses of that phrase. That is: both to see *with* imperial eyes and to see *through the falsehoods* of an imperial gaze. The result is a sort of double vision. She concludes the section: "The white sand path burned my feet. The plumerias' scent was cloying as Hijikata told me these stories about the Islanders."[61] Sentences we might read *between the lines,* understanding the burning white path as a doubling of the brilliant white uniforms and the cloying scent of flowers as a visceral indication of the body being permeated, not entirely willingly, by an outside force.

The fourth "diary" entry reiterates this practice of double vision. Opening with an exotic description of near-naked, dark-skinned women dancing (typical colonial exotic-erotic fare), Toshi concludes, "I marveled at what a strong race they were, knowing how to weave and wear the straw skirts, remembering how to build the meeting place, even knowing how to cultivate the taro. [. . .] I closed my eyes, full of the feeling that I wanted to depict, with true reverence, the long, long history" of their culture.[62] In direct contrast to the opening vignette, which lauds Japanese-led development, here we have an homage to native society.

Using the same technique of frontloading with praise for an Imperial Japan, Toshi pushed her critique of Japanese development in Micronesia even further three months later, in a piece titled "Painting the South Seas: Two Views" that she published in the women's journal *Shinjoen.* The first "view" consists of a conversation between Toshi and an Islander girl named Mekaru. A fairly flattering portrait of Japanese rule, the dialogue attributed to Mekaru suggests that, enlightened by her Japanese education, she has chosen to forgo premarital sex, to delay marriage until her early twenties, and to marry "someone who goes to an office, to a company, and who has money," that is, someone from the *naichi.* Indeed, Mekaru reveals that she is saving money, "doing laundry and dress-making for Mrs. Nakamura" in the hopes of joining a tour group to Tokyo, where she can see steam engines and snow.[63]

The second "view" is where things get interesting. Toshi's gaze turns now to a portrait of a young man bearing the ubiquitous Japanese name

Tarō, generally bestowed on first-born sons (fig. 1.8). Tarō is wearing a school hat and a scarf, both of which mark him out as having completed at least some schooling in the Japanese education system, but little else. He is sporting only a red loincloth and several tattoos, one of which is a Rising Sun flag crossed over the flag of the Imperial Japanese Navy. Tarō, the article notes, is "mixed race" (*konketsuji*). Tarō tips his hat to Toshi and then begins mimicking her artist's habit: in an amplification of Toshi's usual practice of cultivating a reciprocal gaze, they draw pictures of one another and take turns critiquing one another's efforts until a sudden squall blows up and soaks their materials. Passing time while waiting for the rain to stop,

> Tarō reached into his bag, woven from coconut leaves, and pulled out a betel nut. He sprinkled some slake lime on it, and then tucked it into his cheek and began chewing. I must have looked jealous, because he laughed and "Here," he said, handing me a nut and sprinkling some slake lime on it.
>
> Nervously, afraid of what might happen, I gave it a chew.
>
> I thought my tongue was going to burn off!
>
> "Spit it out if your tongue is burning," he told me. So "bleh" I spit it out.
>
> The peach-colored spit fell onto the waves.
>
> "Bleh." This time my spit was crimson. That whole side of my mouth was warm, and then the heat spread to that side of my head, and then my whole head. A feeling of drunkenness spread through me. I spit the red juice again and again into the clear blue waters.
>
> Tarō said his father was Japanese.
>
> And his mother was a Kanaka. He was headed out to work as a seasonal laborer. To the island with the phosphate mine.
>
> Tarō's mother is awaiting his return. But Tarō's dad isn't around anymore. All Tarō knows is that he was Japanese. Tarō's face paled and he got goose bumps on his skin, tattooed with the Rising Sun and Naval flags. He chewed his betel nut and spit, "bleh bleh," spit out that red juice.

Toshi has taken the descriptions of betel nut chewing directly from a diary entry she wrote on March 21, when she was on the boat to Kayangel for the second day of the journey. Toshi had overslept and missed breakfast, and an Islander woman mischievously offered her some betel nut to

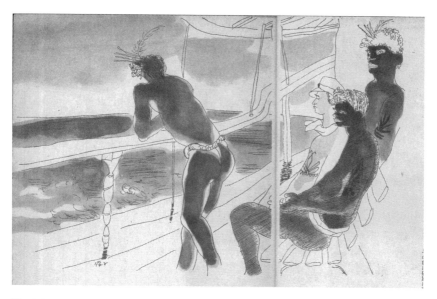

Fig. 1.8 Akamatsu Toshiko. *Untitled*. Published in her article "Nan'yō o egaku: Futatsu no fūkei" (Painting the South Seas: Two views), which ran in the November 1940 issue of *Shinjōen* (New woman's garden).

chew. Toshi ended up with a horrible headache and the woman rubbed her shoulders while she fell asleep. Repurposing that experience for the readers of *Shinjoen,* Toshi replaces the Islander woman with Tarō, visible as the markedly lighter-skinned man in the accompanying sketch. In the person of this young man, Toshi sketches a view of what imperial formation does to young bodies, revealing a Japanese paternalism that operates via mechanisms of sexual conquest, abandonment, resource extraction, and displaced labor.[64]

How far were the consumers of *Shinjoen* prepared to read between the lines in November 1940? That is a question that is impossible to answer definitively. Toshi, however, had come a long way from the (literally) sugar-coated visions of colonial expansion that she illustrated as a ten year-old. "The Sun Lights up the Waves" was no longer an abstract slogan promising the sweetness of candy, the sugar for which was harvested in Japan's colonial holdings in the South Seas. She now saw through imperial eyes with a double vision, and the once-intoxicating prospect of being Japanese in the South Seas now tasted like a burning hot fire in her mouth, a red wad of spit to be hawked into the sea.

Imperially Formed

In this chapter, I have sought to limn the ways in which Toshi, the land-scapes in which she lived, and the people with whom she lived, were imperially formed, shaped by mechanisms of development (*kaitaku*), processes of immigration (*ijū*), and cultures of seeing that emphasized a mandate (both notional and, in Micronesia, legally sanctioned by the League of Nations) for Japan's colonial expansion. Toshi was largely blind to the imperial formation of Hokkaidō, in part because of her age (a young child), in part because of how utterly embedded she was in the colonial structures (temple, school, soldier-farmer), and in part because of how thoroughly educated she was in the practices of imperial vision via training in the arts of perspective, sketching, and oil painting and via acculturation to the cultures of "oceanic" and "Holy War" art exhibition. If she was unable to see the highways, temples, and cornfields of her youth as an imperial ruination of Ainu and their lands, she learned to see the shipyards, governmental offices, Japanese-language schools, and phosphate mines of Micronesia through a doubled vision in which imperial formations were, at best, highly ambivalent structures.

Though her writings are freighted with their own colonial baggage, in particular a neo-anthropological tendency to exoticize and romanticize, Toshi does try, in the private writings of her Micronesian notebooks, to engage with native peoples and customs in a direct, interpersonal, authentic manner. Amidst the intensive atmosphere of internalized censorship that had become mandatory for those who wished to survive in the Japan of the late 1930s and 1940s, however, Toshi struggled, in the months after her return to Tokyo, to bring elements of this doubled vision to the pages of mainstream Japanese periodicals. Perhaps not surprisingly, her words about Tarō spitting a Rising Sun of betel juice into Micronesian waters were almost the last comments about the South Seas she was to publish in adult-oriented venues until after Japan's defeat in 1945. Indeed, Toshi's very last piece for an adult audience, "Soliloquy in the South Seas," utilizes the conceit of a dream. Tired from working on her art, she enters an *abai* and falls asleep. She dreams of moving permanently to the South Seas, building her own atelier with a long veranda, good light, a desk, a bed, and a radio. She would invite all her poor, tired out, disheartened artist friends from Tokyo to live with her, so long as they were content to eat taro and copra instead of rice and butter, and she would bathe in the stream instead of a bath. In the final sentences of the essay, she calls out to her friends (all Islander women), "Mekaru! Eseru! Ebiru! Help me! Help me!" and, as she fades into

wakefulness, she can just make them out "coming closer, so close." One senses that Toshi knows her dream is unattainable, and she seems to find herself drowning in its impossibility.[65]

Perhaps self-redaction was too difficult and the task of interweaving romantic colonialist prose with pointed social critique was too risky for Toshi to continue publishing her double visions for adult audiences. Whatever the reason, Toshi switched genres. The essays for adult readers in *Shinjoen* and *Kaizō* gave way to a different publishing venture: children's literature. Toshi's South Seas–inspired illustrations for children's books and periodicals sustained her through the war years. I turn to these materials and to Toshi's role vis-à-vis the government-sponsored development of "culture for little countrymen" (*shōkokumin bunka*) in the next chapter.

CHAPTER 2

Creating "Culture for Little Countrymen"
The Total Mobilization of Toshi's Micronesian Experience

On March 30, 1940, Toshi sat eating a breakfast of miso soup and taro root, looking out over the tropical forest of Kayangel toward the sea and waiting for the arrival of the delayed Japanese steamship on which she had booked passage back to the main island of Palau. She struck up a conversation with a sixteen-year-old Islander girl named Odeuruguru and recorded their exchange in her notebook: "'It'd be nice if the *Venus* never came, wouldn't it?' asked the girl. 'Well, if the *Venus* never comes, I'll never be able to go back to Palau and I'll never be able to go back to the *naichi*. But I don't really care.'"[1] In later memoires, she recalls that she had begun to hatch an extraordinary plan: "About one kilometer north of Kayangel [. . .] lay a small, uninhabited island. At high tide, the luxuriant green of the palm trees was mirrored beautifully in the shallow water. It's no larger than two kilometers in circumference, I imagine. At low tide, the sea recedes gently and you can walk along the reef from Kayangel. Someone suggested the South Seas Bureau might sell it to me for 50,000 yen. 'I want an island. That island,' I said."[2]

Toshi imagined herself becoming an enlightened settler colonial. Encouraging herself with the story of a Catholic priest who, working alone on the island of Yap, modeled a sculpture of Christ from seashells and constructed a church around it, Toshi envisioned herself "waking early to sketch and paint, in the evenings to use my telescope to gaze at the mirror-like moon and be washed in its light. Living all alone on this island. From time to time, I might provide medicine to sick or injured people from Kayangel, who would come walking to me along the white reef at low tide."[3] In short, having paid the Japanese government for the land, Toshi would set up her atelier on the small island, listen to jazz records, paint and draw

pictures of the native flora, fauna, and people, and sell those artworks to consumers back in the home islands, a sort of resource extraction that, while not nearly so damaging as phosphate mining, nevertheless relied on the "mining" of a certain kind of raw material (Islander poses and framed landscapes), its construction in Japanese hands into a finished product, and its removal from the point of origin.

Ultimately, however, the *Venus* did arrive, taking her back to Palau, and Toshi departed Micronesia for the Japanese home islands on May 25 on the NYK ship bound for Yokohama. Her intention was to sell enough of her Micronesian work to Japanese collectors to be able to return to Micronesia to live permanently. Three months after her return to Japan, during which time she created several oil paintings based on her Micronesian sketches, Toshi managed a solo exhibition of four works: an *abai* on Palau, an Islander girl (her friend Mekaru, actually), an Islander laborer headed to a seasonal job (Tarō, discussed in chapter 1), and a painting of Islander women on a moonlit beach.[4] Toshi's painting of Mekaru is striking (plate 3). The painting—a head and shoulders portrait of a thoroughly modern girl (complete with Western dress and a bobbed, permanent-wave-looking hair style) who just so happens to have the unmistakably dark skin of an indigenous South Seas Islander—captures the influences of a seemingly benign Japanese (modern, enlightened) presence in the southern mandate.

As a flyer announcing the exhibit attests, the paintings hung at the Ginza Kinokuniya Gallery from September 6 through September 10, 1940, accompanied by a series of short write-ups composed by Toshi.[5] The Ginza was a major shopping district, known for the luxury goods and foreign wares available there. As Noriko Aso's recent work shows, department stores had emerged as "cultural showcases" in early-twentieth-century Japan, positioning "themselves alongside—and sometimes in competition with—state cultural institutions," so Toshi's choice of locale was both a natural one for an artist of her time, and an expedient one that positioned her artworks as items available for purchase by a well-to-do clientele.[6]

In this chapter, I excavate the ways in which Toshi's Micronesian experience and the artworks she made from it were transformed into graphic war materiel. I place her art in the context of the generally "fascist aesthetics"[7] of late 1930s and early 1940s Japan, situating it more precisely amidst the cultural mandates of the *shōkokumin bunka* ("culture for little countrymen") movement. In so doing, I trace what I call the "total mobilization" of Toshi's art, charting her work against the expansion and contraction of the theater of war, and chronicling the rise of the child as a literary

Fig. 2.1 Akamatsu Toshiko, Illustrator, Kimura Sōjū, author. *Sekidō kairyū*. Tokyo: Fuji shuppansha, 1940. The oil painting Toshi used to produce the cover image for Kimura's book was based on a pencil sketch she completed on February 25, 1940. Toshi's notes on the back of that sketch critique the destructiveness of the Japanese rule in Palau, which she saw as destroying native culture, native people, and native architecture.

subject and, simultaneously, as an imperial soldier or colonial administrator in the making. Through close readings of Toshi's work, I also develop the concept of "para-graphic" framing, drawing attention to the various verbal devices publishers, censors, authors, and editors employed in an attempt to delineate the particular ideological work that graphic art was meant to perform for the nation.

Mobilizing Experience

Though Toshi did not raise enough money to return to the South Seas, she did catch the eye of a number of artists and publishers, in addition to the regular shoppers and other foot traffic. The visitor's log[8] includes the names of artists Komoda Morisuke (1918–1980, an oil painter), Yamamoto Naotake (dates unknown, an avant-garde painter and Toshi's former lover), and Maruki Iri (1901–1995, a Japanese ink brush artist and Toshi's future lover). Other visitors included Nakatani Yasushi (1909–1993)—an oil painter and children's book artist who sometimes worked with Tsubota Jōji (1890–1982), himself a children's book author—and Tatsumi Seika (1905–1973), a children's book author, poet, protégé of lyricist and poet Kitahara Hakushū (1885–1942), and some-time contributor to the children's periodical *Akai tori*.

In a word, Toshi's career was launched. But launched in a direction that would take her not back to the South Seas of her dreams, but rather directly into the choppy waters of imperialist publishing and that would make her famous not as an oil painter but, largely, as an illustrator of children's books and juvenile literature. By October 1, 1940, she had completed a commission to provide the cover art and frontispiece for Kimura Sōjū's *Sekidō kairyū* (Crossing the equator), a journalistic account of Kimura's travels to the various fronts of the Japanese imperial war in South China and the South Seas[9] (fig. 2.1). The advertising wrapper for the book reads in part: "Today, on the world stage, any number of nations are rising up and any number are falling into ruin. On a quiet night, if you listen hard, away by yourself, you can almost hear people on faraway mountains and plains beyond your vision screaming in a fight to the death. How many tens of thousands of bodies rising up, how many tens of thousands of souls connecting with our hearts!"[10] Kimura continues, noting that he has collected in this volume the most compelling stories, selected from his broad experience on the Chinese continent, in Southeast Asia, and in the tropics. The copy concludes, in bold, triple-sized type: "This is it! The book [giving the rationale for] our national policy of southern advance! The new literature of the Co-Prosperity Sphere!"

Toshi's cover art shows two young Islander women in a boathouse, partially concealed by a red outrigger canoe, an oil painting based on her sketch of February 25, 1940 (Micronesia sketch #53). As discussed in chapter 1, Toshi's notes on the back of that sketch critique the destructiveness of the Japanese rule in Palau, which she saw as destroying native culture, both its architecture and its bodies. "The kids at the local Japanese school," she had written, "what is it that they're hiding away inside as they play there, atop the canoes?" Toshi's private journal entries hint at a complex mixture of hidden emotions and thoughts ranging from fear to attraction, anger to allure. But the advertising wrapper (which, coincidentally, folded over the young girls' faces, covering their mouths) stifles those thoughts, shutting down possible avenues of critique, however faint. Instead, the copy asserts the fighting cries of revolution rather than the cagey silence of uncertainty, claiming the lands and peoples of southern Asia and the Pacific, as well as Toshi's depictions of it and them, as an imperial battleground. In short, the advertising copy placed on top of Toshi's cover art lies directly at odds with the private memos she recorded on the back of the study sketch.

Not all of Toshi's work was for such hawkish endeavors. Her next commission, submitted in December 1940, was to provide cover art for proletarian author Kaneoya Kiyoshi's novel of exotic colonial romance *Hatsu koi* (First love).[11] Toshi was also invited to help form a publishing firm, Kodomo Bunka-sha (Children's culture company), focused on producing artistic (that is, less militarist) children's books. She and her collaborators Kitagawa Tamiji, Terada Takeo, and Kubo Sadajirō managed to publish one book (Kitagawa's *Maho no tsubo,* The magic jar) and galleys for two more (Toshi's *Yuki no kodomo,* Children of the snow, and Terada's *Watashi no ningyō,* My doll) in 1941 before closing down, citing lack of capital and paper shortages.[12] Nevertheless, Toshi did continue to draw on her Micronesian experience to support herself through the war years, providing illustrations for a wide variety of publications, including ethnographic accounts of Pacific natives like *Otsukisama ni nobotta* (Climbing to the moon, 1943), the propagandistic naval account *Umi no ko damashii* (The fighting spirit of youths at sea, 1941), and jingoistic children's books like *Yashi no ki no shita* (Under the palm, 1942), *Yashi no mi no tabi* (Journey of a coconut, 1942), *Minami no shima* (The southern islands, 1943), *Minami no umi* (The South Seas, 1943), and *Taiyō no kodomo* (Children of the sun, 1944), along with an array of shorter occasional pieces.

In other words, despite Toshi's (largely self-censored) misgivings concerning the Japanese rule in Palau and Yap, she chose to use her experiences in Micronesia in support of imperial Japan's colonial advance into the

Pacific and Southeast Asia, and she published her artwork in venues that repurposed it to serve a role as graphic materiel for the various fronts of war. As Margaret Peacock has noted, there is "nothing particularly new about the use of the child as a means to rally populations to war," and times of intense ideological conflict often give rise to "proxy wars" in which images of children are deployed—and images are deployed to children—as part of the "daily responsibility" of cultural mobilization.[13] In other words, the practice of mobilizing art and media to cultivate children as the next generation of soldiers is, unfortunately, all too common. In early-twentieth-century Japan, Toshi participated actively in these mobilization efforts.

The Emergence of Nationalized Children's Culture in Modern Japan

Much of the artwork that Toshi published and exhibited between 1940 and 1945 lies within the purview of the "literature for little countrymen" (*shōkokumin bungaku*) concept. The concept arose from early-twentieth-century debates about the pedagogical and moral uses of juvenile literature, both on the part of proletarian authors (who wished to move children's literature away from fantastical and temporally remote folkloric settings to a focus on contemporary conditions and sketches of daily experience) and on the part of language theorists (who saw children's literature as a place to solidify affective bonds with a national tongue). As Ōfuji Mikio has noted, the move from using children's literature to enforce socially engaged morals and communitarian language practices, to using children's literature to enforce nationalist and militarist aims was less a marked leap than a smooth evolution.[14] While "literature for little countrymen" was not fully formulated until the early 1940s, the "shift from a doctrine of child-centrism (*dōshinshugi*) to one of militaristic drilling (*renseishugi*)" can be traced to at least a decade earlier.[15] In fact, I would point out that tight structural links between the state (especially the Home Ministry and the Ministry of Education) and the publishing industry existed as early as the 1870s and only grew stronger.

Though premodern authors and publishers occasionally created works about and for children (such as the Tokugawa period *akahon,* which often featured folkloric material), the first periodicals marketed specifically to Japanese children went into serialization in the late 1880s,[16] shortly after the birth of the modern Japanese nation-state, an event typically dated to the Meiji Restoration of 1868. One of the Meiji state's many concerns lay with controlling the realm of public information, so early laws—such as the Public Ordinance on Publishing (Shuppan jōrei) of 1869 and the

Public Ordinance Concerning Newspapers (Shinbunshi jōrei) of 1875—gave the Home Ministry the power to control antigovernment sentiment or criticism, to shut down periodicals judged to be offensive to public order or state security, and (as of 1887) to ban offending authors as well. Thus, from the time of the media form's inception, children's periodicals and book publications developed in tandem with national censorship laws.

In addition to these tools for curtailing what could appear in the public media sphere, the Meiji government also engaged the mechanism of a newly compulsory system of elementary education. The Imperial Rescript on Education (Kyōiku ni kansuru chokugo), issued by the Meiji emperor on October 30, 1890, dictated a largely Confucian ideology of training, including the cultivation of loyalty and filial piety, while grounding the curriculum in spiritualized terms and noting that all imperial subjects should be ready to lay down their lives for the Meiji state and the imperial throne. School children were expected to memorize the rescript and to be able to write it on command and recite it at school assemblies.

Thus, a number of scholars have argued that the culture of nationalism and the development of children's culture in Japan share the same ideological "backbone," noting that the state regularly employed both negative censorship (redaction, banning) and positive censorship (encouraging or requiring the publication of certain materials, educating imperial subjects in state ideology to think a certain way) in order to shape popular media.[17] Regardless of this tight control, children's culture flourished. A wide array of publishing firms rushed to create and market materials to this new consumer sector as entrepreneurs developed products that answered to the particular tastes (in terms of topic and genre) and responded to the particular needs (larger type, simpler words, and the inclusion of reading guides for kanji) of young readers. The Meiji state watched this boom in the children's publishing industry closely and regulated it accordingly, understanding that children's literature addressed a crucial demographic in the making of a modern state and that children, more than just a consumer base to be marketed to, were a national resource to be cultivated.

The 1910s through the early 1920s witnessed a second stage in the development of children's culture, culminating in the 1918 emergence of the magazine *Akai tori*, the editorial collective for which espoused "child's heartism" (*dōshinshugi*) as its guiding principle. Though notoriously fuzzy in its anticommercialist formulations, *dōshinshugi* proponents advocated recognizing the humanity and agency of children, acknowledging their unique physical and mental makeup, protecting their "innocence" (*junjō*), and providing

them artistic and literary materials that would foster creative thinking and imagination.[18] The poet Kitahara Hakushū (1885–1942) and the children's book author Tsubota Jōji (1890–1982)—mentioned above in connection to Toshi's exhibit of Micronesian art—were frequent contributors.

In fact, a Kitahara poem opens the inaugural issue, and a brief examination of this verse and its accompanying art give a fair approximation of the journal's conceptions of childhood. In "Squirrel, squirrel, little squirrel" Kitahara imagines, in playfully musical language, the thoughts and desires of a young boy and girl watching squirrels hop about in the garden. The poem begins: "Squirrel, squirrel, little squirrel / Darting and dashing, little squirrel / The fruits of the apricot are red, so red / Eat them, eat them little squirrel!"[19] The artwork captures the degree to which the (imagined) children are subsumed in the squirrels' world, the line drawing shrinking them down to squirrel size, erasing the distance between the children standing on the grass and the squirrels scampering in the trees, and placing the boy and girl amidst the leaves almost within reach of the nearest squirrel (fig. 2.2). The sense of wonder and imagination is palpable as both the poem and the artwork try to present the scene through the eyes of the children, the objective of the *dōshinshugi* ("child heart-ism") movement at its finest.

Fig. 2.2 Kiyomizu Yoshiko, illustrator. *Akai tori* 1 (1918). Princeton University Library.

Proletarian artists and authors soon lodged myriad critiques of *Akai tori*'s position, arguing that it was too idealistic and was divorced from the everyday realities of most children's social lives. With the founding of the Japanese Communist Party in 1922 (the same year that ten-year-old Toshi won praise for her submission to her school's "The Sun Lights up the Waves" art contest) and the Proletarian Arts Movement in 1923, a variety of leftist publishers began producing their own periodicals. *Zen'ei* (Avant-garde), a socialist current events journal, entered serialization in 1922, the proletarian arts magazine *Bungei sensen* (Art battle lines) in 1927, and *Shōnen senki* (Children's battle flag) followed in 1929.[20]

The inaugural issue of *Shōnen senki,* timed to coincide with the international celebration of May Day, presents an entirely different world than what is imagined for children in the pages of *Akai tori.* Instead of a world of wonder and imagination, the magazine shows children participating in labor strikes, offers a heavily redacted article titled "Where does rice come from?" that speaks to peasants' working conditions, and describes the life of a Pioneer (a scouting-like organization for children) in Soviet Russia. Most strikingly, a piece by sixth grader Kasahara Fumi describes how she and her friends, sporting proletarian banners in support of a protest against landowners, were stopped and harassed by policemen. Her drawing of the scene shows police trying to pull her friend Hiraga into the back of a vehicle (fig. 2.3). Though she and her friends were successful at preventing Hiraga's abduction—only his hat and shoes worse for the wear—Fumi's words do not escape untouched, the XXXX of the censor's redactions marking her words as surely as the policemens' grips bruised Hiraga's wrists.

I will return in chapters 3 and 4 to a discussion of the alternate modernities posed by the Japanese proletarian arts and Toshi's experiences with them, but here I will maintain my focus on the development of children's culture. Kasahara's illustrated essay was encouraged, no doubt, by educators and adults familiar with the *seikatsu tsuzurikata* (life-writing) movement. Developed in the late 1910s and early 1920s by progressively minded educators such as Ashida Enosuke (1873–1951), Suzuki Miekichi (1882–1936), and Sasaoka Tadashi (1897–1937), the concept focused on helping children (and adults) develop a strong sense of self by writing detailed, descriptive prose about their own life experiences. While notionally of value for all, life-writing as a part of educational curricula was taken up with particular fervor in rural, impoverished areas where progressive educators found natural allies with proletarian leaders. The movement was especially

Fig. 2.3 Kasahara Fumi, illustrator and author. [Correspondence.] Tokyo: *Shōnen Senki* (Shōwa 4), 1929. Cotsen Children's Library. Department of Rare Books and Special Collections. Princeton University Library.

strong in northern Japan, where it was popularized by Narita Tadahisa (1897–1960). Toshi's own pedagogical practices as an art teacher in the mid-1930s bore the strong imprint of the life-writing movement. But life-writing trod on thin ice; its objectives struck too close to the objectives of proletarian politics, and their audiences were, as indicated by Kasahara's illustrated essay, often one and the same.[21]

Not surprisingly, proletarian publications came in for heavy censorship. The 1922 Law to Control Radical Social Movements (Kageki shakai undō torishimari hō) led to a roundup of communists and socialists. In 1924 the Publications Monitoring Department of the Home Ministry was created, and it began to host regular meetings with publishers, who were invited to "consult" with advisers from the Home Ministry, the Army Ministry, the Navy Ministry, and the Ministry of Foreign Affairs. In a turn of

ominous double-speak, the inaptly termed Peace Preservation Law (Chian iji hō), promulgated on April 22, 1925, increased police powers to prosecute promoters of socialism, advocates of Korean independence, and others attempting to publish "dangerous" or seditious copy.

Things only got worse for the world of proletarian publishing. In 1928 the Peace Preservation Law was revised to add the death penalty for certain violations and to create the Special Higher Force Police (Tokubetsu kōtō keisatsu, or simply Tokkō) to deal with ideological offenses. Countrywide pressure was exerted on leftists, with 1,568 people interrogated and 483 charged in mid-March, a mere two months before *Senki* (the adult magazine that was, almost literally, the parent of *Shōnen senki*) entered serialization as the organ of NAP (the Japanese Proletarian Arts Association). Another round of police interrogations followed in April 1929, just as Toshi began study across town at the Joshi Bijutsu Senmon Gakkō and less than two weeks before the inaugural issue of *Shōnen senki* was to go to press.

The censors had *Shōnen senki* in their sights from the inaugural issue and by July 1929, with the fourth issue, the editors had begun receiving poison pen letters, calling their readers "non-Japanese" and indeed "non-human" for their antiwar stance.[22] As Gregory Kasza has shown, however, leftist publishers employed any number of tactics to avoid confiscation and silencing.[23] In the case of *Shōnen senki,* the editors anticipated heavy government interference with the parent journal *Senki,* with which the children's publication was usually packaged. In a note to readers included in the July issue, the editors explain that as of September 18, the children's magazine will be available for sale separately at bookstores across Japan and that "If publication is disallowed, interested parties can contact the *Senki* central office, which will absolutely make sure that a copy is delivered" (*kanarazu te ni*).[24] The editors had read the writing on the wall correctly. By the following year, the Home Ministry had banned distribution of several works dealing with proletarian children's literature,[25] and *Shōnen senki*'s days were numbered. The end of leftist children's culture had begun.

Perversely, however, the proletarian critique of *Akai tori*'s "child heartism" position proved highly useful to the government's pronationalist, imperialist publishing objectives. During the 1930s and increasingly in the 1940s, conservative authors and artists co-opted the tactics of realism and the practices of social engagement proletarian authors had advocated and had demonstrated in their own works in the late 1920s and turned them to the service of empire and war.[26] The idea that children could and should read about (and, at times, create and publish) art and literature dealing

with themes of everyday social reality was a limber and scalable concept that, when divorced from proletarian politics, could be employed just as easily in large-scale, government-sponsored or government-approved, pro-war publications as it could in minoritarian socialist outlets.

In short, what we see in the first half of the 1900s in Japan is a shift in focus from a concern with the nature of the child to a concern with the needs of the state. By the mid-1930s, state control of publishing and ideological formation had shut down proletarian publications, and many from the *Akai tori* camp (as well as some former proletarian artists) swung to the right to produce a thoroughly nationalist literature that was grounded in the day-to-day realities of war. This literature strove to treat children as special, spiritualized beings who would be the next to shoulder the burdens of the nation, whether as soldier, sailor, colonial administrator, or friend (*tomo*) to other children-subjects of various ethnicities and races from across the ever-expanding Co-Prosperity Sphere.

Creating Culture for Little Countrymen

As restrictions on freedom of the press continued to mount in the mid-1930s and the doctrines of cultural ultranationalism came to the fore,[27] the Home Ministry trained its sights on children's ideological formation, an approach that eventually resulted in the articulation of a full-fledged government-sponsored movement to create "culture for little countrymen" (*shōkokumin bunka*). In late February 1933 Japan withdrew from the League of Nations. One month later Toshi graduated from Arts College, and one of her classmates Minami Hiroko—the daughter of Minami Jirō (1874–1955), erstwhile minister of war and current governor general of Korea, later convicted of war crimes and sentenced to life imprisonment—helped her to find lodging.[28] Her classmate's political and familial connections also helped Toshi secure a position as an arts teacher at an elementary school in the metropolitan area, a post she held for several years.[29] In this position, Toshi would have been responsible for impressing upon her charges the importance of their roles as "little countrymen."[30]

These roles—and the place of publishers, authors, artists, and educators in cultivating them—became much more clearly and forcefully defined over the course of the mid-1930s, with deliberations and formulations reaching a crescendo in 1938. On February 6 of that year, the Home Ministry Police Affairs Bureau Books Division (Naimushō keihokyoku toshoka) summoned children's book publishers to its offices to announce, among other things, that picture books and *manga* would now be subject to

vetting and full censorship. In April the National Mobilization Law (Kokka sōdōin hō) was promulgated. In one typical show of solidarity, the *Asahi Newspaper* sponsored an exhibit of war art at the Tokyo Metropolitan Museum in May. Starting on October 5, the *Asahi* ran a four-part series under the title "A Criticism of Youth Periodicals" (Shōnen shōjo zasshi hihan), announcing that the Home Ministry would begin a campaign to "cleanse children's literature" (*jidōsho no jōka*).[31] That month, the Home Ministry began drafting and circulating a memo on Guidelines for the Improvement of Children's Literature (Jidō yomimono kaizen ni kansuru shiji yōkō), and the official Measures to Purify Children's Literature (Jidō yomimono junka hyōtei) went into effect later that month.

The measures were vague, however, and led to something of a state of chaos in the publishing world, particularly because, as Yamanaka Hisashi has noted, "by this point any guidelines (*shiji*) issued by the Home Ministry carried the weight of law (*hōrei dōyō*)," so publishers, authors, and artists were concerned about fines, jail time, and banning.[32] Beginning on October 27, the document's primary author, Saeki Ikurō, gave a three-part interview to the Tokyo *Asahi Newspaper* to explain the policy to the broader public,[33] and he published extensively on the matter. In his writings, Saeki outlines five central concerns of the campaign. Specifically, Saeki noted that the push was to encourage the publication of works that encouraged respect and showcased a spirit of loyalty and filial piety; that emphasized values such as kindness, bravery, and valor; that provided guidance to children in the conduct of their daily lives; that stressed endurance in the face of adversity; and that promoted the formation of a new order for East Asia.[34]

By late 1941 the culture for little countrymen movement had gained the support of an imperial edict, and the Association for Little Countrymen's Culture (Shōkokumin bunka kyōkai) held its inaugural meeting on December 23, a matter of weeks after the bombing of Pearl Harbor. With an audience of several hundred authors, educators, artists, editors, and publishers, the association unveiled its working document, opening with a statement of purpose. "Objective: To contribute to the training of Imperial Japanese by establishing culture for little countrymen upon the foundation of a national culture that hews to the path of our imperial country" (*Honkai wa teikoku no michi ni nottori kokumin bunka no kisotaru Nihon shokokumin bunka o kakuritsu shi motte teikokumin no rensei ni shisuru o mokuteki to su*).[35] Working documents specified that all genres and mediums of children's culture were of concern: periodicals, card games, interior

illustrations in books (*sashie*), poetry, movies, song lyrics, radio programs, and so forth. On February 11, 1942, the association began operations, opening its headquarters on the sixth floor of the Ginza Mitsukoshi department store on February 17.

The 1943 publication of the *Patriotic A-B-C Card Game* (*Aikoku iroha karuta*) provides one example of the sorts of cultural production the association sponsored, both directly and indirectly. In March 1943, just before the conclusion of the school year, the association announced a nationwide contest that invited students and their families to contribute short verses, reflective of little countrymen ideology, which could be used in conjunction with the traditional card game *iroha karuta*. In this game, one player reads aloud a short verse. The other players listen, try to identify the verse, and grab the corresponding illustration card as quickly as possible. The player amassing the most cards wins. The game has the effect of encouraging its players to memorize each phrase. Advertised in newspapers throughout the country, the contest promised that submissions would be reviewed by a committee of artists, authors, association representatives, ministers of state, and military officials, who would choose the verses that best represented the morals and lessons of exemplary children's culture.[36] Submissions could be sent in between March 3 and May 5; that is, during the last weeks of one school year, over the short between-term break, and during the first weeks of the new school year, when students would have graduated to the next grade level. Some 230,000 submissions flooded in in what would have been, for many children, one of their last academic homework assignments. One other adjustment to children's culture, made during the transition between the two school years, were the rulings that mobilized school children to work in factories beginning in April 1943.

The cards themselves are largely unremarkable, their verses and art generally reflective of the total mobilization of Japanese culture by this point in the war and featuring each of the association's main themes: loyalty and filial piety; kindness and bravery; endurance in adversity; attentiveness to physical strength and mental fortitude in daily life; and knowledge of the new world order. For instance, the card for the syllable "wa" shows a pair of straw sandals, to be matched with the verse, "Grandpa came to get me in his straw sandals" (*Waraji de kitaeta ojisan*). Here the inability to purchase modern footwear (leather or rubber-soled shoes or boots), whether because of the family's lack of financial means or the country's lack of material resources, becomes a point of pride (endurance in the face of adversity), stressing the continuity of the generations and the respect

and love that the (imagined) child feels for her or his grandparent. The card for "yo" emphasizes the importance of physical education and training. The visual shows a young boy, clothed in nothing but a *fundoshi* and headband, pulling at the oars of a boat. The accompanying verse reads, "The surging waves of the Black Current, we are the children of the sea" (*Yosekuru Kuroshio umi no ko warera*). In characterizing Japanese boys (and girls) as "children of the sea" who "surge" forth as surely as the brisk ocean current sweeps through the Pacific, the card implies the children's connection to Japan's broader maritime empire, while adverting to the Black Current claims a fact of natural geography to suggest Japan's anchoring position in the wider ecology of the Pacific. The card for "to," with its image of a chalkboard hanging on a palm tree, underscores Japan's leading role in the emerging new world order, as the verse praises the Japanese language, which "binds together all of East Asia" (*Tōa o musubu a i u e o*).

Products of "culture for little countrymen" aimed at the youngest cohorts of children (*yōnen,* which included up to age five or six, and the next level up, aimed at early elementary children ages seven or eight or nine) typically cultivated their readers' powers of imagination, seeking to harness these and train them in service of the nation. Many of these publications connected most strongly to the association's mandate to educate children about other Asian peoples, preparing them to accept and to further the Co-Prosperity Sphere concept. Typical publications show close-ups of people from a variety of ethnic groups, often framed by or holding examples of the major resources imperial Japan was extracting from the area. As with ten year-old Toshi's painting of the candy box (whose sugary contents came from Japanese-run plantations in the South Seas), these images invited Japanese children to consume the delectable products of empire, whether in the form of tropical fruits or in the value-added format of the magazine.

The eye-catching *Children of the South* (*Minami no kodomo*), written by Ehara Shunpei and illustrated by Azuma Kōsei, is a prime example of this type of children's book, focused on familiarizing Japanese children with South and East Asian resources and raw materials. Aimed at children aged six to eight, each page of the book includes a full-color art spread accompanied by a simple sentence written entirely in katakana. One spread, showing three South Seas Islander boys in grass skirts waving Japanese flags and staring at a Japanese sea plane coming in for a landing, reads, "The Rising Sun of Japan glinting on the aeroboat protects the south" (*Minami o mamoru Nippon no Hinomaru no kagayaku hikōtei*).[37] These sorts of materials envisioned, for young readers, the purported give-and-take of

Japanese expansionist policy in Southeast Asia, suggesting that "ethnologically speaking, we may observe that language comes from the north while food and clothing come from the south."[38] In other words, Japanese rule provides people in the south with language and other technologies and infrastructures of modernity, in return for which the south provides Japan with raw materials.

Another typical subgenre of publications for the youngest readers encouraged them to imagine their own (future) valor and bravery. Author Takeda Yukio and illustrator Fuseishi Shigeo's story "Isamu's submarine" (Isamu-san no sensuitei), which appeared in the May 1943 edition of the periodical *Strong Child, Good Child* (*Tsuyoi ko yoi ko*), features a young boy who happens to spot a Japanese submarine in the distance while out walking on the beach (plate 4). He goes on to imagine getting in, traveling to the sea floor, fighting off an octopus, exploring the sea bottom, and eventually helping to expand (in a vague way) Japanese territory eastward. Along with a couple of toys (a submarine and a fighter plane), the illustration pictures the boy, his pillow on the floor behind him as if he has just woken from a nap, sharing his dreamed exploits with his mother, who sits sewing next to him. Projected on the wall behind them, as if in one of the "magic lantern" (slide) shows so popular at the time, stretches a map of the Pacific, Japan's territorial holdings marked out in red. Isamu's imagination has him headed toward a beachhead on the California coast. As with the illustration of the children and squirrels in *Akai tori,* discussed earlier, the intent is to create art and literature that sees the world through a child's eyes. That child is no longer looking at playful animals, however; he is looking at a future of military conquest.

In materials for slightly older children, or in the hands of more sensationalist publishing houses, indirect associations of children with (or as) raw materials could be quite straightforward, particularly from late 1943 onward through the end of the war. Pictorial maps were a staple of juvenile publishing, helping to familiarize young Japanese with geographical features, colonial place names, and the location of natural resources.[39] Likewise, certain artists, editors, and publishing houses were comfortable with direct depictions of children with (and as) war materiel. Consider, for example, the 1944 book *Mado mado* (Window, window) marketed to seven- to nine-year-olds. The conceit of the book is to provide a child's eye onto the Japanese position and to encourage a "spirit of 'no surrender until victory'" in everyone, "man, woman, and child, with no child left behind."[40] Each spread features a "young countryman" engaged in warfare, whether

on sea, in the air, or on the ground. One angle/reverse angle composition featuring a tank, for instance, places a child in the driver's seat of a war machine. Young readers would see their narrative stand-in through the tank's window before viewing, from his point of view, the enemy soldiers he is firing upon.

Aside from books, magazines, and card games, the Culture for Little Countrymen movement also promoted production in a number of other venues. Many of the association's events featured choral singing by youth choirs. The tune "Little Countrymen becoming Soldiers" (Shōkokumin shingun uta), with lyrics by Nagasaka Tokuharu and music by Sasaki Suguru, was particularly popular. "Thundering, thundering, the sounds of our footfalls / injured for our country / with the pride of bravery we / march with our friends from the Co-Prosperity Sphere / marching in step, marching in step, the sound of our footfalls."[41] Members of the association also penned their own lyrics, such as Kitahara Hakushū's song celebrating "The Great Naval Battle at Hawaii" (Hawaii taikaisen), which, judging by the copy owned by Princeton University's Cotsen Library, was rehearsed and performed by the Hibiya Junior High choir in early 1942. *Kami shibai* (oral storytelling accompanied by large storyboards) were another major outlet, both in miniature giveaway sizes[42] and in full-scale models for use in classrooms and other educational settings.[43] Finally, poetry represented another key area of media saturation. The ambit of little countrymen's culture included the production, distribution, and advertising of collections by professional poets, whose words were addressed to young readers, as well as the compilation, editing, and publication of children's own poetic works.[44]

Toshi and Culture for Little Countrymen

This, then, was the cultural sea that Toshi needed to navigate once her Micronesian art exhibit attracted the interest of children's book authors, artists, and publishers in September 1940. Clearly, her fantasy of selling her art, buying an island, and living in relative isolation from imperial (if not colonial) politics was just that: a fantasy. How would she go on to deal with the realities of her position when she was sure to be tapped repeatedly to produce art for works set in the South Seas and when any overt criticisms of imperial policy would be censored and could potentially land her in jail? Perhaps not surprisingly, given Toshi's relatively critical thoughts concerning Japanese rule in Micronesia, there is little about her artwork, *visually speaking,* that directly encourages Japanese children to imagine themselves as soldiers or sailors in the imperial war or that glorifies death in battle. Nor

does her artwork espouse the divine nature of the Japanese nation or foment propagandistic ideals of imperial spiritualism. Her work does, however, reflect many of the Culture for Little Countrymen Association's key concepts: loyalty and filial piety; kindness, bravery, and valor; conduct of daily life in wartime; endurance in the face of adversity; and—especially—the formation of a new world order in Asia.

Toshi's abilities to provide illustrations of the Japanese mandate in the South Seas based on authentic, first-person experience made her a sought-after illustrator in the early 1940s, particularly as the war in the Pacific heated up and Japan's claims to have brought enlightenment and liberation to Pacific peoples needed underscoring. Tatsumi Seika,[45] who had attended Toshi's exhibit and who was a leading proponent of little countrymen ideology, convinced her to work with him on a children's book. He would write the words and she would produce the art. The collaboration resulted in the publication, in July 1943, of *Minami no shima* (The southern islands).[46] There is really no plot to the story and no characters; the narrative simply follows a third person omniscient perspective as we depart from Yokohama and travel to the South Seas, pausing along the way to note the strength of the Black Current in connecting Japan with the southern oceans, the success of Japanese agricultural settlers in developing Saipan for sugar export, the "kindness" of Japanese colonials in showing Yapese Islanders how to wear clothes and speak Japanese, and the efficiency of phosphorous mining on Anguar.

In her illustrations for the book, Toshi alternates between two compositional strategies. The first relies heavily on her personal experiences in the South Seas, featuring close-ups of Islanders generally engaged in traditional activities like pounding taro root, conversing in an *abai,* or carving canoes. Whether in full native clothing or in outfits marking their cultural hybridity (as with the boy in the button-up shirt and tie), Toshi shows the Islanders as strong, healthy, and human. The second compositional strategy stresses the dominance of Japanese infrastructure: a huge tractor, a giant sugar factory, a high-angle view of a Japanese-language classroom, a scene of Islanders dwarfed by an enormous phosphate mine (fig. 2.4). With this second approach, Toshi creates a children's book version of the development (*kaitaku*) photo spreads that had been a staple of adult-oriented Japanese literature on the South Seas throughout the 1920s and 1930s.[47] But her compositions suggest—gingerly, circumspectly—the costs of development, suggesting the human suffering of imperial ruination.[48] Interspersing these industrial visions with quasi-anthropological images of Islanders going

about their own lives, Toshi's illustrations seem to evoke two very different worlds. Indeed, a single scene of a classroom is the only image in which we see Japanese people and Islanders interacting. The impression is that while the landscape receives "imperial formation" via mining and agricultural development, Islander children receive formation via Japanese-language education. Both are framed as the natural resources of Japanese empire.[49]

Both Toshi's illustrations and Tatsumi's text provide a look back in time, to the height of Japanese dominance in the South Seas. Japan had lost Midway the summer before *The Southern Islands* was published, and it had been embroiled in a series of bloody battles with US forces in the Solomon Islands for nearly a year before retreating from Guadalcanal on February 1, 1943. In May of 1943 the navy had dispatched twenty-two painters to the South Pacific and the army had sent nearly the same number, both in an attempt to bolster Japanese morale and encourage a redoubling of military effort and home-front commitment to the war. *The Southern Islands* was published for children just as the first wave of artistic representations for adults stemming from these deployments began to reach public venues.[50]

On the strength of her Micronesian work, Toshi also found herself commissioned to produce art picturing southern locales to which she had never

Fig. 2.4 Akamatsu Toshiko, illustrator. *Minami no shima*. Tokyo: Chūō shuppan kyōkai, 1943.

traveled. As the front lines of the Japanese imperial war spread to encompass Southeast Asia, so did Toshi's artwork. For example, Japanese forces seized Singapore (naming it Shōnan) on February 17, 1942. Half a year later, in October, Toshi completed the illustrations for Tsuchiya Yukio's picture-book version of those events, titled *Yashi no ki no shita* (Under the palm tree). Tsuchiya, who had worked for Mitsubishi in Singapore in the late 1930s and early 1940s, was already a well-regarded author of children's books and soon to become a member of the Culture for Little Countrymen Association. His touching, if willfully naïve, story features a Japanese boy named Masao who lives with his mother and father in Singapore, peacefully coexisting with a mix of ethnic groups from across Asia (people of Malaysian, Indian, Japanese, and Chinese heritage). Masao befriends a local Malay boy named Awan and they play together frequently. (In a ridiculous plot device, they meet because Awan has learned to play the Japanese national anthem *Kimi ga yo* on his harmonica after hearing Masao's alarm clock going off repeatedly.) In the wake of Pearl Harbor and Japanese attacks on Hong Kong, Masao and his family, along with all Japanese in the area, are interned by British troops while Awan and his family flee. In time, Japanese soldiers come to liberate the island from the British. Masao's family is released and he is happily reunited with his friend Awan "under the palm tree."[51]

Throughout, Toshi's illustrations focus on the boys' friendship and consistently frame Singapore as a peacefully multicultural, multiethnic entrepôt. In an early scene we see the rosy-cheeked Masao and his bespectacled father watching a movie, along with Islamic women in *jilbāb* and *khimar,* a bearded South Asian man in a turban, a Chinese man wearing a stiff-collared tunic and sporting a long goatee, a South Seas Islander woman with a flower behind her ear, and a couple of Malay boys in *songkok* hats (plate 5). When they are together, Masao and Awan are frequently in close contact, often resting their arms across one another's shoulders.

Even when Tsuchiya's text suggests she might do otherwise, Toshi's illustrations consistently shy away from depictions of military action, Japanese soldiers' bravery, and British soldiers' cruelty. At one point Masao's father calls him inside. "Standing there were two British soldiers with frightening faces" who have come to intern the family immediately. Unafraid, Masao "puffs out his chest" and follows the soldiers out of the house, stoic and brave to the core. Toshi's depiction of this scene downplays the British soldiers' aggression, stressing the boys' friendship instead as Awan runs to bring Masao a prized possession: his *Kimi ga yo* alarm clock. In Toshi's illustration, Masao marches proudly behind a friendly-looking

British soldier; whether in defiance or imitation, it is impossible to tell. The depictions of Japanese attacks on Hong Kong and Pearl Harbor—glossed in Tsuchiya's text as, "This morning the strong Japanese Navy attacked a place called Hawaiʻi in the United States and sunk many of their ships, while the strong Japanese Army took a place called British Hong Kong by storm, raising cries of 'Banzai!'"—are accomplished by way of a single overhead view of a map with two small flag-waving soldiers standing on Hong Kong and one sailor with a Rising Sun flag steaming off the coast of Hawaiʻi. Even the Japanese liberation of Singapore, accomplished by Japanese soldiers "whose blades were still stained from [their actions in] Burma" is, in Toshi's rendering, suggested by four soldiers walking across a nighttime landscape, without a single weapon in sight.

Tools of Para-graphic Framing

Toshi could easily have provided artwork showing rolling tanks, exploding bombs, and bloody swords. She could have at least made the British soldiers grimace or scowl. But she did not. Where has the belligerence and ideological posturing gone? How does this work fit in with the narratives of aesthetic fascism? In what way does *Under the Palm Tree* respond to the Home Ministry's patriotic "cleansing" of children's literature or to the Culture for Little Countrymen Association's imperially sanctioned objective to "contribute to the training (*rensei*) of Imperial Japanese by establishing culture for little countrymen upon the foundation of a national culture which hews to the path of our imperial country?" The answer is that much of the ideological work happens via an array of prosaic tools. Like the advertising wrapper bounding *Crossing the Equator* discussed at the beginning of this chapter, these "para-graphic" devices provided specific, written directives governing (or attempting to govern) the ways readers might make sense of a particular book, game, song, magazine, or, indeed, interior illustration (*sashie*). As censors and legislators at the time realized, the artwork for children's books, particularly when done well, does not merely serve to "illustrate" the words; rather, it tells its own story, develops its own narratives, and suggests its own ideas. Take Toshi's illustrations for *Under the Palm Tree* out of context, for instance, and they almost pass as products espousing a 1980s multiculturalism (*kokusaika*).[52]

But her artwork does not exist out of context; it is framed, and framed snugly, by a host of para-graphic tools. Increasingly, scholars have come to recognize the importance of "paratextual" information in meaning making associated with books. Tables of contents, glossaries, frontispieces, marginalia, layout, even paper quality and font size, contribute to how readers

make sense of a written work. Of course, this material and rhetorical shaping of the reading experience goes both ways. In adopting a critical approach that considers the artwork (rather than the semantic content, the plot, or words) as the focal site, we can invert the notion of the paratextual, literally "that which accompanies the text," and develop instead the notion of the para-graphic: that which accompanies the visual art. In short, we can recognize that illustrations do not just present information. Rather, their interpretation and the *seeing* of them is bound up with contextual clues and a host of verbal framing in the form of narrative plot, advertising wrappers, notes to parents, prefaces, accompanying copy, and so forth.

In the late 1930s and early 1940s, the Home Ministry was hard at work imagining, legislating, and enforcing particular para-graphic devices for children's culture. In July 1938 the Home Ministry Police Affairs Bureau Books Division circulated a series of internal memos. Labeled "materials for the policing of publication" (*Shuppan keisatsu shiryō*), these memos capture the publishing ethos of the time. Per the July 1938 memo, children's publications should be vetted with an eye toward whether or not they would, "in ten years' time, have cultivated countrymen with a thorough mastery of Japanese spirit" and suggested that whereas the preferred objective of Meiji-era publications had been to promote individual success (*risshin shusse*), current-day publications must be made to inculcate an ethic of "annihilating the self for the sake of the country" (*messhi hōkō*).[53]

Publishers soon discovered that including prefaces was an effective way to satisfy this governmental objective. Riding the wave of the attack at Pearl Harbor, Captain Hara Mitachi's January 1941 book *The Fighting Spirits of Youths at Sea* (*Umi no ko damashii*) recounts a training cruise he embarked on with a crew of "young countrymen" sailors in 1934, an experience aimed at familiarizing the students with the realities of shipside life, allowing them to see firsthand Japan's holdings in the South Seas mandate, and training them in navigational and other relevant naval skills such as deck scrubbing. This outdated (age of sail rather than age of steam) chapter book for young male readers includes no fewer than half a dozen prefaces, all written by high-ranking military officers and politicians. The prefaces whip up a rhetorical frenzy of expansionist *hakkō ichiu* ("all the world under one roof") fervor. They assert a spiritual "connection between Japaneseness and an affinity for the sea" (*kaikoku tamashii ga Nihon tamashii to tōitsu de aru*), and they suggest that, in the wake of Pearl Harbor, "the development of a Greater East Asia and the establishment of a new world order lies entirely upon your shoulders, young men" (*Daitōa no kensetsu hiite*

wa sekai shinchitsujo no kensetsu wa kimiya kakatte shokun no sōken ni aru no dearu).[54] The book's guiding lesson appears as an epitaph: "Who rules the sea, rules the world" (*Umi o seisuru mono wa, sekai wo seisu*).[55]

Toshi's artwork for this volume is remarkably understated. For a cover, she provides a pencil sketch of an unoccupied outrigger canoe floating just off a palm-fringed coral atoll.[56] For interior art, she gives a black and white sketch of a ship in stormy seas, a close-up of an Islander woman in local dress, and an image of palm trees bending in a wind strong enough to have dislodged several coconuts. These sketches are only militaristic or jingoistic by association with the bombastic prefatory material, a minimal contribution to the work's overall narrative of Japanese maritime mastery.

Nor were prefaces to be limited to books intended for older juvenile readers. On July 14, 1938, the Home Ministry convened a meeting with publishers of children's periodicals and books, announcing, among other things, that publishers would now be required to include explanatory remarks even for materials aimed at the youngest of readers and prereaders (whose parents or older siblings would read to them). Another internal memo, dated October 25, clarifies the policy, noting that all books for children must now include a mother's page, a how-to-read note, or a set of guidelines for discussion after reading. In the months that followed, publishers, editors, and authors complied and children's books opened or closed with a page titled "To mothers" (*Okāsamagata e*) or "To parents and siblings" (*Fukei no kata e*). Further, the memo encouraged publishers to solicit treatments of how children live, play, and eat in Greater East Asia, and it required that the artist's name be clearly provided for any and all illustrations, an indication that visual artists would be held accountable for their work in the same ways that verbal artists would.[57]

The prefatory remarks included in works illustrated by Toshi consistently suggest that readers view her artwork as part of a total mobilization of labor in the service of war, leveraging her South Seas experience for the education of the nation. *Under the Palm Tree,* for instance, opens with a note from the author that reads, "I am a Japanese person who writes children's stories (*dōwa*). I am aware of the enormous war in which our country Japan is engaged right now, and I am sure you are too. So, I wanted to write a children's book that would be as useful to our country as the efforts of our fighting soldiers. That's my job. And so I wrote this book with those thoughts in mind. If you and I both do our jobs well, no one will be able to defeat us." Tsuchiya's words, addressed directly to his young readers, encourage them to see his story, Toshi's art, and their own day-to-day best

efforts as fighting contributions to Japanese victory and as jobs that, when well done, will protect the nation. Similarly, Tatsumi Seika's prefatory remarks in *Minami no shima* note that "the illustrations by Akamatsu Toshiko are based on her personal experience" and suggest that the book will be useful to parents and children seeking to follow the news of battles in the Pacific. Rather than being caught off-guard with bulletins about a naval battle occurring someplace they have never heard of ("like Guam"), readers will have been oriented to Japan's holdings in the Pacific. Further, the "review of Japan's many years of experience in the South Seas mandate" may prove useful to parents needing to explain Japan's policies of "economic management of the south" and the idea of the Co-Prosperity Sphere.

While the Home Ministry focused primarily on tools of negative censorship (redactions, bans, fines) and on additive measures (such as the mandatory readers' guides), the Ministry of Education took a complementary route of positive censorship, establishing in May 1939 a program for recognizing recommended books (*Monbushō tosho suisen*). Specifically, the ministry aimed to promote books that contained no ideologically "vulgar" material; were informative without sounding too much like a textbook; clarified, rather than confused, complex issues for younger readers; provided excitement and interest as well as positive models for daily conduct; encouraged self-reliance but not egotism; were produced nicely, with good paper and pleasing illustrations; used *kana* and *furigana* glosses appropriately; and were not too expensive.[58] In 1942, the Culture for Little Countrymen Association undertook a public campaign to reiterate these goals on a familial level, holding exhibits at the Ginza Mitsukoshi department store (April 15–26, 1942) and again at the Osaka Mitsukoshi branch store (June 2–7, 1942) to instruct parents and educators on how to choose suitable books and curate suitable book collections for children.

Several of Toshi's wartime children's books were singled out for praise,[59] including her last full-length work, the 1944 *Children of the Sun* (*Taiyō no kodomo*), which was chosen for inclusion in the Shin Nihon Yōnen Bunko (Library for the New Japanese Child) series.[60] The book bears a dedication: "To the young countrymen of Japan: May you shine bright and strong like the sun" (*Nihon shōkokumin san—taiyō no gotoku, genki ni akaruku*).[61] In January 1944 the Japanese government had taken over distribution of paper and of all art supplies, releasing materials only for art related to official policy and ruling that, thenceforth, only children's publications would be allowed to use other than black ink. The slim, richly colorful *Children of the Sun* reached bookstores in early December, just two weeks after the first air

raids on the Japanese home islands, which had begun on November 24, 1944; by March 10, the air raids would set Tokyo aflame. Japanese forces had been defeated in the Marianas and on Saipan the previous June and the Imperial Navy had been eviscerated in October at Leyte.

Author Nan'e Jirō's narrative features Matahari, a young, fatherless Javanese boy who wanders the hills near his home, saddened by the long shadows of the setting sun and calling out longingly for his father to return. (The undertones of Japan as patriarch of Asia break through to the semantic surface when the boy fixes his sights on a "mountain that looks just like Mount Fuji.") Matahari almost drowns himself in despair but is saved by an old man who tells him that his father was a brave warrior who died in service to the king: "Just after you were born, white demons came from the west to steal away your country's treasure. They got red demons and blue demons to help them, and they attacked." Obeying his king's orders, Matahari's father pursued the demons across the land and over the sea, slaying many of them before being struck by a poison arrow in the shoulder and dying. Comforted by the story and grateful to the old man for sharing the information, Matahari returns to his mother, where, in an echo of the dedication, "he wasn't the least bit sad and went on to become a bright, strong, very good child who minded his mother well." Nan'e's story is clearly aimed at young Japanese children who have lost a father in the war. It employs an exotic setting and a relatable young character to model how a child might stoically accept the complex matter of a parent's death, find pride in his forbear's service to the nation, and commit himself to orderly conduct within the bosom of the family.

As if marked inclusion in a ministry-approved book series, the dedication to "little countrymen," and a fairly obvious plot line in praise of death in war were not enough in the way of para-graphic devices, *Children of the Sun* also comes with an extensive author's note. This lengthy reader's guide, which follows the story and is addressed to mothers, explains that the white demons "represent the Dutch military, which invaded these lands nearly three hundred and fifty years ago," while the red and blue demons might be understood as "all those other pirates who stalk the seas." Just as with the traditional Javanese shadow puppet theater on which it is based, the story, Nan'e hopes, will impart lessons connected with "the ordering of the home, service to the nation, and respect for ancestors," values that, "unlike the stupid child's play of the British and Americans," undergird Japanese culture, and the wider culture of Greater East Asia, and will lead ultimately to victory. Nan'e goes on to catalog the various natural resources to be

extracted from Southeast Asia—including sugar, rubber, oil, coal, gold, silver, copper, manganese, and tea—and concludes by predicting that these rich areas of the world will once again be consolidated under Japan's roof (*hakkō ichiu*) and washed in Japan's divine light.[62]

Once again, the majority of Toshi's illustrations lavish attention on the tropical flora and on gestures of love and affection between the main characters. The old man holds Matahari in his arms, as does Matahari's mother on several occasions, and the most elaborate and heavily colored layouts show Matahari amidst dense foliage. Not all the ideological work happens in the para-graphic material, however. There are a few instances in which Toshi's illustrations, in their graphic composition, lend their strength to the imperialist objectives of total war and serve to demonize (literally) the enemy. In the most striking of these, Toshi situates Matahari's father in a powerful warrior's pose, the head of the enemy demon hoisted on the end of his sword (fig. 2.5).

In her composition, Toshi chooses to rework the Javanese demon mask as a Japanese *tengu*. A long-nosed, often red-faced and wide-eyed warlike

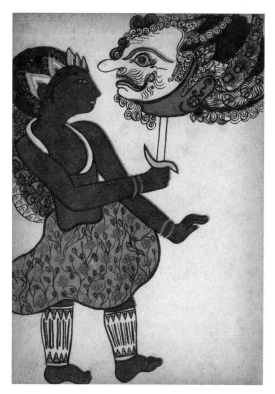

Fig. 2.5 Akamatsu Toshiko, illustrator. *Taiyō no kodomo.* Tokyo: Kokumin tosho kankōkai, 1944. Nan'e Jirō's 1944 children's book *Children of the Sun* (Taiyō no kodomo) is set in Java.

creature common in Japanese folklore, the *tengu*'s downfall is his pride. Early portraits of American military personnel charged with forcing Japan's opening in the mid-1850s under the direction of Commodore Matthew Perry adapted the *tengu* form, giving them a white face and a certain hirsuteness.[63] Toshi's composition takes its cues from these portraits, emphasizing the white skin, blue eyes, and extra hairiness of the "white demon." In so doing, she draws the connection between the gunboat diplomacy forced upon Japan by the United States in the 1850s, the long history of Dutch colonial rule in the East Indies, and the current war between Japan (as valiant defender of Asia and father figure of anticolonial revolt) and the United States (as demonic and prideful despoiler).

In short, there are multiple levels of interpretive decision making, and the idea of para-graphic framing gives precedence to graphic materials as a crucial point, though not the only point, of approach. On a governmental and legislative level, the Home Ministry demanded the inclusion of prefaces and notes to mothers and, by the mid-1940s, determined the size of the print run, while the Ministry of Education sponsored virtual libraries. At the industrial level, publishers determined advertising copy (the contents of prefaces or blurbs), promotional freebies, and (through the mid-1940s) paper quality and the number of colors to be used in reproducing illustrations. Editors chose how to navigate the process of internal censorship: which words to redact, where to rephrase, and when to submit galleys for vetting. Authors determined basic plots and fleshed them out with words and phrases. Artists chose how to sculpt a visual narrative to accompany, enrich, contest, highlight, or undercut the author's work and the parameters of publishing and legislation. And, of course, individual readers responded to and imaginatively shaped the products they encountered.[64]

Strategies of Resistance?

In sum, Toshi *did* choose to naturalize the South Seas as a Japanese sphere of control and, in a small number of her compositions, to further the cause of war, or to contribute to the demonization of the enemy. But these instances are the exception rather than the rule, and their scarcity raises the question of reading Toshi's artwork between the hard lines of the Home Ministry's "cleansing" campaigns and the little countrymen's cultural ambit. In chapter 1 I relied on a technique of reading Toshi's published works in comparison with her journal entries, in order to identify the traces of self-censorship. In the case of her many illustrations for children's publications between 1940 and 1945, however, Toshi left no contemporaneous

private writings, so we must find alternate techniques for establishing how Toshi chose to navigate that landscape of censorship. Thus far I have focused on describing the general aesthetic field of children's publishing, plotting Toshi's artwork within that space. In this final section, I turn to a direct comparison between one of Toshi's published works and the published work of a different illustrator, composed on the same topic and released at roughly the same time for essentially the same audience. Though necessarily imprecise, this comparison at least provides some sense of alternative aesthetic routes Toshi could have chosen and differing artistic choices she could have made. The goal of the comparison, ultimately, is to identify what may have been particular strategies of resistance.

The publishing division of the Imperial Committee on Education (Teikoku kyōikukai shuppanbu) released the children's book *Journey of a Coconut* (*Yashi no mi no tabi*) in November 1942 with artwork by Toshi (plate 6). A brilliantly colorful production, marketed at a still-affordable seventy-five sen, the book was highly popular and was accorded a significant second print run of ten thousand units in May 1943 (and a third run of five thousand in October of that year) after the first run quickly sold out. The story—attributed to Maruyama Kaoru, but possibly written by Toshi herself[65]—is relatively simple. A personified coconut is growing on a palm tree. It decides to find a place to become a palm tree of its own. It drops off, heads out in the current, and travels out to sea. Along the way it encounters a bird, nearly lands on one island, is scared by a shark, sees flying fish, and is finally picked up by Japanese sailors. The sailors put it in a sack, whack it in half, and use it to polish the decks of the ship. Though sad that it did not get to grow up, it is happy to have found a place serving the Imperial Navy. Included in the Shin Nihon Yōnen Bunko (Library for the new Japanese child) series, the book was marketed to the youngest cohort of readers and prereaders (*yōnen*), whose parents or siblings would be reading to or with them.

As *Journey of a Coconut* was at the printers in preparation for its third edition, the Tokyo publishing house Seikaidō released its own version of a traveling coconut story in September 1943: *The Wandering Coconut* (*Yashi no mi donburiko*), with words by well-known children's author Satō Yoshimi and artwork by Imamura Toshio (plate 7). Marketed especially to children ages seven to eight (that is, children who were learning, with guidance, to read on their own), the book cost fifty-five sen and was issued in a run of fifty thousand units. The plot of *The Wandering Coconut* bears a striking resemblance to Toshi's book in its general outlines. A personified coconut is

growing on a palm tree, thinking to itself that it would like to feed its milk to someone, when a Japanese soldier runs by, chasing American troops. The coconut decides to drop off the tree and feed itself to the Japanese pursuer. Unfortunately, it rolls into the ocean instead and is swept out into the sea by a strong current. Carried along, it encounters a seagull and a pelican, sights a Japanese battleship in the distance, is momentarily swallowed by a whale, and talks to various fish and celestial bodies. Finally, the coconut washes up on the shores of Japan and decides to grow into a giant palm tree, growing lots of coconuts whose milk it can feed to the Japanese people.

These two little books, and the fleet of little books like them, perform a great deal of cultural heavy lifting. First, there is the visual and narrative colonization of the South Seas, claiming this maritime space for Japan. Aside from the personified coconuts, Japanese are the only people to be found on the face of the ocean.[66] Second, the books naturalize this maritime sphere, courtesy of the Black Current. The coconuts inevitably find themselves drifting northward toward the Japanese home islands, their journeys paralleled by the migratory movements of an assortment of fish and birds. Third—and this involves a little sleight of hand—there is the military recruiting message. In *Journey of a Coconut,* the little coconut "gazes out to sea, thinking, 'How I would like to travel to unknown islands, far across the sea, [take root there] and grow into a majestic palm tree.'" And so saying, he pushes himself free of his mother and rolls out to sea for a life of adventure. In *The Wandering Coconut,* the little coconut hears "a group of American soldiers fleeing, the sound of a machine gun—*ack ack ack ack*—as Japanese troops flying the Hinomaru flag pursue them. The little coconut thought, 'How I would like to give those strong Japanese soldiers my milk to drink.'" And so thinking, she drops off the tree and rolls, a bit too far, into the ocean.

In both cases, the recruiting message is oblique: neither coconut specifically mentions becoming a soldier, for instance, but both coconuts paraphrase the popular slogan to "annihilate the self in service to the nation" (*messhi hōkō*). Toshi's coconut is, in fact, beheaded and dies a military death (scrubbed across the deck of the Japanese ship), while Imamura's serves the country by producing food for Japanese civilians out of its body. In part, the difference comes down to gender messaging. Toshi's coconut is clearly a young boy and, as such, should be instructed to dream of a life of military service,[67] while Imamura's coconut seems to be a girl (giving her maternal milk as soon as she hits puberty), whose role is to give birth to as many children as possible so that they may go on to serve the nation. While neither

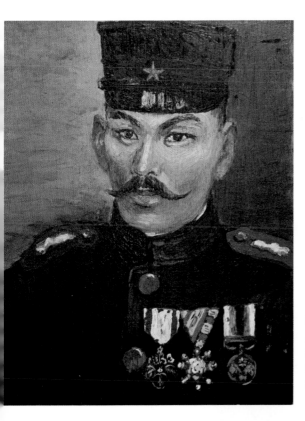

Plate 1. Akamatsu Toshiko. *Akamatsu Seijun no zō* (Portrait of Akamatsu Seijun). Ca. 1930. Oil on canvas. Private collection.

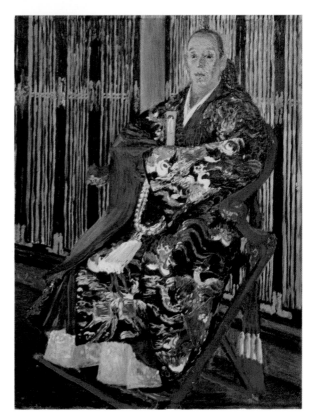

Plate 2. Akamatsu Toshiko. *Nise Atsura Hōshi shōzō* (Portrait of priest Nisei Atsura). Ca. 1930. Oil on canvas. Zenshōji treasure house.

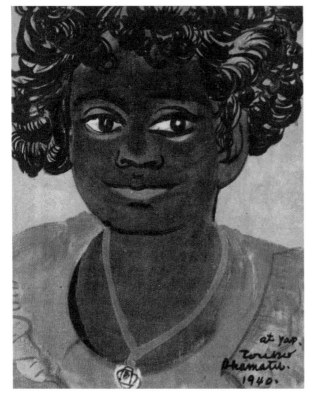

Plate 3. Akamatsu Toshiko. *At Yap* (Portrait of Mekaru). 1940. Oil on canvas. The current location of the painting is unknown, as are its dimensions. A color reproduction ran as part of the article "Nan'yō o egaku: Futatsu no fūkei" (Painting the South Seas: Two views) in the women's journal *Shinjoen*.

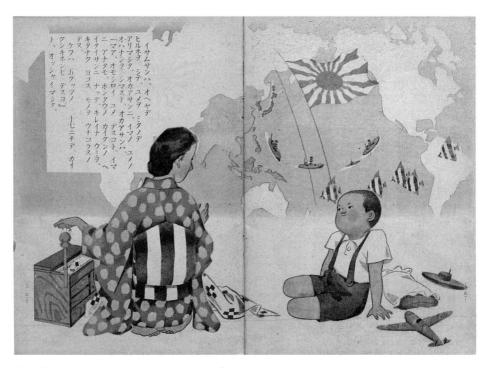

イサムサンハ、オヘヤデ
ヒルネヲ　シテ、ユメヲ　ミタノデ
アリマシタ。オカアサンニ、イマノ
オハナシヲ　シマスト　オカアサンハ、
一マア、オモシロイ　ユメ　デスコト。イマ
ニ　アナタモ　ホントウノ　カイグンノ　ヘ
イタイサンニ　ナッテ、キレイナ　ウミノ、
キタナク　ヨコス　モノヲ　ウチコラス
デスカ　ヨコス　モノヲ　ウチコラス
ケフハ　ハグッツノ
クンキネンビ　デスヨ」
ト、オッシャイマシタ。

Plate 4. "Isamu-san's submarine," written by Takeda Yukio and illustrated by Fuseishi Shigeo. May 1943. Cotsen Children's Library. Department of Rare Books and Special Collections. Princeton University Library.

Plate 5. Akamatsu Toshiko, illustrator, and Tsuchiya Yukio, author. *Yashi no ki no shita*. Tokyo: Shōgakkan, 1942. Cotsen Children's Library. Department of Rare Books and Special Collections. Princeton University Library. In this scene of a crowd in a movie theater, Toshi surrounds the main character (a young Japanese boy with rosy red cheeks) with a friendly, multicultural array of people from colonial Asia.

Plate 6. Akamatsu Toshiko, illustrator. *Yashi no mi no tabi.* Tokyo: Teikoku kyōikukai shuppanbu, 1942. In her cover art, and throughout the book, Toshi personifies the eponymous coconut, rendering him as a fully human, South Seas Islander boy.

Plate 7. Imamura Toshio, illustrator. *Yashi no mi no donburiko.* Tokyo: Seikadō 1943. Cotsen Children's Library. Department of Rare Books and Special Collections. Princeton University Library. Released by a rival publishing house in September 1943, presumably to capitalize on some of the popularity surrounding Akamatsu Toshiko and Maruyama Kaoru's 1942 children's book on a similar theme, *The Wandering Coconut* features markedly different visual decisions. Imamura's artwork ensures that the coconut, while personified with thoughts and feelings in the prose, remains reliably nonhuman.

7–8

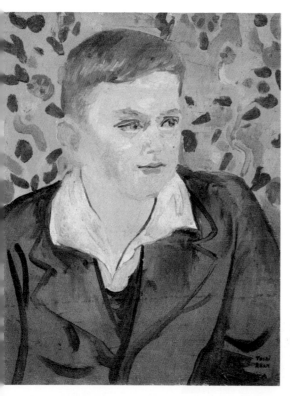

Plate 8. Akamatsu Toshiko. *Sānya: Mosukuwa no shōnen* (Sanya, a young Muscovite). Ca. 1938. Oil on canvas. 40.9 cm x 31.8 cm. Private collection.

Plate 9. Akamatsu Toshiko. *Kaihyōki* (The thaw). 1944. Oil on canvas. 112.2 cm x 146.0 cm. Private collection.

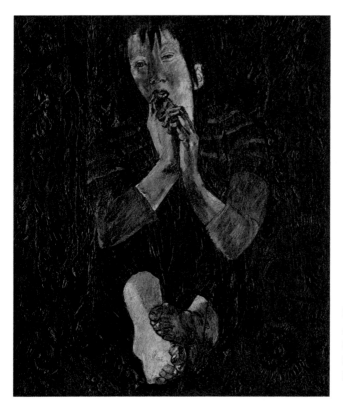

Plate 10. Akamatsu Toshiko. *Jigazō: Kubi tsuri* (Self-portrait: Suffocation). 1944. Oil on canvas. 53.0 cm x 45.5 cm. Private collection.

Plate 11. Akamatsu Toshiko, illustrator. *Shinfujin* 1:1 (May 1946). Held by the Gordon W. Prange Collection, University of Maryland Libraries. Toshi timed her first postwar cover to coincide with the international labor holiday of May Day. In it, she evokes both US wartime images of working women (such as the iconic Rosie the Riveter) and the general style of socialist realism. The badge-like stamp on the woman's left arm, and the various handwritten notations, are the work of censors associated with the Civil Censorship Detachment (CCD), the occupation office charged with vetting nonmilitary communications, including mail, telephone, telegraph, film, radio, newspaper, magazine, and book publications.

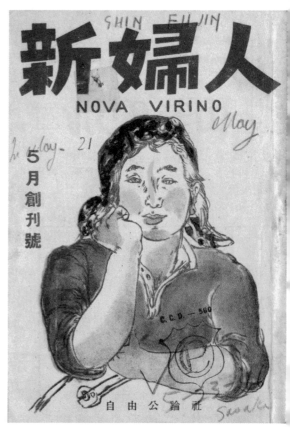

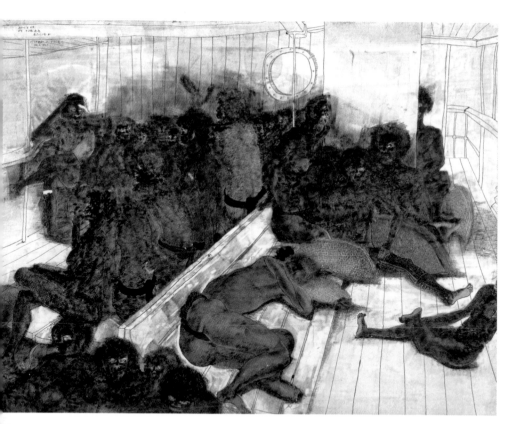

Plate 12. Akamatsu Toshiko. *Angauru e mukau* (Bound for Angaur). 1941. Ink and color on paper. 88.0 cm x 116.0 cm. Private collection. A handwritten note on the canvas references both a temporal and a spatial setting, referencing the Imperial Reign Year: "2601 August, completed at Mitaki. On a ship departing Palau Island bound for Angaur."

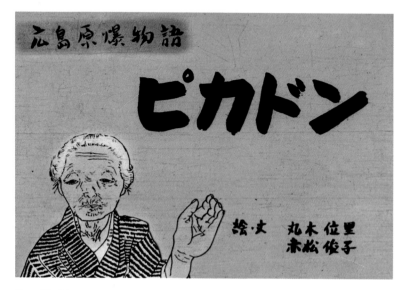

Plate 13. *Pikadon: Hiroshima genbaku monogatari* (Flash-boom: Hiroshima atomic bomb story). Private collection. This photograph shows a projection of one frame from the full-color, 35 mm version.

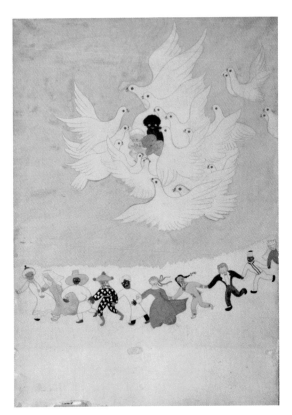

Plate 14. Akamatsu Toshiko. *Untitled.* Ca. 1958. Oil on canvas. Genbaku no zu Maruki Bijutsukan.

Plate 15. Akamatsu Toshiko. Poster for the fourth annual World Conference on Banning Hydrogen and Atomic Bombs (Genshibaku kinshi sekai taikai). 1958. Genbaku no zu Maruki Bijutsukan.

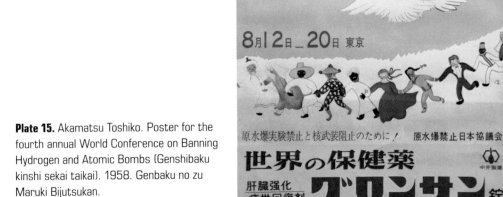

Toshi nor Imamura were explicitly commissioned by the military, their illustrations must be read in the context of the times as clearly complementing official mandates. Indeed, as this chapter has shown, many paragovernmental and paramilitary organizations—whether of artists, authors, publishers, or editors—existed at the time, and most were focused on serving imperial objectives. The Women Artists' Service Corps, for instance, operated by commission of the army, identified its "first major task [as helping] to promote the government's campaign for the recruitment of child soldiers."[68]

Lest anyone overlook the militaristic and self-sacrificial messages, the mandatory notes to mothers offer clarification. In her "note to parents and siblings," Satō Yoshimi records that "The goal of this book is to express to children the deep, natural connections between Southeast Asia (*Nanpō*) and Japan and to arouse their interest in the sea. Those objectives might not be immediately obvious, but I think that if you share this picture book with your children, it will leave its trace in their minds" (*kodomo no kokoro no naka no mono to naru deshō*). Maruyama Kaoru's note on the inside flyleaf of her book with Toshi is more forceful, claiming that the author will be "completely satisfied" if she has been able to "insert the impression, into children's lovely heads, that these three things—the South Seas, coconuts, and the Japanese navy—are inextricably bound to one another." On the one hand, that the authors had to state these pro-expansion, promilitary messages so overtly is one measure of the all-out mobilization of cultural resources at the time and the various sorts of thematic constrictions artists had to deal with. On the other hand, the notes, and indeed the entire premise of both books, is essentially a children's version of *nanshinron* ("discourse of advance to the south"), the concept, ubiquitous by the end of the nineteenth century, that Japan "would find glory, prosperity, and new territory by moving into the 'South Seas.'"[69]

When we set aside the tools of para-graphic framing, however, and focus solely on the visual material, we can get a better sense of the particular aesthetic choices Toshi was making, even as she was publishing (and being paid for) work that received critical praise and governmental recognition as serving the "culture for little countrymen" movement. As a comparison between the artwork for *Journey of a Coconut* and *The Wandering Coconut* will make clear, Toshi employs (or seems to employ) three specific strategies of resistance. First, she consistently chooses to arrange her visual compositions so that they partake in a minimal level of engagement with militaristic material. Second, she regularly employs an artistic gaze that accords, if not full agency, at least full humanity to her culturally "Other"

subjects. Finally, she often makes use of visual techniques learned from the materialist critiques of interwar proletarian arts.

As to the first point, already hinted at in my discussions of *Children of the Sun* and *Under the Palm Tree,* Toshi almost always avoids drawing art that glorifies battle or even presents Japanese soldiers in action. Toward the end of *Journey of a Coconut,* the coconut sights a column of smoke on the horizon. As the ship grows closer, he calls out, "'*Banzai!* It's a Japanese battle ship. Let me wave my Hinomaru flag and signal them.'" His hail is successful, and a small, white launch, rowed by two young seamen, is sent out to pick him up. In her artwork for the passage, Toshi omits the Rising Sun flag as well as the hands-over-head *banzai* gesture, denuding the coconut boy of any nationalistic trappings and focusing on the friendly-looking sailors. For readers who may have come to identify with the coconut boy, it is a deflationary moment that leaves the possibility that our affection may be displaced onto the smiling sailors, the battleship looming ominously—a spiky black silhouette—behind them (fig. 2.6).[70] In contrast, in his art for *The Wandering Coconut,* Imamura Toshio takes advantage of authorial suggestion to provide images of Japanese soldiers routing American forces

Fig. 2.6 Akamatsu Toshiko, illustrator. *Yashi no mi no tabi.* Tokyo: Teikoku kyōikukai shuppanbu, 1942. In her artwork for *Journey of a Coconut,* Toshi consistently downplays nationalistic and militaristic content, even when it is called out in the narrative prose.

(fig. 2.7). A Japanese soldier feeds a clip of ammunition into a realistically drawn machine gun, providing cover for two other soldiers to chase down the enemy, fast escaping into the forest. Everyone in this case has a flag, and everyone visible also holds a gun.

Part of the difference might be attributable to the slightly different age groups to which the two books were marketed. Toshi's book was targeted to children ages three to six while Imamura's was intended for children seven to eight. Targeted age groups might also explain, in part, the degree of personification each artist chooses to employ, though the difference is extreme. Imamura accords minimal effort to humanize his coconut, providing it only with a pair of round, red lips to complement the two naturally occurring eyes. Thus, on the last page of the book, when his coconut becomes merely a tree and no longer a thinking, acting agent, there is

Fig. 2.7 Imamura Toshio, illustrator. *Yashi no mi donburiko.* Tokyo: Seikadō, 1943. Cotsen Children's Library. Department of Rare Books and Special Collections. Princeton University Library. In contrast to Toshi's style, Imamura Toshio uses his visuals to amplify authorial suggestions.

no marked shift in visual technique. If Imamura's protagonist is little more than a coconut with lips, Toshi's protagonist is an Islander boy, of about the same age as her readers, with a coconut balanced on his head (fig. 2.8). He has hands and fingers, a face capable of expressing human emotion. He thinks, talks, climbs, and swims. When, in the last pages of the book, he suddenly becomes merely a coconut, the abrupt shift in visual portrayal is almost shocking (fig. 2.9).

Toshi was well aware of the proletarian artistic technique of employing a material stand-in to reflect upon the instrumentalization of people under capitalist modernity,[71] and it is certainly possible that she intended the ground coconut to be a covert critique of the colonial enterprise. The final spread shows a rising sun over a shining sea, accompanied by the melancholy words, "The coconut was a little sad that he hadn't landed on another island and become a magnificent coconut tree. But at least he had been of use to the Japanese nation, and so thinking, his sadness soon cleared, and a feeling of joy welled up within." In this children's book the nut brown body of the South Seas child—which has momentarily served as a placeholder for all those young Japanese boys who dreamed of becoming

Fig. 2.8 Akamatsu Toshiko, illustrator. *Yashi no mi no tabi.* Tokyo: Teikoku kyōikukai shuppanbu, 1942. Toshi's artwork for *Journey of a Coconut* consistently underscores the humanity of the personified coconut.

sailors in the Imperial Navy—loses its face and is slashed in half, literally ground into the deck of the ship.

Perhaps word and image work against one another here, suggesting either that naval life is not so grand after all or that it preys upon the dreams of young innocents, or perhaps hinting at the human costs of colonial exploitation. It is hard to know what Toshi's young viewers were prepared to see in, between, and beyond the lines of her artwork, but Sari Kawana's study of "little countrymen" as readers suggests that even juvenile readers were aware of the disjuncture between the children's visual culture of the 1910s and 1920s and its visual, rhetorical, and ideological impoverishment by the late 1930s and early 1940s. Kawana argues that "these young readers responded to the most proscriptive texts in unexpected and illuminating ways," generating a variety of "unprescribed readings."[72] Indeed, one of those young readers, Sakuramoto Tomio (who would have been nine years old when *Journey of a Coconut* and *The Wandering Coconut* were published) has argued that even though Toshi's art is characteristic of South Seas discourse of the era, "it was also possible for readers to infer [from the illustrations] a sense of the discrimination that Great East Asian Japanese enlighteners bore toward Islanders."[73] So it is just possible to read the combination of word and image

Fig. 2.9 Akamatsu Toshiko, illustrator. *Yashi no mi no tabi.* Tokyo: Teikoku kyōikukai shuppanbu, 1942. A human boy until this moment, the coconut is suddenly whacked in half and used to scrub the deck of the Japanese warship.

against the dominant grain of a predestined southern advance of the Japanese cultural and military sphere.

We may find those messages in this story, but to do so, we will have to swim, and swim *hard,* against the current. While the role of visual artists has been less studied than that of literary ones, we do know that Toshi was but one of about fifty Japanese artists to visit the South Pacific between 1910 and 1945. Many of these men journeyed south in the role of cultural attachés.[74] The number of artists in the South Pacific increased after Japan withdrew from the League of Nations in 1933, and it peaked in the late 1930s, so Toshi was riding a wave of "southward advance discourse" (*nanshinron*). While Toshi's illustrations in *Journey of a Coconut* may attempt to gesture backward toward a more benign period of cultural engagement in which one could still entertain fantasies of peaceful multiculturalism, her vision cannot escape the long shadow of militaristic expansion, as the ominous presence of the Japanese warship looming on the horizon of her coconut's seascape suggests. Indeed Toshi's book headed the list of seven new publications "recommended" by the Publisher's Association (Shuppan bunkyō)[75] under the guidelines issued by the Ministry of Education, and it was advertised alongside Kitahara Hakushū's pro-imperialist *Collection of Children's Tales: Wind and Flute* (*Dōwashū: kaze to fue*), Niwa Fumio's *Battle at Sea* (*Kaisen,* a journalistic first-person account of the bloody naval war in the Solomon Islands), and *Nanpō no kuni meguri* (An account of countries in the south, a justification of the Co-Prosperity Sphere).[76] The government, media, and publishing industry, at least, viewed Toshi's artwork as scalable, ideologically preparing children to take up the burdens of empire and the tools of war.

National Formation

My goal in this chapter has been to understand the "culture for little countrymen" movement in Japan as a home front counterpart to the policies of development and immigration trained upon the Japanese colonies. In chapter 1 I focused on excavating the tools and techniques involved in the "imperial formation" of Hokkaido and Micronesia as Japanese colonial holdings, unearthing the ways Toshi marketed her images of South Seas Islanders in the larger context of imperial resource extraction and ruination. Building on that conceptual foundation, in this chapter I have sought to explore the ways the Home Ministry, the Ministry of Education, and the publishing industry—together with individual artists and authors—came to treat Japanese children as raw materials to be formed and as natural

resources to be trained into national products. In addition to this larger conceptual argument, I have also developed a materialist and book historical approach aimed at clarifying the specific ways artwork in general (and Toshi's artwork in particular) can be mobilized to function as war materiel, either through particular compositional strategies employed by the artist or by way of tools of "para-graphic" framing.

Of course, we are always using children's culture to shape young people's ideas, desires, ideologies and life plans. And under conditions of total war or intense ideological conflict, the pressures brought to bear upon producers of children's culture can be profound, often justifying (or being claimed to justify) "increased legal/professional surveillance," "federal intervention in educating and raising the young," and "new regulations that more carefully monitor the child and the family during their daily activities."[77] In my approach here, I agree with Sakuramoto Tomio, who argues that everyone—authors, artists, adults, and children—is responsible for his or her actions, during wartime or no.[78] Not every course of action is equally available, however, and I have thus sought to create a nuanced account, both of the probable choices an artist (who wanted to publish) *could* make in 1940s Japan and of the particular choices that Toshi *did* make. While my study focuses on Toshi, it is important to note that she was not alone, not unique in her attempts to sidestep or work against the grain of the times. Indeed, a handful of other artists made similar choices.[79] What is exceptional about her, as I noted in the introduction, is the rich and varied archive of materials she left behind, which allows us to reconstruct so much of her thinking, her choices, and her contemporary context.

I return to the issue of wartime responsibility in chapter 5, and to the questions of how cognizant Toshi was of materialist critiques and proletarian artistic techniques in chapters 3 and 4. In particular, I turn, in the next chapter, to Toshi's experiences in Moscow in the late 1930s and early 1940s in order to trace her developing practice of *dessin* sketching and to investigate how much her engagement with this genre may have helped her to pull away from her initial training in oil painting and from its imperialist underpinnings.

CHAPTER 3

Red Shift

Pre-1945 Visual Culture, Heterochronicity, and Proletarian Eastern Time

As discussed in chapter 2, the 1930s represented a slow death spiral for leftist politics and proletarian arts in Japan. Japan's nationalist leaders, in cultural fields as in other areas, sensed the threat[1] that class revolution posed and sought to interdict the alternate future that proletarian activism promised. They did this by arresting artists, shutting down magazines, banning books, censoring newspaper articles, and erecting an ideological *cordon sanitaire* around the capital. Officers associated with the Special Higher Police Force within the Home Ministry visited repeated waves of interrogation upon artists associated not only with proletarian art, but also with surrealism and other avant-garde Western schools, in an attempt to yoke visual culture firmly to imperialist agendas and nationalist futures.[2] In February 1933, police officers beat to death the proletarian author Kobayashi Takiji (1903–1933), whose battered and bruised body, displayed to friends and family, served as a stark visual statement of political policy toward the arts. Yanase Masamu (1900–1945)—another prominent proletarian and avant-garde artist associated with the experimental group MAVO and known for his multimedia works and communist posters—was jailed as a political subversive under the Peace Preservation Law right around the time that Toshi graduated from the Western painting division of the Women's Arts College (Joshi bijutsu senmon gakkō) and began work as an elementary school teacher in April 1933.

Between 1933 and 1936 Toshi was relatively quiet, her days devoted to preparing lessons and dealing with her other teaching responsibilities. Artistically and politically, she remained a largely unknown quantity. Aside from strictly academic exhibits associated with her college, Toshi

participated in only one public show, exhibiting paintings of two nudes in January 1933 at the Mitsukoshi department store. Beyond that, she was unable to break into the arts world, and she must have been afraid of dying on the vine. By early spring 1937, Toshi decided to take a major gamble. On the advice of her mentor, the Fauvist Kumagai Morikazu, she would quit her teaching job and give up her steady salary of 37.50 yen per month to become a full-time artist. She planned to move to a warren of inexpensive artist's residences just being built in the neighborhood of Ikebukuro, at the northwest edge of the capital, where she could use her savings to rent a small, spare atelier for about 13 yen per month.[3]

Instead of moving to Ikebukuro, however, on April 15, 1937, Toshi took a train from Tokyo to the port of Tsuruga, where she boarded the ferry to Vladivostok, bound for Moscow. Her first sketch from the trip, dated April 20, 1937, is signed Toshi Aka and features a cohort of Red Guards marching down the streets of Vladivostok. In her signature she has abbreviated her last name (Akamatsu, literally "red pine") to just the first half (*aka,* "red"), possibly an oblique indication of solidarity with the soldiers and the ideas they represented for her. She was not attempting to escape the country, however, or to flee an increasingly militarist Japan for the proletarian motherland. Rather, she was part of a diplomatic mission. More specifically, she was the help. She recalls that just before the end of the school year her colleague Hirano Fumiko called her over in the teachers' room and explained that one of her student's fathers was being posted to Moscow and needed a governess. "It's a red country, though, so everyone's tucked tail and is holding back. But I said you're just enough of an oddball, you'd probably say yes."[4]

Toshi weighed the loss of freedom against the source of income and the chance to travel, musing, "In that country that everyone's so afraid of, what kind of art do they have and what kinds of artists are living there? What sorts of towns and what sorts of houses do they have? What do they eat? What do they talk about? Why not go?"[5] And so Toshi departed for the first of two stints as a governess to Japanese diplomatic families posted in Moscow, where she lived from April 1937 until April 1938, and again (after her time in Micronesia, discussed in chapters 1 and 2) from January through May of 1941. Busy from sunup to sundown six days a week, Toshi had Sundays off to wander the city and explore parks, museums, galleries, and public spaces. She was on her own in Moscow, ideological capital of communism and home to still-sizeable collections of postimpressionist European art.[6] Cubist, surrealist, suprematist, and rayonist works filled

exhibition spaces and galleries, May Day parades thronged the streets, banners and sculptures of communist leaders and popular figures decorated the squares, and socialist youth brigades camped in the countryside near the diplomats' summer villas. During a time when suppression of political leftists and avant-garde artists proceeded at a feverish pace in Japan, Toshi found herself living in the heart of "red" culture.

In this chapter I explore the politics of pre-1945 proletarian visual culture in Japan, using Toshi's experiences in Russia, her contemporary accounts of them, her sketch work, and her Moscow-related exhibits as a microhistorical window opening onto alternate visions of the future offered by proletarian culture and the difficulties in displaying those visions publicly in fascist Japan. I attend to the gendered and upstairs/downstairs nature of Toshi's experiences in Moscow, and conceptually I build on Keith Moxey's revisionist art historical claims against a Eurocentric linear periodization. Moxey argues that "historical time is not universal but heterochronic, that time does not move at the same speed in different places"; nor, I would add, does it move along the same trajectories.[7]

Rather than view twentieth-century Japanese art (or Russian art, for that matter) as a form of belated, peripheral modernity keyed to a Euro-American chronology, I argue that Toshi's artwork participates in and helps to envision what we might call an artistic Proletarian Eastern Time, a major feature of which was an extensive artistic slipstream between Russia and East Asia.[8] Indeed, as Jane Ashton Sharp has argued, questions of chronology, modernity, and periphery (particularly vis-à-vis French art) galvanized many proletarian and avant-garde Russian artists in the early 1900s, who struggled with these questions just as did their counterparts in Japan.[9] If Soviet avant-garde artists' "turn to the East [was] a condition of [their] radicality" in the 1910s and 1920s, that eastern-looking gaze was met by an equally powerful Soviet-looking gaze as Japanese artists around the same time often imagined their own artistic and political radicality via proletarian tropes and genres.[10] On her free days in Moscow, Toshi visited museums and galleries to view new Russian artwork, and an examination of her diary entries and sketches calls attention to some of the ways proletarian and avant-garde culture allowed artists (in both Tokyo and Moscow) to contest Parisian Modernist Time and to envision alternate futures via their own aesthetic practices.

The Diplomatic Help: Life in the Yuhashi and Nishi Households

During her first posting in Moscow in 1937 and 1938, Toshi served as the governess and nanny to four children in the Yuhashi family: a fifth-grade girl, a

third-grade boy, and two preschool-aged girls. In later years, two of the children (Shigeo and his younger sister Sayuri) would recall that their mother "was a real tiger mom for education (*haha ga hijō ni yakamashii, kyōiku mama datta*), whereas Toshi was the total opposite. She was quite relaxed and nurtured us as individuals. While looking after us, she was always working on sketches, whether of the city streets or of the countryside."[11] Indeed, Toshi's notes indicate she vowed to complete at least one sketch per day, though her days were quite full. Awake by 7:00 a.m., she would attend to her own toilet and join the family for breakfast at 8:00 a.m. sharp. Between 9:00 a.m. and 2:00 p.m. she was responsible for the children's education and lunch, and from 2:00 to 3:30 she took them on an outing, usually a walk through a nearby park but sometimes a trip to the zoo or a puppet play. Toshi had one hour of free time, from 3:30 until 4:30, which she typically spent sketching or attending to personal errands. At 4:30 she bathed the children, fed them dinner, tucked them in bed, and began preparing the next day's lessons. Before retiring for the evening, she would sometimes study Russian with Mrs. Yuhashi. Sundays she had to herself.

The family was a warm, tightly knit unit, despite Mr. Yuhashi's sometimes tense working conditions. Yuhashi Shigetō (1897–?) served as Russian-language translator for the Japanese Embassy in Moscow in 1937 through 1938, later returning as interpreter for ambassador extraordinary and plenipotentiary Satō Naotake (1882–1971) throughout the latter's tenure in Moscow from 1942 to 1946.[12] During the time Toshi lived with his family, most of Yuhashi's translation work pertained to working out fishing rights in the northern Pacific. These rich maritime areas were contested by Russia and Japan, and international relations remained delicate in the wake of the Russo-Japanese War (1904–1905), the subsequent establishment of Karafuto Prefecture on the southern half of the formerly Russian island of Sakhalin (1907), and Japan's successful demands for coal and petroleum concessions in northern Sakhalin (held from 1920 through 1944). Toshi made several sketches of the Japanese Embassy—the Yuhashi residence was a short walk away along a back street—and noted the regular security detail. "There is a *gepebō* in front of the Japanese Embassy," she wrote on the back of one of her sketches. "Today, even though it's 30 below, they are going back and forth silently, breathing white puffs of steam."[13]

On her second stay in Moscow, this time working for Yuhashi Shigetō's superior Nishi Haruhiko (1893–1986),[14] Toshi's responsibilities were less onerous and her social calendar much more varied. She served as governess to the two Nishi daughters Kiyoko and Miyoko, both in their mid- to late teens, and was especially charged with helping the elder daughter (Kiyoko) prepare for

admission to an arts college. Toshi had access to elite diplomatic life, everything from a first-class compartment on the train across Siberia to a loge with the family at the theater. The Nishi family lived in sumptuous apartments—the Molotov Mansion, in fact—and treated Toshi essentially as a member of the family,[15] inviting her along on their Sunday excursions, whether artistic (museum, opera, theater), sporting (skiing and ice skating), or social (drives in the country, and even some diplomatic dinners).[16] One of Nishi Haruhiko's early postings had been to Changchen (where he served from 1922 to 1925), then headquarters of the Japanese Kwantung Army and of the Manchurian Railway. In the wake of the 1917 Russian Revolution, a large expat community of White Russians had made that city their home. He began learning Russian and, shortly thereafter, was detailed to Moscow in the first of three postings there.[17] On his first two sojourns in Russia, Nishi worked closely with Yuhashi[18] on treaties pertaining to fisheries in the north Pacific and coal and petroleum concessions on Sakhalin/Karafuto, and his young family thrived. Able to travel freely, they explored Siberia and cultivated friendships with Russian families, among whom their children found avid playmates.[19]

Life in 1941 Moscow, however, was not wholly idyllic. Russia faced shortages of some basic supplies, and the stakes of Nishi's negotiations with his Russian counterparts, as well as his Japanese colleagues, were high throughout his third sojourn. Russo-Japanese bilateral relations, never comfortable, soured rapidly with the Japanese-German Anti-Comintern Pact, signed in Berlin on November 25, 1936. Nishi recalls, "After this, the Soviets viewed both countries [Japan and Germany] as virtual enemy states, and that really interfered with and effectively ruptured international relations with Japan. . . . Personally, I was also dealing with people tailing me and other uncomfortable experiences," including having a rock thrown through the embassy's front door.[20] Tensions rose even higher with a series of minor wars in the summer of 1938 (the Battle of Lake Khasan, *Chōkohō jiken*) and the spring of 1939 (the Battles of Khalkhyn Gol, *Nomonhan jiken*) as the Soviet Union, Mongolia, and Imperial Japan tested the ill-defined Manchurian and Outer Mongolian borders. Nishi's major initiative throughout the spring of 1941 was the negotiation of the Soviet-Japanese Non-aggression Pact (Nisso fukashin jōyaku), signed on April 13, 1941. In short, during her stay with the Yuhashis in 1937 through 1938, and again with the Nishis from January through May 1941, Toshi had access to the upper crust of elite Russian society and an entrée (albeit a secondhand one) to the often tense Japanese diplomatic circles. Or, rather, she had access to these when she was not bathing, feeding, teaching, or tucking in the children.

Upstairs, Downstairs: Politics of Class and Gender in Toshi's Russian Sketches

Toshi's desire to know "what sorts of art . . . , towns, and houses Russians have . . . , what they eat and what they talk about," were no idle musings.[21] Rather, as during her time in Micronesia, she used her sketchbook and her paintbrush not only as artistic tools, but also as quasi-sociological ones. She asked questions constantly. Looking out the train window at two women hefting heavy sacks along a narrow road through the taiga, she wondered, "Where in the world are they walking? Where is their house?"[22] She peeked in windows, smiled, and drew what people were eating for breakfast. And she started conversations with the people she encountered in parks and public places. While the Yuhashi children played outside their parents' country villa, Toshi sketched Inga, a young woman with close-cropped hair, wearing a long floral dress, and holding a half-full glass.[23] Sitting on a snowy park bench, she drew a nameless young woman who told Toshi that she had come to Moscow to look for work. Later, in the same park, she sketched a woman named Tanya in her heavy cloak and boots (fig. 3.1).[24]

While her diplomat employers worked on treaties that would gov-ern (or attempt to govern) the conduct of nations, Toshi worked on

Fig. 3.1 Akamatsu Toshiko. *Untitled* (Moscow sketch #169). Pen and pencil on paper. Private collection. The sketch is not dated, but it appears in Toshi's notebooks midway between sketches dated to April 1937 and August 1937, so was likely completed in June or July of that year.

intimate glances into the lives of bit players. She sketched their cheeks, their hands, their clothes. She looked them in the eyes and she tried to learn their names. One day she might strike up a conversation with a friendly-looking older man and discover that he had thirteen children.[25] Another day, she might speak to a Russian soldier and convince him to sit for a series of sketches. At a cultural performance she spoke with Nikolay [Kolya] Bodrov, a Gypsy dancer who saw her darker skin and asked if she was a Gypsy, too, before signing her painting in imperfect Russian: "You are good Tosya [a Russified nickname for Toshi] and I am good Kolya." On the ferry from Vladivostok to Tsuruga in June 1941, she made the acquaintance of Herbert Friedberg, an American tobacconist who signed his name with "hearty good wishes" (Moscow Sketch #297, dated June 1, 1941), Rosa Air Renuzy, whom Toshi described as "an honorable woman" (Moscow Sketch #298, dated June 2, 1941), and a man named Lygallottry who was bunking with his wife in steerage (Moscow Sketch #299).

Toshi wanted to know people's stories, and most often the people willing to speak with her were women, children, and workers. Sketching was an opportunity to observe the life of a neighborhood, learn people's names and daily rhythms, develop conversation, and, when possible, cultivate friendships. In February and March of 1938 she made use of her copious time in parks to complete a series of sketches of Russian children, making small talk as much as she was able. She spoke about the weather with a girl named Lyda: "I'm so happy!" "Why?" "Look! Spring has come!" "That's true." "More or less."[26] She gets the kids into it, and they bring her a young fellow whom they introduce as Vitya, "The kids said, 'He's a soldier.' And, sure enough, he was kitted out to look like a Russian soldier"[27] (fig. 3.2). On at least one occasion, she was able to turn the impromptu outdoor sketch into an opportunity for a formal portrait, which indicates her ability to gain entrance to private, family spaces (plate 8).

Like the stitching on the backside of a tapestry, her notebooks and sketches reveal not only a personal underside to the global events of history writ large, but they also indicate some of the politics of gender and labor in a sphere that was, for Toshi, at once domestic, artistic, and political. On the back of one sketch, of a woman in a heavy coat pushing a baby carriage, Toshi noted acerbically, "Nursemaid taking care of baby. The nursemaids have more responsibility and authority than the mothers. That's not changed since the Revolution" (Moscow Sketch #166). For her part, though

Fig. 3.2 Akamatsu Toshiko. *Vitya.* (Moscow sketch #148). Pencil on paper. February 1938. Private collection.

she had nearly round the clock access to the Yuhashi family, she rarely sketched them or their apartments, preferring to use her pencil and brush to capture the lives of workers. Often these were fellow domestic servants, who she sketched repeatedly when possible (fig. 3.3). In the summer, Muscovite families repaired to their dacha in the woods, taking their servants with them. Whether to escape the heat or because of the smaller quarters, many of these women worked outdoors, and Toshi took to peering over fences and learning their names (fig. 3.4).

Proletarianism, Nationalism, and the East: Toshi's "Downstairs" Aesthetic

Toshi's sketches are not obviously political, insofar as they do not recapitulate typical tropes of proletarian art as practiced in 1930s and 1940s Japan: raised fists, angry grimaces, limited palette dominated by red, black, and white (fig. 3.5). When Toshi's subjects make eye contact, they are not angry or shouting but are exhibiting frank curiosity and, sometimes, gentle smiles. Though situated in their places of work, they do not appear particularly oppressed by their conditions of labor: no gaunt faces, ticking punchclocks, or smoking stacks. By contrast, Toshi's subjects typically seem relatively well-fed, adequately clothed, and at ease. Rather than predominantly muscular men in workers' caps, Toshi pictures mostly women, their

Fig. 3.3 Akamatsu Toshiko. *Roshia daidokoro* (Kitchen in Russia, Moscow sketch #75). August 1937. Watercolor on paper. 25.5 cm x 19.5 cm. Private collection.

hair caught up in kerchiefs, but their arms equally strong, perhaps a nod to the more maternal imagery that Soviet posters featured.[28] Yuhashi Shigetō, for instance, recalled seeing this 1941 "The motherland is calling!" poster plastered all over the buildings along Gorky Avenue, near the Japanese Embassy (fig. 3.6).

Certainly, proletarian tropes of angry workers and raised fists were marked as politically subversive in Japan; the images were subject to censorship and the artists (like Yanase Masamu) subject to imprisonment. That may have been one reason Toshi avoided them. But Toshi was also looking for something new. In her diary entry for March 17, 1941, she jotted down her appraisal of the Exhibit of Modern Soviet Artists (Sobietto gendai shin-shin sokka tenrankai).

Fig. 3.4 Akamatsu Toshiko. *Untitled* (Moscow sketch #187). Private collection. Toshi has handwritten the word "cover" (*hyōshi*) on the back. Indeed, this sketch later appeared on the cover of the journal *Weekly Russia* (Gekkan Roshia), for which she supplied cover art on eighteen occasions between October 1942 and January 1945.

Here and there you'd see a portrait of Stalin or Lenin, and they'd be on the theme of hearing Gorky or Stalin or reading aloud [word marked out, illegible] from their own works, but the propagandistic (*sendenteki*) [word marked out, illegible] flavor of the artwork had grown markedly

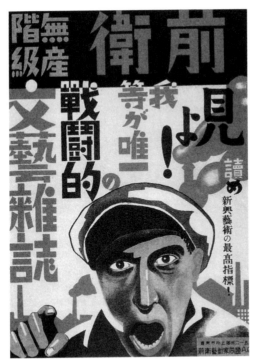

Fig. 3.5 Advertisement for the art magazine *Zen'ei* (Vanguard). 1928. Artwork in the public domain. In part, the ad copy reads, "Look! We are the only combative proletarian arts magazine! Read the best guide to the new art."

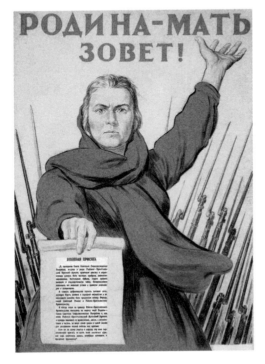

Fig. 3.6 Irakli Toidze. *The Motherland Is Calling!* 1941. Artwork in the public domain.

less pronounced. ~~In particular, the artworks on display~~ And, even for those works that were more propagandistic, ~~the technique was little by little~~ it looked like the artist's technique and attitude toward production was under close scrutiny and they were much more subtle, ~~[illegible, phrase heavily marked through]~~ allowing the judges a bit more leeway. Perhaps you could say that the artists ~~[illegible, phrase heavily marked through]~~ had taken one step away from propagandistic artwork, ~~[illegible, phrase heavily marked through]~~ and one step toward historical artwork (*Mō sendenga toshite yori mo rekishiga toshite no ippo o fumidashiteiru no de arō ka.*)[29]

Clearly uninterested in the merely propagandistic, overtly political art of the immediate post-Revolution period, Toshi was looking for a more subtle angle, something more "historical."

This was a dangerous proposition at a time when the Japanese military was recruiting artists to accompany soldiers and sailors to the front lines to produce a style of war art generically modeled on the monumental history paintings of Europe. As Maya Tsuruya has shown, the genre of war documentary painting (*sensō sakusen kirokuga*) "emerged as state-sponsored public art during the second Sino-Japanese War and the Pacific War between 1937 and 1945," but should not be regarded as a "wartime anomaly."[30] Rather, the genre has a long prehistory, combining elements of the European monumental history painting (as a large format picture depicting a historical theme) with popular forms such as the panorama, the diorama, and the proletarian wall mural (*hekiga*), resulting in a "new concept of art for the masses." Japanese artists could "respond to the state's call for . . . public depictions of sacrifice, thereby harnessing art as a psychological weapon in the total war effort."[31] The war documentary painting was the preferred genre of the Army Art Association (Rikugun bijutsu kyōkai) and its correlate in the Imperial Navy, which tried (unsuccessfully) to recruit Toshi to travel to the Solomon Islands in 1941 to paint scenes from the naval battles there.[32]

Soviet culture, too, was in the throes of a nationalization process. In the 1920s, Russian artists had tended to spend time outside of Russia (typically in Paris) studying modernist artistic techniques and absorbing progressive political ideas. Upon returning home, they had remained relatively autonomous in their actions and markedly utopian in their visions. Though they largely conceived of art as a force for transforming society, they did not generally have an audience in the masses, who—despite the efforts of the Itinerants and their traveling exhibits—remained largely out of touch

with metropolitan developments.[33] By the 1930s, however, more Russian artists were remaining in the country while the state exerted increasing control over and censorship of artistic production, circulation, and display. As Robert C. Williams has argued, "By 1934 Russian tradition, authoritarian party controls, and heroic individualism were the hallmarks of [official] Soviet culture. The sense of encirclement by hostile foreign powers, notably Germany and Japan, produced a new nationalism" and the ideal of the individual "positive hero" developed.[34] Iconic heroes of 1930s Soviet art included Aleksei Stakhanov, a miner who became famous for his exceeding productivity, along with mountain climbers, Arctic explorers, and record-setting airplane pilots. Toshi remained unimpressed; her notebooks contain a dismissive critique of one young painter Oparin's works: "Celebrates young aviators in his paintings. Annoying."[35]

If Toshi was dismissive of nationalistic works, she was equally put off by heavy-handed applications of Parisian styles. She lamented that a certain unnamed painter had "lost his own art to an overly high estimation of Parisian culture and Parisian Parisianity, becoming captive to those conceptual techniques."[36] Toshi was most interested in the Soviet painters who successfully combined some western European modernist elements with "the newness of orientalism" (tōyōfū no atarashisa) to produce paintings that exhibited a sort of "oily viscosity" (aburakkoi nebasa) that she found distinctively and powerfully Russian.[37] In this, her preferences accord with Jane Ashton Sharp's observation that for Russian artists in the early twentieth century, "Avant-garde arguments for the superiority of the East were influenced by European primitivism but are better understood in the context of India and Japan, which allowed artists to strategically embrace certain elements of Western style in a contemporary renewal of precolonial practices."[38] Toshi gave her highest praise to artists like Konstantin Semionovich Vysotsky and Mariam Arshaki Aslamazian who, in the works Toshi viewed, had looked to the peoples and geographies of the Russian "east" for inspiration.

In advocating for a "historical" rather than a "propagandistic" style of art, Toshi was walking a tightrope. As Gennifer Weisenfeld has noted, "the fine line separating high art from the market economy was quickly eroding" in 1930s Japan, meaning that politically engaged art, consumer-oriented art, and technically sophisticated mass art were all tightly interwoven, aesthetically speaking, despite their different political commitments.[39] Judging by her sketches and her notes on the backs of them, what Toshi seems to have been advocating for was not an art that gestures toward the grand sweeps of history, whether that of imperial war embodied by faceless,

nameless soldiers (as in Japan's documentary war painting) or of ideological revolution embodied by iconic, heroic workers (favored by Soviet socialist realism). Rather, in her artistic practice she advocated for observing faces, learning names, listening to stories. Her drawings do not show the heroically strong, socialist workers of Stakhanovite Russia but the women, men, and children whom she toiled unheroically alongside. Toshi's often frames her subjects—working women with sleeves rolled up, aprons and kerchiefs protecting chests and heads—elbow-deep in the process of food production and surrounded by the tools of their labor: pots, pans, cutting boards, and, indeed, kitchen sinks. In short, Toshi was interested in an art that showed the servants rather than the masters, the everyday workers rather than the heroic icons. Rejecting both Parisian modernism and socialist realism, she sought to embrace what we might call a Proletarian Eastern aesthetic. She wanted to make art that attended to what we might call the "downstairs" of history, seeing that downstairs as history's (political and aesthetic) future.

That "downstairs" became much harder for Toshi to access on her second trip. In 1941, she used her 1937–1938 methods to make similar attempts at connection with her Russian peers, but with fewer successful results. She notes that Russians at the time tended to view Japanese people with suspicion and that security had tightened, meaning that her contacts with private Russian citizens were subject to monitoring and people on the street were less willing to talk with her. Her employer noted the change as well. Contrasting his experience in 1941 with his earlier sojourns in Moscow, Nishi Haruhiko recalled that in 1941 he was accompanied by a minder from the time he entered the Soviet Union until the time he left the country. "On the train through Siberia, if I got up in the middle of the night to use the bathroom, someone came with me. [...] If the family went skiing, someone came with us."[40] Diplomatic relations were frosty and he was hardly allowed to meet with any Russians outside of his official work. The media was quick to associate foreigners with the label of "spy," and the Nishis were not able to meet with or enjoy the company of everyday Russians; it was, Nishi writes, "a very lonely time," not only for the Nishi family but also for their live-in governess.[41]

These changes made a deep impact on Toshi's artistic techniques, and her works from 1941 evince, on the whole, a greater distance from her Russian subjects that is only partially attributable to her own subtle elevation in class, from her nanny and governess role in the Yuhashi household to her status as artistic mentor and almost-family-member in the Nishi household. Though she still made sketches of street scenes and working people, a

larger proportion of her sketches and paintings from 1941 treat high cultural events: operas, ethnic dance performances, theater, dinners, and other functions she attended as part of the Nishi's diplomatic retinue.

If Toshi lived in the (lonely) lap of luxury, however, she seems to have grown a little tired of helping the shoulders of luxury into their gowns. Her diary entry for March 16, 1941, contains a lengthy critique in which Toshi explicitly links class consciousness to politics, ethics, and aesthetic practice.

> Clothing should be simple. Complicated pieces, where you have to rely on someone else to help you get dressed, are a luxury. And this whole business of helping someone put on their overcoat or their shawl— that's really unnecessary. ~~And putting on someone's shoes [illegible phrase, marked through heavily.]~~ Of course, helping your lover put on his tie—that's a different matter.
>
> If what they want is a wholesome art, then a wholesome art it has to be (*Kenkōna geijutsu o yokusuru naraba, kenkō denakereba naranu*). If Japan wants wholesomeness, wants to make good on its promises to the East, then they should eradicate tuberculosis. They should take all the rich people's vacation homes and turn them into convalescence wards.
>
> I've often been told that good and evil live cheek by jowl (*Zen'aku ga ryōsei suru to wa yoku itta mono dearu*). If an individual is the type to fortify the good and shrink the evil, then the evil undergoes a transformation and is discharged.
>
> Maybe evil children are born of the sperm that has been discharged thus from the saints of this world.
>
> I wonder how many tens of thousands of them are born for each Christ. How many tens of thousands of people ~~fall into hell~~ go to hell for each buddha?
>
> Everything should just be simple. And so it should be with art, too. If you've got a pencil and paper, that's all you need. Simple, yes, but not crude. (*Subete kanso de arubeki dearu. Geijutsu mo mata shikari. Ippon no enpitsu to kami de atte yoroshii no dearu. Tada, soaku deatte wa naranai.*)[42]

Toshi begins the passage with the issue of class. Clearly she has been asked to help the Nishis put on their coats and button up their dresses one too many times, and she does not fancy herself a valet. Helping someone put on their clothes should be a matter of affection, not a matter of

economic compulsion. Dictum: keep it simple. Wear clothes you can put on yourself.

From that fairly proletarian-sounding stance, she moves to a brief discussion of art, jumping directly into a short rant about Japanese governmental demands that artists produce "wholesome" artwork. Here Toshi likely is reacting to a recent exhibit in Tokyo that was entitled "National Defense and Health" (Kokubō to kenkō tenrankai). Japanese newspapers covered the event, with the *Asahi Shinbun* reporting that,

> Improvement in the physique of our countrymen is the foundation upon which our national defense is built (*Kokumin tai'i kōjō ga kokubō kokka kensetsu no kiso de aru*). In order to emphasize this point, the organizers have gathered information pertaining to the population and physical development of different nations, and displays of photography, artworks, statistical graphs, and dioramas show both Japan's past conditions and our current condition. A wealth of materials from the army and navy, the German Embassy, the Ministry of Welfare, the Committee to Promote International Culture (Kokusai bunka shinkōkai) and other organizations is available.[43]

The exhibit hung on the fifth floor of the Shiragiya Building from March 7 through 16, 1941, and, as the mention of the German Embassy's involvement suggests, drew heavily on Nazi notions of fascist aesthetics and the cult of the body. Toshi's point is, again, about simplicity. If the Japanese government wants to promote good health, to exert a "wholesome" influence on a greater East Asia, then they should keep their noses out of art and dedicate resources to eradicating tuberculosis, requisitioning the property of the rich to heal the poor.

Her next comments belie her religious upbringing as the daughter of a True Pure Land priest, while also raising the question of ethical conduct. She refers to fairly typical tropes that can be found in any number of Buddhist sermons, namely, the idea that good and evil can be understood as physical properties present in the human body. They should either be nurtured and grown (the seeds of good growing into the fruits of wisdom) or starved and discharged (the seeds of evil flushing from the body like pus or, indeed, sperm). Applying a heretical logic that is full of dark humor, she debunks this complicated notion of wholesomeness as well, taking received wisdom in a scintillatingly sacrilegious direction. To get a Christ or a buddha, she suggests, you would need to slake off lots of evil, in the form of

sperm. That would give rise to lots of evil children, the suggestion being that this is where the evil people of today have come from: a sort of horrific religious balloon payment.

Finally she returns to the subject of art. As with the other topics she raises, her point about art hews to an appreciation of simplicity. A pencil and a piece of paper is enough. The simple tools of the sketch artist are enough. Instead of the vastly complicated machinations of government sponsorship, political doublespeak, and attempts to use art as a tool of domestic health policy, better to keep it simple. Going out into the streets, drawing what you see, talking to the people you meet, is enough. Keep it simple, she opines, but not crude. I would call this a "downstairs" aesthetic.

Seeing Red: Critiquing the Dream

Toshi found much of Soviet Russian culture inspiring and responded powerfully to her perceptions of the proletariat. Steaming across Siberia on the train toward Moscow in January 1941, she writes of her deep emotion.

> Suddenly, the radio blares on, right above my head. Tears I would be hard put to explain covered my cheeks. A chorus of bright, deep voices, voices gushing out from thick chests, a wide range of them. The voices of living beings. The long, black iron structure of the train sprinted along through the tundra, the boundless frozen tundra, with its own music. I sat down in the hallway and pressed my face against the cold glass. [. . .]
>
> It was a kolkhoz chorus of men and women. Others might argue that kolkhoz singing isn't a high art form, and it's probably true that it lacks in clear, pure musicality. But there's no denying that these are human voices, living voices, wrapped in strength. The voices of the masses (*shūdan no koe*). ~~Fervent voices.~~ Singing out, "We're alive!" There was no tragedy or bitterness there, just the power of a living collective (*gunshū*).[44]

In Moscow, she attended May Day parades with their crowds and banners ("May our mighty motherland, the Union of Soviet Socialist Republics, flourish and grow stronger!") (fig. 3.7). Her notebooks contain a careful transcription of a passage by Lenin ("Communism begins where selflessness appears, overcoming hard labor, the worry of the ordinary worker about the increase of the productivity of labor."), as well as notes on the

life of Pushkin and a transcription of one of his poems. At one point, she recorded clear elation at her proximity to a Red Youth Brigade encampment and the arrival of a truck full of workers come to dance at a stage in the woods.

If Toshi was a proletarian-inclined artist, or even a budding socialist, she was not a naïve one. Though she was particularly moved by her encounters with everyday people and peasant arts, her aesthetic practices of observation also enabled her (or maybe forced her) to see continuing problems of social inequity, cracks in the socialist dream. Her third sketch, done in Vladivostok shortly after disembarking the ferry from Japan in 1937, shows the funeral procession for a child (Moscow Sketch #3). Another sketch, done on a thin, brown wrapping paper and dating to just a few days later, focuses on a group of vendors, heavily bundled against the cold, selling

Fig. 3.7 Akamatsu Toshiko. Untitled (Moscow sketch #246). Undated. Pencil on paper. Private collection. This sketch is one of seven in a large, still-bound spiral notebook Toshi used to document a specific occasion, almost certainly in April or May of 1939. Based on her diary entries from around the same time period, it seems likely that Toshi brought this notebook with her specifically to document what she observed at a May Day parade.

milk and fish at a small train station outside of Baikal (fig. 3.8). On the
back of the sketch, Toshi writes,

> Even though it's close to the end of April, the cold is piercing and yet
> somehow they can endure it. These people who have made their tradi-
> tions here and put down roots here: they must have some deep well of
> willpower secreted away inside. Of course, I have no idea about politi-
> cal regulations or the allocation of commodities, but to stand out here
> in this freezing cold just to try to sell one little fish from Lake Baikal or
> one container of milk, or something poured into an empty bottle, to
> someone getting off the train? How they must fight to survive! How
> they must fight the cold! I can scarcely fathom it.

These are the words of someone who is more interested in observing peo-
ple's actual living conditions than in romanticizing peasant life into evi-
dence for the Revolution's success.

Indeed, this insistence on a rawness of vision constituted a core part of
her artistic discipline, which she articulates at various points in her diary.
For instance, the passage describing the kolkhoz chorus, cited above, con-
tinues in a less effusive vein:

Fig. 3.8 Akamatsu Toshiko. *Gyūnyū-bai ya sakana-bai* (Selling milk and fish, Moscow
sketch #7). April 26, 1937. Pencil on paper. 12.5 cm x 19.5 cm. Private collection.

Of course, I could not understand the words. ~~The train riding along just, going along~~ I had found the power to continue moving forward, ~~that's what I felt~~ so ~~the soviet power and~~ so ~~I had been shown something~~ it was a wordless sense of oppression. My whole body thrilled with the thought that this is what we should be doing. ~~It was the voice of friends who would go anywhere~~ I found myself thinking of my friends, those who had spoken to me of such unrest and uncertainty, their voices came to me, grumbling in anger. Are we going to be alright?

Four years ago, I traveled to Moscow on this same train and along these same tracks. My dark, sad impressions of that time: big, solid people standing in the ~~rain~~ cold, dark rain, gnawing at black bread while the drizzle soaked through their oily, embroidered quilt coats and the sharp, warm smell of their bodies saturated their clothing. That was my impression, but then they slowly rose to their feet and, looking down at the ground, trudged forward on their sodden straw shoes. I could hear their footfalls clearly. The sodden straw shoes have since changed to rubber-soled ones. The cold, dark rain that had weighed down the sky began to clear a bit, a gap of blue showing and then, silently, widening. Four years later, it's today. I heard the music. The chorus of men and women. Savage voices. Hinterland voices. But, all the same, living voices.

~~The voices broadcast from the radio~~

I am just like a blind person. I am deaf. I know nothing: I have no basis, no evidence for my analysis. I can't speak Russian, and I can't read, and I can't manage any sort of statistical study.

All I have are impressions, the feelings that run through my body. The only method I have is to use my body to sense the movements of the great sky that covers over the earth.

It's not like I talked to anyone. And it's not like I saw anything unusual. But all the same, I felt that resilience. ~~The young people of Japan have to learn to be like this, too~~ I thought they wanted to rise up.

But maybe my impressions were mistaken. I want to get to Moscow as soon as possible. I wonder how the capital of Russia has changed.[45]

What Toshi describes here is an unflinching commitment to look and to keep looking. Even in the midst of an ecstatic reverie, a paean to the resilience of Soviet peasants and the beauty of their arts, she forces herself to

see, and to keep seeing, the cold, wet feet, the dirty coats, the body lan-
guage (slump and trudge) of dejection and exhaustion. Part of why she is so
eager to get to Moscow is so she can see if the suffering has been worth it,
if the Revolution of 1917 is finally starting to make good on its promises of
clearer skies ahead. On her way back to Japan in April of 1941, when her
train stopped at the same small station outside of Baikal, Toshi got off and
looked up and down the platform. Alas, she found the women still there,
still selling milk. She bought two bottles from one of them and drank, leav-
ing the empty bottles with the woman, but recording the woman's words in
her diary: "'I have no children,' she said. 'I have no money.'"[46]

Survival Tactics: Staying Silent, Going Along

Taking an unflinching look at the successes and failures of proletarian rev-
olution in Russia were of deep importance to Toshi, not only because she
was concerned with the hunger and poverty she continued to find in the
Soviet Union, but also because some of her friends in Japan were risking
their careers, and at times their lives, by continuing to believe in the revo-
lutionary dreams of Parisian modernism and Soviet socialism. The question
of what she should tell them weighed on her mind. Continuing to mull
over the import of the cold peasants trudging through the snow in their
wet shoes, she writes:

> There they were twenty years after the Revolution—the Revolution
> that was supposed to ease their lives, make things better—and they
> were living in such straits. It made me wonder if the Revolution hadn't
> made things worse.
>
> This enormous country had come through the confusion and the
> agony of the Revolution so well. And it had faced crop failures, and the
> quickening of counterrevolutionary movements. They took on a de-
> stroyed nation, but the bigger the appetite is, the bigger other things
> are, as well, I imagine. They came through it. If my impressions are
> correct, then I hold them in high regard.
>
> I wonder how I would do, how Japanese people would manage
> [phrase marked through so darkly as to be illegible] To have gotten
> this far! To have endured this much and kept going! Over these last
> twenty some years. To really do it, to stick with it and see it through
> quietly, you'd have to endure such a long period of hardship, such a
> long time of thinking you'd been fooled. I will need to think it through
> again, anew.

I want to tell my friends in Japan, from the bottom of my heart: Let's stay silent and follow along. That way, we won't die (*Nihon no watashi no tomodachi ni kokoro kara iitai. Damatte tsuiteikimashō. Shisuru koto wa nain dakara, to.*)

~~And I want to make those elites in Japan reflect on what has happened and to say what the Japanese nation is doing, to tell us clearly, repeating it until it makes our ears ache,~~ [phrase marked out too heavily to read] ~~and.~~ (*Sorekara Nihon no erai hito ni wa kaerimirashitai, Nihon no kuni wa nani o yō to shiteiruka o~~ [phrase marked through too heavily to read]~~, hakkiri to mimi no itakunaru hodo nanben ~~[phrase marked through too heavily to read]~~*

we won't die. (*ga shisuru koto wa nain dakara.*)[47]

Though this passage is particularly riddled with strike-throughs, incomplete sentences, and rubbed out words,[48] the import is clear. Toshi is afraid that the gamble has not been worth it, concerned that the Revolution is not making good on its promises to make life better for the peasants, and frightened that the Japanese people, facing a similar trial of fire, will not be able to make it through. She remains livid with the Japanese "elites," wanting that upper crust of national leaders to explain clearly and forcefully what is going on, "until it makes our ears ache." Faced with fascism at home and the lived realities of socialism in Russia, she advocates silence. Be quiet, she wants to tell her friends. Stay silent, for now, and live.

During her time in Russia, Toshi saw things about which many artists and leftists in Japan were eager to know, but she had to be quite circumspect in what information and impressions she relayed publicly, in part because of tense international relations between Japan and Russia and in part because of the increasingly tight ideological restrictions on Japanese artistic expression and ideological orientation. As late as 1940, cultural critics could still forge definitions of "national culture" (*kokumin bunka*) that attempted to include two "seemingly contradictory" aspects, as did sociologist and cultural critic Shimizu Ikutarō in a special issue of the arts magazine *Atelier* devoted to the question of what the "new order" (*shintaisei*) meant for the arts.[49] According to Shimizu, it should be possible to recognize art that featured "distinct national characteristics" that could "express the heart of the people" (*kokumin no naibu o hyōgen shi*) while still according a place for works that "enlarged the national parameters" of art (*bijutsu o kokuminteki kibo ni oite kakudai suru*).[50] That is, nationalist art need not be anti-internationalist, so long as Japanese artists

used Western techniques and European ideas for Japanese ends, as a sort of aesthetic land grab.

The cultural space available for such delicate ambiguity, however, was narrowing rapidly. In January of 1941 the major arts journal *Mizue* ran a transcript of a roundtable discussion on the question, "The national defense state and the arts: What should artists do?" Three of the four roundtable participants were staff officers of the Army Information Section (Rikugunshō jyōhōbu), who were led by Major Suzuki Kurazō, while the fourth was the rightist art historian Araki Hideo. Vilifying everything French—from the politics ensuing from the French Revolution to the ideas of individuality apparent in French modernist art—the army officers eviscerated any notion that a properly nationalist Japanese art could be international in flavor.[51] Indeed, Suzuki retorted, "These people who say there are no national borders in art, what sort of stuff are they painting? I went to the Nika group's exhibit and I thought: These artists who say that art has no borders have forgotten their own country. They've gone to France and become their own little French colony."[52]

Though Toshi's art was not on exhibit, she was a member of the Nika group, and the Western-style oil painters that Suzuki here criticizes were her friends and colleagues. In chilling evocations of Nazi cultural eugenics, Suzuki characterizes abstract artists as "tubercular" and modernist painters as "insane," suggesting that they are physically and mentally unfit to serve the country (and perhaps due for eradication).[53] His rhetoric rising to an angry crescendo, he claims, "We will prohibit distribution of materials to artists who do not comply" with the new order. "And we will refuse permission for them to exhibit. And, since that's their daily bread, they'll have no choice but to go along with us" (*han no kuiage dakara nandemo kare demo tsuzuitekuru*).[54]

After the establishment of the cultural "new order" in late 1940, Japanese artists had to wrestle with the question of what to do in the face of cultural mandates for an openly fascist aesthetics and the all-out mobilization of art supplies and exhibition space. Some artists chose to collaborate actively. They sought out, or responded positively to, invitations from the army and navy to "travel with the military" (*jūgun*) on sketch tours of the front lines.[55] Returning to Tokyo, they were accorded studio space and plentiful artistic supplies, which they used to create the often massive "war documentary paintings" (*sensō sakusen kirokuga*). Moreover, their works, once approved, were guaranteed a place in major exhibitions such as the First Greater East Asia War Art Exhibition (Daiikkai daitōa sensō

bijutsu tenrankai). Sponsored by the Asahi Shinbun newspaper company, the exhibit opened at the Tokyo Metropolitan Museum in December 1942 before touring to Osaka and Nagoya, to be seen by an estimated 3.85 million people.

A few artists, most famously Matsumoto Shunsuke, chose to speak out against state controls.[56] A well-known modernist painter, Matsumoto was a member of the Room Nine Association (Kyūshitsukai), an avant-garde subset of the Nika group. Matsumoto published his reply to the Suzuki roundtable, titled "The Living Artist" (Ikiteiru gaka), in the April 1941 issue of *Mizue*. In it, he systematically takes apart Suzuki's arguments, revealing that Suzuki's debts to European philosophy are just as heavy as his own, and he bridles at being judged a second-rate patriot. As Mark H. Sandler has pointed out, Matsumoto's essay champions "the values of freedom of expression, artistic subjectivity, and intuition as both rooted in classical Japanese culture and absolutely necessary for the well-being and expression of the Japanese spirit."[57] Rising to his own rhetorical crescendo, Matsumoto concludes that he, and other artists of conscience, will not stop painting even in the most difficult of circumstances, because the act of creating is the very lifeblood of an artist. "Though we may die, I have faith that we will live on through our works, surviving in the nation that lies one hundred, or one thousand, years into the future."[58] Though in the immediate postwar period and throughout the 1960s Matsumoto was lauded as a courageous defender of artistic freedom for his resistance to the state, it is important to point out that his position was not as wholly antinationalist as many postwar critics would have liked to believe, a topic which I will revisit in chapter 5.[59]

Matsumoto's essay was received coolly. While it excited no major response from the authorities (he was not imprisoned, for instance), neither did it receive any major support from his fellow artists, many of whom were still reeling from the arrests of Fukuzawa Ichirō and Takiguchi Shūzō, which happened within days of the journal's release. Leaders of the surrealist movement, Fukuzawa (a painter) and Takiguchi (a poet and critic) were both associated with the Art Culture Association (Bijutsu bunka kyōkai) and were arrested for thought crimes by the Special Higher Police (Tokkō), who maintained that surrealism was inseparable from communism and that the Communist Party was illegal. According to the sculptor Ide Norio, at the next meeting of the Art Culture Association, one if its members, Furuzawa Iwami, encouraged everyone "to pretend to go along with the military, so that you can survive" (*gun ni kyōryoku suru furi*

o shite, ikinokoru beki), a sentiment that purportedly evoked tears of frustration from fellow member and avant-garde painter Aimitsu.[60] Indeed, the opening words of Matsumoto's essay proved prophetic. "Upon reading the roundtable in the January issue of *Mizue*," he wrote, "I imagine that many artists may have determined that in silence lies wisdom."[61]

Toshi struggled mightily against that silence, even though she saw its wisdom. Indeed, in August and then again in October 1941, she reprised the diary entries examined above for publication in the women's journal *Shinjoen*. In the article, she describes the kolkhoz chorus and the tears running down her cheeks. And, as in the diary entry, she finds herself thinking of her friends. Now, however, she claims to feel "a wave of disgust. Should we be acting this way? Should we really be raising an uproar about and criticizing these things that our country is doing, as if it has nothing to do with us?"[62] She follows this with the description of hungry, ill-clad Russians and notes her anxiousness to get to Moscow to see if her "sad" impressions are accurate or not. Fearing that they are, she continues, "I want to tell my friends in Japan, tell them from the bottom of my heart, 'Be quiet. Let Japan go where it will, and follow along. That way we won't die of hunger. We won't die of hunger.'"[63] But when she gets to Moscow, she is elated to find that things are alright. People are well-fed and well-clothed. Fashionable modern girls and handsome modern boys walk the streets. Moscow, she thinks, is "starting to burst forth with new life" (*tōjitsu shihajime*). Even if war with Germany does break out, she opines, it is hard to see how the Russians will lose. Surely they will suffer, but they will persevere. And, she tacks on, "Japan, too, must win in the end."[64]

Reading the article induces a sense of narrative whiplash. One moment, the kolkhoz chorus is beautifully full of life. In the next, Toshi is full of disgust for her critical friends in Japan. Then she is full of pity for hungry Siberian peasants, and she counsels her Japanese friends to stay silent or face a similar fate. But in the next moment, all is well, Moscow is prosperous, and Russia has the might to defeat Germany should it come to war. And then the parting salvo, Japan will persevere, finding victory in the end. Comparing the published article with the diary entry, we can see that Toshi has periodically interrupted her private writings, splicing nationalist soundbites into her earlier prose and interjecting barbed critiques of artists that nearly parrot those of Major Suzuki. I think we can read Toshi here as trying to buy herself room to speak, ventriloquizing enough tidbits from the cultural New Order to provide cover for her, on the whole, positive evaluation of post-Revolution Russia. If the diary entries are

marked with crossouts and strike-throughs, the published article is equally scarred, as Toshi talks over and contradicts herself at nearly every turn. Trying to find room to speak in such a pervasive culture of thought control proved unsustainable, and Toshi became increasingly quiet about her Moscow experiences.[65]

Like Toshi, most artists did choose silence as the price of survival. And, as she advocated in her diary, Toshi did, to a certain extent, "go along." As discussed in chapters 1 and 2, between 1940 and 1945 she illustrated a number of procolonial, jingoistic children's books and authored occasional travel vignettes set in the Japanese mandate in Micronesia that, collectively, might be read as complicit visions.[66] Still, attending to Toshi's diary and her daily sketch practices shows her constantly in the acts of crossing out, self-redacting, and rethinking her ideas, powerful indications of a dogged ambivalence, a persistent refusal to go gently into the nationalist night, and a continued struggle against the constraints of self-imposed silence.

Exhibiting Moscow: The Art of Proletarian Tourism in 1940s Japan

As examples of "imperial tourism,"[67] Toshi's writings about and sketches of the South Seas were in high demand throughout the early 1940s. By contrast, her Russian work (attempts at what we might call "proletarian tourism") received little play. Though her Moscow-related artwork and travel sketches were not in any sort of official demand in pre-1945 Japan, Toshi did manage to organize several exhibits of her Moscow work, and she did publish one article concerning her time in the Soviet Union, based on the notes and sketches she took while visiting museums in Moscow. Appearing in print in May 1942, the article bore the doubly daring title "Modern French Art in Russia" (Roshia ni aru Furansu gendai bijutsu), thereby signaling a concern with both the "French colony" of artistic modernism and the forbidden territory of Soviet art.

The article—her last wartime attempt to publish substantial material from her time in Moscow—is a fascinating example of bait and switch. The title indicates a focus on French modernist art, promising an examination of western European pieces that just happen to be owned by Russian museums. The illustrations redouble this titular claim. Several pages' worth of reproduced modernist art preface the article proper, paintings by French or French-influenced artists Edgar Degas, Henri Matisse, Vincent Van Gogh, Andre Derain, Paul Signac, Henri Rousseau, Albert Marquet,

and Paul Gauguin. Impressionist, postimpressionist, fauvist, surrealist, and cubist elements dominate these pages. Toshi begins the article by noting that there are three museums[68] in Moscow: the Tretyakov Gallery (a chronological arrangement charting the development of Russian art), the Pushkin State Museum of Fine Arts (reproductions of ancient Egyptian, Greek, and Roman art), and the Moscow Museum of Modern Art (mainly French impressionist and postimpressionist works).

In her essay, however, Toshi ignores the Pushkin more or less entirely, focusing her essay instead on a visual analysis of the artwork in the Tretyakov Gallery and a description of the visitors to the Modern Museum. Of the Tretyakov's collections, Toshi sums up the centuries prior to 1917 in a few short sentences before turning to a fairly lengthy discussion of post-Revolutionary art. She notes that after 1917, art became

> bound up with revolutionary movements and we enter a long period of literary-flavored art in which oil paintings are thrown out, as a favored medium, and replaced by media that are closer to the masses: etchings, charcoal drawings, and pen sketches. Though one might say their realism is excessive, some of the resulting artworks are breathtaking in their forcefulness. One must acknowledge that some of them had the power to guide the masses, at the time of their production, and possibly to move them emotionally. I think we should acknowledge that the art of this country flourished during that period. And yet, how shall I say it, once they had accomplished their goals, once the Revolution had materialized, then the arts suffered a serious setback. The government beat the drum, encouraging these artists, in spite of their support. Statues of Lenin waved their lifeless arms and portraits of Stalin laughed from within the frames of their enormous canvases.
>
> And yet, if we look back critically at even this period, we can see that people's lives grew gradually more comfortable and they wanted still-lives to decorate their homes, so the revolutionary and propagandistic artworks gradually became things of the past and a new art was born, centering on individual daily life. You can see the artists struggling with where to go for assistance: not to Matisse and not to Picasso.[69]

In these comments, Toshi addresses many of the same questions raised by Suzuki and Matsumoto in their respective pieces for *Mizue,* which had been published the year before. What should a "living artist" do during a time of war or revolution? What is the proper relationship between art and

politics, between the state and an individual artist? Where is the future? And what is the role of the arts in pointing the way?

Rather than address the current politics of visual culture in 1940s Japan directly, as Matsumoto did, Toshi approaches the matter via a delicate and complex commentary on 1920s Russia. In speaking about art from Russia's Revolutionary period, Toshi claims that artists accomplished their aims, using their art to serve the Revolution and help it to materialize, but that the state marred that productive relationship by turning art into little more than a propaganda wing of the government. Now that people are coming out of that immediate post-Revolutionary period, they are looking for a kind of art that can speak to their everyday lives and the beauty there, but artists are in danger of taking a wrong turn, relying too much on avant-garde styles from France. Training her comments on 1920s Russia, rather than 1940s Japan, allows Toshi to speak out forcefully against government involvement in and control of the arts.

If her comments on the Tretyakov Gallery focus entirely on the art and its institutional and national settings, Toshi's passages on the Modern Museum mostly describe the triangle of interactions between docent, museum visitor, and artwork. After describing a number of works telegraphically (mostly noting use of color and composition), she turns to a close description of Van Gogh.

> Van Gogh's work is unsurpassed. The artist, the brush, and the subject all fuse in his work, and the world is born anew (*Gohho wa shinpin desu. Sakusha to hitsu to taishō ga hitsotsu ni natte, aratani unda sekai desu*).
>
> A tall young person, one of the museum's docents, interpreted the artwork for the workers (*shōkōsantachi ni setsumei shimashita*). "We can see here how the grasses are wet with morning dew, a fresh green color that shows the beauty of the thick dew." As she spoke, the workers in the back stretched and craned their necks to see. Wending through the fresh green field, a single road, and along it a milk cart creaking along. A long steam train speeding along to the left, the dewy field twisting off to the right, back, back to the horizon. The workers gave a long sigh, and then walked into the next room.

The painting Toshi (or the docent, as relayed by Toshi) is describing, not entirely accurately, is Van Gogh's postimpressionist *Landscape with Carriage and Train in the Background*.[70] In the passage cited above, Toshi watches young workers and laborers as they learn to understand the

painting, as interpreted for them by a young, post-Revolutionary Russian docent. The painting can be divided roughly into thirds. The lower third comprises peasant labor, the slow, human pace of handwork in the fields. In the central tier, with the road and the horse-drawn carriage, Toshi sees a milk wagon, taking product to sell in town. The topmost register features the locomotive, all iron and steam and speed. In the context of the docent-visitor-artwork triad, Toshi's comments suggest a loosely materialist reading, a sense of the quickening pace of time and the changing conditions of labor as human power and the family farm give way, in the middle tier, to horsepower and market production, which themselves are displaced in the top tier by steam power and the further alienation of workers from products. After describing a similar interaction centering on a Gauguin painting, Toshi comments, "Like all other museums, this one has its fair share of visitors, but there are a remarkable number of young workers. They strain to hear the docents' words and take them directly to heart."

Though she has siphoned off the vitriol from her diary entries in framing these comments for public consumption in 1942 Japan, Toshi's position remains consistent. Whether in post-Revolutionary Russia or wartime Japan, when government dictates drive art, they drive art into the ground. Whether in 1920s Russia or 1940s Japan, the future cannot be imported from France. Artists may use French tools at times (modernist art techniques), or Russian ones for that matter (proletarian ideology), but the future is to be found in the local and the everyday. Not as rousing a rallying cry as Matsumoto, perhaps, but quite a clever attack slipped in between the lines. Not coincidentally, Toshi's article appeared in May, in time for the international celebration of the socialist holiday of May Day. Through a sleight-of-hand move, in which she makes 1940s Japan appear in the guise of 1920s Russia, Toshi has coded her essay in a particular way. She accords praise to the realism and vigor of proletarian art in its early days, she derides the top-down governmental cooptation of art in the service of state ideology, and she speaks out in support of impressionist and even surrealist technique. None of these were particularly safe positions for an artist in 1942 Tokyo.

Toshi's only other wartime publications pertaining to her stays in Moscow came in the form of cover art for the cultural news and policy journal *Gekkan Roshia* (Russia monthly), where she published artwork on at least eighteen occasions between October 1942 and January 1945. Her commissions for the journal may have come to her through connections with Nishi Haruhiko and other civil servants in the Japanese diplomatic corps. She drew heavily upon her sketchbooks as sources for the art, at

times creating startling juxtapositions between the scenes depicted on the journal's cover, the ads appearing on their obverse, and the policy pieces announced in the tables of contents. Her cover for July 1943, for instance, shows a Russian family seated peacefully at breakfast (a repurposing of Moscow Sketch #58) while the ads inside praise the Japanese attack at Attu, in the Aleutians, where every last Japanese soldier perished in a widely publicized incident of frenzied nationalism in which the men were posthumously accorded the label "shattered jewels." Juxtaposed against the militarist ad, the breakfasting Russian family seems to peer out, bemused and superior, at beleaguered (and increasingly hungry) Japanese readers.

Similarly, Toshi's cover for May 1944 features women dancing in the street, with the procession of a May Day parade and an enormous portrait of Stalin in the background, a happy scene of socialist celebration. By contrast, the two lead articles concern ominous new directions in Soviet policy toward Asia, and the inside of the cover features an ad, from the Taiwan-based Meiji Sugar Company, asserting, "One million charge toward absolute victory!" The advertising slogan references the "one million" people of the Japanese Empire at a time when the Japanese military was in retreat, beaten back in India, Burma, and the South Pacific. By contrast, Toshi's sketch, done several years earlier but published in May 1944, seems to reference Soviet joy over recent victories in the Crimea. Perhaps the one million charging toward victory here are Russian soldiers, not Japanese imperials.

With the help of her diplomatic connections and the occasional dose of deftly applied humor, Toshi managed to fly just under the radar while continuing to publish and to exhibit Soviet-related artwork throughout the late 1930s and early 1940s. In fact, her first solo show in Japan was titled "An Exhibit of Moscow Sketches" and hung from March 19–21, 1939, at the Ginza Kinokuniya gallery. The show featured fifty-eight of her Moscow pieces[71] and earned her an interview in her hometown newspaper, the *Asahikawa Shinbun*. The article begins by providing the name of her elementary school, hometown, and college before mentioning that Toshi had been a teacher prior to being summoned to serve as the tutor for the Yuhashi diplomatic family stationed in Moscow. The article provides Toshi's current address in Ikebukuro and notes that she lives with her younger brother. Thus ensconced in this respectable—and locatable—patriarchal network, Toshi is allowed to speak. Asked about her impressions of Russia, she cracks a joke: "We should really try out Russian-style black markets. You can buy things there for unbelievably cheap prices! Not like in Japan where a pair of socks worth 1 yen 20 sen will set you back ten times that amount" on the

black market.[72] She uses humor to disarm the potentially touchy subject of her time in "red" territory.

Humor, however, was not enough. Repeatedly, Toshi had to rely upon her political connections. The police initially barred the solo exhibit when they reviewed its title in the preshow advertising materials and the permit request Toshi had to file to rent the space. It was not until Toshi explained to them that she did the sketches while serving as part of a diplomatic mission that they allowed her to proceed, judging her sketches to be free of political propaganda.[73] In February 1943, Toshi again ran afoul of the police, this time for a joint exhibition at the Ginza Aokisha Gallery, held with her former charge Nishi Kiyoko, who had just returned from art studies in Paris. Toshi showed her oil portrait of Sanya and a series of watercolors of the Red Guard Theatre, among other things. The police granted permission for the exhibit once they realized that Kiyoko's father was Nishi Haruhiko, then in the Foreign Affairs Office. But they made Toshi remove the words "Red Guard" from her lists of titles.[74]

Despite police interference, Toshi continued to show her Moscow works and to produce new Russian paintings based on her sketches, but she found few opportunities to exhibit these. In group settings, such as the annual exhibits of the Nika group and of her college alumni group, she mostly showed landscapes bearing innocuous titles like "Birch Forest," which could be taken as evocative of Japan's northern territories (Karafuto, Chishima, and Hokkaidō) rather than necessarily evoking the taiga of Soviet Siberia. When she did try to exhibit her sketches of Russian architecture and her portraits of Russian people, things did not go well. One solo exhibit, which hung from February 19–23, 1943, at the Ginza Seikisha gallery, featured twenty works based both on her time in the South Seas and on her time in Moscow. For the show, she reworked some of her sketches into oil paintings, watercolors, and pen drawings. "A more studied effort" than her earlier exhibitions of sketch work, the critics opined, but the paintings amounted to little more than "minor works for working women, the kind of thing best appreciated at home. Still, at least there is ample evidence of paintbrush nationalism (*saikan hōkoku*)."[75] Chauvinistic and dismissive of her portraits of working Soviet women, the critic's sole word of praise is for the South Seas artwork, which can, at least, be taken as showing appropriate support for the Japanese imperial project in the Pacific islands.

Toshi's last attempt to exhibit Moscow came in September 1944, when, in a joint show with her lover Maruki Iri at the Ginza Kikuya gallery, she hung the oil painting *The Thaw (Moscow)*. A large-scale encyclopedic piece,

the painting is an extravagant statement, not only of modernist aesthetic inspiration and a fondness for the workers of Russia, but also of material commitment to those causes (plate 9). In a time when art supplies were increasingly hard to come by, the resources Toshi put into the piece are simply astounding. (Toshi was likely allowed to purchase the oil, paint, and canvas only because of her productivity in the realm of jingoistic children's books, as discussed in chapter 2.) The pointillist stars in the sky find reflections in the scattered dots of swelling buds in the trees below as the onion domes of the Moscow skyline sweep down, across meadows and glens, to the Siberian tundra. In the woods, stretched along the bottommost edge, we see the two heavily laden women Toshi first wondered about in 1937 (Moscow Sketch #170): "Where in the world are they walking? Where is their house?" In Toshi's 1944 painting, they move through a landscape burgeoning with the promise of spring.

Death by Suffocation

In this chapter I have utilized Toshi's experiences in Russia and the artwork she produced from it as a microhistorical case study, with the goal of marking the different time zones, as it were, in which she lived and worked. Pressured, as were all artists of her generation, to abandon the ideological promises of proletarian art and to turn the aesthetic techniques of Parisian modernism to the service of the Japanese Empire, Toshi struggled to find a way through, a time in which to breathe, a place in which to survive. Whereas her Gauguin-like paintings set in Japan's South Seas mandate garnered her praise and continuing commissions, her oil paintings and sketches of Russia continued to read as dangerously proletarian and were met with criticism and censorship.

Like many of her fellow artists living in Ikebukuro, by 1944 Toshi was struggling to survive, unable to earn enough to eat. Scavenging wild dropwort from the roadsides and harvesting aster sprouts to boil for food,[76] however, she continued to paint. Around the same time that she was working on her large-scale canvas of Moscow in the spring thaw, she completed a self-portrait, one of the very few works she ever undertook in this genre (plate 10). It is titled "Suicide by Suffocation." If Toshi had counseled herself, and her fellow artists, to stay silent and to go along, the existential price of that quiescence was mounting, and the inability to speak had become suffocating. Fortunately for Toshi, a thaw truly was in the offing, and with the end of the war would come a boom in demands for her Soviet-inspired art, to which I shall turn in the next chapter.

CHAPTER 4

Bare Naked Aesthetics
Postwar Arts and Toshi's Populist Manifesto

As discussed in chapters 2 and 3, manifestos were not in short supply in 1930s and 1940s Japan: "culture for little countrymen" (*shōkokumin bunka*) treatises abounded, as did impassioned writings advocating proletarianism, surrealism, and, of course, nationalism and fascism.[1] Toshi avoided them carefully. She allowed her artwork and writings to be drafted into service with "culture for little citizens" publications between 1940 and 1945, and even exhibited a piece in the Fighting Child Soldiers (Tatakau shōnenhei) exhibit in late 1943, which "attempted to motivate parents to send their underage sons to war because of troop shortages."[2] But she managed to avoid physical deployment, using a doctor's excuse to extricate herself from participation in a government-sponsored trip to sketch the front lines of the naval battle in the Solomon Islands. She wrote diary passages that were strongly critical of the colonial government in Micronesia, largely in favor of socialist politics, and utterly incensed at government-mandated campaigns promoting Nazi-inspired, so-called "healthy art." But she kept those thoughts largely private, publishing only a handful of artfully ambivalent essays on the South Seas and one critical piece from her time in Russia (a review of museums in Moscow). This strategy of low-key "going along,"[3] as she called it, stemmed partly from strictures of censorship, partly from a need to earn a living, and partly from a desire to save her own skin.

All that changed in 1945, though, with the lifting of martial law and the imposition of the new, occupation-led cultural initiatives, political mandates, and publishing practices (including its own practices of censorship).[4] Unsurprisingly, there are few material traces of Toshi's activities during the months immediately following Japan's surrender in August 1945.[5] Like most of the population, she was exhausted, hungry, and disoriented,

focused primarily on day-to-day survival. She was also suffering from radiation sickness. Within a few months, however, Toshi began to make her mark in the publishing world once again. By December of 1945, she and husband Iri had joined the Communist Party,[6] and Toshi had gotten her first set of commissions, providing line-art illustrations for a novel being serialized in the leftist journal *Minpo*[7] and artwork for a newspaper column.[8] A third commission, a one-page spread of Russian-themed illustrations for *Yoi ko no tomo* (The good child's companion) continued her practice of publishing children's art.[9] With the New Year, publication venues multiplied: *Mizue* and *Atelier,* two major arts journals, resumed production, and a plethora of new journals and newspapers sprang up. The emperor renounced his divinity in a public radio address on January 1, 1946, and the repatriation of millions of Japanese living abroad in former colonies began.

With new commissions beginning to come in, the pressures of hand-to-mouth survival abated, and Toshi was able to turn to more philosophical, but equally pressing, concerns. What was the role of art going to be in reconstructing a postwar and postfascist Japan? Who would produce such art, and with what materials? Who would view it, who would critique it, and what would that art *do?* Toshi had some strong ideas about these questions, and now she was not shy about sharing them.

As I discussed in the introduction, the overarching concern of this book is to explore how one might attempt to live an ethical and socially engaged life as an artist across the ages of empire, war, defeat, and protest politics. In this chapter, I explore Toshi's word-and-image pieces from the immediate postwar period, beginning with her first published works, printed as early as December 1945, and continuing until the occupation-led postwar red purge of 1950. Placing Toshi's work into conversation with leftist visual aesthetics, arts-related writing, and self-consciously proletarian literary genres such as reportage and "wall stories" (*kabe shōsetsu, heki shōsetsu*), I sketch a picture of the resurgence of populist arts in postwar Japan. Insisting that we read Toshi's visual art, her verbal art, and her social activism as mutually constructed (constitutive of one another), I argue that her work claims art and art making as populist direct action, a type of material politics that, as she put it, "anyone can do." Finally, I articulate, on the basis of these materials, what I understand to be Toshi's theory of art. I call this theory "bare naked aesthetics": a socially engaged art that is not merely the flip side of the "gate of flesh" (*nikutai no mon*) excesses of postwar decadence,[10] but is, rather, a politically committed art of (often literally) naked persistence.

Peace Is Red: Mining Moscow to Pay the Bills

In the fall of 1945, Japanese publishing culture went crimson. In its inaugural postwar issue, the editors of *The People* (Jinmin) included a note to readers reframing the notion of a popular publication, the populace toward which such a publication should be oriented, and the appropriate goals of such a publication. "Beginning publication this month, *Jinmin* is a popular magazine (*taishūshi*) for workers, whether agricultural or industrial." The editors continue, noting that until this point, so-called "popular" magazines in Japan had been little more than organs of the militaristic, imperialist state and did not have the needs or interests of their readers in mind. By contrast, the editors' goals for *Jinmin* are that it "be loved by you, the workers, that it improve your lives, and that it be at all times bright, interesting, and absolutely truthful: a *real* democratic (*minshushugiteki*) magazine."[11] Directly facing this statement of editorial intention, on the other side of the inner margin, readers would have found a sketch of the Kremlin by none other than Akamatsu Toshiko, so that this newly constituted, popular community of readers was immediately rooted in a Russian-themed visual culture as communicated through Toshi's sketch work (fig. 4.1). In other words, Toshi was in at the ground floor of re-envisioning postwar Japanese populist visual aesthetics and antifascist popular reading culture.

As Kozawa Setsuko has pointed out, many Japanese people at the time—Toshi and her husband Iri included—tended to conflate communism, socialism, proletarian culture, democracy, a free America, and a Soviet Russia, jumbling them all together and perceiving them, *en bloc,* as forms of liberation from fascism.[12] Toshi joined the Japanese Communist Party, perhaps as early as September 1945, and began to publish heavily in its party paper *The Red Flag* (*Akahata*) as well as in other, party-sponsored or -endorsed venues, which were plentiful. Indeed, by November 1945 the Japanese Communist Party leadership had identified the expansion of publication and distribution of literature to be a key item on its cultural agenda, thus resuscitating a political publishing boom that had been throttled by the imperial state in the early 1930s.[13]

Toshi was a major beneficiary of this tactical, political decision, and she mined the various notebooks and sketchbooks she had kept during her two stays in Russia, from April 1937 until April 1938 (as governess to the Yuhashi diplomatic family) and again from January to June of 1941 (as governess to the Nishi diplomatic family). In the same way she had leveraged her Micronesian experiences toward colonially oriented exhibitions and commissions in the early 1940s, after 1945 she turned the raw materials

モスコー

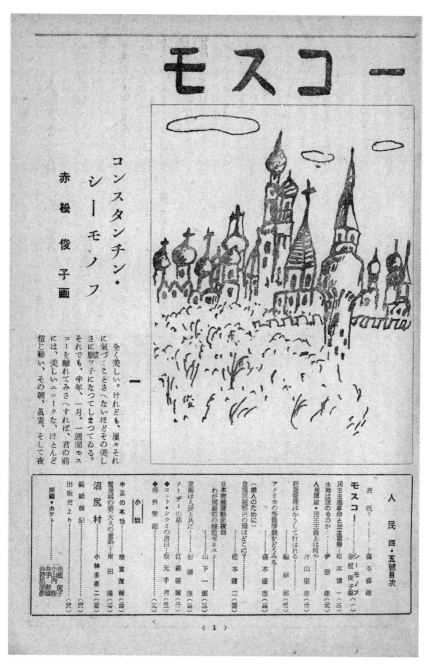

コンスタンチン・シーモノフ

赤松俊子画

全く美しい。けれども、屡々それに氣づくことさへないほどその美しさに馴ッ子になつてしまつてゐる。

それでも、半年、一月、一週間モスコーを離れてみさへすれば、君の前には、美しいユニークな、ほとんど信じ難い、その朝、眞晝、そして夜

一

Fig. 4.1 Akamatsu Toshiko, illustrator. *Jinmin* (April/May 1946). Held by the Gordon W. Prange Collection, University of Maryland Libraries.

of her Russian sojourns into a plethora of socialist publications, recuperating her Soviet experience and making it work for her now in the immediate postwar period. And it was important that her work *work*: she needed the money. Though she had married the older, highly respected, and well-established ink brush artist Maruki Iri (1901–1995) in July 1941, he was little help when it came to finances. In a May 1946 roundtable with fellow female artists Hirabayashi Taiko, Migishi Setsuko, and Seki Takako, Toshi noted that husband Iri had "no earning power" (*keizairyoku o mottenai*), meaning that she had to be the breadwinner. Later in the conversation, she laments the economic pressures that force her "to do journalistic work just to fill [her] stomach," (*kū tame ni wa jānarisutikku ni ugokanakya*) and she dreams of a future world in which artists can create freely without having to think of hand-to-mouth survival, where female artists are not pressured to flirt with critics, and where she could make art with and for laborers rather than having to think about professional critics and the *gadan* arts world.[14]

Thus, at least partially motivated by financial concerns, Toshi went to work and catered to the market by producing masses of Russian-themed art for the popular press. She repurposed diary passages and sketches from her notebooks into illustrated vignettes of Muscovite children's culture,[15] the changing seasons in Moscow and the surrounding countryside,[16] festivals in the Russian capital,[17] and Soviet artistic culture and women's domestic labor.[18] This last theme underscores Toshi's deep involvement with and investment in postwar proletarian cultural work. As Samuel Perry has noted, "The most revolutionary of avant-garde projects lay . . . in the recreation of the very nature of creativity itself," the "location of creativity in the transformation of lived, rather than imaginary, experience."[19] In moving seamlessly from commentary on the so-called "high art" of major Muscovite museums to the everyday cultural labor of kitchen workers' carefully woven conversations, Toshi insists that we recognize both as creative endeavors.

Before long she began receiving commissions for cover art. She timed her first postwar cover, completed for *The New Housewife* (*Shinfujin*) in May 1946, to coincide with the international labor holiday of May Day. Evoking both US wartime images of working women (such as the iconic Rosie the Riveter) and the general style of socialist realism, Toshi's cover features a woman in a red headscarf (a visual suggestion of communist affiliation) and wearing what appears to be a factory uniform with its sleeves rolled up (a visual trope of labor union politics) (plate 11). Holding a wrench in her left hand, her right hand supporting her chin, and a pensive smile

playing across her lips, the woman is a combination of industrial laborer and philosophical figure. Toshi's cover suggests that working women have taken the tools of culture into their own hands, seizing upon their own agency to remake, remold, and to construct a new future. And there was no doubt, in Toshi's vision, that this new future was to be Soviet in nature, as her other journal covers, for *Soviet Culture* (*Sovēto bunka*) (fig. 4.2) and *The People* (Jinmin) from May and June of 1946 suggest, with their Russian soldiers, muscular Soviet women, and Japanese look-alikes.[20]

Soon she was being asked to provide interior illustrations and, in the case of children's books, cover art for adaptations of Russian literature, including works by Konstantin Simonov,[21] Konstantin Paustovsky,[22] Leo Tolstoy,[23] and Nicolai Gogol.[24] Toshi's illustrations for younger readers commonly pick up on humorous, critical, satirical, or ironic elements in the stories, presenting them visually in ways that would have no doubt struck contemporary audiences as critical of recent Japanese politics. Her David-and-Goliath-like rendition of the king and the boy from the Tolstoy story, for instance, shows the king as an ill-tempered and bumbling tyrant, contrasting strongly with the sanitized and sanctified imagery of the wartime Shōwa emperor. Similarly, her depiction of the government official from Gogol's "The Nose" delights in the absurdity and pomposity of this fully-decked-out military figure who cannot control even his own facial features, a far cry from the placidly severe and ever heroic images of decorated generals and admirals common in wartime press photography (fig. 4.3).

Unfortunately, at times Toshi's prose could verge on the propagandistic and the pandering. At its worst, her writing was perhaps even willfully untruthful, largely through the substitution of cheery political platitudes for what had been fairly sobering diary accounts of scenes witnessed in Soviet Russia. The most egregious example comes in an article she wrote in October 1946 for a railway magazine, for which she reprised various diary accounts she kept during her two trips by rail across Siberia. Toshi describes chugging along for hours as the train slips in and out of birch forests, deep valleys, and endless snow-filled plains. Now and again, she writes, one would catch sight of "people in heavy overcoats walking along the road, laughing, singing, and conversing with one another as they traversed the vast plains of Siberia"[25] She also mentions a conversation with a Russian teenager who brought her a flask of hot water during a brief stopover, and she waxes poetic about how one's breath would make ice flowers on the freezing cold windowpanes.

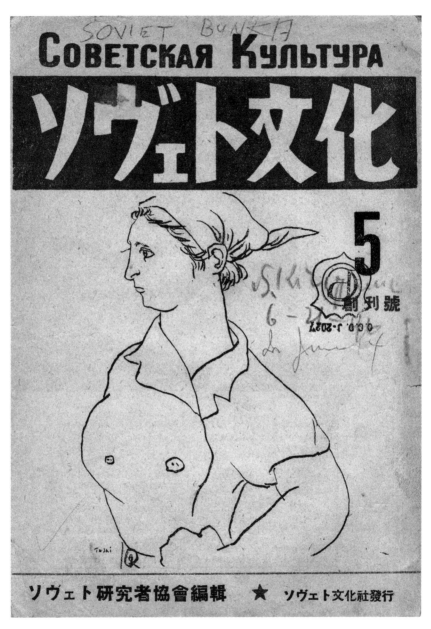

Fig. 4.2 Akamatsu Toshiko, illustrator. *Soveto bunka*. May 1946. Held by the Gordon W. Prange Collection, University of Maryland Libraries.

「せつしやは陸軍大將じや。全体君はどこの部隊じやね。」

— 18 —

Fig. 4.3 Akamatsu Toshiko, illustrator and Nicolai Gogol, author. *Hana ga nigedashita hanashi*. Tokyo: Kokumin tosho kankōkai, May 1948.

Toshi's notebooks from 1941 do in fact include several passages describing her train travel across Siberia, both in 1941 and her memories of her trips to Moscow in 1937 and back home in 1938. While there are plenty of sections waxing poetic about the landscape, the passages describing people in Siberia are generally harrowing. She records, for instance, how in 1937

> [t]he powdery snow danced along the endlessly long tracks, people
> waiting [alongside them] for half a day or more. No provisions, nothing
> to eat or drink with them. And maybe they didn't have anything at all,
> at times lacking even those things one must have in order to live.[26]

In a later passage, commenting now on what she saw in 1941, Toshi described the sun setting over the northeastern plains of Siberia while she mulls over an interaction she had at the previous stop. She had gotten off the train to buy two bottles of milk for twenty rubles and had struck up a conversation with the old lady selling them. Toshi comments, "I was sad to hear what the old lady told me. I'd thought that it was just the people living outside of the cities who were having a hard time, but it seems like it's more widespread than that."[27] Toshi wonders how freely the woman could talk with her, as a foreigner, and she notes that everyone she speaks to seems "sad and worried."[28] Perhaps they knew more than Toshi did of the ongoing Stalinist purges; she seems to have been completely unaware of gulag politics. Nevertheless, Toshi's diary accounts of frigid, starving poor people with boots of straw and oily, sodden jackets wondering how they will make ends meet become, in her published prose, well-dressed, warm, happily singing workers. If, during the late 1930s and early 1940s, Toshi allowed her published art and prose (if not her private writings) to parrot the imperialist zeitgeist, there were times in the late 1940s and 1950s when she similarly allowed her public work to parrot the party line. Fortunately, she did not succumb to it often.[29]

Over time, Toshi began to distance herself from the Communist Party, as did a number of other artists at the time.[30] On April 21, 1946, she and Iri attended the foundational meeting of the Nihon Bijutsu Kyōkai, an organization that aimed to reach across political party lines in an evaluation of artistic wartime responsibility and to work in a forward-looking manner to create art for a newly democratic Japan. Approximately one year later, on May 10, 1947, she and Iri also attended the foundational meeting of the Zen'ei Bijutsukai, a leftist arts organization and a

self-described "movement to create and cultivate culture for the masses" (*taishūtekina bunka undō*) and a "revitalized realism" (*atarashii riarizumu*) constructed from "a politically engaged standpoint" (*seijitekina tachiba*).[31] While her distance from the party grew until she finally broke with it officially sometime in 1949, Toshi remained steadfastly and broadly populist in the coming decades, right up to the end of her life. Even early on, in her descriptions of her political and aesthetic outlook, she tended to use communist buzzwords while espousing a much more broadly populist vision. For instance, in a September 1946 survey on the topic "What are your dreams for the art of the future?," Toshi responded, "We are walking toward liberation. Amongst the bitter struggle and the jubilation, there's the quickening of art's new life. As we urge one another on and work to build it, this new art is born. I see a bright dream of society the likes of which we've never seen before, where people grow in utter liberation, where we believe in people's strength."[32]

Putting Toshi in Her Place

Lauded by some as "the people's artist" (*jinmin no gaka*),[33] Toshi was heavily critiqued by others for her ideological commitments, especially by arts critics who wanted to avoid a return to what they judged to have been the prewar aesthetic dead end of what William Marotti has so aptly termed "ever-larger raised fists."[34] A solo exhibit of Toshi's work in April 1948, featuring some forty pieces and held at a gallery in the Ginza district of Tokyo, elicited several critiques.[35] An anonymous critic, writing for the major arts journal *Bijutsu Techo* in June, opened his review of Toshi's work with a harshly rhetorical question: "Is there a distinction to be made between progressiveness in politics and progressiveness on the canvas? Maybe not. At any rate, Akamatsu Toshiko's art makes little more progress than to drape a red flag over the canvas."[36] Referencing Toshi's affiliation with the Zen'ei Bijutsukai (Avant garde arts society) and centered only on her oil paintings (those on canvas), the reviewer argues that Toshi's art is "grotesque" in the way it forces a sense of optimism amidst scenes of struggle and poverty, and he calls on her to "reflect critically" (*hansei*), as well, on the ways her work simply "exoticizes" her subjects without showing them any real affection. In a parting salvo, he avers that though the masses may love *her,* Toshi's art makes it clear that she does not love *them,* and he dismisses her entirely as a would-be "artist of the people" (*jinmin gaka*).[37] In a second review of the exhibit, another critic in the same journal, one Egawa, judged that the two most accomplished paintings were Toshi's *Self Portrait* (*Jigazō*) and one

titled *Potatoes* (*Jagaimo*), but that on the whole her oil works were "tame" (*sunao*), lacking in complexity and depth. On the other hand, he found the sketches much better, "giving evidence of underlying power" (*urazukeru 'chikara' o shimeshiteita*).[38]

Even friendly reviewers, like fellow female oil painter Migishi Setsuko, called Toshi a "deep-red Russophile" (*jun somi no roshiyamono*). Migishi suggested that Toshi was wasting herself on rather too much "journalistic" art, but she defended her as having a unique style that exceeded mere grotesquerie and deformation.[39] Migishi's conclusion was that as the postwar sensibility for all things "mass" (*shomin*) matured, so would Toshi's art, and she forecasted that arts lovers could anticipate great things from Toshi in the years to come. Admittedly, as Toshi's propagandistic revisions of her Siberian experiences (cited above) attest, these critics had a point. Her prose suggests that, at times, Toshi did have difficulty tempering the crimson tinges of her postwar palette.

More than political leanings, however, the crucial—but indirect and largely buried—critique of Toshi's work had to do primarily with two other, heavily charged issues: medium and gender. For decades, the deeply conservative arts world (*gadan*) had been fighting hard against more experimental forms of artistic production. As Gennifer Weisenfeld has argued, the battle had begun in the 1920s, as groups like MAVO and the Proletarian Arts Movement (NAPF) began rebelling against "what they saw as the mimetic role of Western-style art in the Japanese academy and the notion of an autonomous 'pure art' (*junsei/junsui bijutsu*) limited to the more conventional media of [oil] painting and sculpture."[40] In particular, the arts establishment sought to curb the abstraction and nonobjective forms of groups like MAVO while seeking also to crush the mass-oriented populism of proletarian arts practice. Thus, barbed critiques of Toshi's "journalistic" leanings must be read as pointed attempts to contain her and to frame her as an oil painter, with her sketches serving either as useful, preparatory studies for her oil works or as useless, journalistic dross. Indeed, all published photos from this time period of Toshi at work visually insist upon her as an oil artist, either showing her with palette in hand or as almost claustrophobically hemmed in by layers of bulkily framed canvases (fig. 4.4).

For conservative critics, the postwar "revitalization" (*fukkatsu*) of the visual arts was to begin with a return to oil painting, sculpture, and formal training at major arts academies. As a formally trained oil painter and a graduate of a Tokyo-based arts college, Toshi was close enough to fitting

Fig. 4.4 Unknown photographer. *Fujin gaho* (November 1946). Held by the Gordon W. Prange Collection, University of Maryland Libraries. This photograph of Toshi at work in her atelier from the inside front cover of *Illustrated Women's Gazette* shows the artist surrounded by her oil canvases.

this mold that the pressure exerted on her was intense. Aside from her predilection for mass forms, however, she lacked one other major (if largely unspoken) credential: she was not a man. And in the chauvinistic art world of the time, that could be used against her. An August 1948 article in *Yagumo* is instructive. Though it is titled "Akamatsu Toshiko," most of the article, in fact, concerns her husband Maruki Iri. The article begins by announcing that Toshi and Iri will be giving a joint exhibition of their work in the Ginza neighborhood of Tokyo[41] before turning to a description of Iri. Characterizing him as an affiliate of the Seiryū group of ink brush painting, the reviewer praises Iri's work as "striking, original, and powerful," and notes that, far from pleasing only the critics, he is popular with the ladies, too![42] On his fifth woman when Toshi entered the scene, he seems to have picked her up as his sixth.

When Toshi is healthy, the article continues, she shows Iri some things about oil painting and busies herself doing cheap illustrations (*katto*) for various publications. Her "unique style" blends realism with grotesque deformation. After providing a brief biographical sketch of Toshi—temple daughter hailing from Hokkaidō, nanny, and elementary school teacher—the review concludes, "She's a leftist, a member of the Communist Party, and is 36 years old." In other words, Toshi shows up first and foremost as her husband's latest fling, the new arm candy that displaced his fifth wife. While he is an amazing artist, doing all sorts of great things for the world of *suiboku* painting, she is a bit of an ingénue, hailing from the hinterlands, doing popular art (caricatures) and illustrations for mass publications. In a final snowball of praise, which nevertheless holds a hidden rock of sleight, the reviewer notes that both husband and wife were able to "preserve the integrity of their art, turning their backs on society" and supporting themselves during the war years by publishing children's books and farming. Toshi's wartime labor (and it was almost entirely hers) thus disappears under the mantle of domestic finances: kitchen work that kept a great male artist morally clean.

Envisioning the Soviet Socialist Republic of Japan

Toshi was intensely aware of these gendered politics and of the ways they intersected with both her aesthetic production and her ideological commitments. Indeed, Toshi's abiding attachments were *not* to Russian political forms. Rather, hers was a deep populism that addressed not only issues of class and labor, but also paid particular attention to matters of gender. Toshi was not interested in a regressive visual culture of ever-bigger red fists

in which the male industrial laborer took center stage in a universalized vision of socialism that nevertheless bore strong aesthetic echoes of Russian realism. Instead, she was interested more in envisioning and helping to make real what we might call a proto-feminist Soviet Socialist Republic of Japan. Tellingly, even when not produced for women's magazines, Toshi's cover art consistently features Japanese women as the new socialists, as in her June 1947 art for *Taishu kurabu,* an organ of the Japanese Communist Party, in which she revisits a signature motif: a frontal portrait of a Japanese woman tying on a red headscarf.[43] Her vision of a Japan to come is thus simultaneously populist and female.

Similarly, her crowd scenes commonly feature women marching in the front lines, as in a June 1946 illustration for a May Day vignette published in *Working Women* (*Hataraku fujin*) (fig. 4.5). The image—part of the so-called "Food May Day" protests over government inaction in the face of widespread hunger—features women and men carrying signs reading "No resurgence of imperialism," "Let us eat," and "Toshiba labor union" along with many red and white banners that almost obscure the Imperial Palace in the background. Toshi's prose singles out the sexuality and femininity of her vision. "Boutonnieres jostled on the breasts of the young labor women"

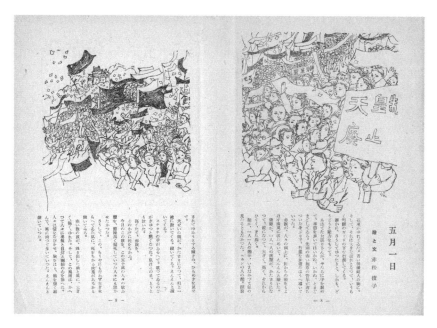

Fig. 4.5 Akamatsu Toshiko, illustrator. *Hataraku fujin* (June 1946). Held by the Gordon W. Prange Collection, University of Maryland Libraries.

as the crowd swelled, starting quietly then building to a deafening crescendo. "I had never before seen faces like this, one by one, the faces of Japan. Faces shining with the glow of liberation. . . . My hands shook as I sketched the scene. My throat closed, sore with song. My eyes streamed tears."[44] Almost the entire front line of Toshi's parade consists of women, their right fists raised in protest. In short, the Japanese bodies she placed in socialist poses were prominently female, a trenchant feminization of the red fist imagery familiar from the prewar period. As I will discuss later in this chapter, the gendered sensuality of these bodies was a core feature of Toshi's vision.

Toshi's most extended and explicit treatment of her gendered vision of a socialist Japan appears in a July 1946 article she wrote for *Genron* (The public opinion), a journal that aimed to capture threads of popular discourse and to introduce them to a wide readership for discussion and debate. Toshi provided a series of illustrated vignettes she titled "Moscow and Tokyo," in which she contrasts life in the Russian capital with life in the Japanese one. The first vignette of the three is set entirely in Russia and is based on entries from her notebooks.[45]

> The sun glints on the water. Starting tomorrow, we'll be in the country outside of Moscow. The communal laundry spot will be filled with energy from morning until nightfall. Women in red kerchiefs will be washing suits, naked children will be jumping and splashing in the water, pulling on the laundry as they swim.[46]

Toshi continues to describe the scene: The mothers will fuss at the children for getting in the way and the youngsters will scamper back out into the river. The man of the house will grab one side of the basket, heavy with washed laundry, and, with his wife hefting the other end, will carry it to the drying poles. Together, they will hang up the laundry there, alongside their neighbors', a busy Sunday for the parents in this family of four. The second vignette continues this domestic scene, as the man of the house is the first to wake up. He goes to draw water from the well in the forest nearby, then returns quietly to heat a pot of tea for his still-sleeping wife. Toshi asserts that everyone chips in to take care of the daily work: "You'll even see the husband tending a pot of soup on the stove or making bread," while the wife might chop wood to heat the oven to make sweets for the kids, or carry heavy baggage. At the dacha, laborers (*rōdōsha*) of both genders, "who work all winter, spend time relaxing" in nature.[47]

What Toshi describes—accurately or not—is a vision of gender equality, a world where there is no "women's work" and no "men's work," but where, rather, each sees what needs to be done and does it, whether physical labor (chopping wood, carrying water) or emotional: She also describes a husband speaking tenderly to his wife, and her sketch for the article shows a man cradling a babe-in-arms. She then pointedly contrasts this with what one would find in summer in Tokyo.[48] Women waking early to get everything ready for their husbands, even tying on their shoes and handing them their briefcases as they head out the door, without even one kind word, to catch the train. The station is crowded with rush-hour patrons, each of whom reads a newspaper and does not talk with his neighbors. The train bangs in, the doors hiss open, and people begin to push their way forward. Everyone is cranky and cramped, and men take advantage of the opportunity to grope and grasp at women, who have to yell at them to stop. A total dystopia, not only in the relation of labor to leisure and man to machine, but in the realm of emotional work, gendered affect, and erotic congress.[49]

Vignette number three returns to Moscow, where Toshi describes several pleasant experiences she had on trains and at train stations, before she concludes that postwar Japanese people could learn a great deal from Russian laborers about how to live, about how to live with one another, and about how to build the kind of world we want to live in. It all begins, she suggests, with simple customs of gender equality and small gestures of friendship, even toward (perhaps especially toward) those who do not look like yourself.[50]

Writing on the Wall: Toshi's Art of Reportage

If Toshi was not willing to publish anything that could be read as a critique of Russian socialist society, she certainly pulled no punches when it came to surveying the situation in Japan, employing recognizable leftist genres such as reportage and the "wall story" to communicate deep critiques of postwar society. In his 1948 *Literature for Laborers* (*Hatarakumono no bungaku dokuhon*), popular proletarian author Tokunaga Sunao explained that reportage (*reporutāju*, or *hōkoku bungaku*) had come into Japan around 1933, inspired by French and German experimental forms of microfiction such as the *conté* and Soviet forms of socialist realist literature such as the literary sketch (*ochierku*), as well as classical Japanese forms like the *zuihitsu* (random jottings).[51] These are all forms of short prose, to be sure, but transwar reportage also held important ideological commitments. "Constructed

out of a single incident, plucked from a single scene," reportage aimed to "reflect the full width and depth of society" and to "open the eyes" of its readers.[52] Reportage, as Sunyoung Park notes, was a "mixture of investigative reporting and journalistic sensationalism" that "offered writers an opportunity to depict social reality from an angle that would be both objective and congenial to the morality and emotions of common folk."[53] Reportage also appealed to authors as a crucially important genre for bridging the distance between leftist political theory and aesthetic practice, both in the Japanese home islands and in its (former) colonial territories.

The wall story, in turn, can be understood as an even more radical attempt to wed aesthetic production with social action. In his literary history of the Japanese proletarian avant-garde, Samuel Perry defines the wall story (*kabe shōsetsu,* sometimes also referred to as *heki shōsetsu*) as a "unique Japanese contribution to international experiments in revolutionary form." Wall stories emerged in 1931 and went on to enjoy regular publication, primarily in Communist Party–affiliated journals, until the draconian red purges of mid-1930s imperial Japan before resurging in 1945.[54] At least notionally, this extremely short form was intended to be pulled out or cut out of the larger publication of which it was a part and posted on the walls of factories, tenement houses, and other workers' gathering spots. (How often this actually happened is uncertain, but the visual layout of published wall stories at times makes use of designs such as brick walls, suggesting public posting as a desideratum.) A hallmark genre of the Japanese proletarian avant-garde, the goal of the wall story, according to Kobayashi Takiji, "was to capture a 'simple, rudimentary' experience that was relevant to workers' lives, one which 'could be read anywhere at any time' and 'would appeal in a direct way to the needs of workers and farmers.'"[55]

Due to their twinned origins, simultaneously as experimental aesthetic forms and as direct political actions, both wall story and reportage often tended to—indeed typically *sought* to—conflate the roles of reader, activist, narrator, and author, thus giving rise to a range of other names for occasionally recognized subgenres, including "correspondence literature" (*tsūshin bungaku*) and "reportage literature" (*hōkoku bungaku*). In short, reportage and the wall story were part of a literary continuum, avant-garde experiments in agitprop that could only be distinguished roughly from one another by virtue of length: The wall story was intended to be short enough for a laborer to read in its entirety during a work break, while reportage could be much longer. In addition to literary versions, reportage also took on visual forms. As Linda Hoaglund has demonstrated, "'reportage painters' was

a loose label attached to left-wing artists" of the 1950s and early 1960s "who rejected conventional aesthetics, while bearing witness to unfolding military and political events."[56]

Indeed, both wall stories and reportage literature were commonly illustrated, generally with inexpensive and easily reproduced line drawings of the sort at which Toshi excelled. Indeed, Toshi provided the illustrations for two self-proclaimed wall stories (*heki shōsetsu*) in early 1946. "Our Friends in Northern Korea" (Kita Chōsen ni iru tomo yo), published on February 3, 1946, in the communist newspaper *Akahata,* and "Rice Quota" (Kyōshutsu kome), published on April 18, 1946, in the same venue. She also illustrated longer works of reportage and proletarian fiction by a number of prominent authors, including Tokunaga Sunao (1899–1958), the son of impoverished farmers; Kobayashi Takiji (1903–1933), who was tortured to death while in police custody; and Shirakawa Atsushi (1907–1986), among others.[57]

As with her Micronesian and Muscovite sketches, Toshi's artwork tends to focus on street-level views and unexpected moments of intimacy. One of her illustrations for Shirakawa's "A Shoeshine Boy's Brush" is typical (fig. 4.6). Centering the sketch on a standing man's crotch, she leads the viewer's eye down his thigh to the face of a young boy, the only person in the image who returns our gaze. Next to him kneels a second boy, looking up at the standing man, who stares straight ahead. There is a jolt of recognition here, a teaching moment: we, the readers, return the boy's gaze while the standing man ignores those around him, even those who service him intimately, the shoeshine boy's fingertips glancing against the man's bared ankle. Toshi completes the image with two adjacent, but visually tilted or skewed, planes. In one we see food vendors at work, the speed of their labor indicated by the piles of rubbish tossed around and behind them. In the third panel of this triptych, we see two couples promenading along a clean, tree-lined street. By association (this is an open-air market where people are selling things), we can surmise that the men are American GIs and the women so-called *pan-pan* girls, street prostitutes whose primary clientele were US soldiers.[58] Like the story of which it is a part, Toshi's image asks us to ponder the nature of capitalist exchange, the costs of social inequity, the use of the female body as an item of sensual consumption, and the private consequences implied in the public exchange of goods and services. Like the reportage fiction it complements, the visual exchange embedded in Toshi's image demands an eye-opening moment of mutual regard.

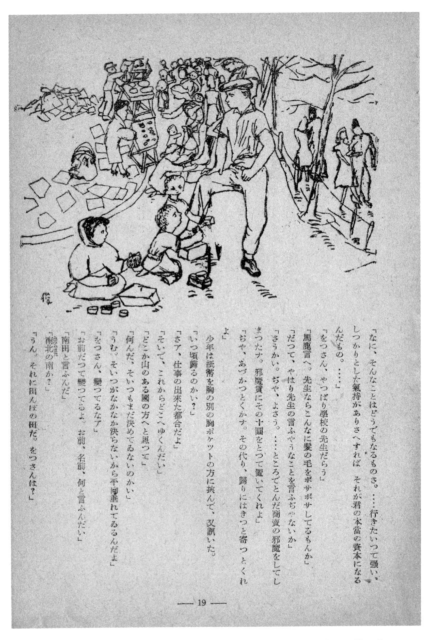

「なに、そんなことはどうでもなるものさ。……行きたいつて强い、しつかりとした氣持がありさへすれば　それが君の本當の資本になるんだもの。……」

「をつさん、やつぱり學校の先生だらう」

「馬鹿言へ。先生ならこんなに髪の毛をボサボサしてるもんか」

「だつて、やはり先生の言ふやうなことを言ふぢやないか」

「さうかい。ちや、よさう。……ところでとんだ商賣の邪魔をしてしまつたナ。邪魔賃にその十圓をとつて置いてくれよ」

「おや、あづかつとくかナ。その代り、歸りにはきつと寄つとくれよ」

少年は紙幣を胸の別の胸ポケツトの方に挾んで、又訊いた。

「いつ頃歸るのかい？」

「さア、仕事の出來た都合だよ」

「そいで、これからどこへゆくんだい」

「どこか山のある國の方へと思つて」

「何んだ、そいつもまだ決めてるないのかい」

「うむ、そいつがなかなか決らないから平圓垂れてゐるんだよ」

「をつさん、變つてるなア」

「お前だつて變つてゝるよ。お前、名前、何と言ふんだい」

「南田と言ふんだ」

「總北の南か？」

「うん、それに困んぼの困だ。をつさんは？」

Fig. 4.6 Akamatsu Toshiko, illustrator. "Shōnen no burasshi." *Fujin kōron* (October 1946). Held by the Gordon W. Prange Collection, University of Maryland Libraries.

In addition to providing artwork for others' compositions, Toshi also wrote and illustrated a number of her own pieces. She published her first wall story, a combined word-and-image piece titled "Scenery" (Fūkei), in March 1946 (fig. 4.7).[59] In it, the author-narrator emerges from the train station into a cold, cutting wind that buffets her parched skin and sends bits of garbage turning and twisting into the air. A street peddler calls out, selling warm dumplings; another is selling hot stew. An intoxicated middle-aged man pisses on the street, his urine a steaming stream. The narrator picks her way through the black market, and the sharp smell of onions sets her mouth to watering. The vendor, who has a mound of onions arrayed before him, presses the hard sell. Unable to afford the full amount, she strikes a bargain, paying sixteen yen for a half portion. Onions in hand, she surveys the scene: Streets filled with rubble, tight knots of people heavily bundled against the cold, two men on crutches, and a starving dog slinking away on impossibly thin legs. "This," she writes, "is Tokyo in February 1946."

The story is set outside the west exit of Ikebukuro Station, just down the street from Toshi's atelier in a warren-like neighborhood of artists' lodgings. This is a scene she would have seen daily, a report on her regular evening route. Visually, she positions us, as viewer/readers, on the margins of the crowd. We see the rubble to our right, the piles of onions near the center margin, the impossibly thin dog at the left-hand edge. As with her illustration for "A Shoeshine Boy's Brush," only one person from within the scene meets our gaze: an injured former soldier leaning on his crutches beside the table of onions. In *viewing* the "scene," we stand at the edge of the crowd; it is by taking the time to *read* the "scene" that we become a part of it, taking on the author-narrator's point of view, as we follow the scent of onions and slip past the man on crutches to approach the vendor's table. Though arrayed across a single spread and short enough to be clipped out and posted on a wall, there is scarcely a standing wall left on which to pin it.

"Scenery" was the first of more than half a dozen wall stories Toshi published between March 1946 and August 1947. While a couple of her pieces focused on celebrating the small victories of women workers,[60] most dealt with poverty and social problems, often blending a first-personal, gendered perspective with observations of and conversations with impoverished men and orphaned children. In "How Long?" (Itsu made), published in the Communist Party–backed journal *The Laborer* (*Rōdōsha*), the author/narrator is doing laundry when a door-to-door peddler comes by selling soap. She cannot afford to buy anything from the man, but they strike up a friendship over multiple visits and she learns that he had spent most of the

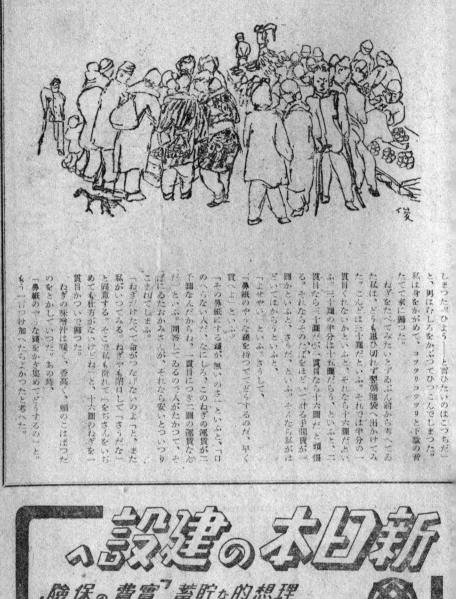

しまった、ひょう──と言ひたいのはこつちだ
と、男はむしろをかぶつてひつこんでしまつた。
私は身をかがめて、コツツリコツツリと下駄の音
たてて家に踊つた。

ねぎをたべてみたいとずゐぶん前から考へての
た私は、どうも愚ひ切れず裂朔池袋へ出かけてみ
た。こんどは三十圓だといふ。それでは半分の一
貫目くれないかといふと、それなら十六圓だとい
ふ。三十圓の半分は十五圓だらう、といふと、二
貫目なら三十圓だ、一貫目なら十六圓だと頑張
る。それならその半分をほしいと計る手間賃が一
圓かといふと、さうだ、といふ。さみだなら私が

「よせやい」といふ。さうして、
「鼻紙のやうな頭を持つてでどうするのだ、早く
買へよ」といふ。

「その鼻紙にける頭が無いのさ」といふと、「コ
のへらない人が」、なにしろ、このねぎの運賃が二
十圓なんだからね、一貫目につき二圓の運賃なん
だ」といふ。問答してゐるうち人がたかつて、そ
ばにゐたおかみさんが、それなら安いとついつり
こまれてしまふ。

「ねぎだけすべて命がつたりないのよ」と、また
私がいつてみる。ねぎやも閉口して「さうだな」
と同意する。そこで私も折れて「をぢさんをいら
めても仕方がないけどね」と、十六圓のねぎを一
貫目かついで歸つた。

「鼻紙のやうな鏡をかき集めてどうするの」と。
のをとかしていつた。あの時、
「ねぎの味噌汁は暖、、香高く、頬のこはばつた
もう一言つけ加へたらよかつたと考へた。

(51)

繪と風景　文　赤松俊子

ヒョウヒョウと風が吹いてゐた。乾いた身を団
る風が野間の蹂躙の紙くづを吹きとばしてゐた。
「—さむい、あつたかいすいとん、すいとんはいか
が」

食用油に糸くづのやうなものをさしこんで、紙
ではつた手製の行燈。暗い燈が夜風に消え入りさ
うである。

水ばなをすすつて、手をより寄せながら、
「おでん、おでんはどうです、いかのおでん」
私は池袋駅西口を出る。晝間の閙市の人混み
は、陽が、輝けのこつてからうじて身を守り終せ
た不思議なふぜいのある樹々の向ふに落ちて行く
と、ばたばたと倒つて行つた。さうして暗い夜風
の中に、からうじた屋臺店が立並ぶ。一ぱいのん
だ男が、薄闇はいわしでもならべてをばさんが坐る
所へ、ジョウジョウと箸をたてて立小便をして居
た。

屋臺店が終つて、暗ぶりの向ふにプンプンと生
ねぎの匂ひがする。のぞくと、ねぎの山である。
ねぎで鬧つてむしろを掛け、男が入つてゐる。
「ねぎはいらんか?」といふ「いくら?」一束六
十圓」
「ひょう——」と、私はとんきょような聲をあげて

war years working in a sardine-processing plant in Karafuto.[61] In "The Shabby Jacket" (Yabureta wataire) Toshi reprises her own elementary school graduation ceremony, to which she wore a dirty and torn padded jacket, earning the scorn of other students and inadvertently shaming her parents.[62] "For the Kids" (Kodomo no tame ni) is a lengthier exposé focused on the fate of so-called "roaming boys" (war orphans) who have been put together into a home on an island in Tokyo Bay (Odaiba). The author/narrator watches them, sketches them, and asks them questions.

> "Mr. Flanagan has come here. Have things changed for you since his visit?"
> "No."
> "Do you want to run away?"
> "Yes."
> "Why?"
> "There's not enough food."
> "Why not?"
> "Our minders eat it."
> "How many of you have escaped?"
> "Just last night twenty or so boys made a run for it."

Apparently, conditions in the institutional home were so dire that occasionally the boys would try to swim to shore, where they believed they would be happy. Most died in the attempt. The author/narrator wonders: What are adults doing? Are we standing by and just watching, doing nothing? Are we exploiting them, or what? Where is their "blue bird of happiness?"[63] As archival documents show, occupation censors struck several of the more harshly critical passages as potentially inciting protest against US forces, though most of the story and all of Toshi's drawings of the boys were allowed to run.

In what was perhaps her most formally ambitious piece—"Not Dying" (Shinanai), which was published in *Modern Literature* (*Kindai bungaku*)—Toshi opens with a headnote. "You say, 'Blessed are the poor.' Are you crazy?"[64] In the narrative that follows, Toshi unpacks this rhetorical query by performing a creative, inside-out thought experiment. Two boys crouch on the train platform at Nippori Station. Both are covered with layers of dirt and grime, and it is only when one of them stirs to scratch his thigh that "I" realizes that the piles of rags are living human beings. One of them, missing half of his teeth, just lies there not moving. "I" looks at him long enough to remark on his long eyelashes. The other is looking up

at the blue sky. "I" guesses they are about twelve years old. Someone comments that they are war orphans, but another bystander suggests they have likely come in from the countryside, where their parents dressed them up this way so they could beg. People walk by, going about their daily lives, refusing to look at the boys, while "I" continues to watch them, thinking of them as Stoic philosophers in the way they simply wait for death to overtake them. "I" imagines their thoughts as they stare back at her, in biting critique of her bourgeois upbringing amidst art and literature, salons and parties.

Briefly, we are in the mind of one of the boys. "Don't believe yourself so different from us, just because you have artistic talent and the blessings of a rich upbringing," he thinks as he stares at the woman. He looks up at the beautiful blue of the sky. The narrator/author then wonders, "If he were in my place, what sort of amazing artwork might he create?" She chides herself: Don't think he's incapable of understanding art just because he has spent his whole life working for enough food to survive. He doesn't have the strength to stand up, but if he did, what then? We are left to ponder the question when suddenly we are back in the boy's mind. "Oh, I see, you're waiting for the day when we will fall over, exhausted, when we will die." But, as the title of the story suggests, the boys will not just die.

Having seen war orphans living on and around train platforms in Tokyo, Toshi begins her story with a description of those children, as narrated from the point of view of a bystander. The story then shifts into the point of view of one (or perhaps both) of the orphans themselves, imagining what they might be thinking and feeling. As with her regular practice of including one person who returns the reader's gaze from within the frame of her wall story illustrations, this angle/reverse angle narrative strategy has the effect of leveraging readers into the story, putting us first into the narrative point of view of the bystander, and then behind the eyes of the orphaned children at whom the bystander/reader might just otherwise glance before looking away. Though not illustrated for its run in *Modern Literature*, "Not Dying" clearly references a sketch Toshi had published the previous month in *The People's News (Jinmin shinbun)* that showed a small group of malnourished children lying on a bench in a train station waiting room (fig. 4.8).[65] As Samuel Perry has argued, the Japanese proletarian cultural movement "was equally engaged in aesthetic speculation as it was in using aesthetics as a revolutionary weapon."[66] For Toshi, the work of art was to help us see, and collage-like assemblages of narrative and visual frames were tools that could shift crucial social perspectives.

引揚同胞スケッチ
ある駅の待合室で　　アカマツ・トシコ

Fig. 4.8 Akamatsu Toshiko, illustrator. "Aru machiaishitsu" (Train station waiting room). *Jinmin shinbun* (The people's news). August 1, 1946.

"Circle" Culture and the Morning Sketch Club

While Toshi clearly conceived of publication, be it of visual art or of literary prose, as bearing directly upon culture and politics, she was not content to experiment and innovate only on the printed page or in the gallery. Instead she sought to form her own "circle" (*sākuru*), a sort of open-access arts workshop. In other words, imagining what sort of art the train station orphans might produce was not, for her, enough. Rather, she actually wanted to work with laborers, to teach men and women and children how to draw and, by doing so, to continue to learn herself how to see. Toshi took a leading role in constructing what is known as "circle culture" (*sākuru bunka*), both in the greater Tokyo area and especially in her own neighborhood of Ikebukuro.

On October 10, 1945, less than two months after Imperial Japan's surrender, the National Labor Union (Zenkoku rōdō kumiai) assembled to reconfederate itself, and by autumn 1946 labor unions around greater Tokyo had begun to form cultural alliances (*bunka dōmei*) and laborers' arts committees (*shokuba bijutsu kyōkai*). These were the beginning of what was to be a decade-long boom in "circle culture." The Japanese Communist Party and its various publications, foremost among them the journal *Jinmin*, threw its weight behind these efforts to put the tools of culture into the hands of the proletariat. Michiba Chikanobu has argued that

while commonly glossed as an "age of chaos" (*konranki*) in which people turned to the pleasures of the "gate of flesh" (*nikutai no mon*) in a decadence born of postwar desperation, the 1950s in Japan might be better understood as a period of incredible cultural experimentation. That decade, he writes, "gave rise to an unprecedented upsurge in circle culture movements, meaning that untold numbers of anonymous, everyday people created culture with their own hands, conceiving of themselves as pillar bearers of society, throwing themselves full force into activities through which they sought to make their workplaces and living areas more humane."[67] They wrote memoirs and poems, mimeographed and circulated novels and stories, formed choruses, published journals, and put on plays in a "dynamic birthing of postwar democratic culture."[68] In his study of one such cluster of circles in the Shimomaruko industrial neighborhood of southern Tokyo, Michiba argues that through forming collaborative circles with one another, workers could do together things that would have been impossible for them to do alone.

Michiba begins his study in 1950, but as I have already suggested, the seeds of circle culture were sown half a decade earlier, in the months immediately following Japan's surrender. When Toshi and her husband Iri joined the Communist Party in autumn 1945, they would have been connected directly into one of the chief organizational structures for cultivating these circles. By April 1946 Toshi was hard at work formulating her thoughts on what role art should play in reconstructing a postwar, postfascist Japan, who would produce this art, who would view and critique it, and what that art would *do* socially. In May, again timed to coincide with the international celebration of May Day, Toshi published the rump of a manifesto in the article "Steps Toward a Renewed Art" (Aratanaru bijutsu no shinro). The essay appeared in *The New Housewife,* and her Rosie the Riveter–like artwork (plate 11) graced the cover.

In the essay, Toshi identified five steps that art and would-be cultural producers must take. Step one involves a thorough self-examination: "We were ignorant. Philosophically and politically ignorant. Each and every one of us artists has no choice but to subject ourselves to an unremitting self-criticism and to set out on a fresh course" *(Muchi de atta. Shisōteki ni, seijiteki ni. Wareware bijutsuka wa wareware jishin kaku hakarande genshuku naru hansei o, aratanaru shuppatsu no hanamuke to senebanaranu).*[69] Second, artists must make a public confession of any wrongdoing. Third, employing an emperor's-new-clothes-like metaphor, she advocates "throwing off the mantle of the past" (*kako no koromo o nugisaru*), taking a critical

look at Japanese art history, and returning to the original artistic impulse toward freshness and simplicity.[70] Step four is to liberate ourselves, she writes, and to cultivate young artists, "standing tall and proud, and savoring our full bodies, our full selves, really enjoying for the first time the newness and freshness of our own naked flesh (*azayakana nikutai*)."[71] Here, we see Toshi averring to the language of "flesh" (*nikutai*), but deflecting it away from sensual hedonism and toward a "naked" practice of critical scrutiny.

Having thus prepared the way, we can take the fifth and final step, in which we will see art produced by laborers and farmers. "Laborers and farm workers," she argues, "have a better grasp of true reality than we artists do," and we should learn from them and their methods, throwing off the practices and tools of the past to create the new art. We all have to "stop thinking of art as just oil painting and ink brush painting" when all you need to make art is a single pencil, a single brush, or a single pen and some time. She calls for "art circles in factories, at work places, on farms," so that laborers can produce art, and she proclaims that professional artists, in turn, should exhibit their works at factories.[72]

That same month, May 1946, Toshi and Iri began hosting an early-morning sketch club (*dessankai*) at their atelier, and they continued to do so through at least October 1947. The emphasis was on drawing the human form and everyone took turns posing nude. A radical move in 1947 Japan, painting and posing in the nude was a critical practice for the group, both to avoid having to pay for a model and to embody, literally, the attitude of unashamed "nakedness" that Toshi advocated for in her essay. In a column titled "Exhibit on Paper," the *People's Newspaper* (*Jinmin shinbun*) announced the open arts workshop: "Every morning from 6:30 until 8:00 a group of some five or six young laborers (*hataraku wakamonotachi*) have been gathering at Akamatsu Toshiko's studio, making use of that precious, limited time before going to their jobs in order to draw pictures." The article continues with a quote from Toshi in which she claims that the amateurs outdid the professional artists in their ability to render a sense of freshness and vividness in their works. "'Just like anyone can write a letter,'" Toshi opined, "'anyone can make great art.'"[73]

While most of the regular attendees seem to have been (would-be) professional artists mainly associated with the Zen'ei bijutsukai (Avant-garde arts association),[74] the workshop was open to all, and laborers were especially encouraged to attend. Sessions typically consisted of each model holding a pose for fifteen minutes while the others, using pencil or

conté, made a quick sketch. According to fellow artist Iwasaki Chihiro, for the first couple of months everyone wore clothes. As the summer came and the studio grew stiflingly hot, Toshi suggested that everyone model nude. That would be the best study and would be cooler. At first several people resisted. Toshi stripped and invited everyone to draw her. Eventually, it became a regular practice for both the model and the artists to remain unclothed for the entire session.[75] Toshi hosted the sessions, shifting between modeling and sketching, and everyone contributed to the group critiques. A number of sketches produced during the circle survive, including a 1947 depiction that Toshi drew of her husband Iri, completed in her hallmark deformation style (fig. 4.9), and another she completed, on October 2, 1947, of fellow artist Iwasaki Chihiro rendered in a more classical style.

True to her vision, Toshi also went into factories, hospitals, and other workers' spaces, sharing her message of art for all. In September 1946, for instance, she and several others in the People's Culture Association (Jinmin bijutsukai) attended a factory culture circle to talk about art. Toshi reports, "All of their eyes lit up" until one of the young men broke the mood, pointing out, "We can't even eat! On these salaries, things are just

Fig. 4.9 Akamatsu Toshiko. Untitled sketch. 1947. Pencil on paper. Private collection. Toshi completed this sketch of husband Maruki Iri in the course of an early-morning sketch club (*dessankai*).

too expensive. We can't afford to waste money. This isn't the sort of place where you can just talk about art!"[76] Toshi responds by saying, first, that workers are the ones who are building society and shaping the world in which we all live. That is an art. And, second, why don't you get together, form a union, and demand better wages? She insists that these things are all deeply connected: what you make (on the factory floor), how much you make, and whether you make "art." Quite possibly, Toshi and her fellow artists had been visiting the factory in an attempt to drum up submissions for the Second Annual Industrial Art Exhibition, which they were helping to organize.[77] Toshi delivered similar remarks early and often, repeating them to university students,[78] to factory workers, to those who gathered at her morning sketch circle, and to patients convalescing at hospitals.[79]

A Manifesto of Naked Aesthetics: Anybody Can Make Art

Thus, between 1945 and 1949, Toshi kept herself incredibly busy both with publication and with in-person activism. These two streams of activity—her slew of Russian- and socialist-themed publications for the popular press on the one hand, and her factory floor activism and sketch circle, on the other—culminated in 1949 in the form of a 144-page manifesto, which she titled *Anybody Can Make Art* (*E wa dare demo kakeru*). She had rehearsed portions of this manifesto any number of times, in talks with workers at in-factory culture circles, in comments at various published roundtable discussions,[80] in the course of her morning drawing circle, and in the pages of journals and newspapers.[81] Notably, Toshi was ahead of the cutting edge in this declaration, preceding the well-known innovations of the Gutai group by half a decade or more.[82]

The earliest iteration of what would become Toshi's manifesto begins with Wakai Shuko, a lice-ridden schoolgirl with some crayons. "Skritch, skritching at her lice-ridden head, Wakai Shuko rubbed at her paper with the crayon. I was surprised—she was an absolutely dirt poor kid. Still, I encouraged her, this kid who had never before held a crayon. I stood in the center of the classroom, listening to the sounds of fifty students' crayons scribbling away." Ten minutes pass, then twenty. Finally, some of the more confident children call out for Toshi to come look at their work. Shuko stays seated, covering her paper with her hands. Toshi catches sight of a corner of it and, impressed with what she sees, she asks Shuko to let her look and then holds it up for all the students to see, "Look: Shuko's first picture ever. Good, isn't it?"[83] She continues the essay, "I was poor.

Growing up, I had nothing. In encouraging Wakai Shuko, I was encouraging my younger self. . . . In my poverty, I picked up a pencil. I refused to lose to poverty. For us, the impoverished, giving in to poverty is the utter defeat."[84] For Toshi, the fight to create an art of and by the people was personal, and she saw her own childhood self, her work as a teacher, her labor as an artist, and her activism as intricately and intimately related.

Her next major attempt to formulate the kernel of her manifesto came one year later, in October 1947, when she published an article titled "Introduction to Art: On the Idea That Anyone Can Understand Art and Anybody Can Make It" in the pages of *Zen'ei bijutsu* (Avant-garde art).[85] In it, she makes two crucial, interrelated moves: she attacks the arts establishment (*gadan*) as antidemocratic and, at the same time, she valorizes a certain kind of primitivism. "When I yell, 'Anyone can understand art!' 'Anyone can make art!' most times there is a huge shout of joy in response," whether from people who had swallowed the lie telling them that only those possessed of special capabilities could make art, or from those who had been sunk in despair. Those who despise all governance, those who have woken to their own sense of self, those who have taken the first steps along the true path to democracy, each is elated in their own way.[86] But, she continues, there are also those who "when I declare that anyone can make art, roll their eyes and widen them in fear." These are usually the chosen few who have been singled out previously for their so-called talents and who now think that if everyone can make art, their own special place in society is in danger of being eliminated. Toshi calls on those who would intone the ideology of democracy in some areas but not in others to clarify their positions and to apply the insights of their philosophy consistently to all areas of life.[87] "And some people will charge that [proclaiming that anyone can make art] is dangerous. These naysayers laugh scornfully at the idea that one might evaluate Picasso's work alongside the sketches of a black South Seas Islander child, or that one might place the works of a 3 ½-year-old child on the same par as those of Matisse. The thinking behind their derision is clear enough, but I wonder: have you ever, even once, actually compared the artwork of today's masters (*isse no taika*) with that of primitives (*genshijin*)? I'd like to suggest that you actually take some time to do this."[88]

Toshi argues that avant-garde European masters like Picasso and Matisse worked hard to overcome the trappings of modernity and the training of academicism, and what they discovered in their art—new and fresh as it seemed to their compatriots—resembled quite closely the kind of

art that native children in the South Seas might make. She thus urges would-be artists in postwar Japan to "throw off the yoke of academicism and the neuroses of modernism" and thus to really "liberate" themselves both aesthetically and politically. She continues, "That's where the hard stuff starts. When you have become naked and free (*hadaka ni nari kaihō sareta*) like that child, it's then that you're able to really construct a foundation, to build it high and tall; it's then that you are in a position to be able to move forward over the rest of your life."[89]

In this article, Toshi combines and conflates the innocence and sensitivity of children's ways of seeing the world with what she understands, from her Micronesian time, as the primitive freedom of Islanders' ways of seeing the world, referring to this all as a stance of "nakedness." For Toshi, this nakedness involves a stripping down to bare essentials (pencil, paper, time) and a stripping away of the modern (vis-à-vis the primitive), the adult (vis-à-vis the childish), the fascist (vis-à-vis the socialist), and the academic (vis-à-vis the amateur) ways of seeing the world and of making art that reflects and shapes that world. When asked elsewhere, "As a painter, what do you think of modern poetry?" Toshi responded, "I detest poets' vanity (*hokori*). I much prefer the bare naked poems of rank amateurs who don't really know what they're doing. And not a feigned nakedness either. Same about drawing. As ever, I love the wrong way (*jadō*) of doing things, which is actually the 'real way' (*hondō*)."[90] This is, in a nutshell, the conceptual and theoretical position that led her to organize her in-studio arts workshop, the sketch circle.

Clearly, there are problems with this position. Her conflation of South Seas Islanders with proletarian amateurs and with children belies a cultural chauvinism, even a racism, masked as a valorization of "primitive" culture and instinct. It would take her some months more to work through these implications and to formulate a more equitable basis for the kind of freshness and dynamism she was after. She accomplished this, in the end, by focusing on three key concepts, which together make up what I would call her "bare naked aesthetics."

Her first key concept centered on the active work of imperial *deformation*. As discussed in chapter 1, Ann Laura Stoler's theorization of "imperial formation" focuses on the notion of ruination, a move that is meant to shift "the emphasis from the optics of ruins to the ongoing nature of the imperial process" and to draw attention to the "deeply saturated, less spectacular forms in which colonialisms leave their mark."[91] Further, a focus on imperial formation attends to the ways in which "empire's ruins contour

and carve through the psychic and material space in which people live and what compounded layers of imperial debris do to them."[92] While imperial formation can highlight architectural leftovers and environmental consequences, as a biopolitical concept it also calls out the ways the legacies of colonization continue to shape the bodies, health, and psychologies of post-colonial peoples, both colonizers and colonized. Recall, for instance, Toshi's heavily self-redacted diary entry, discussed in chapter 1, of the ethnically Japanese boat captain: "[W]aving his short stick around again, he headed off in the direction of the palm grove. I wonder why the captain, normally so upbeat, finds this island so boring. ~~And so he waves his short stick around and, every now and again, strikes it across the buttocks of one of the island girls, and shouts at her and.~~" This scene between Toshi, the captain, and her friend Iratsukatsu was not the first time Toshi had witnessed the sort of formation that came at the sharp end of the imperial baton.

In her case, the brunt of the beating came on the first day of art college in April 1929, an incident she recounts at the start of her 1949 manifesto *Anybody Can Make Art*. The young women in her class are set a task. Handed a piece of paper and a stick of charcoal, they are told to make a sketch of a gypsum bust of Venus. They work at it for a week and then post their sketches in the hall of the school. As Toshi views them, she realizes that while each girl has drawn the same statue, they have also drawn portraits of themselves.

> Look at these fifty statues of Venus. Round-faced Venuses. Long-faced Venuses. Skinny ones. Chubby ones. Mischievous ones. Serious ones, kind ones, and foolish ones. These are sketches done by first-year arts students, girls just beginning arts school. The girl with the red cheeks has come from the northern territories to the capital. The southern girl, with her sunburnt black skin, has come up to the capital, her black eyes shining. From east and west we have come, determined to become great artists.[93]

She, of course, is the red-cheeked girl from the north, and she anticipates her own time in Micronesia by pairing herself with the sunburnt girl from the south. Toshi recalls that she, like all of the girls in the class, had "given expression to my own self. My life power, my strength as a young woman, flowed in an unbroken stream out the tip of my charcoal pencil. . . . These first buds of my own self, they needed to be cultivated. That, and nothing else, is the point of departure for all great art."[94]

The teacher, however, disagrees. He browbeats all the women for producing self-portraits when the assignment had been to create copies of Venus. "Thwack. Thwack. The teacher flicked at the paper [with his stick]. The Venus, sketched in charcoal, began to disappear, puffs of charcoal dust rising like puffs of smoke."[95] He continues to whack at their papers as he lectures them about proportion and symmetry, utterly destroying the drawings the girls have done, along with their illusions of agency and self-expression.

Toshi writes that by the time her cohort graduated, they had all become totally proficient at making lifeless copies of whatever object they were faced with, whether a statue of Agrippa or Apollo, or a live model. Writing now, as a thirty-seven-year-old, she notes her deep regret at how many of her classmates' will to create dried up and crumbled away, no more than a crumpled remembrance of some far-off time before marriage. When she realized, on graduation day, that this is what most of her classmates' paths were going to be, she resolved to shake off the education she had been given and to rediscover "the red-hot warmth" of her own artistic sun.[96] In other words, she vowed to shake off her own imperial formation. Note how the punitive strikes of the teacher's stick, the standardization of the body and its proportions, the "bringing into line" rhetoric all hark back to Toshi's Micronesian notebook entries, in which she railed against the "healthy" art of Nazi Germany and that of Imperial Japanese sanitized bodies.

How, then, to achieve imperial *de*-formation? How to strip away the layers of imperial formation to find the self again? Many Japanese artists shared these concerns, partly out of a desire to cast off fascism and begin anew, but also partly out of a perceived need to demonstrate artistic originality and independence in the face of Western dominance in the arts world. Again, Toshi was several years ahead of other Japanese postwar artists in articulating her thoughts clearly, forcefully, and publicly. If, as discussed earlier in this chapter, Toshi wrote often about "casting off the clothes" (*koromo o nuguisaru*) of outmoded, ill-fitting, or misguided ideologies, she wrote even more often about the importance of making oneself "utterly naked" (*suppadaka*). If Japanese fascism resulted in the layering and burdening of the body, Toshi's sense was that Soviet socialism provided a way to return to the bare self. Consider these otherwise puzzling passages from Toshi's Soviet-inspired writings from the mid-1940s.

A description of a May Day parade:

> Spring, the true Moscow spring, begins with May Day. Winter coats thrown off. Boots too. The school girls show off their long, milky white

peach thighs for all to see, their high, proud breasts thrown forward, their lovely arms flowing out from the dark-colored uniforms, golden hair bouncing in the spring breeze as they march along like Greek goddesses.[97]

A description of a walk in the woods:

A pink, naked woman (*momoiro no rajo*). A sleeping, naked woman. Bathing in the brilliant sunlight, in the clear, fragrant, ozone-rich air of the forest, her rose-colored flesh, lying face down on her stomach in the grass. I could hear the thumping of my heartbeat. The naked lady of the forest. In that moment, I completely forgot everything else that was on my mind."[98]

Another description of a May Day parade:

Ah! So striking! The nearly naked female soldiers, flowers pinned to their chests, blond hair waving, [uniforms] tight over their high breasts so their nipples catch the sun, their commanding hips, their long, splendid thighs so muscular it seems they will burst, their [uniforms] tight around the calves, they march along showing to all their sturdy ankles. (*Aah, sassō to, ratai ni chikai jōshigun, mune ni hana o kazashi, kin'iro no kami nabikase, takai mune ni futatsu no chibusa ga, shimatte kagayaki, dōdōtaru koshi to migoto ni hajikesō ni nikuzuita futomomo no nagaku, sune ni shimari, Akiresu kin no kyōjinsa o misete kōshin suru.*)[99]

Toshi's descriptions of Russian bodies are pure socialist jouissance, the fertility of early spring blending with the fleshly beauty of young, newly fertile bodies, together folding into an eros of communist parade. Nakedness carried a great deal of conceptual weight for Toshi. In part, it is a sensual thing: the freedom of strolling through the woods, unclothed, the warmth of the sun on the skin, the sound of the stream, the softness of wood humus underfoot. In part, it is a political thing, not only walking naked, but walking *unguarded:* the overheard laughter and conversation of the Russian men and women, mostly children and other servants, the proximity of the worker's woodland theater, the Communist Youth Brigade camped nearby, the solidarity of laboring life. And in part, it is an aesthetic thing. When people are naked and unguarded, you can see their bodies

better, how their muscles and bones fit together, how their emotions change their facial expressions. You can draw and sketch them more easily. Finally, when everyone is naked—as members of her in-studio sketch circle generally were—there is no shame in looking and in being looked at. You can look, long and deep. You can look until you see. If Toshi's art school experience exemplified imperial formation, being virtually beaten into drawing perfect look-alike copies of Hellenistic beauty, her Soviet-inspired nakedness aimed to de-form that training.

Building off of imperial de-formation, the second major concept of Toshi's bare naked aesthetics centers on a practice of unremitting, but tender, naked regard. She writes,

> We are all living creatures. Sit quietly and you'll feel the rhythm of your heart, thumping in your chest. You can see it in your wrist, too, that same rhythm.
>
> Raise that hand into the air and really look at it. You'll see that it, too, vibrates to that same rhythm.
>
> Take that hand and pick up a brush or a pencil. You'll see that the tip of your pencil vibrates to the same rhythm, thump thump thump. Maintaining that same quiet, use your left hand to pick up a piece of paper and place it on the table in front of you, and then place the tip of the pencil in your right hand on the paper, just barely touching it. The tip of the pencil shivers along the paper's surface. Now, without trying to still the shivering, move your hand, slowly and silently, making a line across the paper as you listen to the beating of your heart.
>
> Every one of us has a heartbeat and each one's rhythm is slightly different, so [it's not surprising that] each of us should make their own distinctive line.
>
> That line's not going to be straight.
>
> It's going to dip and rise.
>
> Try it when you're sick, when you have a temperature, and your heart is beating more quickly, and you'll find that the rhythm of your line is different from that of one you make when you're in good health.
>
> When you're angry, try it.
>
> When you're sad.
>
> When you've lost all hope.
>
> When you're madly in love.
>
> When you're tensing for battle.

The rhythm and shape of each one will differ. The way you draw the line, the speed with which you draw it will differ, and those differences will show up on the paper.

Each of our heartbeats is distinct, a little bit different from anyone else's, and so our lines are different, too.[100]

This practice of allowing one's heartbeat to move the pencil tip re-enacts, reframes, and reclaims the "strange vibration," "dull rattle," and seismograph-like revving of the broken-down Japanese ship in the South Seas, discussed in chapter 1. Here Toshi reclaims an instance of imperial navigation, recording her own rhythm and marking in that series of thin lines the entanglement of her own heartbeat, her own rhythm and line, with the ridiculous malfunctioning of the ship's engine, itself a heartbeat of colonial failure. Simultaneously, Toshi asserts a basic threshold for artistic line. If you have a heartbeat, a hand, a pencil, and a sheet of paper, you can make your mark. You can make your own essential rhythm visibly manifest. That is art. The rest is technique, which can come from practice.

Indeed, it is likely that this passage is based on remarks she made in the course of the morning sketch circle and her presentations to laborers' cultural groups. In the manifesto, she goes on to identify this "single line" practice as the foundation of art, and naked regard the necessary condition. There is nothing scarier, she suggests, than an utterly straight line or a line that tries to copy someone else's line, for these are the marks of people who have in some quite real way lost their heart and lost themselves; these are the marks of people who have been all too imperially well-formed. Art, she argues, is a mirror, one that is frightening in its seriousness.

The third major concept of Toshi's bare naked aesthetics centers on a dialectical practice of critical self-reflection (hansei), and here she stresses the importance of not erasing. Hang on to your sketches, she advises, because you will need them to learn from, and do not use an eraser to rub out your mistakes, just draw over them. In that way, "The surface of your drawing will teach you, showing you your battle with reality. Drawing pictures is a step in this practice (jissen) of grasping reality and conducting oneself accordingly (E o egaku koto wa, genjitsu o ha'aku shi, sore ni rikkyaku shite kōdō suru jissen no ayumi de aru no desu)."[101] Again, "Your line begins to waver. 'Ugh,' you think, 'I've screwed it up.' So you reach for your eraser to rub it out, but what's behind that way of dealing with it isn't about facing up to your mistakes and critiquing them (mizukara no ayamachi o hihan suru amari, hazukashisa no amari ni keshikakusō to suru

taido to niteimasu). It's more a gesture of embarrassment, of wanting to cover them up. But if it was really a mistake, then that reality's still there; it's not going anywhere. That reality, that truth, it just can't be erased. Even if you rub it out, you can't fool yourself into thinking that just because you can't see it, it's not there."[102]

We see clearly the ethical stakes that, for Toshi, were part and parcel of her practice of looking at the world and making a mark, putting pencil to paper and recording that world through and with your body. Art for her was not about seeing the world aright, but about seeing oneself aright: not seeing to cover up or ignore the errors, but cultivating a deep practice of critical reflection. This is important because giving into shame or embarrassment is a moral fault, as much as it is an aesthetic one. You cannot fix what is wrong if you cannot see it, if you refuse to countenance it, or if you try to hide it from others. "However sad, however embarrassing, an error is an error. It's something you did" (*Donnani kanashikutemo, hazukashikutemo, ayamachi wa ayamachi de atta no desu. Jibun no yatta koto na no desu*).[103] As such, it must be faced head-on in a practice of "thoroughgoing self-criticism (*tettei shita jiko hihan*). Self-criticism is not the same thing as confession (*zange*). It is, rather, a practice of clearly recognizing, and correcting, something so as to be able to move forward." Blending Marxist and Stalinist language (*hansei, jiko hihan*) with Buddhist terminology (*zange*), Toshi argues that doing art is as much an ethical as an aesthetic act.

From Critical Self-Reflection to Culpability

The years from 1945 to 1949[104] were incredibly productive ones for Toshi. Always a prolific artist in visual media, the lifting of imperial-era sanctions and censorship practices afforded her the opportunity to publish widely in a variety of written genres: wall story, reportage, poetry, travel sketch, and even manifesto. At the same time that she was formulating her theory of bare naked aesthetics—the hallmarks of which center on imperial de-formation, naked regard, and critical self-reflection—she was also working as a sometime correspondent for the leftist press. Her former employer Nishi Haruhiko, for whom she worked as a nanny in Moscow, served as defense counsel for his former boss Togo Shigenori from the beginning of the International Military Tribunal for the Far East trials on May 3, 1946, until November 1948. Toshi herself began attending the trials on July 29, 1946, producing a sketch and vignette for *Akahata* and a full-length illustrated article for *Jinmin*. She was also actively involved in what came to be

known as the debates on artistic wartime responsibility (*bijutsu ni miru senso sekinin*), which continued for decades. In the next chapter, I examine the transcultural understanding of legal culpability as exercised via the International Military Tribunal for the Far East (the Tokyo War Crimes Trials), Toshi's role in reporting on those, and her contributions to the discourse on war and the arts.

CHAPTER 5

Art as War Crime

Artistic Wartime Responsibility and the
International Military Tribunal for the Far East

A series of deeply divisive cultural debates pertaining to questions of "war responsibility in the arts" (*bijutsu ni miru sensō sekinin*) opened within a few months of war's end, picked up pace in the late 1940s and early 1950s, and continued to rage well into the 1990s.[1] Secure in her postwar role as a left-wing, propeace, avant-garde artist and communist activist, Toshi escaped public scrutiny until the publication, in 1990, of *Ikebukuro Monparunassu,* a tell-all account of the Parisian West Bank–style avant-garde artists' milieu of interwar Tokyo. Halfway through the book, a sizeable tome, author Usami Shō includes a series of vignettes concerning Toshi. In the first of these, Usami describes Toshi, knife and bucket in hand, scavenging along the wartime roadsides for dropwort to chop up and boil for food.[2] As for many of the artists in the neighborhood, and much of the Japanese population at the time, starvation was a real concern.

The conversation begins by covering familiar ground for Usami, who had interviewed Toshi in 1984 for his nonfictional *Genbaku no zu monogatari* (The story of the nuclear panels). In the midst of the interview, however, Toshi suddenly "discloses, 'I am a war criminal. I illustrated a book that glorified the war'" (*Watashi wa senpan yo. Sensō raisan no ehon o kaita no*).[3] Usami seems stunned. Eventually, he presses the issue in a further interview. After doing some investigating, he now confronts Toshi with not one, but several of her forgotten children's books in a sensitive exchange that also probes the difficulties in attributing responsibility for wartime artistic production. Finally, Usami asks, "Why did you take the job[s]?" Toshi replies, "I hadn't had anything to eat."[4]

156

When Toshi declared herself a war criminal (*senpan*) in late 1989, she knew exactly what she was talking about. Throughout the late 1940s and 1950s she was active in and, in some venues,[5] one of the leaders of public debates concerning wartime artistic responsibility and the proper path for remaking the arts in postwar Japan. As discussed in the previous chapter, she also articulated a robust philosophy concerning the ethical practice of art and proposing art as an ethical practice. And, as this chapter will show, she continued to develop and apply these insights in the decade immediately following the war, during which time she publicly called out a number of artists and arts groups, demanding a critical, unstinting, and public review of wartime artistic production. Finally, Toshi also attended the International Military Tribunal for the Far East (the Tokyo War Crimes Trial, hereafter IMTFE) on at least two occasions, producing an illustrated column for the communist newspaper *Akahata* (The red flag) and a full-length article in *Jinmin* (The people), as well as a few other occasional pieces.[6] She witnessed firsthand the machinations of international justice, the fine parsing of guilt and implication, and the unfolding of the legal parameters for the term "war criminal" (*senmō hanzainin,* commonly abbreviated as *senpan*). Thus, when she called herself a war criminal in 1989, this was the result of a long process of critical self-reflection (*hansei*), a path that an entire generation of artists in Japan either trod intensively, avoided assiduously, or approached cautiously.

In this chapter, I lay out the stakes of this debate, using Toshi's art and writings again as a microhistorical lens, turned now onto an examination of artistic wartime responsibility and the long, in fact still continuing, process of Japan's struggle to come to terms with the histories and realities of aggressive wartime activity. I argue that the artistic wartime responsibility debates, carried out largely in the pages of newspapers and magazines, responded to occupation policies regarding the international prosecution of war crimes. At the same time, the debate was driven by a deep desire for the art world to come to terms with its role as informational and aesthetic middlemen in conveying the vision of a militaristic, imperial Japan to the broader Japanese public, their collaboration in making that vision palatable and even alluring, and their implication in its catastrophic failure. Where the IMTFE brought the military and political elite to the dock, the debates on artistic responsibility had the objective of rooting out fascist ideology and cleansing the arts world. Not coincidentally, it also brought the erstwhile leaders of that world to account, if not on trial at least in public fora.

An overemphasis on prewar/postwar dichotomies in historical writing has meant that Toshi (or at least the public persona embodied in academic

historical memorialization of her) has managed to escape important aspects of her past, appearing in scholarship only as a postwar artist and peace advocate.[7] Similarly, art historical approaches have asserted, at least until recently, that 1945 represents a point of absolute rupture. This view overlooks important artistic and aesthetic continuities across the war experience, as well as downplaying issues of continuing imperial desire. Rather than tracing transwar continuities in artists like Yoshihara Jirō, Katsura Yuki, Okamoto Tarō, or, indeed, Akamatsu Toshiko, anglophone scholarship has tended toward a polarization of wartime Japanese artists.[8] In this discourse, Fujita Tsuguharu (also known as Fujita Tsuguji or Léonard Foujita) is often decried as the most guilty of the collaborationist artists, and the Marukis (Maruki Iri and his wife Toshi) lauded as among the very few who did not make war art.[9] Similarly, while more varied, Japanese scholarship has also tended to valorize the Marukis, treating them primarily as peace activists. For instance, Kozawa Setsuko has argued that any condemnation leveled on "Maruki Toshi of the Nuclear Panels" (*'Genbaku no zu' no Maruki Toshi*) for her wartime children's books is "nothing more than a reaction against the mythologization" of those murals and their creators.[10] Kozawa further suggests that Toshi's culpability is negligible. And yet, as Kokatsu Reiko has pointed out, Toshi's wartime books, "printed in runs of over 10,000, and passed from family member to family member and viewed repeatedly, must have possessed a real power to penetrate the domestic sphere."[11] If, as Jeffrey Olick has claimed,[12] the carrying capacity of a given media is a key to the construction of collective memory, then Toshi's children's books were a force to be reckoned with throughout the war years. My purpose in this chapter is neither to assign, nor to defend against assignations of, artistic responsibility for war. Rather, I draw on deep archival research to examine the ways Toshi narrated her own evolving understanding of wartime complicity so that we, as people who continue to live in the long postwar period, can understand with greater sensitivity the textured and complex nature of war responsibility and its manifestations in Japan.

In addition, through narrating Toshi's struggles to come to terms with her past, I simultaneously explore the still-unfolding understandings of justice as meted out by the International Military Tribunal for the Far East (IMTFE) and as mitigated through Japanese media coverage of it in the late 1940s and early 1950s. I draw attention to the particular language that artists and art critics used to talk about artistic compliance with Japanese militarism. Pointing out the preferential use of terms like "whore" (*shōgi, shōfu*) and "puppet" (*karakuri*), I draw attention to a narrative, developed

early on from within artistic wartime responsibility discourse (*bijutsu ni miru sensō sekinin ron*), in which artists figured the guilty amongst themselves as the sensual servants of the military. I argue that this problematic gesture—at once sexualizing, feminizing, and financially capitalizing upon art and artists—posits the Japanese art world as one of the first fronts of military aggression. Thus, I suggest that, in something of a precursor to (and, perhaps, a pre-emptive co-optation of) late-twentieth-century international reparations movements (pace Lisa Yoneyama), Japanese artists anticipated some of the IMTFE's lasting problems with respect to its handling of crimes against humanity while also helping to lay the foundation for the still-pervasive "victim consciousness" (*higaisha ishiki*) stance that continues to dog efforts to reckon with Japanese aggression. Finally, I show that transwar continuity—the persistent engagement in artistic production across the war experience—is crucial to understanding the postwar period. Indeed, it was the practice of continuing to "paint the next picture" that eventually led Toshi first to come to terms with Japanese wartime aggression and eventually to confront her own culpability.[13]

Artistic Wartime Responsibility: Setting the Terms of Debate

The first shot in the battle over artistic wartime responsibility was fired scarcely two months after Japan's military surrender, appearing on page two of the *Asahi News* evening edition for October 14, 1945. Miyata Shigeo (1900–1971), a doctor who had spent two years at the Pasteur Institute in Paris and had studied oil painting under the venerable Umehara Ryūzaburō (1888–1986), writes

> I recently read in your newspaper that you wish to sponsor an art exhibit to welcome the occupation forces, and I am wholly in support of that endeavor. . . . However, surely I was not the only reader who was aghast when, upon reading the list of oil painters whose works would be represented, I found the names of Fujita Tsuguharu, Inokuma Gen'ichirō, and Tsuruta Gorō! Everyone knows they called the shots for the Army Art Association and were the first to jump on the wartime fascist bandwagon. Surely, they [the General Headquarters under MacArthur] will not go so far as to arraign artists as war criminals, but if there ever was a time to show one's conscience and to keep a low profile, this is it. . . . Their whorish actions have not just brought shame upon themselves; they have implicated all of us artists (*Sono shōfutekina kyōdō wa karera jishin no haji bakari de wa nai, bijutsukai zentai no men yogoshita*).[14]

Miyata continues, wondering what in the world the Art Critics Association could have been thinking when it chose the works to be represented, and he laments that this is no way to start the remaking of Japan, in which artists are, he hopes, to play such a big part.

Miyata's concern that occupation forces might scour the art world for potential war criminals was not unfounded. The month previous, on September 11, 1945, General MacArthur ordered the arrest of some forty people on suspicion of war crimes. Most were members of Tōjō's war cabinet, with Tōjō described in the *New York Times* as "prisoner No. 1" and Tōgō Shigenori, "Foreign Minister in Tojo's 'Pearl Harbor Cabinet,'" listed second.[15] Also caught up in the dragnet were Japanese military men, such as Homma Masaharu, who was connected to the "death march" of Americans in the Philippines, and foreign government officials, including a "Gestapo chief" and members of the Burmese "puppet" and Filipino "collaborationist" governments. Finally, three of the detainees were cultural figures, all foreigners and all radio personalities. In closing, the *New York Times* article predicted that "The first forty designations of war criminals are merely the precursors of thousands. The Japanese dupes who in the newspapers and on the radio have been playing the game of their former masters are already awakened."[16]

Indeed, the Potsdam Declaration, which had been signed earlier in September 1945 and which set out the terms for Japanese surrender, required that "There must be eliminated for all time the authority and influence of those who have deceived and misled the people of Japan into embarking on world conquest, for we insist that a new order of peace, security, and justice will be impossible until irresponsible militarism is driven from the world."[17] The declaration did not specify the exact spheres from which militarists would be purged, leaving the door open for arrests not only of military and political personnel, but also of cultural actors. The ambit of the IMTFE remained fuzzily defined, and worryingly so for artists and other cultural producers. General MacArthur's memorandum on the "Removal and Exclusion of Undesirable Personnel from Public Office" (SCAPIN-550), issued on January 4, 1946, included a call for the investigation of persons in the publishing business, with Section G ("Additional Militarists and Ultra-Nationalists") mandating the purge of "any person who has played an active and predominant governmental part in the Japanese program of aggression or who by speech, writing or action has shown himself to be an active exponent of militant nationalism and aggression."[18] Thus, Miyata's commonsensical advice to all in the arts world to keep a low

profile and to avoid drawing attention to the military sponsorship of artists, its commissioning of war art, and artists' participation in the army and navy propaganda divisions seems not at all far-fetched.

Miyata's letter set off a firestorm of responses. Tsuruta and Fujita shot back defensive and dismissive replies, published in the *Asahi News* on October 25. Tsuruta hedges, arguing pedantically that "not everyone who previously painted war art is necessarily a militarist" (*genrai sensōga o egaku mono wa kanarazushimo gunkokushugi to wa kagiranai*).[19] Fujita, for his part, defends his patriotism and declares that he will continue to express his love of country. "During the war," he writes, "I worked for my country out of a pure love of nation" (*sensōchū kokka e no junsuinaru aijō o motte shigoto o seishita*) and, now that the war is over, he suggests that he will reflect critically (*hansei*) on the reasons for Japan's loss and will take that same pure love for country and turn it toward the building of a peaceful Japan. "As artists, we will continue to act in good faith, turning our love of country toward the world and making of it one, combined love."[20] Fujita's response is a forceful and unrepentant twisting of emerging postwar internationalism, an act of semantic rope making almost, in which nationalism remains a major strand of the new world order.

The debate then moved from the newspaper to the pages of *Bijutsu*, the only arts magazine still in publication at war's end, where it continued to unfold for several months, taking on greater complexity. Essentially the entire November 1945 issue of *Bijutsu* was devoted to the question of artistic wartime responsibility and prospects for remaking the art world. Three articles, in particular, stand out for the ways they capture the key terms of the debate.

In the lead article, art critic Uemura Takachiyo (1911–1998) argued that artists and cultural workers are crucial to the reconstruction of a postwar Japanese culture that is dedicated to democracy, freedom, and international cooperation. Not all artists, however, support such a vision, as recent history has shown all too well: "War profiteers (*sensō seikin ya senji ritokusha*) are not to be found only amongst industrialists and politicians, but— we must not forget—among artists as well." And he worries that "war profiteering cultural producers" (*senji ritokushateki bunkajin*) will take up mouthing democracy in the postwar simply as a means to get back into power, controlling, among other things, access to exhibition space.[21] Uehara thus provides one key term in the debate over artistic wartime responsibility: profit. Who, which artists, benefited from military patronage, either by achieving power (over exhibition space), access (to art supplies), or financial support (for travel overseas to the battlefronts)?

In a second article, submitted for publication on September 2, the critic Okawa Takei (1906–1945) opens by stating that there are any number of reasons why Japan lost the war and any number of areas—political, financial, social, and cultural—in which repairs are pressing. But for those who work in the world of the arts, "it is our country's general 'cultural deficit' (*bunkateki suijun no sa*) that is most alarming."[22] He calls for a comprehensive disentangling of art from war. This can only be accomplished, he suggests, by a thorough investigation of wartime art (*sensōga*): where it is, when it was created, by whom, how, and under what circumstances. If the artists themselves think there is artistic merit in the works they made, then they should defend them on artistic grounds, he argues. Okawa introduces a second key term, focusing the debate firmly on a specific genre, the war documentary painting (*sensō sakusen kirokuga*). As Mayu Tsuruya has argued, the war documentary painting emerged as state-sponsored public art between 1937 and 1945. Generally rendered on a particularly large canvas (approximately seventy-two inches high by one hundred inches wide) and executed by "military service painters" (*jūgunka*), they were meant to "accurately portray military campaigns in realistic detail and yet be more than a mere photographic copy of the subject," combining "documentary quality" (*kirokusei*) with a strong artistic appeal to the emotions.[23] The government specifically recruited artists trained as Western-style oil painters (*yōga*) because of the emphasis that training placed on pictorial realism. Between 1937 and 1945 several hundred war documentary paintings were produced, with artists directly sponsored by the Army Art Association (Rikugun bijutsu kyōkai), the Navy Art Association (Kaigun bijutsu kyōkai), and other military propaganda units. While on tour to observe the war and complete sketch studies, artists enjoyed officer-level accommodations; back at home, they received preferential treatment in getting art supplies, enhanced access to exhibition space, and the benefits of publicity and high social status.

If Uemura has focused the discussion on the question of profit, and Okawa has limited it to the specific genre of war documentary paintings, the artist Ihara Uzaburō (1894–1976) adds two more key terms to the debate: legal doubt and individual reflection. An oil painter known in the 1920s and 1930s for his portraits and nudes, from 1932 onward he taught at the hawkish Tokyo Fine Arts Academy. In the late 1930s and early 1940s, he was recruited to create numerous war documentary paintings, traveling with the military to Burma, Thailand, and China. If Miyata's accusations went home,[24] Ihara could have found himself a prime target

for investigation by the IMTFE. Thus it was in his best interest to poke as many holes in Miyata's logic as possible. His list of objections is lengthy. We cannot, he points out, simply say categorically that everyone who made art with war themes is guilty of militarism and that only the people who never made war documentary paintings are the real artists: perhaps they painted the home front or made portraits of military personnel. Nor can we just go down the payrolls and see who was being directly sponsored or supported by the military and assign them blame, because that would leave a lot of people who went to the front of their own accord (not under orders) out of the reckoning. The pressures to sign up were real. The cash supplied to artists was minimal, certainly not any sort of profiteering. Furthermore, the Holy War Arts Exhibitions were immensely popular all around the country, so one cannot single out the artists without implicating the audiences as well. Thus, he concludes, any legal proceedings would become hopelessly mired in logistical and definitional issues. It is fine and good, he opines, if individual artists want to reflect on their own actions and consider their own deeds, but "for my part, I want to hurry up and just be done with this whole war art issue" (*sensō bijutsu mondai nado, hayaku suppari gēmu setto to ikitai mono de aru*).[25] After convincingly arguing the difficulties besetting a legal approach, Ihara offers a better (but for him equally unappealing) approach: critical self-examination.

Though over the next few years much more editorial ink was spilled over the question of artistic wartime responsibility,[26] the articles in the late October 1945 *Asahi News* and the responses in the November 1945 issue of *Bijutsu* had established the contours of the discussion. Shaped specifically in the context of preparations for the IMTFE, the question of "responsibility" (*sekinin*) shrank to the more juridical question of "war crime" (*hanzai*). Simultaneously, a broad review of wart art (*sensōga* in its more capacious sense) receded into a tight focus on the singular genre of war documentary painting (*sensō sakusen kirokuga*). Artists could undertake a path of critical self-reflection (*hansei*) if they so wished, but the question of artistic war crimes would center on issues of agency: choice or coercion? Did artists "whore" themselves out (*shōgi, shōfu*) to the military, gratifying military men with war art in return for the favors of canvas and the caresses of paint? Or were artists mere "puppets" (*karakuri*) of the military, dancing to a tune not of their own choosing, justifying an unsavory and unsought "job" (*shigoto*) by adverting to love of country?

Purging the Art World: Nihon Bijutsukai and the Court of Public Opinion

Though ultimately no artists were called to trial in the IMTFE, the court of public opinion burned white hot. In April 1946, Toshi and her husband Iri attended the foundational meeting of the Nihon Bijutsukai (Japan Art Association), the goal of which was to promote democratic art.[27] The group's organizational documents state that "we are not trying to publicly denounce specific people, to initiate a purging or any other proceedings for punishment, or to designate criminals but, rather, from the top down to cleanse the art world, to clear away from our artistic works and from our thoughts any sort of polluted ideology such as militaristic fascism" (*sekinin-sha no shimei o happyō shitari, kōshoku tsuihō nado no shobatsu shudan o motome hanzainin o tsukuru no ga mokuteki dewanaku, bijutsukai kara gunkokushugi fashizumu nado ni odaku sareta shisō o sakuhin ya riron no ue kara fuitesaru ni aru*). They propose to accomplish this through a process of "critical self-reflection" (*jikō hihan*).[28]

Statements of intention aside, the association did in fact create a blacklist of artists, which, though apparently never published, circulated actively through rumor and gossip and may have actually been presented to MacArthur's headquarters in anticipation of the IMTFE, which convened later that month.[29] The Japan Art Association named fourteen artists (including Fujita Tsuguharu, Yokoyama Taikan, Hasegawa Haruko, Tsuruta Gorō, and Kawabata Ryūshi) as potential war criminals and suggested that all members of certain organizations (the Army Art Association, Navy Art Association, Women's Patriotic Association, and so forth) should at the very least subject themselves to severe self-examination.[30]

Much of Toshi's writing from 1946 and 1947 bears the conceptual stamp of the Japan Art Association's foundational vision,[31] which she no doubt helped to shape and which she refined in her own essays. In May 1946 she articulated a comprehensive plan for the rebuilding of the Japanese arts. As mentioned in the previous chapter, she opened the article with a section titled "The Crime of Ignorance" (Muchi no sai'aku): "We were ignorant. Philosophically and politically ignorant. Each and every one of us artists has no choice but to subject ourselves to an unremitting self-criticism and to set out on a fresh course." She then immediately zeroes in on some of the key terms in the artistic wartime responsibility debate, evoking the tropes of both the whore and the puppet. Writing for a largely female audience—the essay was published in *Shinfujin* (The new housewife)—she argues, "At times this childish nature of ours has been loved by, has

delighted, has been abused by (*moteasobareru*) those with whom we have worked. At times, we have become the playthings of the wealthy. At times, we have danced like puppets on a string for the military." Figuring female artists as immature children and—disturbingly—at the same time as the sexual playthings of men, Toshi suggests that agency is a complex and layered experience. Nevertheless, she calls out for criticism those female artists who "cut their hair, donned khaki" and "danced" for the military in northern China; in other words, the military service painters (*jūgun gaka*) who created war documentary art: "young, innocent (*mujaki*) female artists-in-training who were ordered, 'Today General So-and-so is going to make an appearance. Make sure to get every detail of [the scene] right.'" You may have danced to their tunes out of ignorance, she argues, but it is high time to consider these "twenty some years of life in hell" and to "reflect on your sins thoroughly and completely" (*tsumi no jikaku to tettei seru hansei o*). Toshi adds a particularly socialist spin to her formulation, arguing that as "seekers of truth" (*kyūdōsha,* a Maoist term popularized in Japan in the late 1940s), artists need to "heal our bodies, purify our hearts" and recommit ourselves as artists in this time and place.[32]

She then provides a five-step plan for how to accomplish this crucial political and artistic recommitment. After performing a thorough self-criticism, the next step is to "make public confession" (*taishu no mae ni oite shazai sarubeki*), calling one's actions what they are: "war crimes" (*senpan*). The second step, then, is to look critically at Japanese art history. Japan's national treasures, she argues, are items of imperial culture, kept away from the eyes of the public except on special exhibition days. As such, they were national treasures in name only, not being of, by, or for the people, who were meant to stupidly revere them as numinous items. Having recognized how deeply entangled the artistic tradition is with emperor worship, the third step is to liberate and cultivate the young artists of Japan in the urgency of the here and now: "We must cast off those old robes—those heavy constraints and outmoded ideologies—and move forward, standing tall and proud, and savoring our full bodies, our full selves, really enjoying for the first time the newness and freshness of our own naked flesh." With the momentum gained, steps four and five will flow more easily. Toshi predicts that we will begin to see "art produced by laborers and farmers" (*rōdōsha, nōmin bijutsuka no shutsugen*): step four. And, in the fifth and final stage, cultural producers in Japan will build a "solid body of culture," (*rittaitekina bunka*) which, like Soviet and American culture, will be "dynamic" and forward-looking.[33] In short, Toshi imagines a sort of paradigm in which

critical self-reflection, public confession, and a purging of fascist and impe-rialist ideology will result in a bright future of socialist artistry.[34]

As other articles from the time show, Toshi formulated these thoughts in direct response to the IMTFE proceedings. In an October 1946 round-table, the transcript of which was published in the March 1947 issue of *Jiyu bijutsu* (Free art), she opines,

> If I had done war documentary paintings (*sensōga*) during the war, I feel like I'd have to be deeply ashamed of the depths of my artistic igno-rance (*gaka no fumei no itasu tokoro toshite fukaku hajinebanaranu*). And for those who continued to produce that sort of art, they'd have to really examine critically (*fukaku hansei shi*) their mistakes and I think they should make a public statement about it. We don't know if the Tokyo War Crimes Tribunals will go so far as to examine artists as war criminals (*senpansha*), and so it might not be absolutely necessary to do it, but I think artists really should reflect critically on [their actions] and say something publicly.

She goes on to argue that if artists are not willing to do that, then there is the danger we will end up in a situation where people say "'Well, everyone did something that wasn't right, and they're not war criminals' and where is that logic going to stop? We'll end up deciding that even Tōjō should go scot free!"[35]

Nor was Toshi content to merely suggest that others undergo critical self-reflection. On at least two occasions, she used her journalistic brush to publicly call out those who would not call out themselves. In October 1946 Toshi had intended to attend the first postwar exhibit of the Nikakai, the arts group where she had gained her first affiliation just after her graduation from art college, but she was hospitalized (suffering from radiation sick-ness, as it turned out). Nevertheless, she writes, she feels able to offer a cri-tique of the show "without ever having seen it," as the title of her review suggests (*Minakutomo hihyō dekiru wake*). Repeating, almost verbatim at times, the Japan Art Association's blacklist language, she critiques "people who borrow the name of democratization despite the fact that they are still nurturing, deep in their hearts, an unrepentant respect for the [past] gov-ernment" (*minshuka no na o karate imadani nukekirenu sanson no kimochi o mune ni hisomete no kōdō na no desu*). She particularly calls out those who "are attempting to conceal how they danced to the tunes of militarism and fascism" (*kakō no gunbatsu to musubitsuki fashizumu no senjō ni odotta*

sugata o, kakusō to shiteiru hito) during the past two decades by turning to a surface attestation of democratized art. She closes with hopes that what she has written encourages all those whom she has indicated to engage in "deep self-reflection" (*fukai hansei*).[36]

The next month, in a review of an Issuikai exhibit that Toshi *had* been able to attend, she was even more precise, naming names. Her review of Yasui Sōtarō is blistering. Yasui (1888–1955) had studied oil painting under Asai Chū at the Shōgoin Yōga Kenkyūjo and the Kansai Bijutsuin before spending time in Paris. His 1930 *Portrait of a Woman* (*Fujinzō*) won widespread acclaim and admittance to the Imperial Fine Arts Academy in 1935. From 1944 onward, he was a professor at the hawkish Tokyo Academy of the Arts, and it is largely his students' paintings that were on display at the Thirty-First Nikakai Exhibit Toshi had reviewed earlier.[37] In her review of the Issuikai show, she calls out Yasui for "just playing around in his atelier" and "not trying to show anything of the world beyond its walls." In this way, she says, one finds oneself keeping quiet and going along with fascist trends of healthy, beautiful, statuesque bodies. "Must be nice to pretend to know nothing" (*Nani mo shiranai to iu koto wa, nan to iu shiawasena koto deshō*). Toshi continues, arguing that for people like herself "who believe in the value of deformation" and in looking long and hard, this know-nothingism is difficult to swallow. But if ignorance is bliss, Yasui "must be a happy man." She continues her rant in damning terms: "Because they chose to not know, how many thousands and tens of thousands of young men died in the war, shouting, 'Long live the Emperor!' And because he doesn't want to know anything even now, after the war is over, he just wears his soft brown hat and drinks up his warm milk. Well, I suppose no one has died shouting, 'Yasui Sensei, *banzai!*' so his sins are relatively minor" (*Yasui sensei ni banzai! o sakende shinda hito wa arimasen kara, tsumi wa karui wake de arimasu*).[38]

Clearly Toshi is working out her own thoughts concerning not just artistic wartime responsibility, but the postwar continuation of fascist trends. Pretending to know nothing is, she deems, a sin (*tsumi*). Just forging ahead and ignoring the world that lies beyond the walls of your studio is wrong, because before you know it, you are painting statuesque portraits of women and modeling a generalized fascist aesthetics. What's worse, now that the war is over and one might actually speak one's mind, might deem that it is now safe to know, she argues, we see people continuing to churn out another generation of artists who are just as committed to knowing nothing. She is referring to artists like Kōno Misao, whose *White Dream*

(*Shiroi yume*) she finds displays not so much a frank eroticism, which would be praiseworthy, but female sexual subservience, the economic realities of a woman being paid to play the coquette. Rather than problematize any of this, Toshi remarks, the painting revels in it, and "the longer I look at it, the more turned off I get."[39] She closes by saying that on the whole, she was "absolutely shocked at the exhibit's lack of social engagement" (*hishakaisei to iu mono wa odoroku bakkari desu*).[40] Nevertheless, she finds promise in some of the artists, and she hopes they will actually come out of their studios at some point and take a good, hard look at the world. The stronger artists in the group may yet be able to do that; the weaker ones, she fears, are destined to fade into obscurity.

For her part, Toshi seems to have had no sense (yet) of her own culpability, her own role in creating artwork that served militaristic and nationalist ends. She did publicly acknowledge one regret in an article from April 1947. While living in Russia, Toshi had done an oil portrait of a Russian domestic worker. Before Toshi returned to Japan, the woman had come to ask for it, but Toshi refused to give it to her; she wanted to exhibit it back in Tokyo and make a name for herself. Six years later, while giving her studio a spring cleaning, she finds the painting in a pile of others and thinks, "Her rich face, that honest gaze. Why in the world hadn't I given the painting to Ryūba? I am appalled at my own selfishness. Of all the things that I regret over the course of my career, this is certainly one" (*Kore wa watashi no, shōgaichū no zannenna jiken no hitotsu dearu*).[41]

What those other regrets may be, she declines to say. In fact, a November 1947 column suggests the presence of some willfully blank pages in Toshi's book of memory. For the column, the editors of *Hiroba* (Public square) sent out a postcard with two questions—"1. What were you doing five years ago? 2. What are you doing now, five years later?"—to various public figures, who mailed in their replies. Toshi's response reads as follows:

1. I was making art in my three-mat atelier. I couldn't get painting supplies, so I was doing sketches.
2. I'm still making art in my atelier, no surprise! But the world around that atelier has really changed. We've got a people's government (*jinmin seifu*), steam is billowing out from the factory smokestacks, workers are singing joyfully. So the art I make isn't dark and sad any longer. Instead, I'm working on healthy, vigorous pieces, one after the next.[42]

The first question asks what Toshi was doing in October and November 1942. Her answer is crisp but incomplete. Not surprisingly, research shows a more complex story than what she has shared. In late September or early October, she would have been busy taking down the pieces she had exhibited at the annual Nikka show at the Tokyo Metropolitan, which had been on display for nearly a month. Toshi had exhibited one piece, no longer extant, titled *Nobiyuku Nihon* (Japan rises), which evoked imperial Rising Sun imagery.[43] On October 1, she published a full-color, two-page spread in the children's periodical *Yoi otomotachi* (Good friends) showing Malaysian children and Japanese soldiers eating papaya together.[44] On the 6th through 8th of October, she exhibited sketches of her impressions of Moscow and, again, the oil painting titled "Japan Rises" (*Nobiyuku Nihon*) at the Ginza Kikuya Gallery in a joint exhibition with other graduates of her college. On October 25, she published the brilliantly colorful children's book *Yashi no ki no shita* (Under the palms), which, in line with Co-Prosperity Sphere doctrine, depicts the Japanese takeover of British Malaya (as well as other locales like Hong Kong and Hawai'i) as liberation from Western imperialism. And on November 20, she published a second full-color children's book *Yashi no mi no tabi* (Journey of a coconut), analyzed at length in chapter 2. As noted at the start of this chapter, during the interview with Usami nearly fifty years later, it would be *Journey of a Coconut* that, in Toshi's mature view, rendered her a war criminal.

So Toshi was making art—not only sketches, but also oil paintings and richly colorful children's book illustrations—in the fall of 1942. And, at least on the surface, that art does not appear "dark" or "sad," though perhaps the act of creating it may have felt that way. Possibly a fortuitous slip of the memory, this incomplete account, this blind spot, arose at least in part from the ways the IMTFE's narrative of the war, and critics' early responses to it, foreclosed upon a more expansive evaluation of art's role in promoting militarism. And so it is to Toshi's remarkable experience as an observer at the IMTFE that we now turn, because although Toshi articulated her own beliefs concerning wartime responsibility (examined above), she was also an active consumer and engaged observer of the more constricted view of responsibility defined by the international military court.

Under the Flags of Civilization: Observing the IMTFE

The IMTFE was open to the public. Passes to the trials could be picked up at any of three locations in Tokyo and at two more in Yokohama. One could also request passes by writing to the Control Office, giving the date,

indicating a preference for morning or afternoon session admission, and noting the number of passes desired.[45] There are any number of ways Toshi may have acquired her spectator passes. She may have learned of their availability through her former employer Nishi Haruhiko, for whom she had worked as a nanny in Moscow from January to June of 1941. Toshi had remained close to the family: Nishi and his wife served as the witnesses for Toshi and Iri when they married on July 22, 1941, and Toshi had stayed in regular contact with one of Nishi's daughters, who was also a painter. In the spring of 1946, Nishi was serving as defense counsel to Tōgō Shigenori, his former boss, who was being tried for war crimes and who would go on to die in Sugamo Prison. Alternately, Toshi may have acquired the passes through the offices of the communist newspaper *Akahata,* for whom she was a correspondent and where she published her first column on the IM-TFE. Or she may have gone in person to one of the pickup locales, such as the Officers Red Cross Club in Tokyo, and waited in line with everyone else.[46] However they received their tickets, holders of the small pinkish slips that served as spectators' passes were entitled to entrance for one half-day's proceedings and were seated according to nationality. Judging from the contents of her published columns, Toshi attended the IMTFE on at least two occasions, first on July 29, 1946, and then again in mid-August.

Toshi's descriptions of entering the courtroom read like a science fiction account of a port call on another planet. In an illustrated vignette, titled "Under the Flags of Civilization" (*Bunmei no hata no shita ni*), penned for *Akahata,* she wrote,

> As soon as I entered the courtroom the first thing I felt was the freezing cold of the air conditioning. Because there were no fans running, the harsh overhead lights shone down directly on us. The news cameras rolled along smoothly. In the witness stand stood Professor Bates from Nanking University, narrating the shameless horrors of the marauding Japanese army (29th, at the Ichigaya International Military Tribunal for the Far East).[47]

Toshi's sketch of the scene shows the bank of judges seated below the flags of the eleven prosecuting nations, a group of seated lawyers, and a military police officer standing, watchful, on the floor below them (fig. 5.1). A second sketch, situated just below the first, shows the dock of defendants. Both sketches are crowded, thick not only with bodies but with the signs of technological prowess and mediation: a movie camera rolls in

the upper left-hand corner, a communications receiver flashes at top right, microphones on tripods stand witness by both lawyers and defendants, their pointed angles echoing the rigid stance of the MPs and the triangular peaks of the flags, and nearly everyone seems to huddle in concentration, huge earphones clamped to the sides of their heads. At first glance, there is little that seems natural or human about this situation; it is justice served cold, indeed.

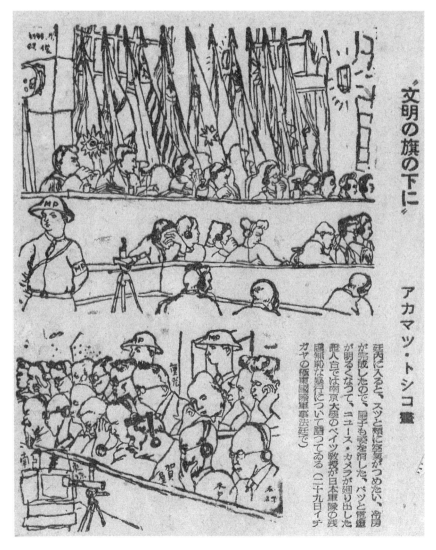

Fig. 5.1 Akamatsu Toshiko, author and illustrator. "Bunmei no hata no shita ni." *Akahata* (Aug. 3, 1946).

Toshi played up these sensations of technological and civilizational displacement in her much lengthier write-up for *Jinmin* (The people). For that venue, she began her article at the train station, where she is trying to purchase a ticket. The clerk at the ticket window keeps trying to send her to Sugamo, and she has to explain that Sugamo is the detention facility, whereas she is trying to get to the trial itself. After finally receiving a ticket to the correct destination, she heads to the platform, thinking, "This [tribunal] is such a critically important event, and everyone's talking about it, but when it comes right down to it, no one seems to know where it's actually taking place. Unbelievable!"[48] Arriving at Ichigaya station, she asks the station master for directions. He tells her to follow the jeeps to a giant gray building. Toshi recalls that the building is dark gray because during the final days of war, its exterior had been splashed with black ink so it would be less of a target in the endless air strikes. The ink, she notes, has yet to wear off. She climbs the hill to a giant sign that reads Halt! (*Tomare!*), where she produces her pink pass. And, with a pleasant "OK" from the guard on duty, she is through. Thus the introductory paragraphs of Toshi's lengthy article provide readers with a how-to guide for attending the trials.

These framing remarks also pick up on Toshi's thoughts, examined at length in chapter 4, about the importance of not erasing. In describing sketch-work as an ethical practice, she argues that one should never erase one's mistakes, because "what's behind that way of dealing with it isn't about facing up to your mistakes and critiquing them. It's more of a gesture of embarrassment, of wanting to cover them up." The mistake, she argues, is "not going anywhere. . . . Even if you rub it out, you can't fool yourself into thinking that, just because you can't see it, it's not there."[49] Similarly, the dark ink stains marking the Ichigaya court building—formerly the headquarters of the Japanese Imperial Army—provide a stark visual reminder, a lasting ocular clue to the many casualties and violent incursions of the recently concluded war.

If the outside of the building is a reminder of Japanese "mistakes" that cannot be rubbed out, the interior of the building represents, for Toshi, a nearly fantastical realm, awesome in its power and innervating in its foreignness. As soon as she passes through the gates, she becomes uncomfortably self-conscious about her own appearance. A group of US soldiers walks by, legs ramrod straight, and she finds herself standing up a little straighter and wishing she had worn nicer clothes. She enters the building (fig. 5.2):

It was just like entering the Dragon King's Palace. The door swung open and the moment I stepped inside I was struck by a cold silence.

There they sat, some six hundred people, each one a little bit different. I stood there, not knowing what to do.

There they were, all lined up, the flags of those civilized countries (*bunmei no kuni*), the eleven Allied nations, shining red and glittering gold. I got the sense that I shouldn't just stand there, so I found an empty seat in the Japanese observers' area and sat down. . . . [At first, it had seemed like everything was] utterly silent, but as I settled in, I began to hear, from somewhere behind me, the clear voice of the translators, and of the questioners, and of those being questioned. There were voices, but no one seemed to be speaking. . . .

Who is it that's talking? In this perfectly cool, crisp atmosphere, a man was making sweeping gestures. And there was a flashing red light on the desk in front of him. Aha! He's translating right now. And then, blink blink, the red light flashed on the desk in front of those men, lined up before the eleven flags. I heard this thick, heavy, somewhat sensual voice: the Chief Justice. And then the light flashing again.[50]

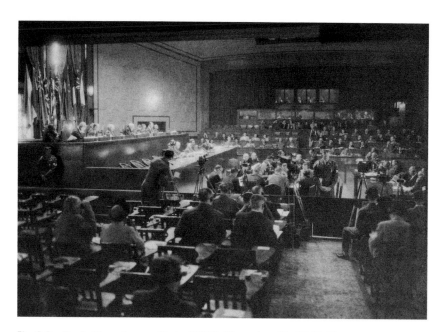

Fig. 5.2 Kyodo News Agency Photo K1376. November 12, 1948. Photographer: Nagashima Kunihiko. Held by the Gordon W. Prange Collection, University of Maryland Libraries. The handwritten memo submitted by the Kyodo News Agency in conjunction with this photograph reads in part: "November 12. 10:30 a.m. Awaiting with bated breath the reading of today's judgment at the International Military Tribunal." Note here, too, the bright lights, headsets, and camera tripods.

She listens closely to Joseph Keenan (United States assistant attorney general and chief of counsel for the prosecution) speak, in English, and though she is not able to follow what he says, her impression is of listening to a well-performed recitation (*rōdoku*), of the sort one might hear at the imperial court or at a religious ceremony.

Taking a cue from everyone else, finally she raises a set of earphones to her head and holds them tight. Suddenly the distant voice is booming in her mind. Then the words start to come through in translation. As they do,

> that old man in the docks swallowed. Even this—the subvocalizations of the witness for the defense—would not fail to be heard. And there were no distracting background noises either. Just that crisp quiet, the red light from the receivers blinking on and off, the voices of those testifying. There were two glassed-in boxes, inside of which two women, each with glistening blonde hair, took memos. The ceiling was lined with lamps that lit up the room, each and every corner of it, like a goldfish bowl illuminated by a searchlight. The lights beat down, showing every wrinkle and crease. And there was a slithering, liquid sort of machine rhythm, of the film moving through the high-grade camera. The defendants blinked rapidly under the onslaught of bright lights[51]

Toshi feels that she has entered another realm, one that is powerful, foreboding, and strange.

The Dragon King's Palace, according to Buddhist-inspired legend, is a land under the sea, a place where the teachings of the Buddha are perfectly preserved in a library of total insight, which the visionary few may visit in order to restore textual detail and corrective knowledge to the human world. The Dragon King himself, as depicted in the classical Japanese masterpiece *The Tale of Genji,* can be a sensual figure, appearing on stormy seas with veiled messages about political power.[52] Toshi thus sets up an extended metaphorical conceit whereby she (and, through her, her readers) visit a realm of technological, civilizational, and moral superiority, suggesting that both Western dominance, as well as a desire to "cast off" fascism, dominate her artistic priorities. The IMTFE courtroom: A place that is cool and crisp, strange and unfamiliar, hidden in plain sight at the margins of her normal world. A place where customs and languages are unfamiliar, where Toshi feels small, insignificant, and out of place. A place where major decisions are made that will have impact on the everyday world beyond its

walls, though that world seems vanishingly far away and nearly impossible to reach when one is not there.

In this new place, this proximate realm of technological power and the machinery of justice, Toshi finds that she cannot even recognize that which she had thought was so familiar. Her wartime world is rendered strange, and she remarks upon the cognitive dissonance caused by seeing well-known figures in this new light.

> And where was the defendant, Tōjō? Was he that one there at the very end? The buzz cut-in-chief, right there in pince-nez glasses and khaki uniform—was that him? Or maybe he was the one two seats further down the row? But they all looked like they could be Tōjō.
>
> In high spirits even as tacking into the wind. Self-confident even though riddled with error, filled with an age of boast and swagger. Every one of their faces was infused with it.
>
> A bottomless arrogance. And now, was there the faintest sign of some sort of human realization (*ningentekina jikaku*), in these moments before their vanity would be pulled away? Those faces: no individuality in them. Like all those war orphans I had seen around Kyoto Station and Ueno Station. All starved just alike, deprived of basic nutrition so long that their skull bones and cheekbones stuck out, their noses shrunken, their faces too small, so disfigured I could not tell them apart, either.[53]

At the Dragon King's Court that is the IMTFE, Toshi finds that Tōjō and his cohort are not "gods of war," as the popular wartime accolades had it, but, rather, less than human. "Those arrogant war criminals; before they even realize what they've done, they've already forgotten their errors (*ayamachi*). They're nothing more than a flap of skin pulled tight across a skull." Thus, despite all their crimes, despite all their hate-filled actions, she feels an overwhelming pity (*aware*) for them, because "they have lost their humanity, having shed it somewhere along the way" (*ningensei o okiwasureta, ningensei o datsuraku shita*).[54]

What Sketching Does: Deformation as Search for Individual Humanity

It is at this moment—caught between the twinned emotions of awe at the technological prowess of the IMTFE prosecution and the disorientation of not being able to discern the individual Japanese defendants—that Toshi

takes out her pencil and starts to sketch. Why? Other than that she is an artist who is accustomed to drawing what she sees, what work does she understand her engagement with pencil and paper to be doing? I would argue that Toshi conceives of sketching as a counter to fascist realism, a concerted deconstruction of the imperative to verisimilitude (*kirokusei*) as practiced in the war documentary painting, with its demands to leverage realistic detail toward an emotional nationalistic appeal. Instead, she understands the genre of caricature (*fūshiga*) and the aesthetic mode of deformation (*deforume*) as liberatory techniques, tied specifically to the political form of democracy. She was not alone in this stance. An editor's note, appended to one of her 1946 publications, draws attention to the importance of caricature and political satire in the "formation of a newly democratic society" and lauds Toshi for the role she is playing in its creation.[55]

As Toshi conceives of it, the technique of sketching works on two fronts at once. On the one hand, close sketchwork reveals the subject's individual, interior emotional world (rather than, as in war documentary painting, using the paintbrush to coat realism with the oily overlay of nationalist sentiment). In a specific discussion of her IMTFE drawings as caricatures, Toshi writes,

> At the port, in the field, in palace chambers, above the clouds, in the weed-grown lots of the burnt-out city ruins, in thickets of bamboo. Person; artist; the faculty for raw, naked sensation (*Ningen, gaka, sup-padaka no namanamashii kankaku no mochinushi.*) In the eyes of a skilled artist, it's all color, a collection of subject matter.
>
> At the Tokyo War Crimes Tribunal, in an air-conditioned room surrounded by the high heat of summer, the red flash of receivers rebels, disturbing the tranquility of a civilized court of law. The defendant Tōjō sits there immobile, as if already a corpse. He is no match for the orderliness of the proceedings and the atmosphere of democracy with its flashes of quick wit and even humor. There is simply no way in which a Japanese character of that sort—dripping with barbarity yet shot through with a sense of stinginess—can stand up to it; indeed, that former sense of self seems to have been utterly driven away, forgotten. . . .
>
> Then suddenly he wipes sweat from his face. Sweat, in this cold room.[56]

Here Toshi positions the naked regard of her sketch practice as performing much the same work as the civilized protocols of the court of law. The

exaggerations of her lines, perhaps amusing in their deformation, mirror the jocular wit of the courtroom (a humor which was, unfortunately, deleted from the censored version of the article).[57] Just as a court of law has the power to arraign any person as defendant, the sketch artist, through her "faculty for raw, naked sensation," has the prerogative to summon anyone as sitting subject: emperor, farm hand, US soldier, dock worker, orphan in a burnt-out ruin. Training her artistic gaze on Tōjō, she removes him from his wartime position of nearly sacred inviolability, drawing the lines, curves, shadows, and plains of his face just as anyone else's (fig. 5.3). Her sketchwork, functioning now in tandem with the juridical process of questioning the witness, brings forward one fact—one line—into the light at a time, carefully building up a portrait of a man. A man who, ultimately, is no match for this process of civilized, but cold and unsparing, scrutiny. A man who, though he seems impassive, reveals himself to be sweating, even in this freezing cold room (fig. 5.4).

On the other hand, sketching also provokes a concurrent pain in the viewer/seer (whether that is the artist herself, as she works, or one who regards the artist's completed work), attesting to one's "battle with reality" (*genjitsu o ha'aku shi*), as Toshi put it elsewhere.[58] One of her major artistic influences at this point in her career was the Prussian (later German) printmaker Käthe Kollwitz (1867–1945), who was threatened with deportation to a Nazi concentration camp for her antiwar and antifascist woodcuts. In an assessment of Kollwitz' "satire" (*fūshisei*), published in 1947, Toshi argues, "Reality hurts. Because, faced with reality, lies just fall apart. (*Shinjitsu no mae de wa, gomakashi no oshaberi wa naritatanai.*) There's some art that, the more excuses you make, the more it makes you hurt, until finally you cry out in pain. Käthe's art is like that." Toshi goes on to praise Kollwitz' art for the way it "strikes you in the chest, with a giant thud."[59] Sketchwork, then, is a powerful diagnostic, an observational tool, a technique for understanding others and penetrating to the core of the matter.

If, as Toshi suggests elsewhere, the scariest thing in the world is an absolutely straight line,[60] then, by extension, the scariest human visage is a face that has no humanity, a face that is nothing but a mask of arrogance, a face that could belong to anybody and nobody. And that is why it is so disconcerting for her not to be able to recognize Tōjō. Because it means that she cannot see him as a human being, because it means that for her Tōjō and Itagaki and Hoshino and Kido and Kimura are all interchangeable.[61] Until she starts to sketch them. Then she can begin to see their individuality: Tōjō's veins, the way "his skin [is] stretched tight over his jaw and

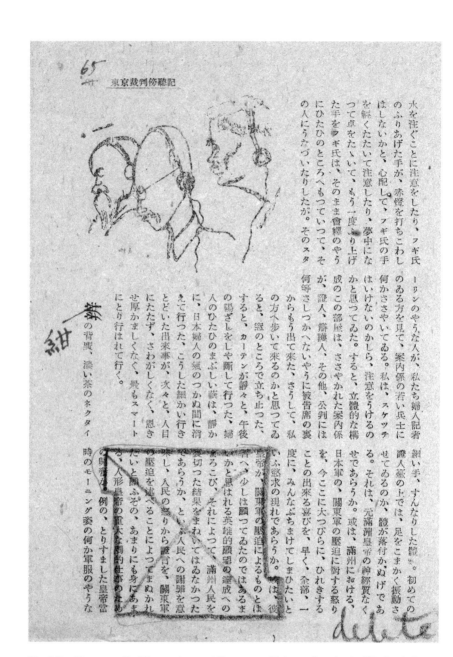

火を注ぐことに注意をしたり、フギ氏のふりあげた手が、赤燈を打ちこわしはしないかと、心配して、フギ氏の手を輕くたゝいて注意したり、夢中になつて卓をたゝいて、もう一度ふり上げた手をフギ氏は、そのまま會釋のやうにひたひのところへもつていつて。その人にうなづいたりしたが。そのスタ

細い手、すんなりした體。初めての證人臺の上では、足をこまかく振動させてゐるのか、體が落付かぬげである。それは、元滿洲皇帝の神經質なくせでゞあらうか。或は、滿州における日本軍の、關東軍の壓迫に對する怒りを、今ここに大つびらに、ひれきすることの出來る喜びを、早く、全部、一度に、みんなぶちまけてしまひたいといふ慾求の現れであらうか。は、彼

一リンのやうな人が、私たち婦人記者のある方を見て、案内係の若い兵士にはいけないのかしら、注意をうけるる。私は、スケツチせてゐるのか、體が落付かぬげであかと思つてゐた。すると、立體的な椅成のこの部屋は、ささやかれた案内係にひたひのところへもつていつて。そが、證人、辯護人、その他、公判には

何等さしつかへないやうに被告席の裏の方へもう一出て來た、さうして、私の方へ歩いて來るのかと思つてゐると、窓のところで立ち止つた、すると、カーテンが靜々と、午後の陽ざしをしや斷して行つた、婦人のひたひのまぶしい蔭は、靜かに、日本婦人の氣のつかぬ間に消えて行つた、こうした細かい行きとどいた出來事が、次々と、人目にたゝず、さわがしくなく、思きせ厚かましくなく、最もスマートにとり行はれて行く。

皇帝か、關東軍の壓迫によるものとはかと思はれる。少しは願つてゐたのではあるまあるこび、それは願はれる英雄的願望の達成へのそれによつて、滿州人民をあらうか、といふ人民への謝罪を意味し、人民の怒りから證言を、關東軍の壓迫を逃べることによつてまぬかれ人形皇帝の重大な劇的仕事のため例の、とりすました皇帝當時のモーニング姿の背廣、濃い茶のネクタイ

Fig. 5.3 Akamatsu Toshiko, author and illustrator. "Tokyo saiban bōchōki." *Jinmin* 8 (Dec. 15, 1946). Held by the Gordon W. Prange Collection, University of Maryland Libraries.

Fig. 5.4 Sun News Agency Photo S1032. November 10, 1948. Held by the Gordon W. Prange Collection, University of Maryland Libraries. Handwritten memos attached to the photograph indicate that it was taken on the afternoon of November 10, 1948, during which Tōjō listened to the court's judgment on culpability for actions in the Pacific theater.

cheekbones"; how Minami's mustache seems to droop when he listens closely; how Kaya "still looks like he's got a bit of fight left in him"; how Hoshino "cannot seem to sit still," every now and again taking off his glasses and "peering up at us with those incredibly near-sighted eyes of his. At one point he looks angrily up at the observers' box, perhaps having spotted me up there sketching, and rubs his chin in an irritated manner";[62] how Itagaki "runs his eyes across the public seating area, perhaps checking if someone from his family has come."[63]

Narratives of War

As Lisa Yoneyama has astutely pointed out, "Settling accounts of wars involves more than calculating the losses and damages brought on by the defeated regime's aggression. Reckoning with the costs of hostility, postwar settlements also performatively define the war's meaning for the postbelligerence world. They offer answers to questions about the war's origin; how it was fought; by, with, and against whom; according to what periodization; for what purposes, and ultimately for whose and what justice."[64] Thus the oral deliberations of the IMTFE, and the journal articles and newspaper columns of the artistic wartime responsibility debates, can be read as attempts to think about how the war was fought (on militaristic, industrial, political, spiritual, and cultural levels) and by whom. Are artists then soldiers? Or the puppets and playthings of soldiers?

Rather than enforcing a periodization, however, the IMTFE organized itself geographically, by front. The prosecution opened its case in May 1946. For the first three weeks of July, proceedings focused on Japanese aggression in Manchuria/Manchukuo. From July 22 through September 19, the prosecution shifted to actions on the Chinese continent. Then for ten days eyes turned to Europe with the Tripartite Pact. From September 30 to October 7, testimony pertained to French Indochina and then, from the 8th to the 20th of October, to Japan's actions vis-à-vis Russia. From October 21 to December 2, deliberations focused on the war in the Pacific. Examinations then turned to actions against Dutch holdings in Southeast Asia on December 3 through 9. The prosecution dealt last with Class B criminals before finally resting its case on January 24, 1947.

One of the major issues at stake in the IMTFE's geographical schematization of the Japanese war of aggression, and in the "artistic wartime responsibility" debates taking place simultaneously, was the positing of a cultural home front, a narrative according to which a war on culture and a war on art had *preceded* the wars in China and the Pacific. This is the narrative favored by the IMTFE in the opening statements:

> In the hearings hereinafter referred to in this indictment the internal and foreign policies of Japan were dominated and directed by a criminal militaristic clique, and such policies were the cause of serious world troubles, aggressive wars, and great damage to the interest of peace-loving people, as well as the interests of the Japanese people themselves. The mind of the Japanese people was systematically poisoned with harmful ideas of the alleged racial superiority of Japan over the other peoples of Asia and even of the whole world.[65]

The indictment goes on to state that the accused men sought to "psychologically prepare Japanese public opinion for aggressive warfare . . . teaching nationalistic policies of expansion, disseminating war propaganda, and exercising strict control over the press and radio."[66] Thus the people on trial represent a thuggish, militaristic gang that took as its first victims artists, publishers, academics, and other cultural producers who could be made to participate in the mental poisoning of the general population.

After her first day in court, Toshi could have no doubt that the Japanese military had committed numerous counts of war crimes and crimes against humanity: by day's end, she had sat through several hours of Miner

Searle Bates' testimony. A professor at Nanking University, Bates provided eyewitness testimony to what would become known as the Rape of Nanking. To cite but one typical exchange:

> Q: What was the conduct of the Japanese soldiers toward the civilians after the Japanese were in control of the city of Nanking?
>
> A: The question is so big, I don't know where to begin. I can only say that I, myself, observed a whole series of shootings of individual civilians without any provocation or apparent reason whatsoever; that one Chinese was taken from my own house and killed. From my next door neighbor's house, two men, who rose up in anxiety when soldiers seized and raped their wives, were taken, shot at the edge of the pond by my house and thrown into it. The bodies of civilians lay in the streets and alleys in the vicinity of my own house for many days after the Japanese entry. The total spread of this killing was so extensive that no one can give a complete picture of it.[67]

Bates continues his testimony, noting one instance in which a woman was raped in succession by seventeen Japanese soldiers, another in which a girl of nine years was raped, and a third in which a grandmother of seventy-six years of age was raped, all on the grounds of Nanking University, where he was part of a relief society.[68]

If the first major contention of the IMTFE narrative was that the Japanese military was a criminally aggressive organization, the second key argument was that the majority of the Japanese populace had been made accomplices to the military's grand design, had been brainwashed essentially into acting as puppets. On her second day in court, Toshi witnessed the accomplice-as-puppet defense playing out in real time as Pu Yi, erstwhile emperor of Manchuria, took the stand.[69] Concerning his role in signing treaties with the Japanese, Pu Yi testified, "I was not doing it of my own free will. I did not have my own hand, I didn't have my own mouth. For ten years, I didn't know what freedom meant." He continued, arguing that "the people of Manchukuo, though they had to work under the rule of Japan, were not willing" and that "when I had to give approval to what had been prepared, I wasn't doing that myself. In other words, from the Emperor down to the man in the street, all were controlled by the Japanese in one way or another."[70]

Toshi was intensely interested in Pu Yi's performance of his testimony. She writes, "Navy suit, dark brown tie, thin hands, slender body. His first

time on the witness stand, he kept jiggling his leg and he couldn't seem to hold still." Toshi recalls having seen many a photo of this "puppet emperor" (*ningyō tennō*) in coat tails and in military fancy dress, and she wonders just how complicit—or controlled—he was.[71] She watches him closely, studying him, trying to figure out what kind of person he is. All the nervous tics distract her. He cannot sit still; how often her own parents had scolded her for that flaw! "As he spoke, he stuck his arms up in the air, or jerked them to the front or to the side, acting out how the Kwantung Army had controlled him like a doll (*ningyō*), how he had had no freedom to act on his own."[72] Pu Yi continues to perform his testimony, with "sweeping gestures" and a "booming voice," when all of a sudden he strikes the wooden rail in front of him. The people listening, most of whom do not understand Manchurian, are quite surprised and jerk the receivers away from their ears. "And then the translation comes, in English and in Japanese: 'The Kwantung Army killed my wife. . . .' Bang. That bang when he hit the rail: that was the sound of his wife being killed."[73]

Of the five illustrations she prepared to accompany her article in *Jinmin,* two of the sketches capture Pu Yi at the witness stand. In the first sketch, immediately below the article's title, Toshi provides a wide view of the courtroom (fig. 5.5). The judges' bench and the row of flags file up from the bottom left-hand corner toward the vanishing point. Just below the open door, and in front of the ranks of the defendants, we find a helmeted MP and then a small man, standing in a U-shaped box, with his right hand raised. This is Pu Yi. A second image, later in the article, provides a close-up of this scene (fig. 5.6). In this second view, Pu Yi seems, as in Toshi's prose description, childish and a bit ridiculous. An untamed cowlick sticks up over his right ear, his suit is hopelessly rumpled, and his glasses seem steamed up, only one pupil showing through the panes. His left arm seems disarticulated from his body, while his right arm appears boneless, nothing but an empty suit sleeve with a flapping, backwards hand at the end. By contrast, the MP, standing just behind him and over his right shoulder, is normally proportioned, something of a bemused smile playing across his balanced features.

One gets the sense that, at least in this instance, Toshi found the puppet defense laughable. Of course, this narrative—"criminal military clique controls people like puppets"—was not the only one available, either now or at the time. Kiyose Ichirō, chief counsel for Tōjō and one of the heads of the Japanese legal defense team, began his memoir of the IMTFE by laying out several of the competing narratives:

東京裁判傍聴記

文と繪　赤松俊子

「巣鴨でせうか？」
「あれは拘留所です。」市ヶ谷で

せう」
と、いふので、とも角、省線を市ヶ谷驛まで乗ることにする。あれほど重大な關心事であり、じぶんたちも、あれ、これと、論議し合つてゐるのに、いざ、となると、それが、どこで行はれてゐるかといふことの見當すらついてゐないのにあきれる。切符を渡しながら驛員に

「ジープが登つて行くでせう、あの坂の右手のでつかい灰色の建物がさうです」と欲へてもらふ。負けいくさの最中に、防空のためだといふので灰色と黒に塗りわけられたそのままの陰氣な角ばつた建物。この坂がさうだなと登らうとすると。〃止レ〃といふ日本文字がばかに大きい。びつくりしてピンク色のバスを出して手の上にのせて門を入る。一寸、小腰をかがめてのぞいて、

Fig. 5.5　Akamatsu Toshiko, author and illustrator. "Tokyo saiban bōchōki." *Jinmin* 8 (Dec. 15, 1946). Held by the Gordon W. Prange Collection, University of Maryland Libraries. Toshi completed this sketch of the courtroom either on August 16 or August 19, 1946. She included the sketch with her "ear witness account of the Tokyo trial," published in redacted form in *The People* (*Jinmin*) later that year.

く、そのあまりにも秩序だち、序々に
はつきりと、自らの行跡が示し出され
て行くことは、それをまのあ
たりに見せられて、靜かに、
或時は、ひようい つなまでの
辯護人の辯護にさへ腹立たし
さを感じてゐるのではなから
うか。

この痛ましくもさへ見え
る、しようそうは、自らの生
命を縮めて行くであらう。既
に、證言の際も、辯護人の言
葉も無益なものと、あらゆる
決定を知つてゐるであらう
東條は、全く、亡靈の像であ
る。

このあきらめに似た虚脱の
神經には、何物もひびいては
來ないのではないからうか。
何物もなかつたかのやうに誰が、そ
んな、悪い陰謀を企てたのか、どうし
て、こんな大それた戦争を引きおこし

たのか、全く、それは、ああ、地球上
の奴等が、へえ、なんちゆう 悪者か
がく然として東條は、眼鏡をはづし
て汗をふく、この涼しい装置の公判延
の中で。

滿州皇帝フギ氏は、關東軍の脅迫的
すすめによつて皇帝となり、關東軍の
壓迫の、強制によつて、滿洲の人々を
も戦にかりたて戦場となした。その皇
帝は、今日、法廷の證人として、主役
を演じてゐる。
皇帝といふ語からくる共通感、天皇
我等のあこがれの天皇と言はしめよう
とされてゐるところの天皇。
天皇は、誰の脅迫か進言かはしらぬ
が、宣戦布告の詔勅を出したのではな
かつたかしら。その事は東條閣下も御
存知の筈。
そのみことのりによつて、私の弟は
千島で凍傷にかゝり、びつこになつて
歸つてきた。妹のむこになつてもらは
うと考へたまた立派な青年は南の島で
死んだ。

ね。えつ、その主謀者の一人は東條だ
つて、東條、東條、何といふ、わしが
東條ぢやと、なる程ね。わしは東條で

Fig. 5.6　Akamatsu Toshiko, author and illustrator. "Tokyo saiban bōchōki." *Jinmin* 8 (Dec. 15, 1946). Held by the Gordon W. Prange Collection, University of Maryland Libraries.

It began in September of 1931 and concluded in September of 1945, this enormous tragedy, unprecedented in the history of Asia, and has been all summed up now by the Tokyo War Crimes Trial. Why did this war start at all? And what was its defining character? Was it an ideological struggle, a conflict between world views? Was it a fight for basic existence between the yellow and the white races? Was it a protest against the haves on the part of the have-nots? Was it a conspiracy cooked up by a gang of thugs who turned events to their own ends? Or was it an act of the gods, whose origins are beyond the power of human comprehension to grasp? Or perhaps, again, it was a sort of inescapable karma? Wartime communications were, for the enemy as well as for us, confused. And now that the dust of the battlefield has settled, we can, by seeking a court of law and speaking under oath of personal experiences, begin to untangle some of these threads.[74]

Kiyose is quite clear. The drama of the IMTFE was at least as much about straightening out a narrative for what the war was, what its causes were, and why it came to be, as it was about the matter of assigning guilt or innocence. Nevertheless, in the debates on wartime artistic responsibility at least, the juridical frame of guilt and innocence, and the legal parsing of the designation "war criminal," prevailed, offering one of two verdicts: guilty as charged, or innocent by reason of puppetry.

Making the Problem of War Art (Dis)Appear: Post-1950s Developments

For artists who had remained active during the war years, there were limited options for moving forward in the postwar period, given the IMTFE-informed visions for restructuring and rebuilding the art world. One option was to claim the puppet defense, to assert that one was forced into nationalistic or militaristic service against one's will. A second option was to reflect critically upon one's actions and to admit one's guilt. A third option was to remain unrepentant, and often the corollary to this was to go into self-imposed exile, as did Fujita, who departed for France in 1949. A fourth option was to ignore the matter entirely by simply not drawing attention to one's wartime activities and allowing the sands of time to cover them over.

This final option proved by far the most common course of action. This was true for a variety of reasons. As covered earlier, the IMTFE influence on the artistic wartime responsibility debate was pervasive enough and powerful enough to foreclose upon any far-reaching or thoroughgoing

examination of wartime artistic production, focusing instead upon one
particular genre (the war documentary painting) and two particular met-
rics of guilt (profit and proximity of collaboration with the military). Also,
so many libraries, government buildings, and private holdings had been
destroyed (whether by air raids and the resultant fires, or perhaps by artists
themselves) that artists could not be certain what of their art survived and,
at any rate, were generally busy enough trying to move forward that they
did not go looking for lost canvases, particularly if those canvases could
only bring trouble. Finally, of the war documentary painting canvases that
did survive and that were identified categorically as such, most were made
to simply . . . disappear.

On June 5, 1946, General Headquarters (GHQ), acting on the orders
of Gen. Douglas MacArthur, seized more than 150 war documentary
paintings and impounded them at the Tokyo Metropolitan Museum. As
Kawada Akihisa has pointed out, General MacArthur was in a delicate
position regarding the paintings. On the one hand, if the works qualified as
art, then they would need to be protected under international convention.
On the other hand, if they were deemed to be mere propaganda, then de-
stroying them would be the most expedient course, lest they re-arouse bel-
ligerent sentiment.[75] Unable or unwilling to come to a determination,
MacArthur ordered that occupation forces seize whatever examples they
came across, storing them away where they could not be publicly displayed.
In 1951, with the end of the occupation nearing, the matter remained un-
decided, and so the collection was shipped to the United States, where it
gathered dust in storage at the Department of Defense. In 1966, photogra-
pher Nakagawa Ichirō gained permission to make color photographs of the
collection, and he published a full-color catalogue in Japan the following
year.[76] In 1970, the US Department of Defense returned the collection to
Japan, where they remain today "on permanent loan." The paintings were
in uneven condition and needed repair, justifying several more years of oc-
clusion from the public eye.

In 1975, the first postwar public display of the repaired paintings was
planned for the Tokyo Kokuritsu Kindai Bijutsukan (MOMAT), but it was
cancelled just before the opening out of "concern for the feelings of other
countries."[77] While it was possible for researchers to get permission to view
the collection, or at least portions of it, virtually no one bothered.[78] In the
late 1970s and into the early 1980s, arts critic Hariu Ichirō and others at-
tempted, to no avail, to raise public funds to build a museum of war and art
in downtown Tokyo, which would include the war documentary paintings,

antiwar art by Japanese artists (such as Toshi and her husband Iri), and works dealing with the Korean and Vietnam wars.[79] While, as of 2017, the full collection has not been displayed since the turn of the century, MO-MAT has held occasional exhibitions of select canvases, first in 2009, when about fifteen of the most well-preserved canvases hung for several months in a special exhibit, and then again in 2015, when a dozen of the paintings plus all those completed by Fujita were on display. Since 2015, other museums have begun to display wartime paintings, suggesting that this taboo is finally beginning to lift.

Nevertheless, though the IMTFE trials concluded in November 1948, resulting in the execution of seven convicted Class A war criminals the following month, and the occupation drew to a close in April 1952, the legacies of their structures of reparation and their narratives of war continue to inflect postwar cultural discourse. With the occlusion of the war documentary paintings from public view, the debates on wartime artistic responsibility remain unsettled, open-ended, still contentious, and still evolving. A rough periodization of post-1952 discourse on artistic wartime responsibility suggests the degree to which new developments in and resurgences of the debate have been tied to the shifting fortunes of the occupation-seized collection of war documentary paintings. One can identify four general stages of this development.

In the first stage, which lasted from 1952 through the early 1960s, most commentary recapitulated the original terms of debate from 1946 and 1947, laying particular stress on the need for critical self-examination—rather than just finger pointing—and calling for structural reform of the arts establishment (*gadan*).[80] Hariu Ichirō, who perhaps did more than any other arts critic to keep the question of wartime artistic responsibility alive, traced the problem back to the history of Western arts' instrumentalizaton under imperial rule beginning in the Meiji period and posited that the postwar Japanese art world had yet to work through this structural legacy. He went on to critique artists (one suspects he may have had Toshi and her cohort in mind) who had simply switched from fulfilling the dictates of the military to responding to the mandates of the Communist Party.[81]

A second stage, kicked off in 1967 by the publication of Nakagawa's color photographs of the seized paintings and lasting until the planned MOMAT exhibit in 1975, shifted the debate and turned its attention to the human costs of war and the scapegoat function that the war documentary artists had been made to fill. Hariu Ichirō, now responding to the massive media coverage given to Nakagawa's publication—which included an

exhibit at the Seibu department store, special TV coverage, and multiple articles in the *Weekly Yomiuri (Yomiuri shukan)*—critiqued popular responses to war art as "steeped in an uncritical nostalgia for the past" (*kakō no muhihanna nostarujia ni michiteite*) and organized a special issue of the arts journal *Mizue* to counter that trend.[82] Warning against succumbing to the soporific of romanticized memory, he advocated increased attention to art depicting the human costs of war and, working with some twenty colleagues, organized a counterexhibit at the Nihon Gallery. Hariu ends his piece by chastising the Japanese public for its willingness to forget.

Artist Kikuhata Mokuma, member of the experimental Kyūshū-ha group, responded to Hariu's call to remember, recalling how powerfully affected he was when, as a child, he visited the Second Holy War Arts Exhibit, where sixteen of the documentary war paintings had been on display. Kikuhata suggests that, while valuable, Hariu's approach has largely ignored aesthetics in its pursuit of history, and Kikuhata proposes to detail the emotional and aesthetic appeal of war art.[83] Recognizing the artistry of the paintings, Kikuhata's basic position is that with defeat, a rapid switch was demanded—an about-face move from popular nationalism to pacific internationalism—and that this was accomplished, at least partially, by degrading war art as mere propaganda. "The Japanese people," he notes, "recanted nationalism" (*Nihonjin no nashonarizumu no fumie*).[84] The word "recant" (*fumie*) refers to a specific practice whereby the Tokugawa shogunate (1600–1868) required suspected Japanese Christians to step on (*fumi*) a likeness (*e*) of Jesus or Mary, thereby performing their loyalty to the Japanese government and their denial of Christian faith. Kikuhata thus understands a cluster of events—Miyata's October 1945 article in the *Asahi News*, the responses in *Bijutsu*, the creation of a blacklist of artists, the destruction of many pieces of war art by their creators, the sequestering of war documentary paintings by GHQ, and the continued finger pointing of the 1950s—as an elaborate recanting of wartime nationalism, a public performance of and expression of faith in the new belief system of postwar MacArthurian democracy. Kikuhata thus diagnoses, correctly I think, the ways in which "stepping on" war documentary art and scapegoating its artists has obscured other, more complex and complicated histories of nationalist and militarist sentiment, not only on the part of artists, but also amongst the general public.

The aborted 1975 MOMAT exhibit ignited a third wave of discourse, this time focused on underscoring the pedagogical value of war art and the need for a renarrativization of the war to include everyday people's

involvement in a "grassroots fascism."[85] Hariu—working now with Oda Tatsuo and Yoshida Yoshie, among others—began to excavate the full history of war documentary paintings and to push for the formation of a museum that would pair the prowar documentary paintings with explicitly antiwar art for pedagogical purposes.[86] Following Kikuhata's lead, he argues that "If Japanese people closed their eyes [to reality] during the war, then those of us living in the postwar period have closed our eyes in our own way," allowing war art to recede into the darkness and choosing to forget that everyday people were responsible for the incredible popularity of the documentary war paintings. War art was, he states, the result of a "popular movement" (*minkan undō*) and not just a response to directives from above.[87] Kikuhata, for his part, completed a book-length study of imperialism and Japanese art,[88] while Watanabe Shōichi, echoing Kikuhata's *fumie* argument, focused attention on the ways "the IMTFE really warped history" by focusing condemnation on a few men and vacating the need for everyday people to have to confront the facts of Japanese aggression.[89]

With the coming of age of a generation of scholars and artists who did not live through the war years, a fourth stage of scholarship on artistic wartime responsibility has developed since the 1990s. Led by Kozawa Setsuko in Japan[90] and joined by a host of international scholars,[91] this new wave of scholarship raises three interconnected questions, to which I turn in chapter 6. What was the role of gender in the production, circulation, and evaluation of war art? How can we account for so many artists' seamless transitions between the avant-garde arts of the 1930s and the fascist arts of the 1940s? And, finally, what role can scholarship play in helping to broaden the narrative from one of wartime victimhood (*higaisha ishiki*) to one that includes due attention to wartime aggression (*kagaisha ishiki*)?[92]

Making the Next Painting
Toshi gave two interviews in the fall of 1989, just as this fourth wave of critical responses to artistic wartime responsibility was beginning to rise. In the first, she and husband Maruki Iri spoke with US-based researchers Haruko and Theodore Cook, who were conducting interviews for their oral history of Japan at war. Over the course of the conversation, Toshi talks about how graduates of art schools often were immediately called up to serve in the military or ordered to paint war art, and how those who refused were labeled unpatriotic and could be imprisoned or beaten. She recalls the persistent shortages of food and the real pressures of hunger: "Even if you didn't paint war art, you could feel good for those who did. . . . You

didn't think, 'Their ideology is wrong.' You just felt happy that they could eat."[93] And she recounts how she and Iri were visited by a saber-rattling military officer who tried to recruit them, noting wryly that it "was difficult to paint under such circumstances, with such 'encouragement.'"[94] Compared to her fiery denunciation of artistic war criminals in the late 1940s, Toshi's outlook has mellowed considerably. She admits that it was hard not to succumb to the pressure and the threats. "I feel it would be enough, then, if they just said, 'I'm sorry, sorry for what I did.' . . . If only they'd say it, they could go on, paint their next painting."[95] Personally, however, Toshi and Iri maintained in the Cook interview that "We wouldn't make war art."[96] Before the coming of the New Year, however, Toshi gave a second interview, this time speaking with longtime interlocutor Usami Shō. In that interview, she made a different claim, announcing, "I am a war criminal. I illustrated a book that glorified the war" (*Watashi wa senpan yo. Sensō raisan no ehon o kaita no*).[97]

What shifted? What can possibly account for these two polar opposite claims, made within weeks of one another? I would argue that Toshi—and with her most contributors to artistic wartime responsibility discourse—got the causal order wrong. Toshi, like the vast majority of her peers and of critics since, have argued that critical self-reflection (*hansei*) is the first step toward rebuilding the arts world, that only after reflection and confession can one go on to tear down the *gadan* establishment, restructure arts policy, root out fascist ideology, and "paint the next painting." But, as Toshi's own experience bears out, it was precisely her painting of the "next picture" that spurred her, over time, to come to terms first with Japanese wartime aggression writ large and then, suddenly, one autumn day, to face her own culpability. I take up this thread in chapter 6, arguing that Toshi's deepening self-reflection vis-à-vis her own artistic wartime output was accomplished in tandem with, and inextricably intertwined with, her "next pictures," many of which focused on memorial reckonings with the extraordinary violence of war, whether as inflicted on Japanese bodies by American nuclear bombing (Hiroshima, Nagasaki, the Lucky Dragon), on Japanese bodies by imperial formation (as in Ashio and Minamata) and, ultimately, *by* Japanese bodies on colonial (Okinawan and Korean) and Chinese (Nanking) ones.

CHAPTER 6

Art as Direct Action
Hiroshima and the *Nuclear Panels*

Toshi's first trip to Hiroshima came in July 1941. Recently returned from her second stay in Moscow, she had married fellow artist Maruki Iri earlier that month and he was taking her to meet his extended family in his hometown of Mitaki, which lay in the hills on the edge of the Hiroshima basin.[1] The couple spent several days there, long enough for Iri to work on a few ink paintings of the nearby gorges and for Toshi to make a dozen sketches of the landscape, begin an oil portrait of Iri's father Kinsuke, and complete two ink paintings of her time in the South Seas. She planned to exhibit the ink works—"Bound for Angaur Island" (plate 12) and "Rest House"— upon her return to Tokyo, then the capital of a sprawling and ever-growing Imperial Japan. A handwritten note on the "Angaur" canvas belies this temporal calibration, referencing the Imperial Reign Year: "2601 August, completed at Mitaki. On a ship departing Palau Island bound for Angaur."[2] In ways that she would have shuddered to imagine, Hiroshima and the greater Japanese Empire were to remain tragically entangled themes in her artwork for the next half a century.

Four years later, in late July of 1945, Hiroshima remained one of the few major cities in the Japanese home islands that had not been decimated by fire bombings. Bombed out of their Tokyo atelier in January, Toshi and Iri evacuated to Urawa, some ten miles east of Tokyo, pulling their art supplies and meager belongings in a handcart. There they had been subsistence farming, eating snails, and scavenging for any other source of calories.[3] It was clear, however, that they were not going to be able to survive for much longer, and they were thinking of moving to Hiroshima, where Iri's family continued to farm successfully. On July 26, 1945, Iri bought a train ticket for Hiroshima, but the tracks were too badly damaged—the bridge at

Tenryōgawa had been bombed the day before—and repairs would take several days.[4] Before Iri could obtain another ticket, the US Marines captured the tiny island of Tinian on August 3, enabling the *Enola Gay* to take off three days later, bearing its atomic payload to Hiroshima. On August 8, Iri read reports that a "new kind of bomb had been dropped" (*shingata bakudan tōka*) on Hiroshima and he immediately left to search for his family.[5] He arrived in Hiroshima after dark on the night of August 11 to find piles of rubble and corpses everywhere. Following the Mitaki River upstream, he passed a number of people who had gone down to its banks to escape the flames, collapsing there in the bamboo groves. Eventually he located his family home, which, though blown sideways by the blast, still stood for several more days.[6] An uncle and two nieces had died immediately, but the rest of his family was, for now, injured but still alive.

Back in Urawa, Toshi was desperately worried and decided to follow Iri to Hiroshima, arriving on August 15. In Mitaki, Iri gathered lumber from the splintered ruins and built a stable structure for the family to take shelter in, while Toshi and sister-in-law Aya scoured fields and streams at the edges of the burnt city ruins for eggplants, pumpkins, and shellfish. They burned corpses and cared for the living as best they could, returning to Tokyo on September 10 at Iri's family's insistence. Iri's father walked them to the station, where they shared a small cup of cider saké. It was the last time they would see Kinsuke, who succumbed to radiation sickness some weeks later.[7]

Other than two sketches made during her month-long stay in Hiroshima—one labeled "1945 August 6: Atomic bomb" (*Shōwa nijūnen hachigatsu muika: Genshi bakudan*) (fig. 6.1) and the other showing a half-collapsed building (fig. 6.2)—Toshi drew no sketches, made no paintings, recorded no notes, and wrote no articles about what she saw in Hiroshima. What she saw, and her inability to respond to it as an artist, haunted her for years.[8] Of course, there were ethical, practical, and psychological reasons for her artistic inactivity. She recalls thinking, "If I, as someone who was uninjured, was going to stare at those who had been hurt, then it seemed like, rather than art, I should bring them aid, more than pictures, I should bring food. And I did my best at that, all the while trying not to look at the corpses. . . . There was no paper, and no pencils, and I'm sure any number of other excuses could spring to mind." But Toshi was never one to let herself off the hook, continuing, "A true artist would have immediately trained her eyes on that impermissible hell of human existence, would have faced up to that reality with anger and rawness, and would have put her pencil to paper, right? But me? I was nothing but a coward."[9]

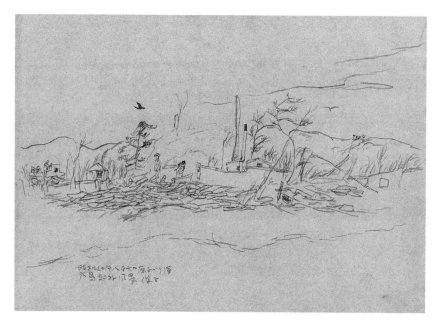

Fig. 6.1 Akamatsu Toshiko. *Shōwa nijūnen hachigatsu muika: genshi bakudan* (1945 August 6: Atomic bomb). 1945. Pencil on paper. Private collection.

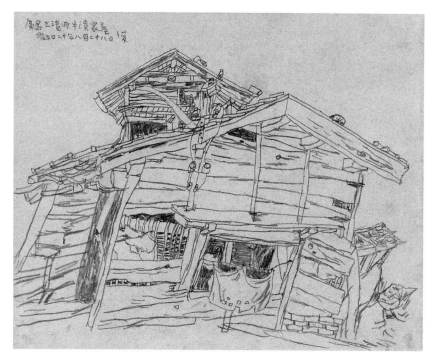

Fig. 6.2 Akamatsu Toshiko. *Hiroshima Mitaki-chō hankai kaya* (Hiroshima Mitaki Village: Half-collapsed house). August 28, 1945. Pencil on paper. Private collection.

Whether coward or merely human, by December 1949 Toshi was ready to face what she had seen, working with Iri to complete the first of what was to become a series of panels depicting the atomic aftermath. Over the next several decades, they produced fifteen nuclear panels, showing them in Japan and internationally to a viewership of millions. The paintings are large, each almost two meters high and more than seven meters long. The human beings in them are life-sized and presented at eye level, and each painting is made up of eight separable panels, which the Marukis rolled up for easy transport. The mostly monochrome ink washes show tangled masses of naked human bodies punctuated with the occasional red of blood or flame. Each work explores the aftermath from a different iconic angle: the procession of victims away from the hypocenter, people huddled in bamboo thickets for shelter, those who drank the poisoned water and died, those burned in the secondary fires that scorched the city.

In later years, the Marukis' subject matter expanded beyond Hiroshima and Nagasaki to include other wartime violations of human rights, such as those at Nanking and Auschwitz, as well as environmental tragedies like Minamata. After years of exhibiting their panels in schools, temples, labor halls, and galleries, in 1967 they established their own museum to permanently display the core nuclear series alongside other pieces of their artwork.[10] The Marukis' work and their commentaries on it (particularly Toshi's testimonials) remain a staple of "liberation education" (*kaihō kyōiku*) publications, while Japanese school students continue to visit the museum heavily as do educational groups from abroad.[11] In 1995 the couple was nominated for the Nobel Peace Prize in recognition of their tireless efforts to combat nuclear proliferation and to visualize the horrors of war.[12] In addition to their antiwar and anti-nuclear-proliferation messages, the panels also materialize Toshi's slow, painstakingly difficult, but brave and committed attempt to come to terms with Japanese aggression—her country's and her own—during the war years. To understand this process of critical reflection, we must understand the massively collaborative nature of Toshi and Iri's nuclear art and the performative elements of Toshi's engagement with their visual productions.

In this chapter, I argue that for Toshi, the fifteen *Nuclear Panels* comprise the material record of, and touchstone for, a series of "direct actions," a commitment to, as William Marotti has described it, "the possibility that art practices emerging from art might contribute to or achieve revolutionary results."[13] Drawing on her childhood experiences of growing up in a Buddhist temple, and on her socialist-inspired notion of art as socially

engaged, Toshi took on a specific role vis-à-vis the *Nuclear Panels,* and she did so with increasing force and acumen over the years. Putting herself into them (metaphorically as artist, literally as model, and conceptually as notional participant) and before them (as performative interlocutor and collaborative cocreator) transformed her understanding of her own wartime experiences, underscored the intricate interweaving of suffering and culpability, and reconfirmed her faith in the social role of the artist.

"Ghosts" and the Visual Moratorium on Atomic Bodies

As many other scholars have noted, the US-led military occupation of Japan "abolished wartime controls on expression, only to impose somewhat milder restrictions of its own."[14] On September 19, 1945, the offices of the Supreme Commander for the Allied Powers (SCAP) issued its Press Code for Japan, mandating a set of core rules governing what sorts of material could and could not be freely circulated in the now-occupied country. Largely concerned with maintaining the "public tranquility" and preventing the development of any "propaganda line" (at first of a fascist or nationalist bent, but later used to quell socialist and communist sentiments), the directive also stipulated that "There shall be no destructive criticism of Allied Forces of Occupation and nothing which might invite mistrust or resentment of those troops."[15] This directive, item 4 of the press code, was interpreted to mean that information on the loss of civilian life and other details of the human suffering in Hiroshima and Nagasaki should not be released to the public.

In other words, there was to be a visual and verbal moratorium on describing atomic bodies. No photos, no films, no newspaper descriptions of the dead. Accounts of architectural damage and dry statistics of tonnage and range would pass censorship.[16] But no bodies.[17] In this manner, the entire embodied experience of Hiroshima and Nagasaki, now understood as metonyms for the atomic dead, were hypocentered: rendered simply . . . absent, if not with the flash of a "new kind of bomb," then with the clack of a few keys of the typewriter. Survivors of the atomic blasts, who fanned out across Japan in the weeks and months following surrender, found themselves struggling to explain that the atomic bombs were not just *bigger* conventional bombs, but an entirely *different* order of weapon. Their descriptions, when offered, were often met with frank disbelief.

By July 1948 Toshi's health had deteriorated significantly. Suffering from the effects of long-term malnutrition, tuberculosis, overwork, and radiation sickness, she accepted Iri's decision to move away from Tokyo.[18]

Through friends, they heard of a cottage near Katase village, in the seaside mountains of Kanagawa Prefecture, an idyllic locale. They were able to rent it virtually for free, as the property had recently been the scene of a robbery and murder. At the end of a road rutted with jeep tracks, the house was littered with empty cans and the garden was filled with garbage, but there was plenty of fresh air, fish, and vegetables on which to nourish Toshi and—perhaps equally important—keep her away from the constant work demands of the city.[19] As the third anniversary of the Hiroshima bombing approached, Toshi's health had begun to improve.

One evening, after a long dark day of rain, Toshi and Iri talked about their experiences in Hiroshima, deciding finally that they could not *not* paint it.[20] They began to model for one another—nude, because the atomic blast and resulting fires had torn or burned the clothes off most people— and ended up completing hundreds upon hundreds of sketch studies (figs. 6.3 and 6.4). Emerging from what she called her "atomic stupor" (*genbaku boke*), Toshi determined, "We should have started earlier, but even now it's not too late."[21] They planned a large-scale collaborative piece, which they would debut at the 1950 Independent Exhibit. As Thomas Havens notes, the Independent, held annually between 1949 and 1963 at the Tokyo Metropolitan Art Museum, was "by far the most significant exhibition for avant-garde artists. . . . Anyone, regardless of affiliation, was free to display one or two original works not previously seen," a practice that traces to the 1884 Salon des Independants exhibit in Paris.[22]

For their depiction of the atomic aftermath, Toshi and Iri focused on drawing sketches of female nudes, at least in part because of their personal connections to the city. Iri's nieces had been detailed, along with the rest of their school class, to work in the Hiroshima city center building earthen dams, and the couple's first nuclear panel was something of an attempt to imagine these girls' last moments. Toshi and Iri completed some five hundred sketches and then arranged them on large pieces of *washi* (Japanese paper), trying for a collage-like effect, but they were unsatisfied with the result, so they started again, this time working freehand from the left-hand edge. Unable to spread out the entire painting, split between eight large pieces of paper, in their small atelier, they hung sections of it on the walls, effectively surrounding themselves with a walking mass of atomic bodies. When they took this first painting to Tokyo to display it at the Independent, they had trouble getting the separate panels to lay flat, and they had to touch up parts of the painting *in situ* (fig. 6.5).

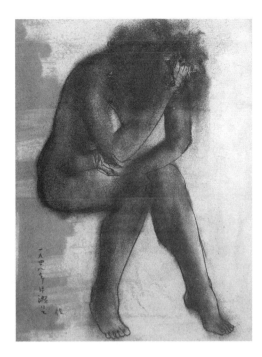

Fig. 6.3 Akamatsu Toshiko. *Untitled*. 1948. Ink and charcoal on paper. Private collection. This sketch is one of a series that Toshi completed while living at Katase and appears to be one of the earliest studies for what would go on to become the *Nuclear Panels* (*Genbaku no zu*).

Fig. 6.4 Akamatsu Toshiko. *Untitled*. 1948. Pencil and charcoal on paper. Private collection. This sketch, also completed at Katase, was an early study for what would become the first of the *Nuclear Panels*, *Ghosts* (*Yūrei*).

Fig. 6.5 Akamatsu Toshiko and Maruki Iri. *Genbaku no zu ichibu: Yūrei* (Nuclear panel number one: Ghosts). 1950. 180.0 cm x 720.0 cm. Ink on paper, mounted on a linked set of four folding screens. Genbaku no zu Maruki Bijutsukan.

The Marukis' exhibition of *Ghosts* from February 8 to 17, 1950, marked the first public display of the effects of atomic irradiation on the human body.[23] Their original title for the piece *Atomic Bomb* (*Genshi bakudan*) was deemed too "inflammatory," likely to evoke occupation censorship and cause problems for the exhibition as a whole, so they changed the title to the more oblique *August Sixth* (*Hachigatsu muika*).[24] The piece is better known today as *Ghosts* (*Yūrei*).[25]

"Ghosts": Visual Analysis and Critical Responses to the 1950 Independent Exhibition

If Toshi's two sketches of Hiroshima, done in August 1945, show no bodies, one hallmark of *Ghosts*—and of the later panels in the nuclear series—was its near-total saturation by the human form. Whereas SCAP mandates allowed for publication of information concerning architectural damage, to the exclusion of bodies, Toshi and Iri's artwork absolutely reverses that paradigm, allowing us to look *only* at bodies. As Toshi explained in a roundtable discussion held in December 1950: "If you want to paint the atomic bombing, do you paint that boiling cloud, or

the bombed out ruins, or maybe just the Nagasaki bell? But the most painful thing is that all those people died; it's this gut-wrenching anger (*shaku ni sawaru to iu kimochi*), and so we decided we had to paint only the people."[26]

As a trained oil painter, Toshi specialized in depictions of the human form and, as earlier chapters have demonstrated, was well known and highly regarded for her sketch work. Iri, on the other hand, was a self-taught *suiboku* (ink brush) artist. Though each had been teaching the other for several years, with Toshi experimenting in ink brush work and Iri taking up sketching, they combined their strengths to create the *Nuclear Panels*. Typically, Toshi would make the initial sketches of the human forms. Iri would splash ink atop the images, and then Toshi would redraw the lines, atop the ink wash, thereby "giving life to the flesh. Then Iri added more ink over that and washed it off with water. Then Toshi would go back over it with charcoal, bringing out the texture of the muscles and such," a truly collaborative effort.[27] The process could be quite antagonistic. In a rare, free-verse poem, Toshi described it as a crucible:

One person who does *suiboku*
One person who uses oils
But the crucible of revolutionary art
radiates an incredible heat
glowing scarlet red.
That's the crucible.
That's the boiling hot crucible.
It throws off a blinding white glow
and the substance that flows from it
is something never seen before,
the culture of the world.[28]

Similarly, arts critic and longtime associate of the Marukis Yoshida Yoshie has joked that rather than "collaborative artwork" (*kyōdō seisaku*) at times the couple seemed to be engaged in "mutual warfare" (*kyōtō seisaku*).[29] The end result, however, was often sublime.

Viewing the painting takes time for, as John Dower has so aptly pointed out, Toshi and Iri's artwork combines horror with beauty. "If the Marukis had done nothing more than recreate atrocity and violence," he writes, "then we could not bear to look at their paintings for more than a moment. We would close our eyes. We would turn away."[30] Their subject matter *is* horrible: skin hangs like ribbons from arms, bloodied kneecaps protrude from the skin. A closer look at a nearly untouched girl reveals that her face is charred black and her right arm a gnarled stump. A perfectly beautiful baby lies—alone? dead? abandoned?—on the ground. Even the cat is charred, sprawled out dead beside a body that is half flesh and half scoured bone. But Toshi and Iri have painted these human and animal forms carefully. The bodies have depth and plasticity, their faces are individual, their suffering is human.

Furthermore, in considering their artwork, it is important to recall that while the Marukis traveled to Hiroshima soon after the bombing, they were not there to see the procession of the injured as they sought to escape the city center. From the outset, then, the painting was to be a consciously delineated space through which the artists sought to collect, construct, and perform cultural memory. In part, the intent of *Ghosts* is to depict what has been kept secret, to clarify what has been unknown, and to gesture toward what cannot ever be known. Toshi's recollection of the germination of *Ghosts* is instructive. She had purchased a mirror from a second-hand store and, she writes, "I got naked and stood in front of the mirror, raised my

arms up about halfway, and tried to pose as one of the people in Hiroshima then: the fabric around my waist in tatters, the skin hanging from my arms and my swollen face, in my belly an unborn child, a life extinguished along with its mother's."[31] Electrified by the power of her reflection, she called Iri into the room and he made a quick sketch of her, which survives at the far left of the composition (fig. 6.6).[32] Through physically performing the moves and gestures she heard described by survivors, Toshi embodies memories that, strictly speaking, are not her own, making them visible and bringing them into a visualized narrative.[33]

Response to Toshi and Iri's painting was mixed. The exhibit at the annual Independent show represented something of a comeback for the couple, who had been out of circulation in the arts world for more than a year at that point, and advance notice of their entry in the exhibition had alerted the public that the couple had just completed a large, collaborative piece,

Fig. 6.6 Detail from *Ghosts*. Toshi sketched herself in the mirror, modeling the pregnant woman at far left.

itself a feat sure to raise interest for its blending of classical ink painting (Iri's forté) with modern oil painting and sketch work (Toshi's strength).[34] Many reviews called attention to the large size of the painting—"Renaissance in scale"—and to the "medieval" motifs, which evoked comparison to Buddhist hell paintings and depictions of other Buddhist realms of suffering, such as that of the hungry ghosts.[35] The highest praise, not surprisingly, came in the pages of Communist Party newspapers and magazines, whose authors commended the artists for dealing "with an enormous issue, one which all Japanese people need to think about," and proclaiming that "all who stood before it understood clearly that it was a cry" of pain, calling for "No more Hiroshimas! No more hydrogen bombs!"[36]

Other critics were more balanced in their appraisal. Kamon Yasuo praised the way Toshi and Iri brought out the "tensions in the subject matter. Humanity's eroticism, humanity's grotesquerie—I find that this piece really keeps one's attention."[37] And Hayashi Fumio opined that most of the pieces in the Independent exhibit "struck [him] as 'literary' in nature, as, shall we say, 'indirect,'" but that Toshi and Iri's entry stood out as more powerful. "One must give it high marks, indeed, for the fact that it takes on a certain theme, the cruelty of the atomic bombing. And yet the naked bodies of the victims are just, somehow, unnatural, drawn like ghosts—for example, the way they are holding their hands. The other details are probably accurate in their depiction of the horror, but I think the artists need to go one step further, aesthetically, in terms of expressing the humanity, the anger and the sorrow, of their subjects."[38] Elsewhere, however, Hayashi was less charitable, declaring that the painting was "nothing more than a freak show" (*Hitotsu no misemono ni natteiru*).[39]

Still other critics, clearly with SCAP censorship mandates in mind, felt that *Ghosts* verged on anti-American propaganda.[40] And certainly the connection between oversized canvases bearing depictions of war and exhibited in public for massive crowds had a troubled history for most museum-goers in 1950 Japan. As discussed in chapter 5, from the mid-1930s onward, massive rallies around larger-than-life-sized works of war art was common. The annual Holy War Art Exhibit, to name but one event, was well-orchestrated, heavily attended, and widely covered in the media. Some of the canvases, particularly those by Fujita Tsuguharu (of the erstwhile Army Art Association) featured tangles of bodies scarcely discernible in the grimly dark hues of battle, scenes not very different from the Marukis' nuclear artwork. Indeed, the technical name for wartime military paintings—*sensō sakusen kirokuga* (documentary war painting)—could just as easily apply to

the Marukis' postwar antinuclear painting, and if the former was tarred with the brush of militaristic propaganda by 1950, then the latter could easily be understood, however facilely, as anti-American propaganda.

Indeed, speaking after the fact in 1952, Hiroshima artist Fukui Yoshiro remembers thinking that *Ghosts* was "hideous and ugly" and he panned the Marukis' "imaginary pictures" as "lurid scenes . . . widely circulated [from 1950 onward] by the Communist Party in its anti-America propaganda campaign."[41] Nor was Fukui a lone voice in this regard. Toshi's recollections suggest that, once the exhibition opened,

> we heard a lot of criticism: "This is an exaggeration." "Surely people weren't naked like this." "This is too much, clearly propaganda." But then an older person shouted out, "This is no exaggeration. I am from Hiroshima. I saw the bomb (*pika*) and it was much worse than even this." Stunned, people turned around and asked him about what Hiroshima was like on that day. He said, "I feel like my grandchildren or my daughter might walk right out of this painting. But you can't capture something like that bomb in just one picture. Make more. Make lots more. You will probably think of them as your paintings, since you're the ones making them, but these paintings are really for us."[42]

Toshi responded to the criticism, and to this specific man's request, just one week after the exhibit closed. Writing on the front page of the labor newspaper *Fujin minshu shinbun* (Women's democracy), she declared, in a scorching rebuke of all who would write off *Ghosts* as mere exaggeration for the purposes of communist propaganda,

> It was a procession of ghosts.
> In a flash, clothes burned, faces and hands and bellies swelled. Blisters burst and skin hung down in strips from one's arms. With nowhere to go for help, people held their arms in front of their bodies, moaning "It hurts. It hurts," just like children and stumbling along in a big group. Wives, children, and husbands, one after the next, burned so badly that they were unable to recognize one another. The black rain fell like a waterfall of ink, soaking the houses, flattened into rubble, soaking the streets, the naked people. The piles of corpses, so many corpses filling the city that one couldn't even walk without stepping on them, the stench from them, carried on the breeze, so horrible that one could hardly breathe.

Maruki Iri arrived in Hiroshima three days after the bombing. I followed after him. We lost our father in the blast.

We lost so many of our relatives in that moment. Five years passed.

What did we do in that time? Perhaps we were still crazy with the suffering of war. And so we tried our best to forget the sadness of the bomb.

While we were putting together the nuclear painting (*genbaku no zu*) our sadness was close to anger, burning hotter and hotter.

As artists who lived *August Sixth*, we had discovered what it was we had to do. A second painting, and a third: we must spend our lives painting [these scenes] as a memory for humankind (*jinrui no kiroku toshite inochi o kakete egaki kisanebanaranai*).[43]

Prior to the Independent exhibit, Toshi and Iri had only intended to create a single nuclear painting, and they had not intended to provide public commentary on the content, political import, or veracity of their work.[44] But the overwhelming response—from the public at large, if not from all critics—pushed them to continue the series. The artists had put everything they had into *Ghosts,* devoting nearly a year of studio time to its creation. They had posed family and friends countless times to create the study sketches, and Toshi, through this practice, had come to imagine herself into the scene. For her, the public response to the Independent show reignited her commitment to populist aesthetics and socially engaged art, propelling her into a half-century-long, embodied practice of performative commentary and involving her and Iri in a massively collaborative art practice, initially centered on Hiroshima and eventually expanding to attend to atrocities committed not only *on,* but also *by,* Japanese people.

Art and Revolution: The Concept of "Direct Action"

Following the exhibition of *Ghosts* at the 1950 Independent, Toshi and Iri responded to the public demand for more images of Hiroshima, returning to their atelier in the mountains to begin work on two further paintings: *Fire* (*Hi*) and *Water* (*Mizu*).[45] Crucially, both paintings had their genesis in, and contained images from, testimonies offered to the Marukis by survivors of the atomic blast and individuals who came to view *Ghosts*. One man recounted that the atomic blast knocked over the

houses in his neighborhood, which erupted into flame. As he escaped the ruins of his own house, he came across one of his neighbors, trapped beneath a heavy beam and holding her infant-in-arms. The man tried to convince the woman to hand over the child, so that it at least would survive, but the woman refused, fearing that her child would only die later, alone and abandoned, in the streets. The man watched, helpless, as mother and child were consumed in flames.[46] This shared memory became a part of *Fire*. Another person told of having seen a mother who had escaped the flames with her infant-in-arms. Arriving safely at the river, the mother tried to give her child suckle, only to find that it had died.[47] This scene became the kernel of *Water*. Completing the two paintings in time for the fifth anniversary of the Hiroshima bombing, the Marukis placed the triad on display on August 6, 1950, announcing, "The two of us, working as a team, have put every bit of our strength into these three paintings. And now we have but to wait, for people to view them and to offer their critiques."[48]

This public call for broad critical response, and the artists' commitment to fold that response into further paintings in a dialectical manner, was a hallmark of the couple's artistic practice. The communist newspaper *Akahata* recognized the Marukis' "revolutionary new way of conceptualizing and creating artwork," writing that "The two artists have exceeded the bounds of two-person collaboration and engaged the masses, learning from them and responding to their needs by painting works that the masses call for—an impressive 'direct line' to the people."[49] In their creative process then, the Marukis were—and were understood at the time to be—melding avant-garde and proletarian art into a new form of massively collaborative aesthetic production. In other words: populist art as direct action.[50]

As indicated in chapter 4, from the mid-1940s until the mid-1950s the Japanese art world was dominated by socialist realism and reportage painting. By 1955, however, growing tensions between Comintern and the Japanese Communist Party (JCP), and between the party and avant-garde artists, meant that reportage programs sponsored by the JCP had come to an end, and the character of the Independent began to change, "with the steady proliferation of increasingly provocative and bizarre objets, performances, and installation works." Critical tastes also began to change: "Popular critics like Hariu Ichirō, who had previously supported the reportage works, began to champion a return to Dada."[51] Thus, some art historians argue that reportage and socially engaged art were on the wane by 1955, with a new wave of arts practice, cohering around the notion of "direct

action," poised to take the stage.[52] I would argue, however, that the Maru-kis' working practices throughout the 1950s were anticipating this turn to "direct action." Or, more precisely, that the sort of populist politics they practiced were the generative crucible of direct action in art, a fact obscured by later artists' attempts to eschew the socialist realism and close political entanglements that characterized much art of the late 1940s and early 1950s. In other words, I argue that the Marukis' work in the *Nuclear Panels* represents a crucial development, leveraging political "direct action" into artistic production and thus anticipating the "direct action paintings" of later avant-garde groups such as Gutai.

But what is "direct action?" As William Marotti notes in his incisive study of postwar artist Akasegawa Genpei (the "red" of the arts group Hi Red Center),[53] the term *chokusetsu kōdō* "had been made famous by the Meiji radical Kōtoku Shūsui (1871–1911) as the translation of the anarcho-syndicalist concept of direct action."[54] Conceived generally "as the possibil-ity of some form of direct attack on capitalism by workers and peasants," Kōtoku understood direct action to entail a "direct confrontation" with the state, rather than working with the state to gain suffrage, establish political parties, or design parliamentary procedures.[55] In 1950s Japan, avant-garde artists increasingly came to understand direct action as "the possibility that art practices emerging from art might contribute to or achieve revolution-ary results."[56] In the late 1950s and into the 1960s, avant-garde artists—seeking to highlight the break with the Communist Party and with socialist politics, and indeed the entire political system in general—experimented wildly with form. Junk art, large installations, assemblages, happenings, action painting performances, distorted and enlarged photographs, and strange objet became the norm.

Understood as "action" (*akshon*) art, these experimental pieces share four core characteristics. First, an attention to the problem of form as such, form as a site of struggle and intervention. Second, a desire to get beyond the "art institutional frame" to engage in direct action through artistic practice, a desire that sometimes resulted in taking art out of mu-seums and into the streets.[57] Third, a goal of bringing spectators into ac-tive roles and cocreative engagement with the artwork. And fourth, the intent to engage the everyday through critical art acts. If these are the characteristics of recognized *akshon* pieces from the late 1950s and 1960s—experimentation with form, exceeding the arts establishment frame, cocreation with viewers, and engaging the everyday—how do the *Nuclear Panels* measure up?[58]

Form: Performing Commentary

By the 1960s, the *aesthetic* term "direct action" typically denoted a focus on facture—the creation of the artwork as spectacle itself—rather than implying social engagement per se. In the 1950s, however, this distinction between political "direct action" and aesthetic *akshon* was indeterminate, and my sense is that Toshi, among others, would have refused to distinguish between these two modes.[59] Her regular engagement of audiences—their testimony, their reactions, their feedback—were, in and of themselves, incitements to the cocreation, the cofacture as it were, of the *Nuclear Panels* as an evolving series. Formal inadequacy was by far the most common critique of the socialist realism and reportage art that had dominated the Independent Exhibit, and the arts world more generally, in the decade from 1945 to 1955. And it was on formal grounds that the Marukis received most of their negative press, critiques asking them to "go a step further, aesthetically"[60] or faulting them for relying on propagandistic exaggeration or overworked medieval motifs in their sketch work. I would suggest, however, that dismissal of the Marukis' work as uninteresting at the level of form is too simplistic and one-dimensional in that it completely misses the incredible experimentation in which Toshi engaged as a performative interlocutor working the edges of the paintings. In short, I would argue that the *Nuclear Panels* should be understood, formally, not only as visual objects but also as interactive performance art, and that the interpretive panels, whose text is always displayed alongside the paintings in museums today, constitute the material residue of that performative valence.[61]

For Toshi, the *Nuclear Panels* were always part of a multimedia production in which she offered dramatic verbal "commentary" (*kaisetsu*) or "narration" (*etoki*) while standing alongside, or engaging the crowds in front of, the visual works. On August 18, 1950, for instance, a number of leftist groups gathered in the Yūrakuchō neighborhood of Tokyo to discuss, celebrate, and commemorate the Marukis' completion of the first three nuclear works—*Ghosts, Fire,* and *Water*—which had been on display from the 15th to the 20th of August 1950 at the Ginza Mitsukoshi department store. Though not specifically sponsored by the Japanese Communist Party,[62] the gathering was still less than legal and was held without notifying the occupation headquarters. When the hall filled and police arrived, demanding that the meeting break up immediately, the organizers pushed back, maintaining (cunningly) that it was not a communist meeting but an art display. And, indeed, Toshi was to be found standing in front of the panels narrating their contents, while "husband

Maruki Iri stood, close-mouthed, beside her." Toshi was overcome with emotion, breaking down in tears, at which point Iri directed her to "talk about something other than the paintings," a remark she ignored.[63] She later wrote, "It's not normal for an artist to stand in front of her artwork offering explanations, and I had to fight against a sense of embarrassment to do it, but the people listening to me would cry, and I would cry as I talked, and there just wasn't any room for shame."[64]

In fact, she had been giving spoken commentary nearly constantly since the exhibit's opening. According to some accounts as many as fifteen thousand people visited the exhibit on the first day.[65] Toshi recalls that people constantly asked, "Why do so many of them [the people in *Ghosts*] have their hands out in front of themselves?" And "Why is everyone naked?"

> So I started giving explanations. I stood in front of my own art and explained what was going on. Iri told me to stop, but I felt that people deserved an explanation. . . . A real debate broke out in front of the paintings. Iri said, "Look what you've started! Hush already." And so I wrote up a description and attached it to the artwork.[66]

This write-up, the first instantiation of the interpretive panels that are still in use at the Maruki Gallery, did not stem the tide of questions, and Toshi resolved to continue offering verbal commentary in front of the artworks whenever she was present, in person, at an exhibit. When not providing verbal commentary on the panels and interacting with viewers, Toshi commonly sketched the crowds, evincing her intensive interest in how spectators interacted with the art, whether stroking the paper, addressing the human figures, or making offerings for the peaceful repose of the dead (fig. 6.7).

Indeed, Toshi's verbal commentaries grew and changed over time as she shaped them to reflect her audience (school children, labor union members, Korean residents of Japan, Hiroshima survivors, museum-goers in the United States, comrades in the People's Republic of China, and so forth) and as she updated them to include new information and insights offered by viewers themselves. She published any number of variations in the commentaries over the years, with newspapers often carrying a full or partial transcript of her vocal performance.[67] With the gradual concretization of this performative aspect of the artworks—following the establishment of the Maruki Gallery, the passing of most atomic survivors, and Toshi's own death—this vocal element materialized into the short poems that now

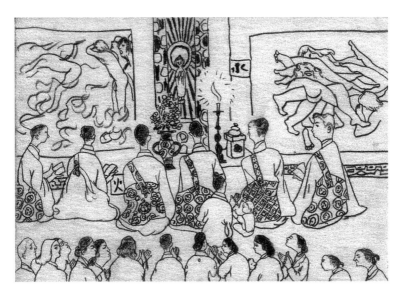

Fig. 6.7 Akamatsu Toshiko. Untitled. 1951. Pencil and charcoal on paper. Private collection. The first five works in the *Nuclear Panels* series (*Ghosts, Fire, Water, Rainbow,* and *Boys and Girls*) were on display at Toshi's natal temple Zenshōji, in Chippubetsu, from November 10 through 12, 1951. Parishioners, from the temple and from surrounding villages, lined up in the snow outside to await their turn to enter. Many brought offerings with them— apples, flowers, prayers, incense, and cash—and the monetary donations were generous enough to be able to offer a full, formal Buddhist ceremony on the last day of the exhibit, intoning prayers for the pacification of the spirits of the nuclear dead.

appear alongside the panels whenever they are displayed. In these poems, however, we can still sense the urgency and emotional power of Toshi's original embodied practice, as in the current poem for "Water," a portion of which reads

Water, water
All wandering searching for water
Fleeing from the licking flames searching for a last drop of water

A hurt mother clutching her child running along the river
Falling into the deep part and scrambling back desperately to the
 shallow
Run! through the fierce flames enveloping the river
Stopping only to cool her face in the water.[68]

In my understanding, then, the *Nuclear Panels* are multimedia pieces: part painting, part performance art, and now part poem. Though they clearly have reportage elements, the immediacy of the gatherings (at which they were displayed, interpreted, and subjected to crowd input, extension, challenge, and correction) means that they stayed engaged as a form of direct action, at least during the early years of peripatetic exhibition. I do not, therefore, recognize any gap between art and direct action on which they can be faulted for formal inadequacy.[69]

Frame: Beyond the Establishment

A second core characteristic of direct action was the attempt to exceed the arts establishment (*gadan*) frame, that is, to get out of the museum and into the streets, away from juried exhibits and toward freely produced and freely circulated art, to eschew the critical judgments of stuffy arts journals and ignite social revolution. The Marukis excelled at this, bringing their *Nuclear Panels* and Toshi's accompanying verbal performance to elementary school gymnasiums, labor union halls, Buddhist temples, train stations, street crossings, political rallies, and a host of other settings. According to Okamura Yukinori's research, which has included archival searches as well as surveys and collaborative calls for the sharing of materials, the Marukis organized and attended no fewer than thirteen displays of the *Nuclear Panels* in 1950. The first three were of *Ghosts* only, while the other ten included *Fire* and *Water*. Five were in the Tokyo area and two in Hiroshima, while the remaining displays traveled to small towns and midsized municipalities across western Japan. The following year, in 1951, they organized and attended, by current count, an astonishing forty-five displays, as far south as Wakayama Prefecture (near Nara) and as far north as Asahikawa (in Hokkaidō).[70] Ōyama Kunio has estimated that in 1950 and 1951 alone, the *Nuclear Panels* were on display for a total of 323 days with some 649,000 people viewing them.[71] Initially, the panels had been mounted in temporary frames for the 1950 Independent Exhibit, and rolled up for transport. To enable easier movement of the extremely large artworks and to protect them from wear and tear, the couple hit upon the idea of mounting them on sturdy folding screens. These could be collapsed, attached to backpack-like straps, and carried by two people.[72]

Toshi maintained a notebook in which she furiously scribbled notes, trying to keep track of when and where the panels were to go on display, what preparations she needed to make (for cameraman, day-of flyers), who the contact people were (the responsible parties, legally accountable for the

rental of the space), and so forth. The notebook is an absolute flurry of information, itself comprising a visually arresting record of how all-consuming this commitment was for her, and she also used it to jot down notes on conversations she had with viewers. She drew on these notes later in her artistic process, sometimes turning them into scenes in future panels, sometimes composing newspaper columns and journal articles based around them or adding them to her verbal repertoire. One page of the manuscript,[73] for instance, shows telegraphic notes about the "GHQ" and an exchange she had with a US soldier and a *pan-pan* girl ("No moa Hiroshima. Purizu sain."), an episode that later made it into one of her memoirs.

> Yokusuka. I put up a big sign that read "Exhibit of *Nuclear Panels* Here." Right next door was a GI bar with its red and blue neon flashing. Two days in a row a French-language poster protesting nuclear weapons had been torn down. But I kept standing in front of my art and talking.
>
> Along came a navy shipman, *geta* on his feet, smacking his chewing gum, tall and thin and blue-eyed, his arm wrapped around a young *pan-pan* girl.
>
> "No more Hiroshimas." Get your boyfriend to sign, too, I said, passing over the pencil. "Sure," she nodded. "Hey, it says No More Hiroshimas. Sign up!" and she shoved the pencil at his chest. Meek and mild, he took the pencil and signed his name in uncertain letters.
>
> She must have spread the word because before long, we had a wave of Navy men and *pan-pan* girls in summer dresses and *geta* all lined up to sign.[74]

This exchange happens not at a private salon, a museum, or a gallery debut, but at street level, outside a GI bar where everyman soldiers consort with Japanese prostitutes.

To cite but one other instance, on November 18, 1951, high school student Yoshitome Yō attended an exhibit of the *Nuclear Panels* that was taking place at a local elementary school auditorium in Yonago City. He had been encouraged by his friend Nonoshita Tōru, who thought Yoshitome would be excited by both the artistic and the political aspects of the exhibit. Yoshitome recalls that the auditorium was still a shambles, not yet fully repaired from the air raids of 1945. "The walls were filthy, the glass in the windows was broken, the ceiling sagged, and there were electrical

wires dangling everywhere. The place was really dark" and it was hard to see the details of the artwork.[75] Nevertheless, he was inspired enough by what he saw that day to leave his hometown, search out the Marukis in Katase, and join them there to study painting. In fact, public demand to see the paintings was so intense that Toshi and Iri entrusted them to teams of these students, who toured them around the country for the next fifteen years.

As one more measure of their willingness to distance themselves from the arts establishment, it is worth bearing in mind that these exhibits of the *Nuclear Panels* were, strictly speaking, illegal. They contravened dominant interpretations of item 4 of the Press Code for Japan (SCAPIN-33, discussed above). As Okamura Yukinori and others have shown, after the Independent debut in February 1950, the Marukis adopted a conscious strategy vis-à-vis media concerning the traveling exhibits. Prior to 1952, advance notice of the exhibits was generally not carried in major newspapers. Rather, notices appeared in local papers, student newsletters, and in small-batch mimeographed circulars.[76] Aside from this, day-of notices were often handwritten on the spot (generally by Iri, a calligrapher) and posted around the neighborhood only hours before the shows. Okamura suggests that this was a tactic aimed at avoiding the notice of occupation authorities, who almost certainly would have shut down the exhibits as fomenting anti-American sentiment.[77] The Marukis' tactics were something of an end run around both the artistic establishment and the political establishment, communicating instead directly with people all over Japan.

Cocreation with Viewers: Testimony

The Marukis' peripatetic nuclear displays throughout 1950 and 1951 actively engaged people not just as audience members or spectators, but also as active collaborators invited to comment on, challenge, extend, correct, and question the artwork and to engage with it in a host of other ways. One regular feature of viewer interaction with the panels involved people "touching and stroking" the painting's surface.[78] In an early exhibit, Toshi put up a sign asking people not to touch the paintings, lest they damage them, but she quickly gave up, reasoning that people simply needed to engage with the art in this manner. In other venues, people spoke to the paintings, burned incense and made offerings of fruit and sutra recitations before them, recited poetry, held political rallies, and gathered signatures on anti-war and anti-nuclear-proliferation petitions.

Commonly, as Toshi was providing her spoken word commentary, members of the audience would come forward, take the microphone, and begin relating their own stories of Hiroshima. "Whether in Muroran up in Hokkaidō, or way down in Kyūshū, somehow standing in front of the panels gives them the courage to speak of their own experiences": a daughter who for four days was unable to put down the chopsticks she had been holding at the time of the blast, a neighbor who burned alive, a child lost.[79] Many of these testimonies found their way into scenes the Marukis painted in future panels; others recirculated in Toshi's spoken commentary or in alternate media, such as Toshi's many children's books.[80] Because the *Nuclear Panels,* as visual art and as spoken word performance, were made up so thoroughly of the many testimonies the Marukis heard from survivors all over Japan, Toshi suggested that the works were, in fact, "crowd-produced paintings of tragedy" (*taisei ga egakasareta higan no zu*).[81]

Of course, some of their most intensively collaborative interactions came at displays in and around Hiroshima. A display held in 1950 from October 5 through 9 at the Citi Genshinchi Bunkakaikan (City cultural hall at the hypocenter) involved the recitation of poems composed by atomic bomb survivors, a roundtable discussion with Toshi and Iri (moderated by Tsubuo Shigeji, poet and Communist Party member), and other interactive events.[82] On October 6, the Marukis gave an interview to *Chūgoku shinbun,* the major Hiroshima paper—a rare departure, for them, from less well-known venues—to announce the just-opened exhibit and to make an appeal to the citizens of Hiroshima. "Though [these paintings] are based on the things we saw with our own eyes right after the bombing, we were not there at the time of the blast. So we hope to use this exhibition as an opportunity to hear directly from those who experienced the blast, going on to make a fourth and a fifth panel" in the series.[83] An overview of the exhibit, published in late October, noted that while attendance at the three-day event in Hiroshima was nowhere near the levels at the Tokyo exhibits, still some 2,668 tickets had been sold and a number of people joined Toshi, "standing with her in front of the paintings to describe the scenes" and to add their testimony.[84] Indeed, though the Marukis intended to cap the series, first at three panels, then at five, and then at ten, their cocollaborators across Japan demanded that they continue their work for decades, throughout the Cold War period. All in all they ended up completing fifteen paintings in the series, not finishing the last (*Nagasaki*) until 1982.[85]

Critical Engagement with the Everyday:
Alternative Media and Distribution

For Toshi, Iri, and the millions of Japanese people who viewed, interacted with, and coconstructed the *Nuclear Panels,* the possibility of a nuclear war erupting on the Korean peninsula was a tangible and immediate threat. The Marukis were clearly content to have their artwork, in however instrumentalized a fashion, serve as a goad toward antinuclear and antiwar sentiment.[86] Throughout 1950 and 1951, Toshi (and often Iri) traveled with the *Nuclear Panels,* taking them the full length of the Japanese home islands. Even though admission fees were generally minimal or even free, the couple was well aware that demand to see the paintings—the need that everyday people felt to engage with their depictions of the atomic aftermath—far outstripped their abilities to display it. Relinquishing control of their artwork for several years and in several ways, the Marukis sought to increase the "direct action" impact of their collaborative artwork by pursuing alternative forms of media throughout the 1950s and into the 1960s.

The first instance of the Marukis' use of alternative media came scarcely one month after the initial display of *Ghosts* at the Independent exhibit. On March 8, 1950, Toshi participated in the Osaka International Women's Day Cultural Festival (*Osaka kokusai fujin dei bunkasai*), where some one thousand women gathered with youth in City Hall North. The emotionally charged rally began at 1:00 p.m., with speeches and slogan chanting, and ended at 5:00 p.m. with a demonstration parade that wound around the hall. According to newspaper reports from the time, Toshi displayed a "reproduction" (*mosha*) of *Ghosts* at the entrance of the hall, where she offered spoken-word commentary narrating the tragedy at Hiroshima, thus "strengthening the resolve" of some five thousand march participants in the antiwar cause.[87] In other words, demand to see *Ghosts* was intense enough to call for the creation of the reproduction, so that the painting could, in essence, be in two places at once.[88] As Okamura Yukinori's research has revealed, immediately after the painting's debut in Tokyo at the close of the Independent Exhibit, Toshi and Iri returned to their atelier in Katase, where Hamada Yoshihide and several other of the young artists then living with the Marukis began work on creating a reproduction under the couple's direction. Both the original painting (*honsaku*) and the reproduction (*saiseisakuban*) traveled the country, each with a small team of students whom the Marukis entrusted with the painting and the testimonies.

The reproductions—eventually versions of *Fire* and *Water* were made too—do not seem to have been as powerful as the originals. Toshi reported

that "My voice would get hoarse as I stood in front [of the reproduction], running in cold sweat, as I tried to convey through the power of the voice what I felt the image alone could not transmit."[89] Indeed, the composition is more crowded than the original, the lines more distinct, and the *sumi* wash less textured in the reproduction, and this, along with a number of other smaller differences, significantly lessens the visual impact of the panels. In some ways, the reproductions are too visually obvious, and thus easier to look away from. Nevertheless, the reproductions remained on display until 1996 and are now in possession of the Hiroshima City Museum of Contemporary Art (Hiroshima-shi gendai bijutsukan).

Answering the nearly insatiable demand for public viewings of the artwork, Toshi and Iri engaged a variety of other alternative media as well, often working collaboratively and openly with a larger team of artists, students, and organizers. Considering how best to reach children with their message and artwork, Toshi and Iri collaborated with the Peace Association (Heiwa o mamoru kai) to create and distribute a picture book titled *Pikadon* (Flash boom). Published on the fifth anniversary of the bombings, the book ran to sixty-six pages. In it, an old woman (modeled on Iri's mother, Suma) narrates, via flashback, her story of surviving the atomic bombing. Though children would be comforted to know that the narrator survives, the picture book spares no detail, including any number of images of the dead and dying. The page titled "Hypocenter," for instance, reads, "In the train a young girl held tightly onto the hand straps. She didn't appear injured at all, but there she lay, dead, her head resting against the head of a soldier, who was burnt black all over."[90] The accompanying image shows the girl and the soldier, still airborne from the explosion, with her clothing burning off her body and his facial skin melting.

According to Kamishō Ichirō, Ikeda Sachiko called on the Marukis while they were at work on *Fire* and *Water*. Then employed as an editor for the Potsdam Press, Ikeda had been inspired by Chinese pictorial publications for hypoliterate peasants, and she wanted to see if the Marukis would be willing to try their hand at creating one. They agreed and, working at lightning speed, had the storyboards prepared within about a week and a half. The Potsdam Press, funded at least in part by private financiers involved in trade between Japan and the Soviet Union, printed some thirty thousand copies of the book and distributed them through labor unions across Japan. Rather than following a coherent, linear plot, the story jumbles together scenes, places, themes, and details from the first three *Nuclear Panels* in an impressionistic manner: drowned bodies, people caught under

the rubble, irradiated pumpkins, swallows with their wing feathers burnt off, a mother and child swallowed in fire. Kozawa Setsuko has argued that the *Nuclear Panels* are in fact a "giant picture book" focused on the people who died in the bombing, while *Pikadon* is a "small picture book" told from the vantage point of a survivor, so that her everyday life and the tenacity of continued survival becomes the focus of this version of the panels.[91]

As straightforward in its verbal elements as it was in its visuals, the picture book eschews the passive verb constructions that were pervasive in media coverage at the time—the bomb "was dropped" (*tōka sareta*)—for an agential, if still indirect, phrasing. From August 7 through 13, 1950, Toshi and Iri displayed sixty-four sketches from *Pikadon* at the Nihonbashi Maruzen Gallery in Tokyo, in something of a book launch. And, indeed, the book was poised to be enormously popular, but the Marukis had flown too close to the sun. Before a second run, which the press planned to sell for thirty yen, could be printed, occupation forces issued an order prohibiting sales and confiscated the original artwork, which has yet to be recovered and may have been destroyed by the CCD (Civil Censorship Detachment).[92] Probably the sentence that drew the eyes of occupation censors comes on the very first page. The old woman remarks candidly, "It's not like the bomb fell by itself; somebody had to drop it" (*Pika wa hito ga otosanya ochitekon*). She repeats this sentiment again on the very last spread, remarking, "The bomb wasn't like a landslide. It didn't just fall by itself" (*Pika wa yamabokareta a chigau. Hito ga otosanya ochitekon*).[93]

This was not the only time the Marukis walked a tightrope with the forces of occupation censorship. They also collaborated on the creation of a filmic version of *Pikadon,* which was produced sometime between April and June of 1950 (plate 13).[94] Using 35 mm, and filming in full color, they (or someone with whom they worked) created a thirty-six-frame slide show and an accompanying *kaisetsu* (commentary) booklet that included instructions on its use. Titled *Pikadon: Hiroshima genbaku monogatari* (Flash boom: Hiroshima atomic bomb story), the film could be projected, one slide at a time, while the operator read the accompanying text aloud. Little is known about when, where, and how often the slide show was used, but we do know that in 1952, on the 15th through 17th of August, some 9,907 adults and more than 3,000 children saw the film during a three-day event protesting the Tachikawa Airbase, which was then being used by the US military as a liftoff site for bombing runs during the Korean War.[95]

Once censorship practices loosened after the occupation's end, the Marukis also collaborated on the creation of a slide show version of the

Nuclear Panels themselves, creating a thirty-eight-slide film. The instructional page in the promotional materials for this visual version notes that the slides cover the first five *Nuclear Panels* (*Ghosts, Fire, Water, Rainbow,* and *Boys and Girls*), which have been making ceaseless tours of Japan. The ad copy continues, noting that because the panels themselves are "panoramic" in size, they might not be suitable for all venues. By contrast, the slide version allows for display in smaller spaces and the operator is directed to "quietly pull the film along [in front of the projector light], so that it appears that the viewers are walking slowly in front of the exhibit." Each section of the panels has been made to fit a single slide. The accompanying text for the first slide begins with the dropping of the bomb from a B-29 on August 6 of Shōwa 20 (1945) and says that Maruki Iri and Akamatsu Toshiko have drawn the suffering of the "victims of the bomb" (*genbaku no giseisha*) in moving variety and detail, out of a sincere desire to end war.[96] Most of the narrative commentary (*kaisetsu*) repeats passages verbatim from Toshi's verbal performances and her published versions of those,[97] but these have been interspersed with information on the artists and viewing suggestions, directing viewers to consider a particular detail: "What are those two girls gazing out at?" "Beside the bodies of humans, the corpse of a chicken." "A baby, dropped there on the ground. Where are its parents?"

In creating visual materials—slide shows, picture books, and large-scale paintings—showing the deadly effects of the atomic bombing on the human body, and in implicating the US military as culpable for that bombing, the Marukis flew in the face of SCAPIN-33 and occupation censorship practices. On May 13, 1946, censors had set a precedent by banning distribution of a film showing the bombing of Hiroshima, and the CCD followed up with similar bans regularly through the end of the occupation in April 1952. Occupation sensitivity to visual and verbal depictions of the atomic aftermath grew even more fine-tuned in the wake of the Stockholm Appeal. Promulgated on March 15, 1950, by the World Peace Council, the appeal called for an absolute ban on nuclear weapons. Originated by French communist and physicist Frédéric Joliot-Curie and signed by some 6.4 million Japanese during 1950 and 1951, the text of the appeal reads:

> We demand the outlawing of atomic weapons as instruments of intimidation and mass murder of peoples. We demand strict international control to enforce this measure. We believe that any government which first uses atomic weapons against any other country whatsoever will be committing a crime against humanity and should be dealt with as a

war criminal. We call on all men and women of good will throughout the world to sign this appeal.

The Marukis and others working with them regularly collected signatures—for this and other petitions—at protest events connected with the display of their artworks.[98] As discussed in chapter 5, Toshi had attended sessions of the International Military Tribunal for the Far East (IMTFE) and had a clear idea of the discourse surrounding accusations of "war crimes" (*hanzai*) in Japan. There can be no doubt that the Marukis, and Toshi in particular, understood their nuclear artwork to constitute "direct action."[99]

But, Does It Work?

Visual displays of the *Nuclear Panels,* then, were part and parcel of a broader culture of protest in 1950s and 1960s Japan and an international peace effort that spanned the globe. In addition to numerous displays in Japan, information on which is still being actively collected by the Maruki Gallery and other research units, the *Nuclear Panels* traveled widely in international venues throughout the Cold War, embarking on a European tour in 1955 (including stops in Denmark, Hungary, Romania, England, and Italy), a world tour in 1956 (China, Korea, Mongolia, the USSR, West Germany, Belgium, Ceylon, and South Africa, among other stops), an Australian tour in 1958, and a US tour in 1970 and 1971. The series continues to travel today. Jingūji, a socially engaged Zen temple in Matsumoto, organizes an annual exhibit of several of the *Nuclear Panels* each August, during the late summer festival of the dead (Obon),[100] for instance, and the full series returned to the United States for a limited East Coast tour in the summer of 2015.

Throughout the 1970s and 1980s—and climaxing with the fiftieth anniversary of the bombings in 1995 and the couple's nomination for the Nobel Peace Prize—Toshi and Iri have been all but canonized as pacifist heroes. In English-language scholarship and criticism, they are remembered exclusively for their work on the *Nuclear Panels,*[101] and a hagiographical pull has proven almost inescapable domestically as well, where the couple figures largely as the "grandfather and grandmother" (*jiji baba*) of arts-based antiwar protest.[102] It is telling that Hariu Ichirō, one of the critics most engaged with the project of interpreting the Marukis' work, argued in 2004 that for many years the panels have been "considered without any particular basis to be anti-war and pro-peace, but no one . . . discussed

what the panels were depicting or how they did it."[103] Hariu's criticism assumes, of course, that the paintings *do,* in fact, combat war, promote peace, and contribute to the nuclear de-escalation of the planet. But do they really? And if so, how?

As W. J. T. Mitchell has argued, there is a palpable difference between what pictures *do* and what pictures *want.* He asks, "Are images the terrain on which political struggle should be waged, the site on which a new ethics is to be articulated? . . . There is a strong temptation to answer these questions with a resounding yes, and to take the critique of visual culture as a straightforward strategy of political intervention."[104] Of course, this is precisely the "temptation" to which Toshi succumbed, the strategy she invoked, and the set of assumptions from which she worked. Nowhere is this clearer than in Toshi's draft response to a telegram from the Japanese Communist Party. In late 1952, officers of the JCP sent Toshi and Iri a telegram congratulating them on their recent exhibit of *Ghosts.* In her response, Toshi enumerates some of the reasons that they made the *Nuclear Panels.*

> Our nieces and many of our friends were killed by the blast, and we also lost our father. We created the *Nuclear Panels* out of a sincere desire to pray for their peaceful repose (*meifuku o inoru*) and for that of all the many people and acquaintances who died. . . . Everyone was crying as they looked at the paintings. And, as they cried, they would continue to look. I have never before experienced such a mixture of sorrow and joy. I saw the people look, first with surprise, and then with tears in their eyes.[105]

In addition to consoling the dead, providing an outlet of grief and rage for the living, and sharing information about the bombing, the paintings have the power, Toshi avers, to stop war. She and Iri will continue their artistic work and their activism, she writes, "not letting our brushes be idle for even a moment," in order to "awaken humankind from the nightmare of war."[106] She vows, viscerally, "*Ghosts* will continue to travel until the day when we have finally choked the nightmare of war to death" (*Yūrei no zu wa sensō no akumu no nodokubi ni saikō no toime o sasu sono hi made ikite samayoi tsuzukeru no desu*).[107]

Action? Or desire? To return to Mitchell's critique: "Scopic regimes can be overturned repeatedly without any visible effect on either visual or political culture" and thus, he argues, it is time to "scale down the rhetoric of the 'power of images'" and to "refine and complicate our estimate of their power

and the way it works." Accordingly, he shifts from an optic of power to one of desire, "from the model of the dominant power to be opposed, to the model of the subaltern . . . to be invited to speak."[108] It is in issuing an invitation to speak—to speak back to the art, and to demand more from the artists—that the Marukis' *Nuclear Panels* make their most lasting contribution.

The Invitation to Speak and the Incorporation of Aggression

The early paintings in the nuclear series—the eight murals from *Ghosts* (1950) to *Relief* (1954)—focus attention on human suffering. But to what extent does the artwork also forge a connection between suffering and its causes? In other words, do the Marukis' paintings also take up the theme of personal culpability? Once again, Toshi's comments regarding the creation of the panels provides crucial insights into her evolving sense of what work the paintings should—and do—perform. Toshi's narratives suggest that she used the paintings to pre-emptively position herself before a mirror of personal reckoning. In this sense, *Death of the American POWs* represents a major shift away from the earlier mode of victim consciousness, moving instead toward a much more nuanced understanding of the complexities surrounding the pain that humans visit upon one another.

In the wake of their first North American exhibition in 1970 and 1971, the Marukis were moved, largely by viewer commentary, to revisit the issue of American casualties in Hiroshima, a topic they had first broached some twenty years earlier in *Rainbow.* Though Iri was initially resistant to the project, Toshi wanted to devote an entire mural to the deaths of American POWs in Hiroshima. The couple once again invited public input, asking people to share personal stories, memories, and materials. Based on multiple, largely anonymous, firsthand accounts, the Marukis established that shortly after the bombing, local Japanese forces dragged at least one surviving American POW from his cell near the hypocenter and into the street. A particularly vocal commander pulled in passersby, handing around a baton and demanding that each person strike a blow in vengeance. *Death of the American POWs* thus reveals that Toshi's earlier interpretive information for the mural *Rainbow,* which had suggested that American soldiers died from nuclear irradiation, declared some things to be true that were not, calling attention to the fact that the murals are not close-ended, fully accurate truths but rather require continued engagement as new information comes to the fore.

As in *Ghosts,* Toshi mentally projected herself into the now-revised scene. She describes her internal narrative as follows: "What if I had been

walking by Division Headquarters, had that baton passed to me, and been told 'Hit him!' What would I have done? This was the same time period when I was being forced to practice charging a straw figure with a spear, while yelling 'American and British bastards!' Might I not have also, full of fear, joined in among the others?"[109] These thoughts in mind, Toshi knotted a kerchief on her head and posed with a police baton in her hand, midstrike. Iri, now engaged in the project, sketched her in this pose. The naked bodies of dead and dying POWs claim the mural's central spaces, but the final image confronting the viewer is that of a kerchiefed woman, reaching over a mound of skulls with an upraised right arm (fig. 6.8). Toshi's conceptual work suggests the degree to which the panels are composed not ontologically but, rather, epistemologically. That is, while she *is* neither the

Fig. 6.8 Detail from Akamatsu Toshiko and Maruki Iri. *Genbaku no zu jūsanbu: Beihei horyō no shi* (Nuclear panel number thirteen: Death of the American POWs). 1971. 180.0 cm x 720.0 cm. Ink on paper, mounted on a linked set of four folding screens. Genbaku no zu Maruki Bijutsukan.

particular victim nor aggressor whom she impersonates, she performs herself *as* that person, a process of knowledge creation.

It has become almost a truism to observe, as one council member for the American Holocaust Museum has phrased it, "a universal willingness to commemorate suffering experienced rather than suffering caused,"[110] and indeed, as many critics have pointed out, the Marukis' earliest works adopt a victim's point of view. Beginning with this mural, however, the Marukis have begun to employ a more complicated visual dynamic, one that evinces a polyphonic engagement with issues of suffering, aggression, and culpability. The painting clearly complicates simplistic notions of a dichotomy between victim and aggressor: the skulls of Japanese whose flesh had been vaporized in the blast lie intermingled with the corpses of American soldiers, while the explanatory notes claim explicitly that the POWs were "murdered by angry Japanese" in retaliation.[111]

Importantly, Toshi's gesture of moral reckoning occurs in the subjunctive mood, composed "as if" she had been at the scene. Victor Turner has suggested that the subjunctive mood characterizes performance as a kind of meta-communication that allows for the growth of reflexivity, a liminal state in which people can reflect on the causes of crisis.[112] Recognizing Toshi's subjunctive innovation creates possibilities for viewing the panel not as a static, documentary piece but rather as open-ended and processual. After all, if Toshi can project herself into the scene, revisiting a historical moment to query what her personal responses to that moment might have been, potentially any viewer willing to engage in such self-reflection could do the same.

If *Death of the American POWs* is indeed an open invitation to self-reflection for people other than Toshi, the mirror is still cloudy. Perhaps we may polish it by clarifying what exactly this mural reflects. Recall that Toshi was not actually physically present for the beating of the American POWs, meaning that this mural visualizes not personal memory but rather what Wulf Kansteiner has called "collected memory"; that is, the mural is an artistically constructed "aggregate of individual memories,"[113] none of which are Toshi's own. For details of the clothing and physical appearance of the soldiers, she and Iri issued a public appeal for eyewitness testimony. Note the reliance on hearsay in the written commentary: "Some three hundred thousand Japanese died from the bombs you dropped. But we heard that your bombs also killed twenty-three of your own youth. Americans who had parachuted from B-29s on air raids before the bombing of Hiroshima were held there as prisoners of war. Some said

there were also women POWs."[114] The caption highlights the polyphony of the composition by noting a discrepancy between a more commonly accepted memory ("we heard") and the variant memories of a smaller sub-group ("Some said").

Nor did Toshi stop at imagining herself—and, by extension, others who were not there—participating in heinous acts on Japanese soil. In the summer of 1953, Toshi and Iri were preparing for the first international exhibitions of their *Nuclear Panels,* the first stop for which was to be Beijing. In preparation for this display, Toshi composed an address to the Chinese people. She opens thus:

> To everyone in the People's Democratic Republic of China:
> We send our heartfelt wishes for the continued brave work of con-structing the great democratic people's republic of China. And we ask your forgiveness for the many sins committed during the Second World War by Japanese people upon you, our comrades with whom we share the same blood and the same skin color (*onaji chi no onaji hifu no iro no dōhō ga kizuiteiru ama to chi to Dainiji sekai taisen ni tsuite Nihonjin ga okashita tsumi o oyurushikudasai*). We dedicate our lives in order to en-sure that Japanese people do not again commit these same errors (*ayamari*).[115]

Toshi was well aware of Japanese atrocities in China, having sat through portions of testimony concerning the Rape of Nanking during the International Military Tribunal for the Far East. She continues, noting that she prays before the buddhas daily for the return of peace to Asia (she is writing in the closing days of the Korean War), and she hopes that the panels will continue their work of "cultivating an abhorrence for war" in the world at large.[116] There is much work to do, however. After providing a version of her regular commentary on *Ghosts,* she concludes the address:

> Not us, not those ghosts, not even a buddha has ever been able to choke to death the evil demon of war who is so elusive—not yet, not yet.
> Until that day comes, that day of peace, we will continue to paint—a sixth panel, and a seventh.
> We invite your critiques, however scathing they may be, of our work.[117]

The Beijing exhibit, co-organized by the well-known and highly regarded Chinese artist Jiang Zhaohe and advertised as an "exhibit of Japanese

tragedy by two peace award–winning Japanese artists," received little public criticism, perhaps because of Toshi and Iri's then still-active communist connections; they were even introduced to Mao Zedong during their visit.[118]

If they got no "scathing" critiques from China, they surely got plenty in the wake of their US exhibits. At an exhibit in Pasadena, California, she was confronted by a viewer who wanted to know how she would feel if an American artist came to Japan, exhibiting works of art focused on the Rape of Nanking. Upon her return to Japan, she found herself swamped with mail, mounds of English-language newspaper articles on the subject. Poring over these, she recalls wondering, "Did we really not know at all what was going on? I remember hushed voices, whispering, 'Just don't rape anyone,' when our family members and friends went off to the war. We knew. We didn't know the details, but we knew. We didn't pursue it further. We let it pass in through some part of our mind and out the other in an act of silent consent."[119] She started digging for information from Japanese-language sources. A friend confided in her that he had been deployed to China, where, he says, each soldier was ordered to kill ten people. Toshi reflects that had she been in her friend's place, "chances are that I would have done the devil's work."[120]

Knowing, now, that she will have to paint another large-scale work, she engages in further subjunctive work.

> That man was just about my same age. Most men in their late 50s and early 60s had been sent to the war. Maybe it's easier for me to talk about the Nanking Massacre because I'm a woman. If I'd been born a boy, I'd have received the red slip ordering me to muster and I've have been sent off with a "Return brave and victorious" and a Rising Sun flag and war songs and all. And I may well have been shipped off to Nanking.
>
> And if I'd been ordered, "Kill!" And if I'd answered, "I am against killing." "Do you dare disobey a commanding officer? A commanding officer's order is an imperial order!" And I'd have been punished. Would my fear have gotten the best of me, then? Would I have swung over to the side of the murderers?[121]

This practice of critical self-reflection, a willingness to engage in a harrowing "what if" mode, thus constitutes an active, recurrent working method for Toshi and is a core part of her conceptual effort in much of the large-scale, mural-like artwork on which she collaborated with Iri in her mature years. In this process of moral reckoning, the "what if" carries full weight,

assuming a continuity of thought, word, and deed where the one (thought) is the beginning of the next (word) and the next (deed) along a continuum of moral expansion. This is consistent with general Buddhist ethics and philosophy, with which Toshi, as a priest's daughter, would have been deeply familiar, so that to have erred "only" in thought is not categorically different from having erred in word ("American and British bastards!") or in deed (beheading and raping Chinese civilians). Though not part of the nuclear series proper, *The Rape of Nanking* is an absolutely necessary response and correlative to those works. Today it is displayed alongside the *Nuclear Panels* at the Maruki Gallery.

In her continuing verbal and performative commentaries on and extensions of her collaborative visual artwork, Toshi draws attention to the processual quality of memory production and underscores the uncomfortable moral complexities adhering to the experience of viewing others' suffering. As Holocaust scholar Yair Auron argues, there are not one, but rather two things that "jeopardize the very existence of human society [:] violation of the rights of a human being and indifference in the face of suffering."[122] As witnesses to such suffering, we are burdened with the responsibility of proving ourselves to be not indifferent. Speaking now just of the artists, on several occasions Toshi did use penitential language to describe her artistic engagement, as when she notes that she painted *The Rape of Nanking* with "a deep feeling of apology and a whole-hearted, emotionally laden sense of contrition."[123] Likewise, the final word for the caption to *Crows,* which depicts Japanese discrimination against Koreans, reveals the depth and nature of the artists' emotional engagement with their subject matter. The caption ends with the word *gasshō,* a joining of one's hands in prayer. If art hopes to shift the "scopic regime" of the viewer, then one measure of its success—perhaps the necessary first measure—is the ability of art to shape the viewing practices of the artist and, in so doing, to shift what and how that artist sees. In this sense, the immediate object of Toshi's "direct action" in creating the *Nuclear Panels* was—if not exclusively at least explicitly—Toshi herself.

Afterword

Double Time and the Art of Seeing through Empire

Consider the untitled canvas (plate 14). *When* is this painting? In what time does it take place? When do the doves, soft as clouds, come out of the clear blue sky and sweep up these naked babies in their wings? In what time do adults, in skin tones and costumes evocative of a range of cultures, grab hands and run for the horizon with looks of joy on their faces? When (and what) have they run from, and when (and whence) are they bound?

The image itself provides some clues. A division of space overlaps a division in time: naked children, those fragile bodies that bear all beginnings, rest in the wings of doves while clothed adults (their forebears, or elder siblings?) race across the ground below. But these bodies reach us in reverse temporal order, as it is the children who lead. In terms of perspective, they are painted larger and so reside in the foreground of the picture, with the adults racing to catch up. So, one sort of time, one "when" is discerned: the turning and returning of human generations.

A second "when" pervades the images, as well, suggested by the doves as symbols of peace. The children hover in a cloud of peace, suspended above the earth's surface, while the adults rush toward them, quickly enough that hair, ribbons, dress hems, and shirt tails billow out behind. Their bodies lean forward, almost falling into the nascent, infantile future of imagined peace. The painting is easily turned inside-out, however, flipped to envision an alternate future in which adults flee wildly, escaping other objects that fall and fire from the sky: fighter planes rather than doves, bombs of war rather than wings of peace, a future in which the cloud of white birds and the hope of children to come is undone by the specter of a mushroom cloud and the threat of airborne annihilation. The "when" here is the future: whether one of pacific promise or of deathly annihilation.

As the painting becomes a poster (plate 15), new temporal specificities surface, some are foreclosed upon, and others are confirmed. In the time it

takes the eye to move, scanning the poster from top to bottom and left to right, the "when" of the image takes on specificity. The golden title, "World Conference on Banning Hydrogen and Atomic Bombs" (Genshibaku kin-shi sekai taikai) alerts us that we are in the atomic age and the smaller text, in white ("Fourth annual"), that we have survived that age for four years. In red, a red that echoes the crimson eyes of the doves and the scarlet dress of the running woman, we learn a date and place: August 12 through 20, Tokyo. The running adults—a sampling of South Asians, East Asians, Pacific Islanders, and Europeans that, in its "red and yellow, black and white" multiculturalism suggests early Cold War aspirations—now sprint in the direction of "banning the hydrogen bomb and ceasing further development" of atomic weapons, slogan of the Gensuikyō (Japanese Organization to Ban Hydrogen and Atomic Bombs). In this race for life, they receive the support of Guronsan tablets, "medicine for the world," said here to be effective in strengthening the liver and in restoring health and vigor.

Looking closely between the sprinting legs of the man in white, at far right, we see that the artist is, of course, Toshi (俊). This attribution brings forth further temporal layers and lenses. The dark-skinned child atop the triad of babies is the coconut/child from her wartime children's book *Journey of a Coconut* (*Yashi no mi no tabi,* 1942), the art for which she later considered (in 1989) to have constituted a war crime. The blond-haired baby looks like a younger version of Sanya, the Russian boy of whom she made a portrait during her first stay in Moscow (1938). The third baby, a Hiroshima-born child of postwar peace, is a holdover from Toshi's poster for the first annual rally to ban the bomb (1954), which featured a Japanese woman, wearing a kerchief bearing the word "Peace" and holding a baby in her arms. The image thus fuses a wide temporal variety of life experiences, creating an aspirational vision in which an atomic, Japanese baby can rest securely between a particular South Seas imperial past and the early promise of a possible Soviet-style revolution.

We might ask again: *When* is this painting? And in what time does it take place?

Another possible answer, this time theoretical in nature. As Keith Moxey has argued, "the work of art carries its own time" and the time of art is, and always will be, multiple.[124] He proposes two approaches, to be held in productive tension. On the one hand, heterochrony: the idea that "local temporalities" matter and that "the histories of non-Western cultures

cannot simply be assimilated into an evolutionary narrative that privileges the Euro-American past without distorting the meaning that time may have had in other contexts."[125] On the other hand, anachrony: the notion that "works of art cannot be kept at bay on the assumption that they belong to periods and places other than the present. The intensity and complexity of response is as embedded in time as are the works itself."[126]

Heterochrony writ large suggests the question: Is "modern" Japanese art always a belated modernity? Certainly the Meiji (1868–1912) government understood art—and particularly Western-style perspectival oil painting—as a strategic tool of modernization and an opportunity for imperial formation, as discussed in chapter 1. Heterochrony writ small, as explored in chapter 2, contextualizes the reasons why a girl from colonial Hokkaidō in Japan's far northern territories might go to art college in the imperial capital of Tokyo and thence on a sketching tour of the Japanese mandate in Micronesia. Upon her return to Tokyo, her personal experiences in the South Seas only make (public, publishable) sense as graphic war materiel, "culture for little citizens" according to one (fascist) view of Japan's temporal trajectory.

Thinking through anachronism, by contrast, allows us to see how aesthetically retrograde (where? for whom?) artistic movements can become avant-garde forms, not on some fool's errand but in a way that performs (or at least as W. J. T. Mitchell reminds us, "wants" to perform, is believed by its creators to perform) specific cultural *work*. The affective response to, and massive popularity of, proletarian arts in transwar Japan disrupts an ordinary sequence of events (prewar, war, postwar), bespeaking a continuity of desire: the persistence of "red" culture discussed in chapters 3 and 4.

Maintaining a double vision, seeing both heterochronistically and anachronistically, keeps art alive and in dialogue with both the present moment of affective response and the living context of ongoing remediation. Japanese debates on artistic wartime responsibility (chapter 5) continue unabated, as each new generation reconsiders the ethics, aesthetics, and politics of war painting. What might it have meant to them then? What does is mean for us now? Likewise, a productive double vision throws overlooked details into sharp relief, calling attention to the experimental nature of what might appear, at first glance, stale and retrograde. Thus we can identify forward-facing impulses toward direct action even in old-fashioned reportage (chapter 6).

In this manner of doubled vision, I believe that the poster, like the artist who created it, asks us to see through empire. To see through empire,

here, indicates two acts of vision occurring simultaneously. "Seeing through," in one sense: to recognize the fallacy of, to understand something as illusion; and, "seeing through" in a second sense: to employ as a lens, as in seeing through a magnifying glass or telescope. Writing in 1958, the same year she created the painting and poster above, Toshi reconsidered her earlier dream of buying an uninhabited island in the South Seas, then part of an imperial Japan.

> I returned to Tokyo, with the intention of making preparations to buy the island.
>
> On my way south, I had traveled steerage in a cargo ship, but with the money I'd earned from my exhibition in Palau, I could afford to travel second class on the return. The ship slipped along effortlessly, speeding back to port in Japan, leaving my brown-skinned friends behind.
>
> I wonder how those friends are faring now. Every time I hear of another hydrogen bomb test, my chest hurts. It's not unthinkable that those Kanakas will be wiped out.[127]

What we have here is a doubling of vision, a seeing of the Pacific through the atomic, and the atomic through the Pacific, and both via the lens of enduring imperial formation. Over the course of the nearly two decades between her first views of Micronesia in 1940 and her somber reflections of 1958, Toshi's awareness of empire—the inevitability of its visions and the distortions of its lens—sharpened. These were busy decades for her: she participated in the cocreation of imperialist children's books; traveled to and wrote in praise of a red Russia; engaged, emulated, and critiqued the occupation of Japan by Allied powers; survived the aftereffects of lingering atomic irradiation; and spoke out in protest of continued nuclear proliferation. Learning to see through empire, Toshi learned to see herself, along with Micronesians exposed to radiation from US nuclear testing in the Pacific, as belonging to a geographically dispersed but ever-growing tribe of *hibakusha* ("irradiated peoples"). Her art, thus, remains doubly avant-garde: it pushes at the borders of the aesthetic status quo from a position that is itself deeply imbricated with the front lines, and the lasting fault lines, of war.

Toshi's art is one of persistence. Her work is *opportunistic,* taking advantage of deeply compromised positions and enjoying the privilege of problematic associations (wining and dining with the colonial elite in

Japanese Micronesia, for instance). Her work is *daring,* pushing at the edges of what is sayable and showable, and maintaining an emphatically public-facing position of cultural production, as when she shows Tarō hawking his wad of Rising Sun betel juice into the Pacific or Russian docents narrating Van Gogh into socialist time. Her work is *cunning* (ducking censorship practices, whether of the Japanese military or the US occupation, with artful naming of artworks, for example). Her work is *compromised and messy* (as when she romanticizes colonial Hokkaidō, parrots the party line, or markets Islander friendships as oil painted exotica to an imperial clientele). And her work *matters* because, like all persistent labor, it is in constant contention with structural violence.

May we all be as persistent. And may we be mindful that in our everyday living, we can, in fact, build or erode, maintain or even eventually destroy structures of violence.

Notes

Epigraph. Akamatsu, *E wa daredemo kakeru,* 113.

Introduction

1 See Segi, *Nihon no zen'ei,* 140; Akamatsu, *E wa dare demo,* 141, 142, 144. For a more precise accounting of Toshi's vision, see chapter 4 of this book.

2 For more on silk scroll portraits in postwar Japan, see Hoaglund, "Protest Art in 1950s Japan: The Forgotten Reportage Painters."

3 See, for instance, Akamatsu Toshiko, "Fūshiga no koto," 16–17.

4 For more on Toshi's theories concerning social leveling and the "democratization" of art, see chapter 4.

5 Medick, "Mikro-Historie," 46. See also, Brewer, "Microhistory," 87–109, and Gregory, "*Is* Small Beautiful?" 100–110.

6 Magnússon and Szijártó. *What Is Microhistory?,* 69.

7 For more on the artwork as a site of agency, see Gell, *Art and Agency,* 1–25.

8 Baxandall, *Patterns of Intention.*

9 Clark et al. *Afflicted Powers.*

10 The major book-length studies are Kozawa, '*Genbaku no zu*'; Yoshida, *Maruki Iri Toshi no jikū;* Okamura, '*Genbaku no zu*'; and, for younger readers, Usami, '*Genbaku no zu' monogatari.*

11 Jesty, "Arts of Engagement"; Ikeda, "Japan's Haunting War Art."

12 See, for example, Dower, "Art, Children, and the Bomb;" Dower, "War, Peace and Beauty"; Minear, "Review: The Atomic-Bomb Paintings"; Templado, "The Maruki Legacy"; and Wolfe, "Toward a Japanese-American Nuclear Criticism." This wave of anglophone scholarship, it must be said, very much follows Toshi's postwar framing of her own artwork and politics. To cite but one emblematic example, her cover for the 1954 issue of *Bungaku no tomo,* which advertised itself as "a collection of anti-war, peace stories" (*hansen, heiwa no shōsetsushū*), features a young Japanese woman in a brilliant red sweater blowing a dove-shaped whistle, an action Toshi herself seems to have performed at the opening of one of the World Peace Council meetings.

13 My approach in the chapters that follow is indebted, at least in part, to discussions of "colonial sensibility" in colonial Japan. See Sand, "Imperial Japan."

14 Dower, *Embracing Defeat,* 490. For more on this logic of passivity, see Thornber, "Responsibility and Japanese Literature of the Atomic Bomb."

15 For a transwar cultural history centered on museums, see Aso, *Public Properties*. For labor unions, see Garon, *The State and Labor in Modern Japan*. For religious organizations, see Victoria, *Zen at War*. For public policy and government, see Fujitani, *Race for Empire*. For media and propaganda mechanisms, see Culver, *Glorify the Empire*.

16 See, for instance, Treat, *Writing Ground Zero;* Seaton, *Japan's Contested War Memories;* Seraphim, *War Memory and Social Politics in Japan;* Yoneyama, *Cold War Ruins;* and Zwigenberg, *Hiroshima*.

17 Mark, "Resituating Modern Japan."

18 As espoused, for instance, by Murayama Masao, *Thought and Behavior*.

19 See, for example, Young, *Japan's Total Empire;* and Harootunian, *Overcome by Modernity*.

20 Mark, "Resituating Modern Japan," 1110. Other third-wave studies of Japanese fascism include Hashimoto, *The Long Defeat;* Hoffman, *The Fascist Effect;* Mason and Lee, *Reading Colonial Japan;* Yi, *Colonizing Language;* and Kleeman, *In Transit*.

21 See, for instance, Barlow, *Foundations;* Kleeman, *Under an Imperial Sun;* Mason, *Dominant Narratives;* Kwon, *Intimate Empire;* Perry, *Recasting Red Culture;* Fujii, *Complicit Fictions;* Tansman, *The Culture of Japanese Fascism;* Bowen-Struyk, *Red Love;* Yoshimi, *Grassroots Fascism;* Hanscom, *The Real Modern;* Yi, *Colonizing Language;* Cipris, "Responsibility of Intellectuals"; Ching, "Champion of Justice"; Silverberg, "Constructing a New Cultural History of Prewar Japan"; and Treat, "Choosing to Collaborate."

22 See, for instance, Walker, *Toxic Archipelago;* Povinelli, *Economies of Abandonment;* O'Brien, "Resilience Stories"; and Jolly, "Zombification and the Politics of Debility."

23 My thinking here—particularly about the broader implications of, and conceptual frameworks for, understanding Toshi's relationship with Islanders in the Japanese Mandate in Micronesia—has been deeply influenced by a broad array of scholars, including Saranillo, "Why Asian Settler Colonialism Matters"; Suzuki, "And the View from the Ship"; Hall, "Which of These Things Is Not Like the Other"; Kauanui, "A Structure, Not an Event"; Noenoe, *Aloha Betrayed;* Fujikane and Okamura, *Asian Settler Colonialism;* Byrd, *The Transit of Empire;* Lowe, *The Intimacies of Four Continents;* Camacho, *Cultures of Commemoration;* Mita, *Palauan Children under Japanese Rule;* Snelgrove, Dhamoon, and Corntassel, "Unsettling Settler Colonialism"; Wilson, "Postcolonial Pacific Poetries;" and Te Punga Somerville, "Searching for the Trans-Indigenous."

24 On this point, see Jolly, *Communities of Effluence*.

25 Magnússon and Szijártó, *What Is Microhistory?*, 69. For more on the methodology of microhistory, see Brooks, DeCorse, and Walton, eds., *Small Worlds*.

26 For an overview of Toshi's life and artistic production, as well as excellent reproductions of many of her artworks, see Sugiyama, ed. *Maruki Toshi-ten; Genbaku no zu, ed., Maruki Toshi no sekai ten;* and Genbaku no zu, ed. *Maruki Toshi no ega.*

27 Throughout the late 1920s, Iri regularly published short, surrealist poems in the *Geibi nichinichi shinbun.* Many deal with erotic love (including "Koi," published on January 25, 1926, and "Kokoro ga kurau," published on April 12, 1926). He continued to publish regularly in *Geibi* throughout the 1930s, shifting for a time toward microfiction and then, especially after relocating to Tokyo, toward illustrated vignettes.

Chapter 1. From "Northern Gate" to "Southern Advance"

1 Toshi later wrote about these plantations. See Akamatsu, "Nan'yō dayori."

2 For an in-depth discussion of "imperial formation," see Stoler, *Imperial Debris,* 1–38.

3 Mason, *Dominant Narratives,* 4. See also Hardacre, *New Directions in the Study of Meiji Japan.*

4 *Hokkaidō no kinsei shaji kenchiku,* 14.

5 Ketelaar, "Hokkaidō Buddhism and the Early Meiji State," 534, italics in original.

6 For a full account, see Ketelaar, "Hokkaidō Buddhism and the Early Meiji State."

7 These statistics come from *Hokkaidō no kinsei shaji kenchiku,* 20.

8 Mason, *Dominant Narratives.*

9 Blaxell, "Designs of Power," 1.

10 Stoler, *Imperial Debris,* ix, x.

11 Stoler, *Imperial Debris,* 2.

12 *Dai Nihon ji'in ōkagami,* 440–443. *Shinshū Kōshōha Zenshōji kaiki hyakunen kinenshi: Shizen tokufū,* 21, 99–100.

13 Maruki Toshi, *Onna egaki no tanjō,* 17. For a more sobering account of the crushing poverty, freezing weather, and familial discord in which Toshi spent her young years, see her postwar reflections on her childhood education in Akamatsu Toshiko, "Shitei kyōiku ni kansuru shoka no iken: Fubuki."

14 Maruki Toshi, *Onna egaki no tanjō,* 21.

15 Ketelaar, "Hokkaidō Buddhism and the Early Meiji State," 546.

16 Yamanashi, "Western-Style Painting," 19. See also Kaneko, *Mirroring the Japanese Empire.* For more on the deep imbrication of modernity, imperialism, governmentality, and the arts in twentieth-century Japan, see Inaga, *Ega no rinkai,* 22–129.

17 Conant, "Japanese Painting from Edo to Meiji," 37.

18 Yoshida, *Maruki Iri Toshi no jikū,* 63.

19 Yamanashi, "Western-Style Painting," 24. For more on the gendered aspects of oil painting in Meiji-period Japan, see Bryson, "Westernizing Bodies."

20 "Zentondenhei meibo," 92.

21 Mitchell, *What Do Pictures Want?*, 148.

22 For example, the Hokkaidō historian Koshizaki Sōichi (1901–1977) managed to publish a collection of *Ainu-e* (paintings and sketches of Ainu peoples as observed by Tokugawa-era Japanese) in June 1945. Permission to print the collection in what was to be the last summer of the war, and during a time of intense resource guarding and paper shortages, gives one indication of the degree to which the narratives of enlightened rule remained crucial to justifications of Japanese sovereignty over the northern islands. Pictorial evidence of pre-"enlightened" cultures was mobilized, in the case of the Ainu as well as other indigenous populations, to underscore advances made under Japanese rule. The preface asserts that "though Ainu today only live in Hokkaidō, Karafuto and some of the Chishima Islands," they used to occupy parts of the Japanese main islands before they were "subjugated by the Yamato people." "Without written language or pictorial tradition" the Ainu proved unable to write their own histories; in the Tokugawa period Japanese moved north with the "aim of edifying the Ainu" to the extent that "today those of the Ainu race are indistinguishable from Japanese people" in their clothing, housing, appearance, occupations, and living conditions, a situation that is lamentable (only?) to the historian who wishes to understand their pre-enlightened condition and is frustrated to find access only to Meiji-era photographs of high-ranking chiefs lined up with their families outside of modern housing units and wearing rubber-soled shoes on their feet. Koshizaki, *Ainu-e*, preface page 1.

23 Mason, *Dominant Narratives*, 4.

24 *Nan'yō guntō yōran*, 29.

25 From at least the 1890s onward, the "general news" (*zappō*) columns in major Japanese newspapers, such as the *Asahi shinbun*, regularly carried notices advertising business opportunities in the South Seas and plans for colonization. See, for instance, "Nan'yō shokumin keikaku," *Asahi shinbun*, March 31, 1891. For a time, at least, the traffic went both ways: in the mid-1910s South Seas village leaders made sightseeing trips to Tokyo each August. See, for example, "Nihon kankō no Nan'yō shochō," *Asahi shinbun*, July 14, 1915.

26 *Nan'yō guntō yōran*, 1940, opening photographic cluster.

27 Inoue Toshikazu, *Senzen Nihon gurōbarizumu*, 230.

28 See, for instance, Nishino, *Umi no seimeisen*.

29 Takao and Shimomura, *Kōkoku shin chiri*, 1–2.

30 Jansen, "Japan and the World," 187.

31 Blaxell, "Designs of Power," 1.

32 Maruki Toshi, *Onna egaki no tanjō*, 84.

33 Maruki Toshi, *Onna egaki no tanjō*, 85–6.

34 Kawashima, *Jisen dessan shū*, 3.

35 Kawashima, *Hokushi to nanshi no sugata.*

36 Schenking, *Making Waves*, 38.

37 Schenking, *Making Waves*, 42.

38 One representative write-up, appearing in the *Asahi* newspaper, advertises a "plan for colonization in the South Seas," notes an array of potential enterprises and the potential for establishing further Japanese settlements, and issues a call for contact from all interested parties. *Asahi shinbun* morning edition (March 31, 1891), page 1 of advertising section. For more on these early waves of Japanese settler colonials, and the appeal that Micronesia had for cultural producers in particular, see Okaya, *Nankai hyōtō;* Okaya and Aoki, eds., *Bijutsukatachi no Nan'yō guntō;* and Takizawa, "Nan'yō guntō to Nihon kindai bijutsu."

39 Kleeman, *Under an Imperial Sun,* 15.

40 For one account of the effect that the policies concerning the "southern advance" had on arts production, see Takizawa, "Nanshin seisaku to bijutsu."

41 Hijikata, *Hijikata Hisakatsu nikki,* vol. 5. See the entries for January 27, January 29, February 14, February 17, March 5, March 12, March 17, and April 2, 1940.

42 Hijikata, *Hijikata Hisakatsu nikki,* vol 5. Entry for March 17, 1940.

43 Hijikata, *Hijikata Hisakatsu nikki,* vol 5. The entry from Tuesday, March 5, 1940, reads in part: "At Saeki's place we listened to the phonograph and drank coffee and spent forever talking about traditional Palauan things. He even treated us to dinner before sending us home, again by car, around 7:30."

44 The phrase is from Abel, *Redacted,* 9.

45 "Seisen bijutsu no aki: Nika-ten nyūsen happyō." *Hokkaidō shinbun,* August 30, 1938. For more on the Nika group and its female members, see Kokatsu Reiko, ed., *Hashiru onnatachi,* 9–20, 130, and 178. Also, Kitahara Megumi, ed., *Nijūseki no josei bijutsuka,* 53–81. For an English-language assessment of the Nikakai's (Second Section Society's) position with respect to the Japanese arts establishment and Western modernisms in the 1910s and 1920s, see Volk, "Authority, Autonomy," 467–468.

46 Volk, "Authority, Autonomy," 467.

47 For an account of some of Toshi's Micronesian sketch work, see Eubanks, "Avant-Garde in the South Seas."

48 Perhaps her most unabashedly colonialist sketch appeared in the 1940 primer *New Youth Culture (Shinjidō bunka)*: a drawing of Islander girls learning sewing handicraft skills in a Japanese-medium school. Toshi's

drawing shows only the girls, omitting a view of their Japanese teacher, and her prose is carefully circumspect, pointing to the girls' imperial formation (shorn heads due to lice, school uniforms, complete silence, and orderly obedience). Akamatsu, "Yappu-tō no tabi," 182–183.

49 Point 1 reads: "*Futari no kodomo ga kāsan kara heitai ni korosare shinde, sensō ga okori, ie no naka de sawaida node, bikkurishite nigeta. Korōruto hontō no hanashi.*" Point 2 reads: "*Korōruto hontō tatakai Teppō to Amerika no gunkan ga kita. Sono teppō wo karate hontō no hei wo. . . .*" Akamatsu Toshiko, *Nan'yō nōto.*

50 For more on Japanese-language schooling in Imperial Japanese territories and a deeply textured review of the variety of cultural pressures brought to bear through that schooling, see Yi, *Colonizing Language,* 1–23.

51 According to the Maruki Museum's reports of the event, Hisakatsu made these remarks on May 6, 1967, at the opening celebration for the Maruki Gallery. Okamura, "'Akamatsu Toshiko to Nan'yō guntō' *Hijikata Hisakatsu nikki* yori." *Gakugeiin nisshi,* Feb. 11, 2015. Accessed June 10, 2015, http://fine.ap.teacup.com/maruki-g/2471.html.

52 Abel, *Redacted,* 1.

53 Abel, *Redacted,* 2 and 9.

54 Noguchi and others in the South Seas Bureau were hard-pressed, by 1940, to lure new settlers from the home islands, and positive news coverage encouraging immigration was always welcome. An example was the 1941 article in the *Asahi* morning news titled "From the South Seas Islands to Everyone in the *Naichi:* Don't Worry!" penned by a certain "Sugimura Mitsuko in Yap." Sugimura, "Nanyō guntō kara naichi no mina-sama e: shinpai shinaidekudasai." 6. For other recruiting attempts, see Kubota, *Nan'yō no tenchi,* especially 235–237. Also Kubo, *Nan'yō ryokō.*

55 Akamatsu Toshiko, "Nan'yō tokorodokoro," 2.

56 Abel, *Redacted,* 157.

57 Toshi's notebooks contain other memos of colonial failure, such as her jottings about the Japanese settlement at Yamato-mura, which she describes, following a conversation with a Mr. Shiomi and a Mr. Kurioka, in these telegraphic terms: "No facilities for rest and relaxation. No activities to do. [Youth] want to leave town. Circulation of movies. Health services and mail service only two or three times a year. Really nothing to do. Problems with health. Problems with physical development. Until age 2 or 3 they are pretty big. After that, development is delayed. Provisions, water, Inner South Seas Policy. Recovery from illness slow. [. . .] Can see that the group of girls is getting older and older. Need to get married soon. Should it be with someone who's from here? Or should they bring in someone fresh? Didn't last two hours. [. . .] Yamato Village built according to plan. Each family apportioned land. [. . .] What happened with that [not legible] denuded

mountain? Planting pineapples there a mistake. [. . .] Problems unloading pineapples. You can only send the cans to the army or export. Army—5 yen. Export—7 yen. Pineapple plantings now cover entire plain. Thinking of introducing tenant farmers and doing something new with it. What will they plant? Because it's rented land, you'd have to equip it and you wouldn't make anything on the property transfer."

58 Akamatsu Toshiko, "Nan'yō enikki," 226.

59 It is possible that Toshi explicitly discussed this publication strategy with her sometime dinner companion Noguchi Masaaki, who worked for the South Seas Islands Cultural Society. In March, shortly before the trip to Kayangel, Noguchi was ordered to provide ten pages of copy for the pro-imperialist, notionally educational journal *Umi o koete* (Across the seas). Noguchi opens the article with effusive praise for Japanese development the islands. "Those of us living in Palau never really think about the distance between here and the *naichi*. Others might talk to us about the *gaichi*, and about overseas development (*kaigai hatten*), but we ourselves never think of it in that way. We often say to one another, jokingly, that the South Seas Bureau should really be reassigned to the Ministry of the Interior (Naimushō), rather than the Ministry of Colonization (Kaitakushō)" (Noguchi, "Nan'yō guntō ni okeru bunka no binkon," 65). The last paragraphs of his article, however, are a laundry list of unfunded or underfunded initiatives. Noguchi was well aware of what would play in the press and just how to pitch his own prose for publication. Toshi's own writings were subjected to a heavily edited hack job for the September 1940 issue of *Umi o koete,* in which, according to the editors, "Akamatsu Toshiko of the Nika Arts Group has just come back [from her trip to the South Seas Islands] and shares with us here her vivid vignettes of life there for use in elementary schools as free educational materials" (Akamatsu Toshiko [as illustrator, no author listed], "Nan'yō dayori," 82). The vignette follows Toshi to places she never visited (including Saipan) and borrows some of Toshi's artwork and prose to bejewel obviously propagandistic accounts of cheery Islander school children conversing in proper Japanese and celebrating Meiji Day with a footrace.

60 Akamatsu Toshiko, "Nan'yō enikki," 227.

61 Akamatsu Toshiko, "Nan'yō enikki," 227.

62 Akamatsu Toshiko, "Nan'yō enikki," 229.

63 Akamatsu Toshiko. "Nan'yō o egaku," n.p. In fact, tour groups of South Seas Islanders did occasionally make their way to the metropole for sightseeing, as with the group of village chiefs whose picture—they are seated cross-legged and bare-chested on the deck of a steamship—adorns page 5 of the *Asahi Shinbun* morning edition for July 14, 1915.

64 As I demonstrate in this chapter, much of Toshi's artwork and many of her publications provide hints that allow us to read them against the grain of

imperial formation narratives. She is not, however, perfect in this regard, having published, for instance, an illustrated vignette on rubber tapping. See Akamatsu, "Minami no kuni no otayori."

65 Akamatsu Toshiko, "Nan'yō dokugen," 44.

Chapter 2: Creating "Culture for Little Countrymen"

1 From Akamatsu Toshiko's unpublished Micronesian notebook (*Nan'yō nōto*), manuscript pages 26–27. The entry is not dated, but internal evidence and surrounding entries make it clear that it dates to March 30, 1940 (or perhaps March 29).

2 Maruki, *Onna egaki no tanjō*, 91. Though accounting for inflation in the yen between 1940 and 2010 is an imperfect science, not to mention the difficulty of converting the figure to US dollars, the figure Toshi cites is probably close to $400,000 USD in modern currency (calculated for the year 2010).

3 Maruki, *Jōjō ruten*, 193.

4 Maruki, *Jōjō ruten*, 194–195. In addition to this solo show, Toshi also displayed some of her Micronesian sketches at the Twenty-seventh Annual Nika-ten group exhibit from August 29 through September 20, 1940. Okamura, *Shiryō yō nenpu*, 75.

5 Some of these works and a version of the write-ups later appeared in an issue of *Shinjōen* as the article "Futatsu no fūkei" (Two views). Akamatsu, "Futatsu no fūkei," n.p. Though Toshi's description of Mekaru may be read as a subtly positive comment on the Japanese rule in Micronesia, as discussed in chapter 1, her passage describing the situation with Tarō is a scathing, if oblique, condemnation of misplaced Japanese paternalism.

6 Aso, *Public Properties*, 7.

7 Tansman, *The Culture of Japanese Fascism*, 1.

8 Okamura, *Shiryō yō nenpu*, 75.

9 For more on wartime military "reportage" from the various fronts, see Narita, *"Rekishi" wa ikani katarareta ka?*, 106–192. For another example of Toshi's wartime cover art for South Seas–related publications, this time showing Islander women relaxing in the shade, see Akamatsu, *Nanpō minwa*.

10 Akamatsu, *Sekido kairyū*.

11 Akamatsu, *Hatsu koi*.

12 Maruki, *Jōjō ruten*, 224–225; Usami, *Ikebukuro Monparunassu*, 457.

13 Peacock, *Innocent Weapons*, 2, 3. For a summation of Soviet prowar children's publications, see also Kōno, "Ehon to puropaganda."

14 Ōfuji, "Senchūki no jidōbungaku hyōron."

15 Katō Takeo, "Shōkokumin bungaku no hōkō"; *Shōkokumin Bunka* (Jan. 1943), cited in Ōfuji, "Senchūki no jidōbungaku hyōron," 155. For a sense of how the logic of child-centrism shifted to one of militaristic drilling, see

Ogawa Mimei's 1942 study *The Path Towards a New Children's Literature* (*Atarashiki jidō bungaku no michi*).

16 The first wave of children's periodicals consisted of *Shōnen'en* (Children's garden, which began serialization in 1888), *Nihon shōnen* (Japanese children, 1888), *Shōkokumin* (Little countrymen, 1889), *Shōnen bunko* (Children's library, 1889), Shōnen bunbu (*Children's pen and sword,* 1890), and *Shōnen sekai* (Children's world, 1895). For a full account, see Carter, "Tales for Tarō."

17 Yamanaka Hisashi argues this point at length in *Senji jidō bungaku ron,* 43–48. Carter, "Tales for Tarō"; Torigoe, *Jidō zasshi 'shōkokumin' kaidai to saimoku;* Kasza, *The State and Mass Media in Japan;* and Horio, *Nihon jidō bungaku ron,* all make similar arguments.

18 Kan, *Nihon jidō bungaku,* 38–39.

19 The poem continues, "Squirrel, squirrel, little squirrel / Darting and dashing, little squirrel / The sap from the prickly ash is tart, so tart / Drink it, drink it, little squirrel! // Squirrel, squirrel, little squirrel / Darting and dashing, little squirrel / The flowers of the grape vine are white, so white / Shake them, shake them, little squirrel!" Kitahara, "Risu, risu, korisu," 2–3.

20 *Shōnen senki* was the first stand-alone proletarian children's periodical, though adult-oriented publications had produced special children's supplements For example, *Musansha shinbun* (Proletarian news) offered a supplement called *Kodomo no sekai* (Children's world) in 1926, and *Bungei sensen* offered the supplement *Chiisai dōshi* (Little comrades) in 1927.

21 For more on the life-writing movement in prewar Japan and its revival in the postwar period, see Murayama, *Seikatsu tsuzurikata;* Endo, "Pedagogical Experiments." For a sense of how closely aligned life-writing could be with proletarian literary aims, see Kurahara, *Puroretaria bungaku no tame ni.* For Toshi's educational theories and pedagogical practices, see Akamatsu, *E wa dare demo.* An arts-focused iteration of the life-writing movement, known as the "life-drawing movement" (*seikatsu zuga undō*) was, in fact, based in the Asahikawa area of Hokkaidō between 1932 and 1940. Though Toshi had left the area in 1930 to attend arts college in Tokyo, the arts world in the Asahikawa region was a tightly knit community, and Toshi must have been familiar with some of the people involved in the movement. For more, see Miyata Hiroshi, "Senzen no Hokkaidō."

22 *Shōnen senki,* July 1929, 1.

23 Tactics included starting distribution before submitting copies for inspection, submitting precensored copy for inspection and then altering the galleys for final publication, delivering inspection copies just before a weekend or holiday, and so forth. Kasza, *The State and Mass Media in Japan,* 37.

24 *Shōnen senki,* July 1929, 1.

25 The banned works included Makimoto, *Puroretaria Jidō bungaku no shomondai;* Makimoto, *Puroretaria dōyō kōwa;* and Makimoto, *Chiisai dōshi.*

26 In the words of Saeki Ikurō, the biggest problems facing the development of "appropriate" (that is, nationalist) children's literature were the crass commercialism of the publishing industry and the "proclivities of authors and artists who should strive to support, not the 'child' (*jidō*) but the 'everyday life' (*seikatsu*)" of the "little countryman" (*shōkokumin*). Of course, this everyday life should, in turn, be oriented toward service to the nation. Saeki, "Jidō bunka ni kansuru kakusho," 21.

27 In 1934, the Army Information Office mailed a pamphlet of roughly sixty pages to thousands of households across Japan, urging a Nazi-like dedication of all aspects of life (including culture) to the homeland. Yamanaka Hisashi has argued that this mass mailing, titled "Basic Principles for Defending the Nation and a Proposal to Strengthen Those Measures" (Kokuhō no hongi to sono kyōka teishō) and based on Ludendorff's *Der totale Krieg* (Total war), brought about a change in the national atmosphere, which moved notably in the direction of ultranationalism. Yamanaka, *Senji jidō bungaku ron*, 43. In 1936 the Extraordinary Control Law for Seditious Literature (Fuon bunsho rinji torishimari hōan) went into effect, specifying that those responsible for works disturbing the public peace could be sent to jail and punished with hard labor for three years. In May 1936, the Home Ministry created an Information and Propaganda Committee (Naikaku jōhōbu, upgraded to a division in September 1937) to issue official press statements and to "advise" publishing professionals. The committee was staffed by a mixture of military officers, politicians, and publishing professionals. The weeks between December 1937 and February 1938 saw the Popular Front Incident (Jinmen sensen jiken), in which four hundred people were arrested as part of a government suppression of a perceived threat from the political left after the fall of Nanking. Functionally, this marked the end of any effective leftist activity until after the war.

28 Okamura, *Shiryō yō nenpu*, 39; Hiramatsu, *Hirameki no geijutsu*, 108–109.

29 Toshi worked at Ichikawa Elementary School from April 19, 1933, through May 31, 1937, and again from May 19, 1938, through August 31, 1938.

30 Toshi began as the lead teacher for a class of second-grade girls before becoming the art teacher for the entire school. Toshi's art classroom included girls as well as boys. The term *shōkokumin* is not gender-specific; it literally translates to something like "little members of the national race." Given the gendered politics and social chauvinism of the times, however, and the fact that girls and women were clearly meant to play support roles for boys and men, it seems appropriate to translate the term as "little countrymen." "Little citizens" would be a gender-neutral option, but no one in Japan was a "citizen" at that time: they were nonvoting imperial subjects. "Little subjects" is another option, but it loses the nationalist focus, which is paramount. Thus the imperfect translation "little countrymen."

31 Cited in Yamanaka, *Senji jidō bungaku ron*, 57.

32 Yamanaka, *Shōkokumin sensō bunka shi*, 96.

33 Cited in Yamanaka, *Shōkokumin sensō bunka shi*, 96.

34 For more detail, see Saeki, "Jidō bunka ni kansuru kakusho," 18–29. Saeki continued to elaborate his stance, and the legislation's import, in a variety of ways, including his 1943 book *Shōkokumin bunka o megutte* (Toward a culture for little countrymen).

35 Cited in Yamanaka, *Shōkokumin sensō bunka shi*, 350.

36 For further description of the contest, see Yamanakam, *Shōkokumin sensō bunka shi*, 432.

37 Ehara, *Minami no kodomo*.

38 This quote comes from the "note to mothers" included on the back cover of *Minami no kodomo*. For more on the "note to mothers" phenomenon, see the discussion later in this chapter.

39 For an example and discussion of a map of this sort, and a consideration of transwar era board games, see Eubanks, "Playing at Empire."

40 The quote is taken from the editorial note by Yūasa Shūichi in Fuhara, *Mado mado*, n.p.

41 The full lyrics are given in Yamanaka, *Shōkokumin sensō bunka shi*, 411. In translation, they are: "Thundering, thundering, the sounds of our footfalls / Injured for our country / With the pride of bravery we / march with our friends from the Co-Prosperity Sphere / Marching in step, marching in step, the sound of our footfalls // Resounding, resounding, our voices raised in song / We inherit and carry forward the loyal hearts / of the brave men, our war dead / Moving forward with gratitude we / Sing our national anthem, sing our national anthem, *Kimi ga yo* // Fluttering, fluttering, that flag / When we think of the hardships of the battle / we puff out our chests and though we are small / we refuse to be defeated / admiring our flag, admiring our flag, the Hi no Maru // Calling out, calling out, that voice / together with our company of renowned children / we will shoulder the burdens of the future / awaiting the time when we launch / on the Seven Seas, on the Seven Seas, on the continent."

42 The conservative women's magazine *Ie no hikari* (Light of the home) included, as a freebie (*furoku*) for its readers' children, a pocket-sized *kami shibai* (storyboard narrative) titled *Minami no kuni meguri* (A tour of the southern countries). The third edition of the product, just a bit larger than a pack of cards, tells the story of Yō-chan (洋ちゃん), a very young boy who wishes out loud that he could visit the south. He hears a voice on his windowsill inviting him to come along; it's a swallow. He hops onto the swallow's back and is given a ride to various places—south China, Burma, Thailand, Singapore, and so forth—before returning to Japan. He wakes up and realizes it was a dream. His father tells him to study hard and stay healthy and, if he does so, one day he really can go to the south.

43 A particularly harrowing example is the 1944 "What Must I Do?" (Ware wa nani o nasubeki ka?). The story starts with (accurate) scare tactics: US bombers within striking distance of Tokyo, only eight hours distant, which is the same amount of time it takes to travel by train from Tokyo to Nagoya, and another scene of US soldiers rampaging and killing Japanese in the streets, right in front of an elementary school. To avoid this, the presentation continues, "We must fight with every ounce of energy we have left. No waste. No giving up. *Banzai!*"

44 Examples abound, including Yoshida, ed., *Asa no inekoki.* Most collections of girls' and boys' poems focus on explorations of how to handle problems of everyday life in a time of war. Ōashi, *Nobiru shōkokumin no shi* (Poems for rising countrymen) includes, for instance, a poem by one Kawahara Noboru about his responses to his father's being called to the front.

45 Tatsumi Seika served as the editor for *Shin jidō bungaku* (New children's literature), a publishing organ created explicitly as a delivery mechanism for "little countrymen" ideology.

46 Akamatsu, *Minami no shima.*

47 For a discussion of one of these photographic spreads, see chapter 1.

48 For one summation of the degree to which phosphate mining, to take but one example, exacted a heavy price of imperial ruination on the people and ecologies of Palau, see Arnow, *Effects of Phosphate Mining,* a report prepared after World War II in conjunction with the US Department of Interior and the Pacific Islands Trust Territory authorities.

49 For a discussion of "imperial formation," see chapter 1.

50 Culture for little countrymen artwork often used this tactic of repackaging adult-oriented materials for younger audiences. For instance, on June 22, 1942, page 3 of the morning edition of the *Asahi Newspaper* featured a photograph of Javanese Islanders looking skyward and celebrating the arrival of Japanese aircraft. (Japan had captured Java in March of 1942.) A few months later, in September, Toshi collaborated with young adult author Kubo Kyō on a story for *Yoi ko no tomo* (Good children's companion) about a group of Javanese children who see a Japanese Zero flying overhead, shout "Banzai!," and then construct their own Zeroes out of palm leaves. Akamatsu, "Yashi no ha no hikōki."

51 Akamatsu, *Yashi no ki no shita.*

52 Indeed, Toshi recirculated many of these same basic compositional strategies and subjects in her later children's book publishing, particularly in the 1980s and early 1990s, under the auspices of the then-popular national push for "internationalization" (*kokusaika*). See, for instance, Maruki, *Umi no gakutai,* 1991.

53 Cited in Yamanaka, *Shōkokumin sensō bunka shi,* 83.

54 Akamatsu, *Umi no ko damashii.* The first quote is from a nonpaginated preface, and the others are from pages 2 and 3.

55 Akamatsu, *Umi no ko damashii,* 1. Indeed, these bellicose prefaces quite outweigh Hara's account of the training cruise, which is almost boringly uneventful.

56 Some versions of the book replace the cover art, using instead a drawing showing sailors in uniform standing in the mast rigging of a large ship in heavy seas. Though I have not been able to discover any correspondence concerning the change of cover art, it is possible that Toshi's original artwork was judged to be insufficiently evocative of the desired message.

57 Cited in Yamanaka, *Shōkokumin sensō bungakushi,* 91–92.

58 For a discussion, see Yamanaka, *Shōkokumin sensō bunka shi,* 308 and ff.

59 Toshi's *Yashi no mi no tabi* (Journey of a coconut), discussed at length below, was also singled out for praise and chosen for inclusion in the Shin Nihon Yōnen Bunko (Library for the new Japanese child). Though most of her works from this time period were set in the south, she also illustrated material set in Hokkaidō from time to time. Indeed, *Yukiguni no Tarō* (Tarō of the snow country), a chapter book with illustrations by Toshi, was chosen for inclusion in the *Shōkokumin bungeisen* (Selections of art for little countrymen) series. Akamatsu, *Yukiguni no Tarō*. Toshi also published artwork, though irregularly, in youth recruiting venues, such as the boys' magazine *Seinen*. See, for instance, Akamatsu and Murasaki, "Denpo."

60 At the time the rubric *yōnen* indicated the youngest readers (prereaders, actually), aged roughly three to five.

61 Akamatsu, *Taiyō no kodomo.*

62 Note that this reader's guide is illustrated, but not by Toshi. Presumably the drawings are by Nan'e himself, since no other artist is credited, as was required by Home Ministry guidelines.

63 For instance, the Ryōsenji Treasure Museum owns a likeness of Commodore Matthew Perry dating to circa 1854, in which Perry is visualized as a long-nosed *tengu* (a type of demon). For this and similar portraits, see MIT's Black Ships and Samurai open courseware website at https://ocw.mit.edu /ans7870/21f/21f.027/black_ships_and_samurai/gallery/pages/30_038i _Perry_tengu.htm.

64 See Kawana, "Reading Beyond the Lines."

65 According to Usami Shō, though the book's cover lists Maruyama Kaoru as the author and Akamatsu Toshiko as the illustrator, Toshi, in fact, wrote the words and gave them to Maruyama, who "touched them up" [*te wo ireru mono de atta*] (Usami, *Ikebukuro Monparunassu,* 515).

66 Though US soldiers appear in the textual narrative of *The Wandering Coconut,* all we ever see of them is one American flag disappearing into the forest.

67 National schools, both in the home islands and in the colonies, were effective avenues for the delivery of imperial recruiting propaganda, and at

least some young South Sea Islanders were swayed. The evening edition of the *Asahi Newspaper* for October 26, 1938, (page 2) included an article titled "South Seas Youth Want to Join the Army, Fervent Wishes" (Nan'yō shōnen jūgungan, nesshin ni kangeki). The article, relayed by phone from Yokosuka naval base, reports that "islanders from the South Seas Islands, our southern lifeline, have approached the South Seas Bureau" with a request that they "be allowed to serve in the Holy War" as an indication of their ever-deepening "national spirit" (*kokumin seishin*). Thus far, the first volunteers have come from Rota Island and a number of other locales. A certain Mariano Ariora (aged twenty) from Raban Village in northern Saipan and a graduate of Japanese school (*kōmin gakkō*) has submitted a request to the South Seas Bureau requesting that he be allowed to serve "as he is prepared to endure any hardships, however painful" in order to be of service to the country. Not coincidentally, the advertisement for Toshi's new book *Yashi no mi no tabi* (Journey of a coconut) ran just two columns over from a photograph of a South Seas Islander girl standing in front of a chalkboard covered in Japanese *katakana* writing. (See "Shuppan bunkyō suisen gasho.")

68 Kaneko, "New Art Collectives in the Service of the War," 327.

69 Peattie, *Nan'yō,* 2.

70 Toshi employs this tactic in nearly all of her artwork from this time, in marked contrast to many other artists whose work consistently aggrandizes military engagement and encourages young readers to imagine themselves as embattled soldiers and sailors. Nor is this a matter of audience. Though pulp magazines (such as those published by Hakubunkan, Jitsugyō no Nihonsha, and Kōdansha) did tend to be more sensational and were used to "pump imperial ideology" to the masses, the contrast is clear even in more staid publications such as *Kodomo no hikari.* The September 1942 issue is a case in point. For it, Toshi provided a tranquil scene of Southeast Asian peoples walking under the moon, leaving the editors to make the claim, on the back cover, that Toshi's artwork shows peoples in the Co-Prosperity Sphere enjoying the traditional Japanese autumnal pastime of moon viewing (*tsukimi*), thus claiming her art in support of cultural "Japanization" (*dōminka*) policies. By way of comparison, the cover art for the issue, by Ōzawa Shōsuke, shows children parachuting from an airplane; an interior spread by Yamamoto Makoto features three Japanese children saluting three Zeroes flying in formation above Mount Fuji; and another spread, with art by Kiyohara Sai, depicts Japanese children responding in an orderly way during an air raid drill. *Kodomo no hikari,* September 1942. For a discussion of Kōdansha, Hakubunkan, and Jitsugyō no Nihonsha, see Richter, "Entrepreneurship and Culture."

71 For a discussion of this technique, see op de Beeck, *Suspended Animation,* 119–168.

72 Kawana, "Reading Beyond the Lines," 157. See also Kawana, "Science without Conscience."

73 Sakuramoto, *Shōkokumin wa wasurenai,* 245–246.

74 Aside from Toshi, perhaps the only major woman artist with extensive experience in the colonial south was Hasegawa Haruko, who toured Southeast Asia. See Kitahara, *Ajia no josei shintai wa ikani egakareta ka,* 73–121. See also Kaneko, "New Art Collectives in the Service of the War," 322–329.

75 The Publisher's Association had been created as a completely government-controlled entity via the Publication Order (*Shuppan jōrei*) promulgated on March 11, 1943.

76 "Shuppan bunkyō suisen tosho," *Asahi shinbun,* February 12, 1942, morning edition, p. 4, row 6.

77 Peacock, *Innocent Weapons,* 4. For another illuminating account of the role of nationalism in forming children's literature, see Schmidt, *Making Americans,* esp. 125–153.

78 This is Sakuramoto's general argument throughout his *Shōkokumin wa wasurenai.*

79 Yoshihara Jirō, Okamoto Tarō, and Katsura Yuki, among others, all attempted to carve out an artistic space for themselves that stood in contradistinction to the increasingly fascist aesthetics of their times. For more, see Kunimoto, *Stakes of Exposure.*

Chapter 3: Red Shift

1 On the nature of this perceived threat, see Uchiyama, "The Munitions Worker."

2 Proletarian arts groups continued to exist through the mid-1930s but were subject to increasing interference. In 1930, the All Japan Proletarian Arts Association (Zen Nihon musansha geijutsu renmei, NAP for short), producers of the journal *Senki* (Battle flag), formed the Japanese Proletarian Culture Association (Nihon puroretaria bunka renmei, Federacio de Proletaj Kultur Organizoj Japanaj, KOPF for short). Commencing activities in November 1931, KOFP sought to establish cultural "circles" amongst factory workers and farmers, among other activities, and in April 1932 the Japanese Proletarian Arts School (Nihon puroretaria bijutso gakkō) opened, only for its organizers to meet violent suppression in June of that year. For an in-depth study of labor and politics in twentieth-century Japan, and particularly the 1920s and 1930s, see Garon, *The State and Labor in Modern Japan.* One of the major interventions of Garon's work is to efface monolithic treatments of "the state" by offering a series of detailed analyses of specific, agential actors: upper-class Kenseikai leaders and Home Ministry officials. Where Garon approaches the subject from the vantage

point of politics, I approach it from that of aesthetics and cultural production.

3 *Toshima-ku rekishiteki kenzōbutsu*, 96–97. For more on the artists' neighborhoods of Ikebukuro, see Itabashi Art Museum, ed., *Futatsu no Monparunasu;* and Jefurowa, "Jiyu arui wa shō."

4 Maruki, *Onna egaki no tanjō*, 76. As mentioned in chapter 3, Toshi's teaching practices were reminiscent of populist, proletarian-inspired arts pedagogies, such as *seikatsu tsuzurikata* (life-writing) and the *seikatsu zuga undō* (the life-drawing movement), that had been popular in northern Japan in the 1930s. Though the broader movements had been effectively quashed by this time, Toshi's own in-classroom practices seem to have continued to bear their imprint, enough so that she was something of an "oddball" amongst her peers, someone who other teachers thought would be willing to live in Soviet Russia.

5 Maruki, *Onna egaki no tanjō*, 77. Toshi does not specify what her fellow teachers find so frightening about Russia. Though Stalin's Great Purge to remove "dissenters" from the Communist Party was under way from 1936 until 1938, it is unlikely that Toshi or her coworkers in Japan would have known about it. More likely, the vague comment refers to Japanese perceptions regarding the purported threats of socialism, communism, and proletarianism, for which Moscow was the ideological capital. In addition, international relations had been tense since Japan's victory in the Russo-Japanese War and continued to be strained as Japan's territorial expansions in Manchuria pressed against the eastern edges of Russia's Siberian holdings.

6 Though before Stalin's denunciation of Western modernist art, Toshi's visits to Moscow came after the 1920s "bargain sales" of modernist art from Russian museums into private collections, which had resulted in a drastic thinning of paintings in the Hermitage's permanent collection. For more information, see Semyonova and Iljine, eds., *Selling Russia's Treasures,* esp. 224–243.

7 Moxey, *Visual Time,* 1. In addition to heterochronicity, Moxey argues a second point (in favor of anachronicity), which I revisit in the afterword.

8 Throughout his scholarship, John Clark has argued a similar point regarding the many "modernities" of Japanese painting, the rapidity of their development, and the complexity of the transfer, such that artistic modernism(s) were thoroughly localized in Japan by at least 1920. He maintains, quite sensibly, that one must admit "a range of possible definitions for 'modern' or 'modernism,'" not only within Japan, but across the globe. That said, Clark does not often extend his scholarship to consider the ways in which proletarian artists in Japan, as elsewhere, developed their own alternate modernist visions. Clark, *Modernities of Japanese Art,* 80. For

further comments concerning east-west slipstreams in Russian art, see Rosenfeld, "Between East and West."

9 Sharp, *Russian Modernism between East and West*, 20–55. Situating Japanese artistic modernity in a single paragraph is an impossible task and I have only given the roughest of outlines here, limiting my comments to Toshi's specific milieu. Readers are encouraged to consult further scholarship, such as Wu, "Japan Encounters the Avant-Garde"; Mitter, "Decentering Modernism"; Tiampo, *Gutai;* Tomii, *Radicalism in the Wilderness;* and Volk, *In Pursuit of Universalism.*

10 Sharp, *Russian Modernism between East and West*, 7. On the internationalism of Japanese proletarian arts, see Omuka, *'Teikoku' to bijutsu*, 31–88. Also Omuka, "'Shin Roshia den' to Taishōki no shinkō bijutsu"; and Omuka, "Modanizumu no hon'yaku."

11 Tomizawa, "Hiroshima hyōgen no kiseki," n.p.

12 For a full first-personal account, see Yuhashi, *Senji Nisso kōshō shōshi.* For a brief political biography of Satō Naotake, see National Diet Library, "Portraits of Modern Japanese Historical Figures."

13 Toshi penciled her remark about the Russian guards outside the embassy on the back of Moscow Sketch #189, which she composed on February 9, 1938. Sketch #21, "The back way from Nikitsuky" (*Nikitsuki no uramichi*), is misdated. Toshi has recorded the date as May 18, 1837 (rather than the correct date of 1937). The word *gepebō* is likely Toshi's own truncated portmanteau of the Russian words "Gosudarskvenniy Politseiskiy" ("national police") and the English word "box" (which, in Japanese usage, means a small roofed enclosure, such as a guardhouse).

14 Both Nishi and Yuhashi were cut from the same cloth as the "social bureaucrats" described by Sheldon Garon. These so-called "new men" (*shinjin*) possessed a "highly cultivated sense of elitism and activism. . . . One official summed up the self-image of his colleagues in the Social Bureau in these terms: 'In Japan, if His Majesty's bureaucrats weren't progressive, they wouldn't amount to much.' The 'new men' who first championed the rights of labor in 1919–1920 consisted of the best and brightest amongst their entering cohort. Almost all had placed among the top group of candidates in the general administrate examination, thereby ensuring rapid advancement to the highest post in the Home Ministry. Granted substantial authority in their twenties and thirties, these officials possessed extraordinary confidence in their abilities to engineer social change." Within scarcely a decade, these men were to crash up against the limits of liberal reform. Garon, *The State and Labor in Modern Japan*, 81.

15 In fact, Mr. and Mrs. Nishi later served as the two official witnesses for Toshi's marriage to Maruki Iri. Usami, *Ikebukuro Monparunassu*, 464–465.

16 For instance, Toshi attended a diplomatic event on the evening of April 13, 1941, in celebration of the newly signed Soviet-Japanese Non-Aggression Pact. Seated within hearing distance of Russian and Japanese diplomats, she recalls that, "At the height of the party, Military Ambassador Tatekawa Yoshitsugu and Special Ambassador Plenipotentiary Matsuoka sat down in some chairs next to us. Special Ambassador Matsuoka, who was incredibly drunk, clapped Ambassador Tatekawa on the shoulder, 'Hey, I gave you 250,000 yen when I was over in Manchuria, right?' At the time my monthly salary had just been raised to 100 yen and, shocked, I looked around at them. I couldn't believe they'd engage in that sort of talk right there, in front of the children and teachers. The party was drawing to a close and Ambassador Matsuoka went around the room, shaking hands with everyone. 'Give those kids a wholesome education, alright? I'm counting on you,' he said, squeezing my hand in his own. That hand of his that had just clapped the military minister on the shoulder. I couldn't help flinching, and I wanted to pull my hand away." Maruki, *Onna egaki no tanjō*, 105. Nishi Haruhiko recounts the same story in his memoirs. Questioning the strength of the friendship between Tatekawa and Matsuoka, supposed to have developed during their time together in Manchuria, he writes that he found it "hard to say if the friendship was genuine. Matsuoka got drunk in Moscow and spread it around that he had given 100,000 yen to Tatekawa during their time together at Mantetsu, but they didn't seem to be on very good terms with one another." Nishi, *Kaisō no Nihon gaikō*, 102.

17 Formal diplomatic relations between Japan and Russia were established in 1925, and Nishi first served as the secretary of the Japanese Embassy in Moscow from its founding in 1925 until 1928, returning as counselor of the Embassy from June 1939 through August 1940, and then vice minister for foreign affairs (January 1941–September 1942, residing in Moscow from January through May, 1941). Even when not living in Moscow, Nishi made frequent trips to the city to work on agreements regarding fisheries and the extraction of coal and petroleum on Sakhalin/Karafuto and off the coasts of the Russian Far East.

18 In his preface to Yuhashi's book, Nishi praises the clarity of Yuhashi's translations and notes how instrumental the younger man was to diplomatic exchange in Moscow. Yuhashi, *Senji Nisso kōshō shōshi*, 1.

19 For a more in-depth account of this time, see Nishi, *Watashi no gaikō hakusho*, 180–187.

20 Nishi, *Kaisō no Nihon gaikō*, 71, 72.

21 Maruki, *Onna egaki no tanjō*, 77.

22 Handwritten on the reverse of Moscow Sketch #170.

23 Moscow Sketch #38, dated June 21, 1937.

24 Moscow Sketch #131, dated March 4, 1938. Toshi later repurposed several of her Moscow sketches in postwar proletarian publications, such as Maeshiba Kakuzō's 1947 study of Soviet governmentality *Hataraku hitobito no kuni.*

25 Toshi records this interaction in a handwritten note on the reverse of Moscow Sketch #144.

26 Toshi records this interaction in a handwritten note on the reverse of Moscow Sketch #145.

27 Toshi records this interaction in a handwritten note on the reverse of Moscow Sketch #148.

28 Yuhashi, *Senji Nisso kōshō shōshi,* iv.

29 Akamatsu, *Mosukuwa nikki,* 47.

30 Tsuruya, "Sensō Sakusen Kirokuga," 99.

31 Tsuruya, "Sensō Sakusen Kirokuga," 100.

32 Toshi was to accompany the prose author Niwa Fumio. Niwa was sent on without her, his travel resulting in the journalistic *Naval Battle* (Kaisen), which was produced in both adult reader and "little countrymen" versions. For more on the juvenile version, see Hattori, "Niwa Fumio no 'Shōkokuminban.'"

33 For a brief overview, see Bowlt, "Neo-Primitivism and Russian Painting," 132–140. Also Steiner, "A Battle for the 'People's Cause' or for the Market Case," 627–646.

34 Williams, "The Nationalization of Early Soviet Culture," 168.

35 Akamatsu, *Mosukuwa nikki,* 48.

36 Akamatsu, *Mosukuwa nikki,* 42.

37 Akamatsu, *Mosukuwa nikki,* 49, 50.

38 Sharp, *Russian Modernism between East and West,* 5.

39 Weisenfeld, "The Expanding Arts of the Interwar Period," 83.

40 Nishi, *Kaisō no Nihon gaikō,* 75.

41 Nishi, *Watashi no gaikō hakusho,* 189.

42 Akamatsu, *Mosukuwa nikki,* 46.

43 "Kokubō to kenkō tenrankai," *Asahi Shinbun,* March 5, 1941, 2.

44 Akamatsu, *Mosukuwa nikki,* 19–20.

45 Akamatsu, *Mosukuwa nikki,* 20–22.

46 Akamatsu, *Mosukuwa nikki,* 60–61.

47 Akamatsu, *Mosukuwa nikki,* 22.

48 Upon entering and leaving the country, Toshi's possessions (like all other international travelers') were subject to close inspection. Indeed, upon entering Russia in January 1941 she had an item (a wooden box) confiscated from her luggage when the customs officers were unable to open it. Akamatsu, *Mosukuwa nikki,* 15–16. Though we cannot be certain why Toshi marked out some phrases, it is possible that she was employing a sort of protective self-censorship.

49 Shimizu, "Bijutsu to shintaisei," 1.

50 Shimizu, "Bijutsu to shintaisei," 1.

51 Akiyama et al., "Kokubō kokka to bijutsu," 129–139.

52 Akiyama et al., "Kokubō kokka to bijutsu," 132.

53 Akiyama et al., "Kokubō kokka to bijutsu," 136.

54 Akiyama et al., "Kokubō kokka to bijutsu," 135.

55 See Shepherdson-Scott, "Art Photography, Industry, and Empire"; and Shepherdson-Scott, "A Legacy of Persuasion."

56 Matsumoto, "Ikiteiru gaka." For an excellent summary of Matsumoto's essay, and the *Mizue* roundtable that provoked it, see Sandler, "The Living Artist."

57 Sandler, "The Living Artist," 79.

58 Matsumoto, "Ikiteiru gaka," 247.

59 Indeed, Matsumoto also produced artwork that supported the war effort. On the "Shunpei myth" (*Shunpei shinwa*), see Kozawa, *Aban gyarudo no sensō taiken.*

60 Usami, *Ikebukuro Monparunassu*, 473.

61 Matsumoto, "Ikiteiru gaka," 236.

62 Akamatsu, "Soren no inshō," 104. The phrase reads, "*Watashi no chikaku no chijintachi o nikurashikusae omotta. Watashitachi wa kō shiteite yoi no darō ka? Hitogoto no yō ni jibun no kuni no dekigoto o wameitari hihyō shitite yoi no darō ka, to.*"

63 Akamatsu, "Soren no inshō," 105. The phrase is "*Watashi wa Nippon no tomodachi ni kokoro kara iitai. Damatte Nippon no yukō to suru tokoro ni tsuite yukō. Gashi suru koto wa nain dakara, to. Gashi suru koto wa nain da kara.*"

64 Akamatsu, "Soren no inshō," 106.

65 She did publish one other piece in *Shinjoen* in October of that year. It is much shorter, and much more subdued. See Akamatsu, "Mosukō nite."

66 Here I am punning on the title of James Fujii's influential study of modern Japanese literature. In *Complicit Fictions*, Fujii argues that "one condition of the canonization of works such as [Natsume Sōseki's] *Kokoro* is a narrowly constricted focus on minute nuances of private perceptions, thoughts, and feelings" that enabled the author to "pointedly ignore the grammar of nationness within which Japan sought [international] recognition. Yet . . . the text's engagement with issues of modernity that arise in the narration of silence and death unwittingly reproduce the concurrent narratives of nation and empire and the construction of a 'modern' Japanese history." Fujii, *Complicit Fictions*, 150.

67 As Kenneth Ruoff notes, "Until the war situation deteriorated precipitously in mid-1942, tourism thrived under Japan's authoritarian government precisely because it often served, or at least could be justified as serving, official goals." Ruoff, *Imperial Japan at its Zenith*, 7.

68 Toshi mistakenly calls the Tretyakov Gallery the "Tretyakovsky Museum."
 When Toshi departed Moscow for the second time, in May 1941, the works
 in the Tretyakov were just beginning to be wrapped, boxed, and shipped out
 of the capital to avoid their being damaged or looted during the war. The
 Pushkin State Museum underwent many name changes, eventually being
 named in honor of Pushkin shortly before Toshi's first visit, in 1937, to
 honor the centennial of his death. The Moscow Museum of Modern Art
 consisted mainly of Sergei Ivanovich Shchukin's collections of French works.
 A wealthy Russian businessman, Shchukin bought his first Monet in Paris in
 1897 and later amassed some 258 pieces that decorated the walls of his
 palatial home in Moscow. After the 1917 Revolution, the state appropriated
 his belongings and Shchukin escaped to Paris, where he died in exile. His
 mansion became the Moscow Museum of Modern Art and his collection
 was merged with works belonging to Ivan Morozov. The museum was shut
 down in 1948 when Stalin declared the holdings to be bourgeois and
 wrongly oriented.

69 Akamatsu, "Roshia ni aru Furansu gendai bijutsu," n.p.

70 When Toshi visited Moscow, this piece belonged to the Moscow Museum of
 Modern Art. When Stalin declared in 1948 that the museum's holdings were
 wrongly oriented, the museum was dissolved and its holdings dispersed.
 Many were sold to collectors elsewhere in the world. Van Gogh's *Landscape
 with Carriage and Train in the Background* (painting, oil on canvas. Auvers-
 sur-Oise, June 1890) was moved to the National Pushkin Museum.

71 The exhibited artworks are listed by title in Joshi Bijutsu Daigaku
 hyakushūnen henshū i'inkai, ed. *Joshi Bijutsu Daigaku hyakunenshi*, 70–71.
 It is impossible to determine which exact works were on display by relying
 only on the titles, which are fairly vague ("Old Woman," "Work,"
 "Laundry," "A Road," etc.). Based on newspaper reports, the works on
 display seem to have been mostly sketches, along with a few watercolors and
 ink drawings, and perhaps a couple of oil paintings. See "Furusato joryū
 gaka ga teitō ni sukecchiden," *Asahikawa shinbun*, May 13, 1939, 7.

72 "Kyōdo joryū gaka ga teito ni sukecchi ten," *Asahikawa shinbun*, March 14,
 1939, 7. Humor was a crucial aspect of survival for Toshi, and she often used
 jokes and playful sarcasm as feints, behind which she posed quick jabs. For
 example, in March 1943 she published a pair of illustrated vignettes.
 (Akamatsu, "Yūkanna yosei.") In the first, a woman parades, self-
 parodically, down the middle of the Ginza (the most fashionable district of
 Tokyo), sporting overalls, work shirt, and headscarf while everyone around
 her stares in disbelief at her ridiculous nod to "the fashion of the day." It is
 likely that this piece is autobiographical; one of Toshi's notebooks includes a
 note: "My atelier is freezing cold, so I borrowed a pair of my brother's
 trousers to wear. He's short, so the length is fine, but since I'm heavier than

he is, it looks kind of strange. Went out dressed like that. In the rain. People were staring at me, though some said, 'Wow!'" (Note inserted between pages 137 and 138 of *Mosukuwa nikki*. Clearly, the note was written, not in Moscow, but when she was living with her brother in Ikebukuro.) The second vignette takes place at a crowded bathhouse, where a group of women tries to figure out how to get clean, in the dark, without enough buckets—or enough water—to go around. The tension is broken with jokes and laughter. In both cases, self-deprecating humor provides cover for critique, whether of financial decline or ragged infrastructure. For one account of the Ikebukuro artists' scene in the late 1930s, and the importance of humor within it, see Akamatsu, *Jiyūgaoka parutenon*. Hotta's novel, really a semiautobiographical roman á clef, features Toshi (known as Rumiko) as a main character, along with her lover Maruki Iri (appearing under the name Chikamatsu). The novel, though completed in 1937 and dealing with events through the mid-1930s, was not published until after the war.

73 Maruki, *Onna egaki no tanjō*, 108.
74 Maruki, *Jōjō ruten*, 221–223.
75 *Junkan bijutsu shinpō* 51 (Feb. 10, 1943): 11.
76 Usami, *Ikebukuro Monparunassu*, 450.

Chapter 4: Bare Naked Aesthetics

1 Takiguchi Shūzō's Japanese translation of André Breton's *Le surrealism et la peinture* was published in 1930, the same year that saw the establishment of the National Research Institute for Cultural Properties, the ambit of which was to identify, study, and preserve Japan's national (which is not quite to say nationalist) art. On the question of a "fascist" aesthetics in Japan, see Tansman, *The Culture of Japanese Fascism*. On the evolution of Japanese law regarding national cultural properties, see Aso, *Public Properties.*
2 Kunimoto, *Stakes of Exposure,* 29. For more on the exhibit, see Kira, "Joryū gaka hōkōtai," 132–134.
3 For Toshi's comments, see chapter 3 and Akamatsu, *Mosukuwa nikki*, 60–61. Her phrase is *"damatte tsuitteiku,"* literally "to stay silent and to follow along."
4 For accounts of occupation-era censorship, see Abel, *Redacted;* Kami and Ozaki, *Ikebukuro Monparunasu;* and Eto, "The Sealed Linguistic Space."
5 In chapter 6 I discuss what few material records we have of Toshi's activities in August to November of 1945.
6 Maruki, *Jōjō ruten*, 249–250.
7 Akamatsu, "Akibare," 4. Serialization ran daily, for the entire month of December.
8 Akamatsu, "Himawari no hana," n.p. Toshi maintained disorganized notebooks of her published artwork, generally in the form of newspaper

clippings. She has trimmed off the name of the newspaper in this case, though it is likely the communist flagship paper *Akahata*. Ichijō's text, a prose poem, concerns women gathered at a labor union meeting. Toshi's artwork is a line drawing of four women kneeling on the floor with small cups (for saké or tea) in front of them. One of the women has an open book on her lap and they are all in what looks to be factory uniforms.

9 In her illustrations (for an adaptation of a Tolstoy story), Toshi makes the most of her knowledge of traditional Russian boys' clothing and of Russian Orthodox imagery. Akamatsu, "Futari no kyōdai," 29–33. Indeed, Toshi continued to receive commissions for Russian-inspired art throughout her career. See, for instance, Akamatsu, *Bokura no gekiba;* Akamatsu, *Shiroi muku inu;* Akamatsu, "USSR;" Akamatsu, *Iwan no baka;* Akamatsu, *Taiyō yori mo;* and even Akamatsu, *Gokkeru monogatari,* which, though a work of German Romanticism, Toshi still illustrates with Russian imagery. For a late example, see Maruki Toshi, *Roshiya no warabeuta*. For a catalog of Toshi's transwar children's book illustrations, see Genbaku no zu, ed., *Maruki Toshi ehon*.

10 The word *nikutai* in this instance refers to the predominance of motifs concerning the "carnal body" in postwar Japanese cultural productions. As Doug Slaymaker points out, the carnal body and its excesses—with sex, drugs, alcohol, and so forth—functioned as a metaphor of, and a touchstone for, a counterideology, a gate of bodily excess (*nikutai no mon*), that stood in direct contradiction to the wartime ideology of the *kokutai* (national polity, national body). *Nikutai no mon* (The gate of flesh) is also the title of one of the earliest works in this literary movement, published by Tamura Tajirō in 1947. For more, see Slaymaker, *The Body in Postwar Japanese Fiction*.

11 *Jinmin* 1:1 (April and May 1946): inside front cover.

12 Kozawa, *Genbaku no zu*, 65, 249.

13 Tokuda, "Tō kakudai kyōka," 4–5. Tokuda was the first chairman of the Japanese Communist Party. Arrested on suspicion of violating the Peace Preservation Law in 1928, he spent the next eighteen years in jail before being released in October 1945, one month before this article went to press. For more on Communist Party publishing practices and proletarian literature in the 1920s and 1930s, see Perry, *Recasting Red Culture*.

14 Akamatsu et al. "Josei o kataru," 56, 59.

15 Akamatsu, "No ni utau kodomo."

16 Akamatsu, "Mosukō no haru"; Akamatsu, "Hana no bokujō"; Akamatsu, "Aki"; and Akamatsu, "Soviē no shinshun."

17 Akamatsu, "Matsuri no yoru"; Akamatsu, "Musukō no Kurisumasu": Akamatsu, "Mosukō no yoru."

18 Akamatsu, "Mosukō no geijutsuteki fun'iki." See also Akamatsu, "Sovēto no josei."

19 Perry, *Recasting Red Culture,* 94.

20 Toshi provided countless covers for left-leaning journals throughout the late 1940s. For *Minshu no tomo* (The people's friend) alone, for instance, she sketched a nude man (Oct. 1947 cover), a nude woman (Feb. 1948), Soviet dancers (March 1948, based on Moscow sketch #62 and #72), Soviet laborers walking to market (April 1948), Russian people picnicking in a park (combined May/June 1948 issue), and a Russian girl in a swimsuit (Aug. 1948), along with several other features.

21 Akamatsu, "Mosukō."

22 Akamatsu, "Ame ni akeru." This is an adaptation of Paustovsky's brand-new 1946 novel *The Rainy Dawn,* for which Toshi provided three illustrations. One of her illustrations is based directly on her Moscow Sketch #132, which she had done on March 5, 1938; another of the illustrations is based on Moscow Sketch #336 (actually a watercolor), which was done at the Red Guard Theatre. Toshi also illustrated the second and final installment of the adaptation. *Fujin gaho* 41:10 (Nov./Dec. 1946): 54–57.

23 Akamatsu, *Fushigina taiko.* This was an adaptation of Tolstoy's story "The Empty Drum."

24 Akamatsu, "Hana o nigedashita otoko." This popular adaptation of Gogol's short story "The Nose," prepared by Suzuki Takashi, was released the next month as part of a book-length collection of Gogol's stories. Akamatsu, *Hana ga nigedashita hanashi.* Indeed, much of Toshi's art at this time, and particularly her art for children's books, delights in visually mocking authority while drawing deeply on Russian folk motifs. For other examples, see Akamatsu, *Jyakku to mame no ki,* and Akamatsu, *Gobō no ouchi.*

25 Akamatsu Toshiko, "Shiberia," 26.

26 Akamatsu, *Mosukuwa nikki,* 23.

27 Akamatsu, *Mosukuwa nikki,* 61.

28 Akamatsu, *Mosukuwa nikki,* 63.

29 To the best of my knowledge, the one other example of what we might consider misdirection by omission comes in a roundtable from 1947. Asked to comment on the understanding of "labor" (*rōdō*), as she observed it in Soviet Russia, Toshi talks about model laborers, going so far as to reference miner and official Hero of Socialist Labor Alexey Stakhanov, and comments on the provision of food, medicine, and a living wage as well as praising the equality of the sexes. Though not specifically at odds with her own experiences, these comments are more reflective of generalized communist propaganda, and there is a sense that here she is simply parroting the party line. She could have, for instance, given a much more fine-grained response by talking about her own experiences as a governess and some of the relationships she developed with other domestic servants, her Russian peers. Akamatsu et al., "Zadankai: Hataraku mono no sekai."

30 See Jesty, "The Realism Debate."

31 Nagoya-shi Bijutsukan, *Sengo Nihon no riarizumu,* 10.

32 Akamatsu, "Ankēto," 10. See also her comments in the roundtable "Kakushinki bijutsukai no shōten o tsuku zadankai." Similarly, in response to a survey on the question, "What do you want to accomplish this year?" Toshi responded, "In terms of my work for the year 1948, what I really want is to make, to actually realize, artworks that speak to the new masses (*atarashii taishūsei o motta sakuhin o gutaitekini seisaku shite ikitai*)," and then she goes on to mention some examples, including images of lovers walking together under the sun, political demonstrations, landscapes, black markets, and so forth. Akamatsu, "Kotoshi wa nani o yaritai ka?" 11. Though she broke with the party proper, she remained enamored of the promise that socialism, communism, and populism held for artistic and social reform. See, for instance, Akamatsu, "Chiisai chiisai"; and Akamatsu, "Kyōsan'en tobiaruki."

33 An article in the arts magazine *Bijutsu bunka* in fact declared Toshi to be "the people's artist" in the October 1946 issue. Irie, "Jinmin no gaka Akamatsu-san," 7.

34 Marotti, *Money, Trains, and Guillotines,* 132.

35 The exhibit hung from April 21 through April 26, 1948, in the Amanomoto gallery (also sometimes known as Tengen Garo) in the Ginza. Advertisements for the exhibit mention ten oil paintings completed just after the war and/or forty works from Toshi's time in Russia, but no list of the works, or further comment on either content or medium, is available. Many sketches held at the Maruki Gallery archive, however, provide some clues. For instance, a group of about a dozen sketches are mounted on what looks like thin brown wrapping paper and are labeled in both English and Japanese. Other groups bear red numbers (1 through 19) in the margin, or penciled numbers on the back. From this, and from published reviews such as the ones cited here, we can discern that Toshi's regular practice was to include several oil paintings, along with the charcoal or pencil sketches used as studies for those paintings. At times, she seems to have also exhibited watercolors alongside sketches and larger oil works.

36 Anonymous, "Akamatsu Toshiko ron," 21.

37 Anonymous, "Akamatsu Toshiko ron," 21.

38 Egawa, "Akamatsu Toshiko koten," 56.

39 Migishi, "Geijutsu no fukkatsu," inside front cover.

40 Weisenfeld, "The Expanding Arts of the Interwar Period," 67.

41 I have found no further information about this exhibition. She and Iri were preparing for, and did exhibit three pieces each at, the November 1948 Second Nihon Independent, held at the Tokyo Municipal Museum. And they both exhibited works at the Seventh Zen'ei Bijutsukai show held at a

Nihonbashi gallery September 1–7, 1949. But neither of these seems to be the joint, two-artist show that the reviewer references.

42 Anonymous, "Akamatsu Toshiko," n.p.

43 Toshi's ties to the Chinese Communist Party ran quite deep for a time. To cite but one emblematic instance of this connection, she provided the cover art for the party's 1958 publication *Stories of the Chinese Red Army* (Chūgoku sekigun monogatari).

44 Akamatsu, "Gogatsu tsuitachi," 8.

45 The passages reprised for the journal article bear the closest resemblance to the scenes described in *Mosukuwa nikki,* 129. The illustration for the article appears to be a reworking of Moscow Sketch #187, perhaps with some elements from other sketches (such as #64) done while staying at the summer dacha in the countryside outside of Moscow.

46 Akamatsu, "Mosukō to Tōkyō," 39.

47 Akamatsu, "Mosukō to Tōkyō," 40.

48 Some of Toshi's comments in this article echo those of Andrée Viollis (1870–1950), a well-known French journalist who published travelogues of a number of then-exotic locales (Afghanistan, Russia, Indochina, South Africa, and so forth). One of these was her 1934 book *Le Japon intime,* an account of her observations during 1931 and 1932 when she was stationed in Japan reporting on the Sino-Japanese wars. From January through September of 1946, Toshi provided illustrations for a translation of Viollis's work, which was serialized in the women's journal *Hope* (*Hōpu*) as part of its "Watashi no mita Nihon" (Eyewitness Japan) column. The ambit of the column was to provide a view of Japan and Japanese culture as observed at firsthand, and many columns contained some aspect of social and cultural critique, especially focused on the low place of women in Japanese society. She also provided artwork for an article by Itō Masakazu in the July 1946 issue of *Fujin gaho,* in which Itō responds to the question, "If communist culture spreads throughout the world, what sort of impact would that have on [Japanese] women's lives?" *Fujin gaho* 41:7 (July 1946): 34. In other pieces, Toshi also intermixed commentary on high art, politics, and women's domestic labor, as in "Mosukō no geijutsuteki fun'iki," 10–12.

49 Toshi was in good company when it came to imagining a Soviet Japan that would remake gender roles and affective relations. See Bowen-Struyk, *Red Love.*

50 Though not a major feature of her postwar writings for adult audiences, the critique of Japanese discrimination against ethnic others, first seen in Toshi's Micronesian articles, continues in her Muscovite writing. See, for instance, Akamatsu, "Shirakaba no mori." In this brief piece, Toshi describes walking in a Moscow park for an hour or two in the freezing cold, when an accordion player approaches her and asks for directions. She tells him she is a foreigner

and has no idea, and they strike up a conversation about her home country. Toshi comments on his kindness in speaking with her and his lack of discrimination against her as a non-Russian. Toshi's article can be read as a subtle critique, an unspoken contrast between Japanese and Russian treatment of ethnic others, which is a topic that would have been particularly poignant in postwar Japan, a country that had just been stripped of its colonies. Whether accurate or not, this perceived freedom from ethnic discrimination was something that other Japanese visitors to Soviet Russia mentioned in their memoirs. See, for instance, the comments in the section subtitled "Minzoku sabetsu naki Sovēto" (No ethnic discrimination in the Soviet Union) in the booklet *Ware ware ga mita Sovēto Rosshia,* 28–32. In her children's literature, Toshi was much more explicit about the values of ethnic multiculturalism and the dangers of discrimination.

51 Tokunaga, *Hatarakumono no bungaku dokuhon,* 62–64. Tokunaga's essay for the volume is drawn from an earlier 1946 article published in *Minshu no tomo.*

52 Tokunaga, *Hatarakumono no bungaku dokuhon,* 66.

53 Park, *The Proletarian Wave,* 114.

54 Perry, *Recasting Red Culture,* 6.

55 Kobayashi Takiji, "Kabe shōsetsu to 'mijikai' tanpen shōsetsu: puroretaria bungaku no atarashii doryoku," in Itagaki Takaho, ed. *Shinkō geijutsu kenkyū,* vol. 2, *Shu to shite geijutsu no keishiki ni kansuru tokushū* (Tokyo: Tōkō Shoin, 1931), 9–13; cited in Perry, *Recasting Red Culture,* 82.

56 Hoaglund, "Protest Art in 1950s Japan."

57 Toshi provided illustrations for a June 1947 republication of Kobayashi's by-then famous novella *The Crab Cannery Ship,* which had first been published in 1929 (Akamatsu, *Kani kōsen*), and, though not attributed on the book jacket, she likely also did the cover art for a second Kobayashi publication that same year (Akamatsu, *Tōseikatsusha*). She also illustrated Tokunaga Sunao's March 1947 *Nakanakatta yowamushi* (The weakling who didn't cry), his May 1947 novella *Machiko,* and his 1948 novel *Hataraku ikka,* as well as Shirakawa Atsushi's October 1946 story "A Shoeshine Boy's Brush" (*Shōnen no burasshi*), Okamoto Yoshio's 1948 proletarian novel *Gakkō no ie,* the cover art for Kamiyama Shigeo's 1948 proletarian novel *Shi mo mata sabishi,* and the 1948 edition of Nakanishi Inosuke's once-banned proletarian novel *Hokusen no ichiya* (One night in North Korea), among others.

58 For more on visual and literary representations of the *pan-pan* girls and an account of their history, see Sakamoto, "Pan-Pan Girls."

59 Akamatsu, "Fūkei."

60 Toshi sets "Machi no hyōjō" (Faces around town, published in May 1946) at the local post office, where a small joke by a quick-thinking girl eases the tensions of people waiting in a long line and becomes the kernel of a friendship between her and a girl working behind the counter. Her August

1947 piece "On beauty" (*Bi to iu koto*) starts with an autobiographical sketch of her girlhood in Hokkaidō before describing the fashion, as it were, of working women. The story suggests that work clothes are beautiful, be it the traditional clothing of a farm girl, the coveralls of a factory woman, or the high heels and permanent wave of a secretary.

61 Akamatsu, "Itsu made."

62 Akamatsu, "Yabureta wataire."

63 Akamatsu, "Kodomo no tame ni," 24.

64 Akamatsu, "Shinanai," 36. The headnote is a near quote from Christian scripture, Matthew 5:3, one translation of which reads, "Blessed are the poor [in spirit], for theirs is the kingdom of heaven." Toshi was, in fact, in the midst of illustrating a Japanese translation of the Bible (the first volume of which was published in October 1946). She had likely come across this phrase (in its Japanese translation) at that time and had been thinking about it actively for several weeks. Akamatsu, *Seisho Monogatari.*

65 Akamatsu, "Aru eki no machiaishitsu de," page number unclear.

66 Perry, *Recasting Red Culture,* 121–122.

67 Michiba, *Shimomaruko bunka shūdan,* 1.

68 Michiba, *Shimomaruko bunka shūdan,* 2.

69 Akamatsu, "Aratanaru bijutsu no shinro," 40.

70 Akamatsu, "Aratanaru bijutsu no shinro," 40.

71 Akamatsu, "Aratanaru bijutsu no shinro," 43.

72 Akamatsu, "Aratanaru bijutsu no shinro," 45.

73 Anonymous, "Shijō shoten," n.p. In his later writings, Iri agreed with Toshi's assessment that these sketch sessions were as important for the professionals as for the amateurs, noting that, "As a *suiboku* artist, I had never been trained much in drawing nudes or gypsum statues, but once I started to participate in these naked sketch sessions, I really came to appreciate how fundamental drawing is and, thereafter, when I painted mountains or trees or what have you, it came a lot easier. . . . I think the sketches I did then [at the circle meetings] are the best I've ever made." Maruki Iri, *Ruru henreki,* 50. While the vast majority of Toshi's circle activities focused on visual arts, she also lent her support to movements that attempted to foster amateur theater. See, for instance, her Russian-inspired illustrations for the Juvenile Literature Association's (Jidō bungakusha kyōkai) 1950 collection of plays, *Nihon gakkō gekisen.*

74 For an account of oil painter Sada Katsu (1914–1993) and illustrator Mita Genjirō's (1918–2000) reminisces on this score, see Matsumoto, *Iwasaki Chihiro no seishun,* 83–84.

75 See Hirayama, *Wakaki Chihiro e no tabi: shita,* 70–71. See also Okamura, *Maruki Bijutsukan bukkuretto 3,* 87–88.

76 Akamatsu, "Watashitachi no bijutsu," 40.

77 An ad in the October 21,1946, *People's newspaper* (*Jinmin shinbun*) announces the exhibit and solicits participation. The ad is accompanied by a sketch done by Iri, most likely a product of the morning sketch circle.

78 The article is addressed to a group of students at Hosei University, members of the bourgeoisie. In the course of her comments, Toshi recounts some scenes of her own impoverished youth before then describing this conversation at the factory culture circle. She ends the piece by asking the students to "reflect on yourselves and, when you have come to a realization (*ninshoku*)" about what sort of world you want to live in and what you are willing to do to help get there, then "take up your studies at this [university] and walk the path of the educated. Fight bravely!" Akamatsu, "Watashitachi no bijutsu," 41.

79 Hoshi Minoru mentions that he first met Toshi at a hospital, where she was giving a talk to patients on the topic "*E wa dare ni demo wakaru, e dare demo kakeru*" (Anyone can understand art and anybody can make art). See Hoshi, "Akamatsu Toshiko-sensei o tazuneru," 25.

80 Akamatsu et al., "Kakushinki bijutsukai," 12–25. See especially her comments on pages 14–15 concerning the construction of a "country of culture" (*bunka kokka*). Also, Akamatsu et al., "Zadankai: Hataraku mono no sekai," 17–21. In response to the question, "What, to your mind, would a worker's heaven (*hataraku mono no tengoku*) be like?" Toshi replies that, as an artist, she would like to see "a second Rennaisance, one that recognizes the full potential of every person, one in which a culture of liberty and pleasure has spread across the entire world" (*dainiji renessansu de, sono ato ni jinrui no zennōryoku wo ishoku shi, kyōraku suru koto ga dekiru kenkōna bunka ga chikyūjō ni*) (21).

81 Akamatsu, "Yabureta wataire," 16–18. She later reworked this article, concerning her own impoverished upbringing, into a chapter of the book-length manifesto.

82 Perhaps most famously, the Gutai group espoused a similar ideology. See Tiampo, *Gutai;* Tiampo et al., *Gutai: Splendid Playground;* and Kee, "Situating a Singular Kind of 'Action.'"

83 Akamatsu, "Watashitachi no bijutsu," 39. In this article, the girl's name is given as Wakai Shuko. In the book version (*E wa dare demo kakeru*, 29–32), the girl's name has been altered to Akai Shuko.

84 Akamatsu, "Watashitachi no bijutsu," 41.

85 Akamatsu, "Egaki nyūmon," 28–30. The following quotes are from the handwritten galleys provided to the occupation censors. Censors' notes indicate that the intended print run was two thousand and that no deletions or other alterations to Toshi's prose would be required.

86 Akamatsu, "Egaki nyūmon," 28.

87 Akamatsu, "Egaki nyūmon," 28–29.

88 Akamatsu, "Egaki nyūmon," 29.

89 Akamatsu, "Egaki nyūmon," 29.

90 Akamatsu, "Gaka to shite anata wa gendai shi o dō kangaeraremasu ka?" 43.

91 Stoler, *Imperial Debris,* ix, x.

92 Stoler, *Imperial Debris,* 2.

93 Akamatsu, *E wa dare demo,* 9.

94 Akamatsu, *E wa dare demo,* 11.

95 Akamatsu, *E wa dare demo,* 12.

96 Akamatsu, *E wa dare demo,* 14.

97 Akamatsu, "Mosukō no haru," 34.

98 Akamatsu, "Mori no Mosukwa," 31.

99 Akamatsu, "Mosukō no gogatsu," 33. For an earlier version of this scene, which Toshi has extended and embellished in the later publication, see Akamatsu, "Mē dē no omoide." For other variation of this scene, which stresses feminine embodiment, see Akamatsu, "Kōshin suru"; and Akamatsu, "Aka momen no hata." For further examples of the Soviet inflections of nakedness, see Akamatsu, "Dacha nite"; and Akamatsu, *Mosukuwa nikki,* 130–132, as well as Moscow sketches #38, #47, and #76 (which, though labeled a "sketch," is actually a watercolor).

100 Akamatsu, *E wa dare demo,* 90–91.

101 Akamatsu, *E wa dare demo,* 100.

102 Akamatsu, *E wa dare demo,* 101.

103 Akamatsu, *E wa dare demo,* 101.

104 After 1949, things shifted dramatically yet again. Cominform issued a severe criticism of the Japanese Communist Party, after which it split into two wings: one advocating violent revolution and the other taking a gradualist stance. By May 1950, Toshi and her husband Iri distanced themselves even further from leftist politics, withdrawing their membership from the Zen'ei Bijutsukai. The next month saw a series of SCAP-led red purges, as the US occupation in Japan undertook a reverse course in policy, responding to Soviet-supported forces crossing the 38th parallel on the Korean peninsula. On July 8, 1950, President Truman appointed General MacArthur, embodiment of the US occupation in Japan, as the commander-in-chief of UN forces in the Korean War, while US policy toward Japan focused on reindustrialization and the creation of military bases for the prosecution of the Korean War. Part of the course reversal involved the quashing of leftist politics in Japan, one sign of which was that on July 18, 1950, publication of the Communist Party flagship newspaper, *Akahata* (The red flag), was suspended indefinitely.

Chapter 5: Art as War Crime

1 For one account of wartime artist's activities and their later figuring in the debates on responsibility, see Hariu, *Sensō to bijutsu*.

2 Usami, *Ikebukuro Monparunassu*, 513.

3 Usami, *Ikebukuro Monparunassu*, 515. The book to which Toshi is referring is *Yashi no mi no tabi* (Journey of a coconut), examined at length in chapter 2.

4 Usami, *Ikebukuro Monparunassu*, 519.

5 The arts world remained a male-dominated realm. Almost all the essays that appeared in the marquee journals (*Bijutsu, Mizue, Atelier,* and so forth) were written by male artists and critics. Most of Toshi's printed work appeared either in women's journals (such as *Shin fujin*), in publications associated with the Communist Party (*Akahata* and *Jinmin,* for example), or in publishing organs of arts groups of which she was a member (*Jiyu bijutsu* and *Zen'ei bijutsu,* for instance).

6 Toshi also provided sketches for the second volume of *Sabakareru Nippon* (Japan judged). The sketches are not up to her usual quality, and her name is mistyped (as 赤松敏子 instead of 赤松俊子), suggesting that she did not take much interest in, or was not given the opportunity to view, the proofs. Yanagishita et al., *Ajia Shitsurakuen*. She also discussed the IMTFE, albeit briefly, in Akamatsu, "Minasama ni okaseraremashita wa," 5.

7 See Dower, "War, Peace, and Beauty"; and Eubanks, "The Mirror of Memory."

8 See Kunimoto, *The Stakes of Exposure;* Jesty, "Arts of Engagement"; Winther-Tamaki, "Embodiment/Disembodiment"; Havens, *Radicals and Realists;* and Hariu, "Phases of Neo-Dada."

9 For example, as recently as 2001 Mark Sandler contrasted Fujita—who not only created multiple canvases commissioned by the military and served as a leader of the Army Arts Association, but even "signed his name to articles espousing the subservience of art to the cause of national defense and authorized hollow justifications for his actions after the war"—with the Marukis who, "almost alone among their generation of Japanese artists, never collaborated with the military propagandists." Sandler, "A Painter of the 'Holy War,'" 189. The question of Japanese war art has begun to achieve more textured analysis, as can be seen in many of the studies I cite in this chapter, and some scholars have begun to explore the Marukis' work with a more fine-grained lens.

10 Kozawa, "*Genbaku no zu,*" 246.

11 Kokatsu, "Senjika no Nihon," 56.

12 Olick, *The Politics of Regret.*

13 Toshi, as quoted in Cook and Haruko, *Japan at War,* 254.

14 Miyata, "Bijutsuka no sessō."

15 Kiyose Ichirō, head of Tōjō's defense team, provided a perhaps more accurate moniker for Tōgō, calling him "diplomat backed into a corner" *(kyōhaku sareta gaikōkan)*. Kiyose, *Nijūgo hikoku no hyōjō*, 7.

16 "M'Arthur Seizing 40 for War Crimes." Citations are from the CWJ Phelps Collection, held at the University of Virginia.

17 As cited in SCAPIN-550, MacAthur's "Memorandum for: Imperial Japanese Government. Through: Central Liaison Office, Tokyo. Subject: Removal and Exclusion of Undesirable Personnel from Public Office."

18 SCAPIN-550, MacAthur's "Memorandum for: Imperial Japanese Government. Through: Central Liaison Office, Tokyo. Subject: Removal and Exclusion of Undesirable Personnel from Public Office."

19 Tsuruta, "Gaka no tachiba."

20 Fujita, "Gaka no ryōshin."

21 Uemura, "Bijutsu saiken no senketsu mondai," 8.

22 Okawa, "Genshukuna jikō hihan," 25.

23 Tsuruya, "Sensō Sakusen Kirokuga," 101.

24 Ihara's article is dated "late October," suggesting that he likely wrote it in direct response to Miyata's article in the *Asahi News*.

25 Ihara, "Sensō bijutsu nado," 28.

26 The debate raged on in the pages of *Bijutsu* for several more months. The December 1945 issue (2:6) carried several articles on the debate: sculptor and professor of fine arts at Kyoto University Suda Kunitarō's "Kore made no ware bijutsukai" (Our art world to this point, 2–3, 10), Miyata Shigeo's rebuttal "Bijutsuka no 'sessō' ni tsuite" (On the idea of artistic fidelity, 11–12), Ihara Uzaburō's rebuttal to the rebuttal "Saiken bijutsukai ni yōsu" (On what is needed to remake the art world, 18–29), and so forth. One path not taken was a frank appraisal of the paintings' artistic merit and their public appeal. Suzuki Osamu raised this question early on, but it was mostly ignored until Kikuhata Mokuma's work nearly half a century later. See Suzuki, "Sensō bijutsu no kōzai." Suzuki predicts, accurately as it turns out, that war art will simply be made to disappear as "the era of One Million Peoples Fighting As One turns, in the blink of an eye, into the age of War Art As an Act of Sustained Evil" (2).

27 For a contemporary account of how precisely democratic art could be defined and created, see Yanagi, "Rearuizumu to minshu shugi."

28 Kikuhata, *Egaki to sensō*, 12–13.

29 For an in-depth discussion, see Kikuhata's 1972 essay "Fujita yo nemure," republished in Kikuhata, *Egaki to sensō*.

30 Cited in Kikuhata, *Egaki to sensō*, 14–15. Hariu Ichirō has argued that the Nihon Bijutsukai, in creating the blacklist, was "chasing after the phantom of democratic revolution and pursuit of war criminals as ordered by MacArthur's office: in other words, [they were but actors in] a momentary

farce" (*yahari Ma shireibu o hanzai tsuihō ya heiwa kakumei no gen'ei no ue ni okotta: ichijō no chabangeki datta wake de aru*). Hariu, "Sengo bijutsu to sensō sekinin," 548.

31 Toshi left the Nihon Bijutsukai in May 1947, helping to found the splinter group Zen'ei Bijutsukai (Avant-garde arts association), which was in some ways even more radical.

32 Akamatsu, "Aratanaru bijutsu no shinro," 40–42.

33 Akamatsu, "Aratanaru bijutsu no shinro," 41–45.

34 Toshi was aiming at socialist artistry and not artistic socialism. As she said in a roundtable some months later, "Of course, I'd like to see a robust expansion [of the art world] but trying to put that first would be like building a castle upon the sands. I think there are more urgent problems pertaining to the everyday lives of people in this country that we need to resolve first, before we can build a country of culture (*bunka kokka*). By this, I don't mean that [as detractors would have it], 'Artists should become politicians.' I just mean that artists need to have a deep awareness of and appreciation for politics and the various difficulties that people face in their day-to-day lives. And as those political issues are gradually worked out, we'll also work out the cultural ones." She continues by arguing that it has not been long at all since the war's end, and that it is crucial to see that postwar culture is constructed on a strong social basis in order to usher in a new era of art and avoid the pitfalls of the recent past. Akamatsu et al., "Kakushinki bijutsukai no shōten," 14.

35 Akamatsu et al., "Kakushinki bijutsukai no shōten," 16. The roundtable gathered leading voices from a number of different leftist and avant-garde arts groups. The participants were Ogisu Takanori (Shinseisakuha), Takigawa Tarō (Issuikai), Takai Teiji (Kōdō bijutsukai), Matsumoto Kōji (Nikakai), Yabe Tomoe (Genjitsukai), Akamatsu Toshiko (Zen'ei bunkakai), Irie Hiroshi (Nihon bijutsukai), and three people whose affiliations were not noted: Tasaki Hirosuke, Furuyama Jun'ichi, and Murakawa Migorō. Notably, Toshi was the only woman present.

36 Akamatsu, "Minakutomo hihyō dekiru wake," n.p.

37 An editor's note, appended to Toshi's article, indicates that the exhibit hung from September 27 at the Ueno Gakushu'in gallery and featured primarily the work of seven young members of Issuikai.

38 Akamatsu, "Issuikai hyō," 21.

39 Akamatsu, "Issuikai hyō," 22.

40 Akamatsu, "Issuikai hyō," 23.

41 Akamatsu, "Umi no kanatta yūjin," 46.

42 Akamatsu, "Sensō kara heiwa e," 30.

43 *Nobiyuku Nihon* does not survive or, if it does, its whereabouts are unknown. From a postcard produced in association with the exhibit, the painting

seems to show a group of Japanese boys and girls gazing over a meadow with elk toward a rising sun. See Okamura, *Shiryōyō nenpu,* 95. For the (perhaps partial, but certainly miniature) reproduction, see *Nika gashū,* 29, 3.

44 Akamatsu, "Oishii oishii papaya," n.p.

45 "How to See War Trial." Accessed July 8, 2017, http://imtfe.law.virginia.edu /collections/phelps/1/1/how-see-war-trial-news-article.

46 We know that Toshi participated in a roundtable with several US officers in April 1946. The roundtable included two female commissioned officers in the US military, one US civilian, and five Japanese women, including Toshi and Sata Ineko, both communists. One of the American women, Maj. Greta Old, was with the Health Division of the High Command and another, Mary Joyce, was a civilian reporter who was detailed at the time to the Communications Department with the nursing wing of the occupation. Though the evidence is circumstantial, it seems possible that Toshi and a group of other interested Japanese cultural figures went together to the Red Cross Club, combining the roundtable with a chance to pick up passes to the trial. Akamatsu, et al., "Josei to shin seikatsu," n.p.

47 Akamatsu, "Bunmei no hata no shita ni," n.p.

48 Akamatsu, "Tokyo saiban bōchōki," 76. The quotations here are drawn from the galleys submitted for censorship. Because of redactions in earlier articles in the journal, censors' notes indicate that in the approved print run, the pages for this feature would be 60–67.

49 Akamatsu, *E wa dare demo,* 101.

50 Akamatsu, "Tokyo saiban bōchōki," 76.

51 Akamatsu, "Tokyo saiban bōchōki," 76–77.

52 For one discussion, see Robert, "Reflections on a Buddhist Scene."

53 Akamatsu, "Tokyo saiban bōchōki," 78.

54 Akamatsu, "Tokyo saiban bōchōki," 78.

55 Akamatsu, "Fūshiga no koto," 17. Toshi provided caricatures—which she understood as quick line drawings that employed deformation to get at occluded aspects of a person's character—for any number of publications over the late 1940s and 1950s. In addition to accused war criminals, she also regularly sketched people running for office. See, for instance, Akamatsu, "Kaiho e mukau"; and Akamatsu, "Godai seitō."

56 Akamatsu, "Fūshiga no koto," 16–17.

57 One of the two passages struck by censors contains a humorous exchange. "One of the lawyers, speaking to the Chief Justice, complained bitterly, 'I've never seen such undemocratic legal proceedings in my entire life!' to which the Chief Justice replied, 'And I've never before seen a judge who knows less about the rules of court proceedings than you.' Such were the somewhat humorous, somewhat ironic exchanges; what could those 'frog generals' have

possibly made of this banter? The cameras rolled smoothly on." Akamatsu, "Tōkyō saiban bōchōki," 80.

58 Akamatsu, *E wa dare demo,* 100.

59 Akamatsu, "Kēto Koruwitsu," 4.

60 Akamatsu, *E wa dare demo,* 92–98.

61 Akamatsu, "Tōkyō saiban bōchōki," 79.

62 Akamatsu, "Tōkyō saiban bōchōki," 79.

63 Akamatsu, "Tōkyō saiban bōchōki," 82.

64 Yoneyama, *Cold War Ruins,* 4.

65 Transcript from the Prange microfiche of the IMTFE proceedings, 27–28.

66 Transcript from the Prange microfiche of the IMTFE proceedings, 29–30.

67 Transcript from the Morgan collection, 2629–2639. Accessed July 15, 2017, http://imtfe.law.virginia.edu/collections/morgan/6/1/trial-transcript-july-29–1946.

68 Transcript from the Morgan collection, 2634. Accessed July 15, 2017, http://imtfe.law.virginia.edu/collections/morgan/6/1/trial-transcript-july-29–1946.

69 Toshi records that Pu Yi testified the Japanese had ordered his wife killed, a topic that he broached two times: first on August 16, 1946, and then again, following the weekend-long adjournment, on August 19.

70 Transcript from the Morgan collection, pages 13 and 15. Accessed July 15, 2017, http://imtfe.law.virginia.edu/collections/morgan/1/6/interrogation-ai-hsin-cho-lo-pu-yi-henry-pu-yi-0900–1200-hours#.

71 Akamatsu, "Tōkyō saiban bōchōki," 81.

72 Elsewhere, Toshi notes that Pu Yi is claiming to have been acting under Japanese imperial (*tennō heika*) orders. That much is certainly true, she opines, and he suffered under it like the rest of us. But, she points out, it is called "tennō heika" and he was a "tennō." That, she concludes, is the bind he is in now, and he cannot get out of it. So, she says, "I drew a caricature of him, too, just like Goya and other artists before me had drawn caricatures of powerful people." Akamatsu, "Fūshiga no koto," 17.

73 Akamatsu, "Tōkyō saiban bōchōki," 82.

74 Kiyose, *Nijūgo hikoku no hyōjō,* 11.

75 Kōsaka et al., *Gakatachi no sensō,* 108.

76 Nakagawa, *Daitōa sensō myōgashū.*

77 As quoted in Hariu, "Sensō bijutsu, sono genzai made no isō," 6.

78 The art critic Hariu Ichirō and the artist Kikuhata Mokuma were, it would seem, two exceptions to this general trend, about which there is more below. Hariu, "Sensō bijutsu, sono genzai made," 6.

79 Hariu, "Wareware no uchi," 52. In addition to war documentary paintings and works by Maruki Toshi (Akamatsu Toshiko) and Maruki Iri, Hariu envisioned including pieces by several other artists, specifically naming Hamada Kazuaki and Kagetsu Yasuo.

80 See, for instance, Ara et al, "Zadankai: Sensō sekinin o kataru"; and
 Ōkuma, *Kokka'aku: Sensō sekinin wa dare no mono ka?* For a particularly
 well-argued critique of the *gadan,* see Hariu, "Sensōka no bijutsu."

81 Hariu, "Sengo bijutsu to sensō sekinin," 548.

82 Hariu, "Sensōga hihan no konnichiteki shiten," 66.

83 Kikuhata's essay "Fujita yo nemure," initially published in 1972, reappeared
 as part of his collected works. See Kikuhata, *Egaki to sensō: Kikuhata
 Mokuma chosakushū,* vol. 1. For his critique of Hariu, see especially pages
 4–5.

84 Kikuhata, *Egaki to sensō,* 8.

85 Yoshimi, *Grassroots Fascism.*

86 The pedagogical approach to understanding war art remains a popular mode
 of discourse well into the current century, particularly in communist-
 oriented journals. See, for instance, Kujū, "Sensō sanbi to 'tennōsei' no
 raisan"; and Yoshida, "Sensōga to iu ijōsa." In addition, a number of scholars
 have continued archival research into the war documentary paintings. See,
 for instance, Tanaka, *Nihon sensōga keifu to tokushitsu;* Mizoguchi, *Enogu to
 sensō;* and Kōsaka et al, *Gakatachi no sensō.*

87 Hariu, "Wareware no uchi naru sensōga," 46. Hariu's essay is part of a
 special issue, dedicated to contextualizing the planned—and abruptly
 canceled—exhibit of war documentary paintings, which was to have been
 held at MOMAT in 1975.

88 Kikuhata, *Tennō no bijutsu.* Scholarship on what one, following Anne Laura
 Stoler, might call the "imperial formation" of the Japanese arts continues to
 be an active and interesting field. See, for instance, Omuka, *'Teikoku' to
 bijutsu.*

89 Watanabe, "Teikoku kenpō 'senpan' ron," 16.

90 See Kozawa, "Jūgonen sensōki no bijutsu o megutte"; Kozawa, *Aban gyarudo
 no sensō taiken;* Yazawa and Kozawa, *Ongaku/bijutsu no sensō sekinin;* Tan'o
 and Kawada, *Imēji no naka no sensō;* and Segi, *Nihon no zen'ei.*

91 See, for instance, Winther-Tamaki, "Embodiment/Disembodiment";
 Winther-Tamaki, "From Resplendent Signs to Heavy Hands"; Tansman, *The
 Culture of Japanese Fascism;* and Kunimoto, *The Stakes of Exposure.*

92 On this question, see especially Hariu, "Sensō bijutsu, sono genzei made
 no isō."

93 Cook and Haruko, *Japan at War,* 255.

94 Cook and Haruko, *Japan at War,* 256.

95 Cook and Haruko, *Japan at War,* 254.

96 Cook and Haruko, *Japan at War,* 253.

97 Usami, *Ikebukuro Monparunassu,* 515. The book to which Toshi is referring
 is *Yashi no mi no tabi* (Journey of a coconut), examined at length in
 chapter 2.

Chapter 6: Art as Direct Action

1 Iri's transwar archive and oeuvre, while not as varied as Toshi's, is
nevertheless sizeable and I am not able to do it any measure of justice here.
Briefly, Iri's earliest artistic productions include mostly commercial works
(he apprenticed as a sign painter), surrealist poems, travel sketches,
illustrated prose for newspapers, and other, often bitingly humorous or
caustic vignettes. He burst onto the arts scene with a series of solo exhibits in
the mid-1930s and was hailed as a major *suiboku* (ink brush) artist. Like
Toshi and virtually every other artist active at the time, Iri succumbed to the
pressures of militarization of the arts sphere in the late 1930s. (For instance,
in September 1937 he and four other artists each contributed works to go to
wounded soldiers as convalescence gifts, part of a photo op orchestrated by
the journal *Jitsugen*. In October of that same year, he was part of a two-day
exhibit to cheer the war wounded, and two of his works were chosen
subsequently to hang in a military hospital. See Okamura, *Shiryō yō nenpu*,
55.) Unlike Toshi, however, Iri essentially went silent between 1941 and
1945, emerging in the postwar as an avant-garde artist with some political
commitments (never as fully articulated as Toshi's) to leftist movements. For
an overview of Iri's artwork and a sense of his oeuvre, see Tajika, *Garyū /
Lying Dragon;* Genbaku no zu Maruki bijutsukan, *Maruki Iri no sekaiten;*
and Genbaku no zu Maruki bijutsukan, *Maruki Iri/ Maruki Toshi no sekai.*

2 2601 is the Imperial Reign Year, per nationalist reckonings dating the
foundation of the Japanese Empire. For more on the Imperial Reign Year
phenomenon, see Ruoff, *Imperial Japan at its Zenith.*

3 See Akamatsu and Maruki Iri, *Chibifude,* 27–28; and Maruki Iri, *Ruru
henreki,* 41–43.

4 See Maruki Toshiko, *Jōjō ruten,* 239–241; and Maruki Toshi, *Yūrei,* 97.

5 "Hiroshima e teki shingata bakudan."

6 Maruki Iri, *Ruru henreki,* 43–48.

7 Maruki Toshi, *Yūrei,* 104–110.

8 Conversations with Ann Sherif have helped me to think through this section
of my argument, and I have benefited from hearing her speak on numerous
occasions about her research into the print and visual cultures of Hiroshima
and about questions of gender and the Japanese Cold War experience. See
Sherif, "Cold War Era"; Sherif, "Hot War/Cold War"; and Sherif, *Japan's
Cold War.*

9 Maruki Toshi, *Onna egaki no tanjō,* 126.

10 For a photoessay documenting the community of activists and the variety of
activities that the Marukis cultivated in and through the gallery, see
Motohashi, *Futari no gaka.* As Motohashi suggests, the Marukis saw the
museum as much more than simply a building to house their artwork.
Rather, for them, the site functioned as an architectural locale for

community building, activism, and aesthetic action. After the artists' deaths, the gallery continues to carry forth many of these activist and community-building missions. For an overview, see Okamura, *'Genbaku no zu' no aru bijutsukan;* and Okamura, *A Brief Guide.*

11 See, for instance, Ono, "Maruki Bijutsukan o mijika ni."

12 In a letter dated January 18, 1995, Lawrence S. Wittner, professor of history at the University of Albany, nominated Toshi and Iri for the Nobel Peace Prize. Remarking upon the upcoming fiftieth anniversary of the end of the war, Wittner briefly described the artists' experiences in Hiroshima and their courageous decision to begin painting realistic murals of the nuclear aftermath "in 1948, when the atomic bomb was still a forbidden subject in their occupied country." Comparing the murals to the "great anti-war art of Goya and Picasso," Wittner writes, "Overall, no more powerful images exist of the death and destruction through war that have characterized this century—and, conversely, the necessity of peace—than those created by Iri and Toshi Maruki over a period of nearly fifty years." Dr. Wittner faxed a copy of his nomination to museum director Tsuboi Chikara at the Maruki Gallery on September 19, 1995, and this is the copy cited here.

13 Marotti, *Money, Trains, and Guillotines,* 2.

14 Havens, *Radicals and Realists,* 13.

15 SCAPIN-33, "Press Code for Japan," http://dl.ndl.go.jp/info:ndljp/pid/9885095.

16 For a useful indication of the sorts of reporting on the atomic bomb that *was* allowed in postsurrender Japan, see the gleanings in "Sekai no wadai: Atomic Bomb," 52–55. The only people the article describes as suffering on account of nuclear technology are people who seem to be contracting leukemia due to proximity to the cyclotron at New York University (55).

17 For example, in October 1948, Okumura Shigeko (author) and Iwasaki Chihiro (illustrator), both associated with the Communist Party, completed a *kami shibai* (story with large illustrated panels) meant to show children the horrors of war and, particularly, human casualties. Though slated for a print run of two thousand, occupation censors marked it "disapproved in entirety" and forbade its dissemination. Okumura and Iwasaki, *Atatakai kyōshitsu.* (For the submission version and its censors' marks, see Prange collection 506-0023.)

18 This paragraph paraphrases information presented in Maruki Toshiko, *Jōjō ruten,* 51–52 and 253–254.

19 These dates and descriptions are drawn from Maruki Iri, *Ruru henreki,* 51–52; Maruki Toshiko, *Jōjō ruten,* 254–255; and "Fujinkai shōsoku," n.p.

20 See, for instance, Maruki Iri, "Ressha kanseki," n.p.

21 Maruki Toshiko, *Jōjō ruten,* 255.

22 Havens, *Radicals and Realists,* 50.

23 One other artist, who was himself actually present in Hiroshima on August 6, 1945, also composed several pieces focusing on the human suffering caused by the blasts. Fukui Yoshiro survived the atomic bombing of Hiroshima and, within one hour of detonation, he had begun to sketch the burning city, so he was literally "the first artist to sketch the atomic bombing." Once the Marukis had begun to exhibit their nuclear paintings, Fukui followed suit, showing his painting *Fifteen Minutes after the Explosion* (*Sakuretsugo jūgofun*) and other works beginning in April 1952. He gave an interview to Fred Saito in the English-language *Pacific Stars and Stripes,* a daily newspaper published in Tokyo for members of the US armed forces. In the interview, neither Fukui nor Saito mention the Marukis by name, but they refer to "a Communist artist"—the Marukis were not officially expunged from communist roles until 1964—so it is fairly clear that he is referring to Toshi and Iri. See Saito, "Artist Portrays Hiroshima Blast." Occupation authorities were much less concerned with verbal descriptions, especially oblique ones, which often passed censors. See, for instance, Akamatsu, "Shoshū," which mentions missing bodies, keloided faces, and a young girl's crippled hands in the text, while the accompanying illustration shows a busy street scene, sketched on the same spot where the young girl last saw her classmates five years earlier.

24 According to Toshi, for the purposes of the Independent, friends in the Japan Arts Society (Nihon bijutsukai) "asked us to remove the title 'Nuclear painting' (*Genbaku no zu*) and think of an alternate name, as it would be a shame for the Nihon Bijutsukai to be quashed" because occupation forces found the artwork and its title to be "inflammatory." Maruki Toshiko, *Jōjō ruten,* 258.

25 I have combined a number of sources to produce the description in this paragraph, paraphrasing from the following accounts: Akamatsu Toshiko and Maruki Iri, *Gashū fukyūban,* 73–83; Yoshida, *Kaitaigeki no maku orite,* 37–38; and Maruki Toshiko, *Jōjō ruten,* 256–258.

26 Akamatsu, Tsuboi, and Maruki Iri, "Tsuboi, Maruki, Akamatsu shoshi," n.p.

27 Yoshida, *Maruki Iri Toshi no jikū,* 90. The working method Toshi and Iri settled upon closely resembles that of their contemporary, Chinese artist Jiang Zhaohe. Hijikata Tei'ichi, a well-known arts critic in 1940s Japan, described Jiang's practice of executing drawings in charcoal, and then going over them with an ink and/or oil paint brush, resulting in what the critic rated as a highly successful blending of "oil painting in the impressionistic vein" with traditional brush painting techniques. Hijikata Tei'ichi, *Gendai bijutsu,* 232. In the process of conducting archival research for this book, I discovered several cuttings of Jiang Zhaohe's artwork in Toshi's folders, filed with other materials (including her own manuscripts) dating from 1946 to

1948. The cuttings were of Jiang Zhaohe's masterpiece *Refugees,* on which Hijikata had written an essay for a major arts magazine (to which Toshi no doubt subscribed) in 1946. Hijikata Tei'ichi, "Shan Chōhei," 6–8. Toshi and Iri's nuclear artwork also resembles Jiang's work in terms of scale: his *Refugees* (1941) measured nearly two meters high and some thirty meters in length. Portions of the silk scroll have suffered damage, and the current artwork is shorter.

28 Akamatsu Toshiko and Maruki Iri, "Mizu to abura," 48. The poem reads: "*Suiboku o yaru hitori / aburanogu o toku hitori / Daga, kakumei no bunka no ruppo wa / takaku netsu o hasshi, / akaaka to kagayaite. / Sore wa, ruppo. / Sore wa nietagiru ruppo. / Aoshiroi made no hikari o hasshite / honnagasuru mono wa, / aa, imada katsute mizaru / chijō no bunka.*" For Iri's statements of his own artistic practice, articulated from the vantage of a Hiroshima-born artist located for much of his early career outside of the Tokyo arts world, see Maruki Iri, "Sumi, kami, gamen, inshō"; "Sanjūsan no aki"; and "Zai-Hiro Nihon gadan ni yosu."

29 Yoshida made this remark on November 3, 2004, at the Maruki Gallery, where he discussed his role in traveling with the *Nuclear Panels* throughout Japan in the 1950s and performed a version of the spoken commentary he had typically provided at those events. For a partial transcript of his remarks, see Kubo, "Kubo Zaiku nikki." For Yoshida's critiques of the Marukis' work, see Yoshida, *Yoshida Yoshie zenshigoto,* 198–259.

30 Dower, "War, Peace, and Beauty," 34.

31 Maruki Toshi, *Onna egaki no tanjō,* 127.

32 John Junkerman states that the Marukis painted themselves in only one nuclear panel, *Relief.* (See Junkerman, *The Hiroshima Murals,* 17.) When we consider Toshi's engagement with her material in the subjunctive mode, however, Toshi (as a mental projection) also appears in *Ghosts* and *Death of the American POWs.*

33 Okamura Yukinori, current curator of the Maruku Gallery for the Nuclear Panels, points out that Toshi and Iri were also actively researching survivors' testimony, in addition to relying on what they had seen firsthand and heard from relatives and friends during their time in Hiroshima. For instance, the two girls who are looking at each other in the middle of the painting are likely based on a scene from Ōda Yōko's 1948 *Shikabane no machi,* in which the author describes she and her younger sister looking at each other's faces, and imagining, on that basis, what their own face must look like. (Okamura Yukinori, *Shiryō yō nenpu,* 149.) Writing from the vantage point of the early twenty-first century, critic Kozawa Setsuko has argued that we should pay more attention to the fact that the *Nuclear Panels* all began with, were born from, that initial pose—a pregnant woman—and that many of the later panels show scenes of rape. Thus she suggests that critics need to attend

more carefully to the ways in which a consciousness of nuclear depravation and a consciousness of the abuse of women overlap with and inform one another in the series. Kozawa, 'Genbaku no zu,' 123–126.

34 "Chikazuku daisankai Andepandan," n.p.

35 See, for instance, Akamatsu, "Abare no machi," n.p.

36 The first quote is from Inoue Nagasaburō, writing for *Akahata* on February 14, 1950. The second is from a review published in the *Fujin minshu shinbun,* a women's labor union periodical, on February 24, 1950. Both are cited in Okamura, *Shiryō yō nenpu,* 151.

37 Kamon et al., "Gappyōkai," 2.

38 Hayashi, "Hayashi Fumio no hihyō," 68.

39 Kamon et al., "Gappyōkai," 3.

40 Saito, "Artist Portrays Hiroshima Blast," n.p.

41 As quoted in Saito, "Artist Portrays Hiroshima Blast," n.p.

42 Maruki Toshiko, *Jōjō ruten,* 258–259.

43 Akamatsu, *Akamatsu: Genbaku no zu,* 1.

44 When asked by *Akahata* correspondents what she was displaying at the 1950 Independent and "how does it help build the society we want," Toshi responded only that she felt the work would and should speak for itself in that regard. For his part, Iri resolutely refused, for most of the next fifty years, to comment on the *Nuclear Panels* in any in-depth manner. Akamatsu, "Abare no machi," n.p.

45 Actually, they first began work on a painting called *Evening (Yoru)* and even displayed the first portion of it. *Akahata* (March 24, 1950) announced the exhibit, noting that Toshi and Iri had "read the critiques from the Third Independent [of *Ghosts*] and had turned their combined attention to a new work, which would attempt to communicate the tragedy of war"—this piece being *Yoru.* The theme was to be the scene of the evening of August 6, and it was going to show a stupefied man and several people on the brink of death. They started working from the right-hand side and completed about two meters. According to the artists' later writings, they wanted to show the life spirit of the people this time (*ningen ni kakki o obiteiru mono*), but they abandoned the work because they needed to sell some of their paintings in order to afford living expenses. When they returned to it after about three weeks, they were unhappy with it and decided not to continue, shifting instead to *Fire.* (See Akamatsu Toshiko and Maruki Iri, *Gashū fukyūban,* 88–89.) At least one early review of the partially complete work was favorable. "In the post-war eroticism, morals had been stretched to the breaking point, whether in painting or in strip shows. . . . For a woman to take off her clothes or a man to become naked, this demeans morals, making of them [the people] mere erotic grotesquerie. This painting [*Evening*] shows the tragedy of the people who were bombed in Hiroshima, and as a

documentary painting (*kirokuga*) it has great value; and yet, appallingly, to show [these people] as if in a strip show, with that sort of grotesquerie, sacrifices their humanistic aspect. In this respect, *Evening* is a great improvement upon *August Sixth*." "Kiroku," 70.

46 For an overview of how the Marukis began to collect testimony, photographs, letters and other accounts of Hiroshima from survivors—as well as materials related to Nagasaki—see Kozawa, *Genbaku no zu,* 91–106. As others have noted, the *Nuclear Panels* tend to highlight violence done to the bodies of women and children, which can be understood, at least in part, as a specific political call against bombing civilians. This was a major concern in a Japan that was rapidly becoming a staging ground for other, US-led wars in Asia. See Gluck, "The Seventieth Anniversary"; and Sherif, "Cold War."

47 *Water* blends Toshi and Iri's personal experiences in Hiroshima with scenes envisioned from the testimony of others. While the naked mother and infant at the center of the composition are based on oral testimony, the image just below and to the right of it—of the clothed man looking into the face of a drowned corpse—is personal experience.

48 Akamatsu, "Genbaku sanbusaku naru," n.p. For an in-depth visual analysis of the *Nuclear Panels,* the ways they draw upon motifs from Buddhist hell screens, and their use of modernist techniques, see Eubanks, "The Mirror of Memory."

49 "*Genbaku no zu:* Imai Tadashi sakuhin, Shinsei eigasha," 2.

50 For more on the possibilities of populist and anarchist art as direct action, see Adachi, *Zen'ei no idenshi.*

51 Marotti, *Money, Trains, and Guillotines,* 143 and 144.

52 See, for instance, Hariu, "The Phases of Neo-Dada"; Winther-Tamaki, "From Resplendent Signs to Heavy Hands"; Marotti, *Money, Trains, and Guillotines;* Hoaglund, "Protest Art in 1950s Japan"; and Havens, *Radicals and Realists.*

53 The group Hi Red Center took its name from the truncated patronyms of its three founders: Takamatsu Jirō ("taka" meaning "high"), Akasegawa Genpei ("aka" meaning "red"), and Nakanishi Natsuyuki ("naka" meaning "center").

54 Marotti, *Money, Trains, and Guillotines,* 209.

55 Marotti, *Money, Trains, and Guillotines,* 210.

56 Marotti, *Money, Trains, and Guillotines,* 2.

57 Marotti, *Money, Trains, and Guillotines,* 167.

58 The Marukis, Toshi especially, seem to have understood "direct action" a bit differently than other artists of the time, for whom the issue of figuration (versus abstraction) was an overriding issue. One might argue that the *Nuclear Panels* verge on figuration. This equivocation remains an area meriting further consideration, and I hope to return to the issue in future research.

59 Okamura Yukinori has argued that Iri's brushwork for the *Nuclear Panels* bears the influence of a particular technique (decalcomania) used by some Japanese surrealists of the transwar period. Okamura considers Iri's technique "a forerunner of the modernist genre of action painting" (*gendai bijutsu no 'akushon peintingu' no sakigake no yō ni miemasu*). Okamura, unpublished remarks, delivered at the opening of the Maruki show at Boston University Art Gallery, Fall 2015.

60 Hayashi, "Hayashi Fumio no hihyō," 68.

61 In this sense, the *Nuclear Panels* work something like *kamishibai* ("paper play"), the street corner performance art, popular from the 1930s until the widespread availability of television in the 1960s, in which a narrator would vocally interpret a story while displaying scenes, painted or printed on paper. For more see Orbaugh, *Propaganda Performed*. Toshi, in fact, illustrated at least one *kamishibai* story in the immediate postwar period, a work called "Neighbors." Akamatsu, *Otonarisan*.

62 A hand-drawn map and handwritten invitation, held in Toshi's files at the Maruki Gallery, notes that the event will run from 6:00 to 10:00 p.m. The invitation also lists a number of groups, including the Heiwa o mamoru kai (a peace activism group), Yoshi Rōdō Dōmei (a labor union collective), Fujin Minshu Kurabu (a women's democracy group), and the Nihon Bijutsukai (Japan Arts Association) as sponsors.

63 "Namida de katarenu Akamatsu-san," n.p.

64 Maruki Toshi, *Onna egaki no tanjō*, 136. Toshi continued to perform in-person narration and interpretation of the panels throughout her life, and these performances continued to spin off further audience responses, emendations, and additions, many of which took the form of children's books. See, for instance Matsutani and Maruki Toshi, *Tōrō nagashi*; Maruki Toshi and Maruki Iri, *Okinawa shima no koe*; Kimishima Hisako and Maruki Toshi, *Fue o fuku iwa*; and Ishimure Michiko and Maruki Toshi, *Minamata umi no koe*.

65 "Ima sara to iware tsuzukete," 11.

66 Maruki Toshi, *Onna egaki no tanjō*, 133.

67 For instance, see Akamatsu, "Hi," 2; "Genbaku no zu: Tenrankai hiraku," 2; and "Fukushima de *Genbaku no zu* bijutsuten," 2. For more on the Buddhist memorial service offered at Zenshōji, see Akamatsu, "Toshiko furusato ni kaeru"; and Akamatsu, *Onna egaki no tanjō*, 142–149.

68 Maruki Toshi et al, *Genbaku no zu: The Hiroshima Panels*, 20. English translations for this bilingual version were prepared by Nancy Hunter with Yasuo Ishikawa.

69 The Marukis paid close attention to the formal aspects of their works in other ways as well. For instance, for *Fire* Toshi and Iri used torinoko paper and added blue and crimson ink to their monochrome palette. They had

planned also to use gold dust and other, richer colors evocative of classical ink brush paintings of the courtly era, but could not afford it. When asked about the choice of materials (torinoko paper and Japanese sumi ink), Toshi responded, "The atomic bomb didn't explode over Westerners' heads, but over Japanese heads" and so "we choose Japanese materials in order to bring that to mind." Akamatsu Toshiko and Maruki Iri, *Gashū fukyūban*, 87.

70 Okamura, *'Genbaku no zu' zenkoku junkai*, 273.

71 Akamatsu Toshiko and Maruki Iri, *Gashū fukyūban*, 110.

72 For a description of the folding screens and the shift in mounting, see Akamatsu Toshiko and Maruki Iri, *Chibifude*, 42–46.

73 Akamatsu, *Akamatsu: Genbaku no zu*, 4.

74 Maruki Toshi, *Onna egaki no tanjō*, 138.

75 Okamura, *Maruki Bijutsukan bukkuretto 2: 'Genbaku no zu' o ronzu*, 23. When Toshi and Iri needed to rest and recuperate and were no longer able to tour with the panels in person, Nonoshita and several others, including the young Yoshida Yoshie, took up the work, crisscrossing Japan with the panels for another decade. For more information on Nonoshita's decision to join the Marukis at Katase, see *Maruki Bijutsukan nyūsu* 50 (July 1994): 2. As the group traveled with the panels, Yoshitome regularly collected compilations of viewers' responses (*kansō bunshū*), many of which are now kept at the Maruki Gallery for the Nuclear Murals. Toshi and Iri clearly read these materials. For instance, the Aichi University compilation *Genbakuten kansō bunshū* shows Yoshitome's name on the front cover, next to an *ex libris* stamp reading "Iri Toshi."

76 See, for instance, "Chikaku Sapporo de genbakuten"; and Yazawa, "'Genbaku no zu' tenshikai no shashin."

77 Okamura, "Gentōban 'Genbaku no zu' 'Pikadon' to 50 nendai 'Genbaku no zu' no media hyōgen." See also Obata, *Senryōka no 'genbakuten.'* Obata's booklet details the work done by youths, especially junior high and college students, all over Japan who worked for peace by holding exhibitions of the Marukis' nuclear panels and related materials. While at Kyoto University, Obata was the chair of the student committee that organized such events, and in the booklet he collates oral histories from other organizers around the Kansai area. In contrast to these grassroots efforts, note that immediately following the occupation's end, major newspapers such as the *Asahi shinbun* started carrying regular announcements about the exhibits, which continued well into the 1960s and beyond.

78 Maruki Toshi, *Onna egaki no tanjō*, 138. The panels were on display at the Osaka Gekiba from January 27 through February 28, 1951, before embarking on an all-country tour.

79 Akamatsu Toshiko and Maruki Toshi, *Gashū fukyūban*, 105–106.

80 Her children's book *Hiroshima no pika,* for instance, is based on oral testimony a survivor provided during an exhibit of the panels in Muroran held October 28–30, 1951. For Toshi's recollection of this incident, see Usami, *'Genbaku no zu' monogatari,* 105–106 and 151.

81 Akamatsu Toshiko and Maruki Toshi, *Gashū fukyūban,* 104.

82 Akamatsu, Tsuboi Shigeji, and Maruki Iri. "Tsuboi, Maruki, Akamatsu shoshi o kakomu zadankai," 33.

83 "Kakitsuzuku genbakuga Maruki gahakuten," n.p.

84 "Bakushinchi no genbaku kaikan," n.p. Toshi and Iri pursued, or at least welcomed, any number of cocreation opportunities, often responding to requests that they provide forwards to, illustrations for, blurbs about, and responses to viewers' responses. See, for instance, their collaborative work (illustrations and a foreword) for a poetry volume written in response to viewing the nuclear artwork: Akamastu, Maruki, and Iwama, *Boshizō.*

85 For further information on the Marukis' activities and Hiroshima-related media more generally, see Sherif, "Cold War."

86 In the summer of 1952, for instance, a student club in Takasaki hurriedly organized a display of the *Nuclear Panels.* Concerned about the ongoing Korean War, the continued use of Japan as a military base for bombing raids, and the possibility of a recurring nuclear nightmare, the students decided that their first action toward peacemaking should be to host the *Nuclear Panels* in their town (4). Working late into the night and going door to door with handmade posters and peace petitions, the students managed to organize an exhibit for August 11 through 13. Toshi attended and provided spoken commentary in front of the murals, where she was joined by at least one woman from the crowd (6). See Takasaki gakusei kodankai, *1952nen natsu.*

87 "Kaiba kazaru genbaku no e," n.p.

88 For more information, see Okamura, "'Genbaku no zu' futatsu aru no ka?"

89 Okamura, "'Genbaku no zu' futatsu aru no ka?"

90 Akamatsu Toshiko and Maruki Iri, *Pikadon,* n.p.

91 Kozawa,*'Genbaku no zu,'* 106–112.

92 Kamishō, "Shinpan *Pikadon* ni yosete," 73–78. As Kamishō notes, the first edition of the book was produced in both left-opening and right-opening versions. The left-opening one was made first, with "in association with the Heiwa o mamoru kai" on the cover and "Potsdam shoten" on the reverse. On the right-opening version, there is no mention of the Heiwa-kai, and there are a few other differences (the coloring of the title letters, for instance, and several small adjustments to the woman's body). Ikeda, drawing on her experiences with Chinese forms of pictorial literature, may have suggested the change in cover so that the coloring of the title would reflect the meaning, with the "flash" (*pika*) in white and the "boom" (*don*) in black.

The picture book was repopularized by Ōe Kenzaburō, who used several images from it in his mid-1960s series of reports on Hiroshima. Ōe, *Hiroshima nōto.*

93 Akamatsu Toshiko and Maruki Iri, *Pikadon,* n.p. Though written in Hiroshima dialect, and so presented in the voice of Iri's mother Maruki Suma, these comments were also commonly echoed by Toshi in the course of interviews and roundtables. In an article from August 1952, Toshi tries to imagine the room ("civilized, enlightened") in which the bomb was made, the hand ("beautiful") that pushed the button ("or was it a lever that was pulled?"), and the society ("free, democratic, scientific, advanced") that gave birth to such destructive force, before issuing a rousing call for international peace and an absolute ban on nuclear weapons. See Akamatsu, "Nan to iu koto," 34, 35, 37, 38. The same month, in response to a postcard survey asking "What would you do, if you were in your twenties?" she responds, "Why is it that there is no outcry from Hiroshima, that capital of the human nuclear [world], demanding that atomic bombs never be dropped again over the heads of humankind?" (46) She continues by advocating working to alleviate the suffering of the atomic dead by protesting for peace and taking care of atomic orphans (*genbaku no ko*). Akamatsu, "Anata ga nijūdai nara," 46.

94 Okamura, "Gentōban 'Genbaku no zu' *Pikadon* hakkutsu!" For further information, see Okamura, *'Genbaku no zu' zenkoku junkai,* 183 and ff.

95 Okamura, "Gentōban 'Genbaku no zu' 'Pikadon' to 50 nendai 'Genbaku no zu' no media hyōgen." See also Kishi, *Chīsana rōsoku no hi no yō ni.* Kishi was the person responsible for organizing the 1952 Tachikawa screening.

96 Kinuta Yokishine, dir. *Genbaku no zu (gentō).* The film was narrated by Uchida Tōru and produced by Hongō Shin. The promotional materials for the film reference a different title: Akamatsu Toshiko and Maruki Iri, *Genbaku no zu: suraido kaisetsu sho.* For further information, see Okamura, *'Genbaku no zu' zenkoku junkai,* 184 and ff.

97 For example, about 80 percent of the commentary for panel number four (*Rainbow*) comes verbatim from an earlier transcription of Toshi's verbal comments. See Akamatsu Toshiko and Maruki Iri, *Genbaku no zu,* 101–102.

98 In fact, immediately after the end of the occupation, the Marukis began collaborating with director Iwasaki Akira on the creation of a filmic version of the *Nuclear Panels.* Running seventeen minutes, the black-and-white film premiered at Nihon University in the summer of 1952 and was released to the general public in 1953. (Iwasaki Akira, dir. *'Genbaku no zu.'*) The movie covers the first five panels in the still-growing series. For a contemporary review, see "Genbaku no zu: Imai Tadashi sakuhin, Shinsei eigasha." For a short description see Okamura, "Gentōban 'Genbaku no zu' *Pikadon*

hakkutsu!" For a full transcript and thumbnails of several of the stills, see Okamura, *'Genbaku no zu' zenkoku junkai*, 250–257. According to the transcription, there were two petitions being signed in conjunction with viewings of the *Nuclear Panels* in 1950 and 1951. The first (*Genbaku kinshi chōhei hantai chomei*) sought to ban nuclear weapons and pre-empt the re-establishment of a military draft in Japan. The second (*Senso hantai genbaku kinshi heiwa chomei*) spoke out against war in general and in favor of banning atomic weapons and promoting an international culture of peace. For information on displays of the Marukis' artwork as connected to the Stockholm Appeal, see also Obata, *Senryōka no 'genbakuten,'* 49.

99 Here I am making a distinction between Toshi's idea of painting itself as "direct action" and the more restrictive category of "direct action painting," as later groups such as Gutai may have understood the term. While the Marukis' work may not have been "direct action painting" in that the facture or making of the paintings was not part of the display, their work certainly *was* "direct action" in a more political sense.

100 See Nelson, *Experimental Buddhism*, 1221–1225.

101 See Dower, "Art, Children, and the Bomb"; Dower, "War, Peace, and Beauty"; Minear, "Review: The Atomic Bomb Paintings"; Templado, "The Maruki Legacy"; and Wolfe, "Toward a Japanese-American Nuclear Criticism."

102 Sawachi, "Jiji baba," 242. As others have noted, this hagiographical pull is not idiosyncratic to the Marukis and, in fact, characterizes postatomic discourse more broadly. See, for instance, Miyamoto, *Beyond the Mushroom Cloud;* Miyamoto, "Sacred Pariahs"; and Orr, *The Victim as Hero.*

103 Maruki Bijutsukan, *Genbaku no zu: Kyōdō seisaku*, 173. For an art historical account that puts the Marukis' work into conversation with other avowedly or allegedly "antinuclear" artwork in Japan, see Okamura, *Hikaku geijutsu annai;* also see Sakima, *Āto de heiwa.*

104 Mitchell, *What Do Pictures Want?*, 32.

105 Akamatsu, "Reply to the Japanese Communist Party," 1–2. The manuscript, written in Toshi's hand and on her stationery, is datable to late 1952, probably December. In the response, Toshi mentions the "room in Hokkaidō that had not even a space heater" to keep it warm, and she closes with an aspiration to "make 1953 a year of world peace." The first three panels of the nuclear series had been on display at some two dozen different locales in Hokkaidō, touring there from January through June of 1952. Toshi's response is addressed to the Japanese Communist Party Central Office (Nihon kyōsantō chūō shidōbu). The manuscript is held by the Maruki Gallery.

106 Akamatsu, "Reply to the Japanese Communist Party," 3.

107 Akamatsu, "Reply to the Japanese Communist Party," 4.

108 Mitchell, *What Do Pictures Want?*, 33.
109 Maruki Toshi, *Onna egaki no tanjō*, 214.
110 Linenthal, *Preserving Memory*, 199.
111 Junkerman, *The Hiroshima Murals*, 79.
112 Turner, *The Anthropology of Performance*, 101–103.
113 Kansteiner, "Finding Meaning," 186. Kansteiner argues that critics have often conflated collective memory—"collectively shared representations of the past"—with collected memory. He suggests that the latter, which remains attached to individuals, can be studied with psychoanalytical models that cannot, in good faith, be applied to the former. Akiko Takenaka's work has also been very helpful for thinking through the relationships between museums, collection, and recollection. See Takenaka, *Yasukuni Shrine;* Takenaka, "Collecting for Peace"; and Takenaka, "Mobilizing Death."
114 Junkerman, *The Hiroshima Murals*, 79.
115 Akamatsu, "Letter to everyone in the People's Democratic Republic of China," 1. In Toshi's hand and on her stationery, the six-page handwritten draft refers to "that August 6th of eight years ago," and so is datable to July or early August of 1953. The letter is signed "Akamatsu Toshiko and Maruki Iri."
116 Akamatsu, "Letter to everyone in the People's Democratic Republic of China", 3.
117 Akamatsu, "Letter to everyone in the People's Democratic Republic of China", 5.
118 Maruki Toshi, *Onna egaki no tanjō*, 158.
119 Maruki Toshi, *Onna egaki no tanjō*, 229.
120 As cited in the interview: Nagaoka, "*Genbaku no zu* o kakitsuzukeru," 110.
121 Maruki Toshi, *Onna egaki no tanjō*, 230.
122 Auron, *The Pain of Knowledge*, ix.
123 Maruki Toshi, "Hiroshima, Okinawa, Nankin," 64.

Afterword

124 Moxey, *Visual Time*, 45.
125 Moxey, *Visual Time*, 173.
126 Moxey, *Visual Time*, 174.
127 Maruki Toshiko, *Jōjō ruten*, 193. The Maruki Gallery continues to play an active role in disseminating information about, and fomenting activism against, nuclear testing in the Pacific by holding art exhibits, hosting speakers' series, and distributing literature, including Ōishi, *Kore dake wa tsutaeteokitai* and Shimada, *Māsharu no kodomotachi*.

Bibliography

Primary Sources Identifying Toshi as Sole Author/Illustrator

Akamatsu Toshiko. "Abare no machi." *Akahata* (Feb. 15, 1950), n.p.

———, au. *Akamatsu: Genbaku no zu*. Unpublished manuscript.

———, au. and illus. "Aka momen no hata." *Rōdō hyōron* 4:5 (May 1949): 20–21.

———, au. and illus. "Aki." *Sovēto bunka* (Oct. 1947): 16–17.

———, au. "Anata ga nijūdai nara, nani o suru ka?" *Kibō* 7:8 (Aug. 1952): 46.

———, au. "Ankēto: Ashita no bijutsu ni donna yume o motteimasu ka?" *Bijutsu bunka* 1:1 (Sept. 1946): 10.

———, au. "Aratanaru bijutsu no shinro." *Shinfujin* 1:1 (May 1946): 40–46.

———, illus. "Aru eki no machiaishitsu de." *Jinmin shinbun* (Aug. 1, 1946).

———, au. and illus. "Bi to iu koto." *Jinmen sensen Popolo furonto* (Aug. 15, 1947): 43–47.

———, illus. *Bungaku no tomo bessatsu: Hansen heiwa no shōsetsushū*. Cover art. 1954.

———, au. and illus. "Bunmei no hata no shita ni." *Akahata* (Aug. 3, 1946): n.p.

———, au. "Chiisai chiisai." *Sekai* 95 (Nov. 1953): 73–74.

———, au. and illus. "Dacha nite." *Sekai bungaku* 15 (Sept. 1947): 32–33.

———, au. "Egaki nyūmon: E wa darenimo wakaru, kakeru koto ni tsuite." *Zen'ei bijutsu* 1:2 (Oct. 1947): 28–30.

———, au. and illus. *E wa dare demo kakeru*. Tokyo: Shizenbisha, 1949.

———, au. and illus. "Fūkei." *Taihei* (Feb.–March 1946): 30–31.

———, au. and illus. "Fūshiga no koto." *Jiyu bijutsu* (Sept. 1946): 16–17.

———, au. "Gaka to shite anata wa gendai shi o dō kangaeraremasu ka?" *Shi bunka* 3 (Aug. 1948): 43.

———, au. "Genbaku no zu." Unpublished manuscript.

———, au. and illus. "Genbaku no zu." *Fujin minshu shinbun* (Feb. 24, 1950): 1.

———, au. and illus. "Genbaku sanbusaku naru." *Fujin minshu shinbun* (Aug. 5, 1950): n.p.

———, illus. "Godai seitō fujin daihyō ensetsukai." *Yomiuri shinbun* (March 31, 1946): n.p.

———, au. and illus. "Gogatsu tsuitachi." *Hataraku fujin* 1:2 (June 1946): 8–9.

———, au. and illus. "Hana no bokujō." *Gakusei hyōron* 4:3 (June 1947): 38–39.

———, au. and illus. "Hi." *Fujin minshu shinbun* (April 29, 1950): 2.

———, au. "Issuikai hyō." *Jiyu bijutsu* (Nov. 30, 1946): 21.

———, au. and illus. "Itsu made." *Rōdōsha* (Aug. 1946): 20–21.

———, illus. *Jinmin* 1:1 (April–May 1946).

———, illus. "Kaiho e mukau sugata." *Seinin shinbun* (Nov. 20, 1946): n.p.

———, au. "Kēto Koruwitsu no fūshisei." *Fūshi bungaku* 1:1 (April 1947): 4.

———, au. and illus. "Kodomo no tame ni: Shōnen no kōfuku." *Nihon hyōron* 22:8 (Aug. 1947): 21–24.

———, au. and illus. "Kōshin suru Panteon no megamitachi." *Shinjoen* (May 1947): 38–40.

———, au. "Kotoshi wa nani o yaritai ka? Shoka kaitō." *Genron* 2:1 (Jan. 1948): 11.

———, au. and illus. "Kyōsan'en tobiaruki." *Shōsetsu kōron* 5:3 (March 1954): 104–112.

———, au. ["Letter to everyone in the People's Democratic Republic of China."]. Untitled, unpublished manuscript.

———, au. and illus. "Machi no hyōjō." *Reijokai* 24:2 (May 1946): 2–3.

———, au. and illus. "Matsuri no yoru." *Seinin bunka* 1:3 (July 1946): 41.

———, au. and illus. "Mē dē no omoide." *Shunkan asahi* (April 27, 1947): n.p.

———, au. "Minakutomo hihyō dekiru wake." *Fujin minshu shinbun* (Oct. 3, 1946): n.p.

———, au. and illus. "Minami no kuni no otayori." *Mikuroneshia* 1:5 (May 1940): 83.

———, au. "Minasama ni okaseraremashita wa." *Minshu hyōron* 3:3 (June 1947): 5.

———, au. and illus. "Mori no Mosukwa." *Sovēto bunka* (July–Aug. 1946): 30–31.

———, au. and illus. "Mosukō nite." *Shinjoen* 5:10 (Oct. 1941): 1–4.

———, au. and illus. "Mosukō no geijutsuteki fun'iki." *Josei tenbō* 1:4 (Aug. 1946): 10–12.

———, au. and illus. "Mosukō no gogatsu." *Gaikoku bunka* 1:1 (June 1948): 32–34.

———, au. and illus. "Mosukō no haru." *Shinjoen* 10:3 (March 1946): 31–34.

———, au. and illus. "Mosukō no Kurisumasu." *Fujin gaho* 41:12 (Dec. 1946): 31.

———, au. and illus. "Mosukō no yoru." *Kokutetsu bunka* (Jan. 1949): 66–67.

———, au. and illus. "Mosukō to Tōkyō." *Genron* 1:5 (July 1946): 39–42.

———, au. *Mosukuwa nikki.* Unpublished manuscript.

———, au.. "Nan to iu koto." *Nyū ēji* 4:8 (Aug. 1952): 34–38.

———, illus. "Nan'yō dayori." *Umi o koete* 3:9 (Sept. 1940): 82–86.

———, au. and illus. "Nan'yō dokugen." *Bi no kuni* 17:2 (Feb. 1941): 42–44.

———, au. and illus. "Nan'yō enikki." *Kaizō* 22:14 (Aug. 1940): 226.

———, au. *Nan'yō nōto.* Unpublished manuscript.

———, au. and illus. "Nan'yō o egaku: futatsu no fūkei." *Shinjōen* 4:11 (Nov. 1940): n.p.

———, au. and illus. "Nan'yō tokorodokoro." *Tōkaidō geppō* (July 1940): 2.

————, au. and illus. "No ni utau kodomo." *Shojo no tomo* 39:1 (Jan. 1946): 50–53.

————, illus. "Oishii oishii papaya." *Yoi otomodachi* 3:10 (Oct. 1, 1942): n.p.

————, au. ["Reply to the Japanese Communist Party"]. Untitled, unpublished manuscript.

————, au. and illus. "Roshia ni aru Furansu gendai bijutsu." *Seikatsu bijutsu* 2:5 (May 1942): n.p.

————, au. "Sensō kara heiwa e/ Kurayama kara watashi no yume e." *Hiroba* 3 (Nov. 1947): 30.

————, au. and illus. "Shiberia." *Kokutestu jōhō* 1:1 (Oct. 1946): 26.

————, au. "Shinanai." *Kindai bungaku* 1:5 (Sept. 1946): 36.

————, au. and illus. "Shirakaba no mori." *Shinbunko* 2:1 (Dec. 1947): 16–17.

————, au. and illus. "Shitei kyōiku ni kansuru shoka no iken: Fubuki." *Minshu bunka* 2:2–3 (Feb. 1947): 24–27.

————, au. and illus. "Shoshū." *Chūgoku shinbun* (Oct. 7, 1950): n.p.

————, au. and illus. "Soren no inshō." *Shinjoen* 5:8 (Aug. 1941): 102–107.

————, illus. "Sovēto no josei." *Katei bunka* 3:1 (Jan. 1947): 22.

————, illus. "Soviē no shinshun." *Wakai nōgyō* (Jan. 1947): n.p.

————, au. and illus. "Tōkyō saiban bōchōki." *Jinmin* 8 (Dec. 15, 1946): 76–83 [in galleys, 60–67 in published version].

————, au. "Toshiko furusato ni kaeru." *Shinsekai* 7: p. 14.

————, au. and illus. "Umi no kanatta yūjin: Ryūba obasan no koto." *Josei raifu* 2:3 (April 1947): 46.

————, au. and illus. "USSR." *Nippon no kodomo* 10:6 (June 1946): 1–2.

————, au. "Watashitachi no bijutsu." *Hosei Daigaku shinbun* 1:1 (Oct. 1946): 39–41.

————, au. "Yabureta wataire." *Kakushin* 2:3 (April 1947): 16–18.

————, au. and illus. "Yappu-tō no tabi." *Shinjidō bunka*, vol. 1, 175–183. Tokyo: Yūkōsha, 1940.

————, au. and illus. "Yūkanna josei." *Atorie/Seikatsu Bijutsu* 3:3 (March 1943): 36.

Maruki Toshi, au. and illus. *Hiroshima no pika*. Tokyo: Komine shoten, 1980.

————, au. "Hiroshima, Okinawa, Nankin o egaite." *Gekkan Shakaitō* 257 (Dec. 1985): 63–66.

————, au. *Onna egaki no tanjō* (3rd ed.). Tokyo: Nihon tosho sentā, 2000.

————, au. *Yūrei: 'Genbaku no zu' sekai junrei*. Tokyo: Asahi shinbunsha, 1972.

Maruki Toshiko. au. *Jōjō ruten*. Tokyo: Jitsugyō no Nihonsha, 1958.

Primary Sources Identifying Toshi as Collaborating Illustrator or Author

Akamatsu Toshiko, illus., and Adachi Kaoru, au. "Kyōshutsu kome." *Akahata* (April 18, 1946): n.p.

———, illus., and Chinese Communist Party, eds. *Chūgoku sekigun monogatari.*
Beijing: Waiwen chebanzhe, 1958.

———, Major Greta Old, General Caroline Lloyd Jones, Mary Joyce, Sata
Ineko, Migishi Setsuko, and Ishida Aya, with Kunio Myō (moderator) and
Prof. Nakano Yoshiko (translator). "Josei to shin seikatsu: Beigun onna
shōkō." *Shin seikatsu* (May 1946): 34–37.

———, illus., and Hara Mitachi, au. *Umi no ko damashii.* Tokyo: Seimi
shokaku, 1941.

———, Hirabayashi Taiko, Seki Akiko, Migishi Setsuko, and Yamamoto
Yasuhide (moderator). "Josei o kataru: geijutsu e no michi." *Josei sen* 4:2
(May 1946): 52–64.

———, illus., and Hiratsuka Takeji, au. *Taiyō yori mo tsuki yori mo.* Tokyo:
Kōdansha, 1947.

———, illus., and Hirono Michitarō. *Nanpō minwa.* Tokyo: Kōbundō, 1943.

———, illus., and Hotta Shōichi, au. *Jiyūgaoka parutenon.* Tokyo: Shizenbisha,
1948.

———, illus., and Ichijō Tōru, au. "Himawari no hana." [*Akahata?*] (Dec. 5,
1945): n.p.

———, illus., and Itō Sei, au. *Yukiguni no Tarō.* Tokyo: Teikoku kyōiku
shuppan kyōkai, 1943.

———, illus., and Iwama Masao, au., with Maruki Iri, illus. *Boshizō: Heiwa
kashū.* Tokyo: Shundaisha, 1995.

———, illus., and Kamichika Ichiko, Japanese translation (Japanese translation
based on an English translation attributed to "Van Loon"). *Seisho
monogatari: Kyūyaku no maki.* Tokyo: Kiri shobō, 1946.

———, illus., and Kamiyama Shigeo. *Shi mo mata sabishi.* Tokyo: Azama shobō,
1948.

———, illus., and Kaneoya Kiyoshi, au. *Hatsu koi.* Tokyo: Rikugeisha, 1940.

———, illus., and Kimura Sōjū, auth. *Sekido kairyū.* Tokyo: Fuji shuppansha,
1940.

———, illus. and Kobayashi Takiji, au. *Kani kōsen/ Fuzai jinushi.* Tokyo: Shinkō
shuppansha, 1947.

———, illus., and Kobayashi Takiji, au. *Tōseikatsusha.* Tokyo: Minshu shobō,
1947.

———, illus., and Konstantin Paustovsky, au. "Ame ni akeru." *Fujin gaho* 505
(Sept. 1946): 40–43.

———, illus., and Konstantin Paustovsky, au. "Ame ni akeru." *Fujin gaho* 41:10
(Nov./Dec. 1946): 54–57.

———, illus., and Konstantin Simonov, au. "Mosukō." *Jinmin* (April–May
1946): 1–9.

———, illus., and Kubo Kyō, au. "Yashi no ha no hikōki." *Yoi ko no tomo* (Sept.
1942): 93–99.

———, illus., and Leo Tolstoy, au. *Fushigina taiko*. Tokyo: Shōgakkan, May 1947.

———, illus., and Maeshiba Kakuzō, au. *Hataraku hitibito no kuni*. Tokyo: Kōtō shoin, 1947.

———, Mamiya Mosuke, Andō Seikichi, and Shibuya Nitaji. "Zadankai: Hataraku mono no sekai." *Rōdō bunka* (March 1947): 17–21.

——— and Maruki Iri, au. and illus. *Chibifude: gabunshū*. Tokyo: Muromachi shobō, 1954.

——— and Maruki Iri, au. and illus. *Gashū fukyūban: Genbaku no zu*. Tokyo: Aoki shoten, 1950.

——— and Maruki Iri, au. and illus. *Genbaku no zu*. Tokyo: Aoki shoten, 1952.

——— and Maruki Iri, au. and illus. *Genbaku no zu: suraido kaisetsu sho*. Tokyo: Yokohama shinema, 1953.

———, au., and Maruki Iri, illus. "Mizu to abura." *Tanka kenkyū* 4:6 (July 1947): 48.

——— and Maruki Iri, au. and illus. *Pikadon*. Tokyo: Potsudamu shoten, 1950.

———, illus., and Maruyama Kaoru, au. *Yashi no mi no tabi*. Tokyo: Teikoku kyōikukai shuppanbu, 1942.

———, illus., and Morita Tama, au. *Gobō no ouchi*. Tokyo: Jitsugyō no Nihonsha, 1946.

———, illus., and Murasaki Gōrō, au. "Denpo." *Seinen: Danshi-ban* (Sept. 1944): 40–43.

———, illus., and Matsuda Setsuko, au. "Akibare." *Minpo* (Dec. 1, 1945): 4.

———, illus., and Miyatsu Hiroshi, au. *Bokura no gekiba*. Tokyo: Kōzan shoin, 1947.

———, illus., and Nakanishi Inosuke, au. *Hokusen no ichiya*. Tokyo: Jinmen sensensha, 1948.

———, illus., and Nan'e Jirō, au. *Taiyō no kodomo*. Tokyo: Kokumin tosho kankōkai, 1944.

———, illus., and Nicolai Gogol, au. *Hana ga nigedashita hanashi*. Tokyo: Kokumin tosho kankōkai, 1948.

———, illus., and Nicolai Gogol, au. "Hana o nigedashita otoko." *Shōkokumin sekai* 3:4 (April 1948): 14–27.

———, illus., and Jidō bungakusha kyōkai, ed. *Nihon gakkō gekisen*. Tokyo: Sakurai shoten, 1950.

———, Ogisu Takanori, Takigawa Tarō, Takai Teiji, Matsumoto Kōji, Yabe Tomoe, Irie Hiroshi, Tasaki Hirosuke, Furuyama Jun'ichi, and Murakawa Migorō. "Kakushinki bijutsukai no shōten o tsuku zadankai." *Jiyu bijutsu* 2:7 (March 1947): 12–25.

———, illus., and Okamoto Yoshio, au. *Gakkō no ie*. Tokyo: Sakurai shoten, 1948.

———, illus., and Sakai Asahiko, trans. "Futari no kyōdai: Sobietto no ohanashi." *Yoi ko no tomo* (Dec. 1945): 29–33.

———, illus., and Shiotani Tarō, au. *Jyakku to mame no ki.* Tokyo: Asoka shobō, 1946.

———, illus., and Shirakawa Atsushi, au. "Shōnen no burasshi." *Fujin kōron* 353 (Oct. 1946): 17–23.

———, illus., and Takahashi Gozan, au. *Otonarisan.* Tokyo: Kyōiku kamishibai kenkyūkai, 1953.

———, illus., and Tastumi Seika, au. *Minami no shima.* Tokyo: Chūō shuppan kyōkai, 1943.

———, illus., and Tokunaga Sunao, au. *Hataraku ikka.* Tokyo: Sakurai shoten, 1948.

———, illus. and Tokunaga Sunao, au. "Kita Chōsen ni iru tomo yo." *Akahata* (Feb. 3, 1946): n.p.

———, illus. and Tokunaga Sunao, au. *Machiko.* Tokyo: Sakurai shoten, 1947.

———, illus. and Tokunaga Sunao, au. *Nakanakatta yowamushi.* Tokyo: Futaba bunkō, 1947.

———, Tsuboi Shigeji, and Maruki Iri. "Tsuboi, Maruki, Akamatsu shoshi o kakomu zadankai." *Warera no shi* 10 (Dec. 10, 1950): n.p.

———, illus., and Tsuchiya Yukio, au. *Yashi no ki no shita.* Tokyo: Shōgakkan, 1942.

———, illus., and Tsuji Hideo, trans. *Iwan no baka.* Tokyo: Tōkō shoin, 1949.

———, illus., and Tsukuhara Sei'ichi, ed. *Shiroi muku inu.* Tokyo: Asoka shobō, 1947.

Maruki Toshi, illus., and Ishimure Michiko, au. *Minamata umi no koe.* Tokyo: Komine shoten, 1982.

———, illus., and Kimishima Hisako, au. *Fue o fuku iwa.* Tokyo: Popurasha, 1973.

——— and Maruki Iri, au. and illus., with Nancy Hunter and Yasuo Ishikawa, trans. *Genbaku no zu: The Hiroshima Panels.* Higashimatsuyama: Maruki Bijutsukan, 1972.

——— and Maruki Iri, au. and illus. *Okinawa shima no koe: Nuchidō takara 'Inochi koso takara.'* Tokyo: Komine shoten, 1984.

———, illus., and Matsutani Miyoko, au. *Tōrō nagashi.* Tokyo: Kaiseisha, 1985.

———, illus., and Ōtsuka Yūzō, au. *Umi no gakutai.* Tokyo: Rabo kyōiku sentā, 1991.

———, illus., and Uchida Risako, au. *Roshiya no warabeuta.* Tokyo: Kakūsha, 2006.

———, illus., and Yoshioka Tatsuo, trans. *Gokkeru monogatari.* Tokyo: Tōkō shoin, 1949.

Secondary Sources

Abel, Jonathan E. *Redacted: The Archives of Censorship in Transwar Japan.* Berkeley: University of California Press, 2012.

Adachi Gen. *Zen'ei no idenshi: Anakizumu kara sengo bijutsu e.* Tokyo: Brűcke, 2012.

Aichi Daigaku Okazakikai, ed. *Genbakuten kansō bunshū.* Okazaki: Puraza shuppansha, n.d.

Aikoku iroha karuta. Tokyo: Nihon gangu tosei kyōkai, 1943.

Akiyama Kunio, Suzuki Kurazō, Kuroda Senkichirō, Araki Hideo, and Kamigori Takashi, eds. "Kokubō kokka to bijutsu: gaka wa nani o nasubeki ka?" *Mizue* 434 (January 1941): 129–139.

Anonymous. "Akamatsu Toshiko." *Yagumo* 2:5 (Aug. 1948): n.p.

Anonymous. "Akamatsu Toshiko ron." *Bijutsu Techo* 6 (June 1948): 21.

Anonymous. "Shijō shoten." *Jinmin shinbun,* Sept. 20, 1946, n.p.

Ara Masato, Odagiri Hideo, Hirano Ken, Harada Yoshihito, Shirai Hiroshi, Ōkuma Nobuyuki, Yoshimoto Taka'aki, Honda Shūgo, Sugiura Akihira, Sasaki Motokazu, Takei Takeo, and Murakami Hiei. "Zadankai: Sensō sekinin o kataru." *Kindai bungaku* (1956): 1–44.

Arnow, Ted. *Effects of Phosphate Mining on the Ground Water of Angaur, Palau Islands Trust Territory of the Pacific Islands.* Geological Survey Water Supply Paper 1608A. Washington, DC: US Government Printing Office, 1961.

Aso, Noriko. *Public Properties: Museums in Imperial Japan.* Durham, NC: Duke University Press, 2014.

Auron, Yair. *The Pain of Knowledge: Holocaust and Genocide Issues in Education.* Translated by Ruth Ruzga. New Brunswick, NJ: Transaction Publishers, 2005.

"Bakushinchi no genbaku kaikan de Genbaku no zu ten." *Fujin minshu shinbun,* Oct. 21, 1950, n.p.

Barlow, Tani E. *Foundations of Colonial Modernity in East Asia.* Durham, NC: Duke University Press, 1997.

Baxandall, Michael. *Patterns of Intention: On the Historical Explanation of Pictures.* New Haven, CT: Yale University Press, 1985.

Blaxell, Vivian. "Designs of Power: The 'Japanization' of Urban and Rural Space in Colonial Hokkaidō." *Japan Focus* 7:35 (Aug. 2009). http://apjjf.org /-Vivian-Blaxell/3211/article.html. Accessed Jan. 31, 2010.

Bowen-Struyk, Heather. *Red Love Across the Pacific: Political and Sexual Revolutions of the Twentieth Century.* New York: Palgrave MacMillan, 2015.

Bowlt, John E. "Neo-Primitivism and Russian Painting." *Burlington Magazine* 116:852 (March 1974): 132–140.

Brewer, John. "Microhistory and the Histories of Everyday Life." *Cultural and Social History* 7:1 (2010): 87–109.

Brooks, James F., Christopher R. N. DeCorse, and John Walton, eds. *Small Worlds: Method, Meaning, and Narrative in Microhistory.* Santa Fe, NM: School for Advanced Research Press, 2008.

Bryson, Norman. "Westernizing Bodies: Women, Art, and Power in Meiji *Yōga*." In Joshua S. Mostow, Norman Bryson, and Maribeth Graybill, eds., *Gender and Power in the Japanese Visual Field,* 89–118. Honolulu: University of Hawai'i Press, 2002.

Byrd, Jodi. *The Transit of Empire: Indigenous Critiques of Colonialism.* Minneapolis: University of Minnesota Press, 2011.

Camacho, Keith. *Cultures of Commemoration: The Politics of War, Memory, and History in the Mariana Islands.* Honolulu: University of Hawai'i Press, 2011.

Carter, Nona L. "Tales for Tarō: A Study of Japanese Children's Magazines, 1888–1949." PhD diss., University of Pennsylvania, 2009, UMI number 3395684.

"Chikaku Sapporo de genbakuten: Akamatsu Toshiko *Genbaku no zu* wa raiDō." *Hokkaidō daigaku shinbun* (Oct. 5, 1950): 1.

"Chikazuku daisankai Andepandan: Kitai sareru shuppinsaku." *Bijutsu undō* (Jan. 25, 1950): n.p.

Ching, Leo. "Champion of Justice: How Asian Heroes Saved Japanese Imperialism." *PMLA* 126:3 (2011): 644–650.

Cipris, Zeljko. "Responsibility of Intellectuals: Kobayashi Hideo on Japan at War." *Japan Focus* 3:11 (Nov. 2005). http://apjjf.org/-Zeljko-Cipris/1625 /article.html. Accessed Jan. 20, 2009.

Clark, John. *Modernities of Japanese Art.* Leiden: Brill, 2013.

Clark, T. J., with Iain Boal, Joseph Matthews, and Michael Watts. *Afflicted Powers: Capital and Spectacle in a New Age of War.* London: Verso, 2005.

Conant, Ellen P. "Japanese Painting from Edo to Meiji: Rhetoric and Reality." In J. Thomas Rimer, ed., *Since Meiji: Perspectives on the Japanese Visual Arts, 1868–2000,* 34–65. Honolulu: University of Hawai'i Press, 2012.

Cook, Theodore F., and Haruko Taya. *Japan at War: An Oral History.* New York: The New Press, 1992.

Culver, Annika. *Glorify the Empire: Japanese Avant-Garde Propaganda in Manchukuo.* Vancouver: University of British Columbia Press, 2013.

Dai Nihon ji'in ōkagami. Otaru: Kaikōsha, 1938.

Dower, John. "Art, Children, and the Bomb." *Bulletin of Concerned Asian Scholars* 16:2 (April–June 1984): 33–39.

———. *Embracing Defeat.* New York: W. W. Norton and Company, 1999.

———. "War, Peace and Beauty: The Art of Iri Maruki and Toshi Maruki." In John Junkerman, ed., *The Hiroshima Murals: The Art of Iri Maruki and Toshi Maruki,* 9–26. Tokyo: Kodansha International, 1985.

Egawa. "Akamatsu Toshiko koten." *Bijutsu Techo* 6 (June 1948): 56.

Ehara Shunpei, au., and Azuma Kōsei, illus. *Minami no kodomo.* Osaka: Kinjōsha, 1943.

Endo, Mika. "Pedagogical Experiments with Working Class Children in Prewar Japan." PhD diss, University of Chicago, 2011. UMI number 3472842.

Eto Jun, with Jay Rubin, trans. "The Sealed Linguistic Space: The Occupation Censorship and Post-War Japan." *Hikaku bunka zasshi* 2 (1984): 1–42, and 3 (1988): 1–22.

Eubanks, Charlotte. "Avant-Garde in the South Seas: Akamatsu Toshiko's 'Micronesia Sketches.'" *Verge: Studies in Global Asias* 1:2 (Fall 2015): 1–20.

———. "The Mirror of Memory: Constructions of Hell in the Marukis' Nuclear Series." *PMLA* 124:5 (October 2009): 1614–1631.

———. "Playing at Empire: The Ludic Fantasy of *Sugoroku* in Early-Twentieth-Century Japan." *Verge: Studies in Global Asias* 2:2 (Fall 2016): 36–57.

Fuhara Yoshinori, au., and Arai Gorō, illus. *Mado mado.* Tokyo: Shunkōdō, 1944.

Fujii, James. *Complicit Fictions: The Subject in the Modern Japanese Prose Narrative.* Berkeley: University of California Press, 1993.

Fujikane, Candace, and Jonathan Y. Okamura, eds. *Asian Settler Colonialism: From Local Governance to the Habits of Everyday Life.* Honolulu: University of Hawai'i Press, 2008.

Fujinkai shōsoku." *Fujin minshu shinbun,* July 1, 1948, n.p.

Fujita Tsuguharu. "Gaka no ryōshin." *Asahi shinbun,* Oct. 25, 1945, evening edition, p. 2, row 9, column 1.

Fujitani, Takashi. *Race for Empire: Koreans as Japanese and Japanese as Americans during World War II.* Berkeley: University of California Press, 2011.

"Fukushima de *Genbaku no zu* bijutsuten." *Yūmin shinbun,* June 26, 1951, evening edition, 2.

"Furusato joryū gaka ga teitō ni sukecchiden: Zai Ro ichinenamari no Akamatsusan." *Asahikawa shinbun,* May 13, 1939, 7.

Garon, Sheldon. *The State and Labor in Modern Japan.* Berkeley: University of California Press, 1987.

Gell, Alfred. *Art and Agency: An Anthropological Theory.* Oxford: Clarendon Press, 1998.

Genbaku no zu Maruki bijutsukan, ed. *Maruki Iri/Maruki Toshi no sekai: Inochi e no atsui shisen: shiryō.* Higashimatsuyama-shi: Genbaku no zu Maruki bijutsukan, 1995.

———. *Maruki Iri no sekai ten: Inochi e no atsui shisen.* Higashimatsuyama-shi: Genbaku no zu Maruki bijutsukan, 1995.

———. *Maruki Toshi ehon no sekai: Azayakana shikisai no kōkyōkyoku.* Higashimatsuyama-shi: Genbaku no zu Maruki bijutsukan, 2008.

———. *Maruki Toshi no ega: Joshi bijutsu jidai kara 'Genbaku no zu' made.* Higashimatsuyama-shi: Genbaku no zu Maruki bijutsukan, 2007.

———. *Maruki Toshi no sekai ten: Inochi e no atsui shisen.* Higashimatsuyama-shi: Genbaku no zu Maruki bijutsukan, 1995.

"*Genbaku no zu*: Imai Tadashi sakuhin, Shinsei eigasha." *Akahata,* Nov. 7, 1952, 2.

"Genbaku no zu: Tenrankai hiraku: Ugomeku nikutai, jigoku ezu." *Nara Nichinichi Shinbun,* May 16, 1950, 2.

Gluck, Carol. "The Seventieth Anniversary of World War II's End in Asia." *Journal of Asian Studies* 74:3 (Aug. 2015): 531–537.

Gregory, Brad S. "Review Essay: *Is* Small Beautiful? Microhistory and the History of Everyday Life." *History and Theory* 38:1 (Feb. 1999): 100–110.

Hall, Lisa Kahaleole. "Which of These Things Is Not Like the Other: Hawaiians and Other Pacific Islanders Are Not Asian Americans, and All Pacific Islanders Are Not Hawaiian." *American Quarterly* 67:3 (2015): 727–747.

Hanscom, Chris. *The Real Modern: Literary Modernism and the Crisis of Representation in Colonial Korea.* Cambridge, MA: Harvard University Press, 2013.

Hardacre, Helen, with Adam L. Kern, ed. *New Directions in the Study of Meiji Japan.* Leiden: Brill, 1997.

Hariu Ichirō. "Sengo bijutsu to sensō sekinin." *Bungaku* 27:5 (April 1959): 543–557.

———. "Sensō bijutsu, sono genzai made no isō: tokushū: kakumei to sensō no taburō." *Shuka* 11 (Fall 1998): 2–6.

———. "Sensōga hihan no konnichiteki shiten: tokushū: sensō kirokuga no jidai, 1." *Mizue* 752 (Oct. 1967): 66–68.

———. "Sensōka no bijutsu." *Bungaku* 29:5 (May 1961): 518–524.

———. *Sensō to bijutsu: 1937–1945.* Tokyo: Kokusho Kankōkai, 2007.

———, "The Phases of Neo-Dada in Postwar Art." Translated by Yamazaki Yumiko. In Ōita-shi Bijutsukan, ed., *Neo-Dada Japan 1958–1988: Isozaki Arata to Howaito Hausu no menmen,* 276–281. Ōita: Ōita-shi Bijutsukan, 1988.

———. "Wareware no uchi naru sensōga." *Bijutsu techo* (Sept. 1977): 46–57.

Harootunian, Harry D. *Overcome by Modernity: History, Culture, and Community in Interwar Japan.* Princeton, NJ: Princeton University Press, 2000.

Hashimoto, Akiko. *The Long Defeat: Cultural Trauma, Memory, and Identity in Japan.* New York: Oxford University Press, 2015.

Hattori Yōko. "Niwa Fumio no 'Shōkokuminban Soromon kaisen' ron: Gensaku to no hikaku kakuken o chūshin." *Nihon Fukushi Daigaku kenkyū kiyō: Gendai to bunka* 130 (Sept. 2014): 63–75.

Havens, Thomas. *Radicals and Realists in the Japanese Nonverbal Arts: The Avant-Garde Rejection of Modernism.* Honolulu: University of Hawai'i Press, 2006.

Hayashi Fumio. "Hayashi Fumio no hihyō." *BBBB* 5 (April 1, 1950): 68.

Hijikata, Hisakatsu, with Ken'ichi Sudō and Hisao Shimizu, eds. *Hijikata Hisakatsu nikki.* Suita-shi: Kokuritsu Minzokugaku Hakubutsukan, 2010.

Hijikata Tei'ichi. *Gendai bijutsu: Kindai bijutsu to shiarizumu.* Tokyo: Agatsuma shobō, 1948.

———. "Shan Chōhei to gendai no Shina bijutsu." *Bijutsu* (Feb. 1946): 6–8.

Hiramatsu Toshiaki. *Hirameki no geijutsu: ruru jinsei: Maruki Iri/Toshi no yuigon.* Tokyo: Kigei shobō, 2002.

Hirayama Tomoko. *Wakaki Chihiro e no tabi: shita.* Tokyo: Shin Nihon shuppansha, 2002.

"Hiroshima e teki shingata bakudan: B29, shōshū de raishū kōgeki; sōtō no higai, saishō wa mokka chōsachū; Daihon'ei happyō." *Asahi shinbun,* Aug. 8, 1945, p. 1, row 1, column 1.

Hoaglund, Linda. "Protest Art in 1950s Japan: The Forgotten Reportage Painters." https://ocw.mit.edu/ans7870/21f/21f.027/protest_art_50s_japan /anp1_essay03.html. Accessed July 7, 2017.

Hoffman, Reto. *The Fascist Effect: Japan and Italy, 1915–1952.* Ithaca, NY: Cornell University Press, 2015.

Hokkaidō no kinsei shaji kenchiku. Sapporo: Hokkaidō kyōikui'inkai, 1989.

Horio Kōhei. *Nihin jidō bungaku ron.* Tokyo: Chūbu Nihon kyōiku bunkakai, 1991.

Hoshi Minoru. "Akamatsu Toshiko-sensei o tazuneru." *Kenkō kaigi* 1:1 (March 1949): 25.

Ihara Uzaburō. "Sensō bijutsu nado." *Bijutsu* 2:5 (Nov. 1945): 28.

Ikeda, Asato. "Japan's Haunting War Art: Propaganda Paintings, War Responsibility, and Museums." PhD diss., Carleton University (Canada), 2008. MR40602.

Inaga Shigemi. *Ega no rinkai: Kindai higashi Ajia bijutsushi no shikkoku to meiun.* Nagoya: Nagoya Daigaku shuppankai, 2014.

Inoue Toshikazu. *Senzen Nihon gurōbarizumu: 1930 nendai no kyōkun.* Tokyo: Shinchōsha, 2011.

"Ima sara to iware tsuzukete." *Nitchū* (Nov. 1975): 11–12.

Irie Hiroshi. "Jinmin no gaka Akamatsu-san." *Bijutsu bunka* 1:1 (Oct. 1946): 7.

Itabashi Art Museum, ed. *Futatsu no Monparunasu: Paris & Tokyo.* Tokyo: Itabashi Art Museum, 1990.

Itō Masakazu. [Untitled response to survey.] *Fujin gaho* 41:7 (July 1946): 34.

Iwasaki Akira, dir., with Imai Tadashi and Aoyama Michiharu. *'Genbaku no zu.'* Monochrome film. Tokyo: Shinseisha, 1952.

Jansen, Marius. "Japan and the World." In Helen Hardacre with Adam L. Kern, ed. *New Directions in the Study of Meiji Japan,* 285–310. Leiden: Brill, 1997.

Jefurowa, Aran, and Chiba Takeo, trans. "Jiyu arui wa shō." *Nichifutsu bunka* 42 (March 1983): 60–80.

Jesty, Justin. "Arts of Engagement: Art and Social Movements in Japan's Early Postwar." PhD diss., University of Chicago, 2010. UMI number 3432735.

———. "The Realism Debate and the Politics of Modern Art in Early Postwar Japan." *Japan Forum* 26:4 (2014): 508–529.

Jolly, Rosemary. "Communities of Effluence." Manuscript in preparation.

———. "Zombification and the Politics of Debility at Work in the Global Post-Colony: Towards a Postcolonial Reading of Medicine and the Possibility of Effluent Resilience." Forthcoming.

Joshi Bijutsu Daigaku hyakushūnen henshū i'inkai, ed. *Joshi Bijutsu Daigaku hyakunenshi*. Tokyo: Joshi Bijutsu Daigaku, 2003.

Junkerman, John, ed. *The Hiroshima Murals: The Art of Iri Maruki and Toshi Maruki*. Tokyo: Kodansha International, 1985.

"Kaiba kazaru genbaku no e." *Fujin minshu shinbun*, March 12, 1950, n.p.

"Kakitsuzuku genbakuga Maruki gahakuten." *Chūgoku shinbun*, Oct. 6, 1950, n.p.

Kami Shōuichirō and Ozaki Masato. *Ikebukuro Monparunassu sozoru aruki: 'Ikebukuro Monparunassu' no dōgakatachi*. Tokyo: Aka'ishi shoten, 2006.

Kamishō Ichirō. "Shinpan *Pikadon* ni yosete." In Akamatsu Toshiko and Maruki Iri, *Pikadon*, 73–78. Tokyo: Tōhō shuppanban, 1982.

Kamon Yasuo et al. "Gappyōkai: Daisankai Nihon Andependanten sōhyō." *Bijutsu undō* 10 (Feb. 10, 1950): 2–3.

Kan Tadamachi. *Nihon jidō bungaku*. Tokyo: Ōtsuki shoten, 1966.

Kaneko, Maki. *Mirroring the Japanese Empire: The Male Figure in Yōga Painting, 1930–1950*. Leiden: Brill, 2015.

———. "New Art Collectives in the Service of the War: The Formation of Art Organizations during the Asia-Pacific War." *positions* 21:2 (Spring 2013): 309–350.

Kansteiner, Wulf. "Finding Meaning in Memory: A Methodological Critique of Collective Memory Studies." *History and Theory* 41:2 (May 2002): 179–197.

Kasahara Fumi, au. and illus. [Correspondence.] *Shōnen senki* (Children's battle line). Tokyo: Senki (Shōwa 4), 1929.

Kasza, Gregory. *The State and Mass Media in Japan, 1918–1945*. Berkeley: University of California Press, 1988.

Kauanui, J. Kēhaulani. "'A Structure, Not an Event:' Settler Colonialism and Enduring Indigeneity." *Lateral: Journal of the Cultural Studies Association* 5:1 (Spring 2016). http://csalateral.org/issue/5-1/forum-alt-humanities-settler -colonialism-enduring-indigeneity-kauanui/. Accessed November 10, 2017.

Kawana, Sari. "Reading Beyond the Lines: Young Readers and Wartime Japanese Literature." *Book History* 13 (2010): 154–184.

———. "Science without Conscience: Unno Jūza and the *Tenkō* of Convenience." In Kevin Reinhart and Dennis Washburn, eds., *Converting Cultures: Religion, Ideology, and Transformations of Modernity*, 183–208. Boston: Brill, 2007.

Kawashima Ri'ichirō. *Hokushi to Nanshi no sugata*. Tokyo: Ryūseikaku, 1940.

———. *Jisen dessan shū*. Tokyo: Kensetsusha, 1947.

Kee, Joan. "Situating a Singular Kind of 'Action:' Early Gutai Painting, 1954–1957." *Oxford Art Journal* 26:2 (2003): 123–140.

Ketelaar, James. "Hokkaido Buddhism and the Early Meiji State." In Helen Hardacre with Adam L. Kern, ed. *New Directions in the Study of Meiji Japan*, 531–548. Leiden: Brill, 1997.

Kikuhata Mokuma. *Egaki to sensō: Kikuhata Mokuma chosakushū*, vol. 1. Fukuoka: Kaitōsha, 1993.

———. *Tennō no bijutsu: Shisō to sensōga*. Tokyo: Firumu āto sha, 1978.

Kinuta Yokishine, dir. *Genbaku no zu (gentō)*. Yokohama shinema. Monochrome film, 1953.

Kira Tomoko. "Joryū gaka hōkōtai to 'Daitōasen kōkoku fujo kaidōzu' ni tsuite." *Bijutsushi* 154 (Oct. 2002): 129–145.

"Kiroku." *Atorie* 281 (June 1950): 70.

Kishi Kiyoji. *Chīsana rōsoku no hi no yō ni*. Tokyo: Keyaki shuppan, 1984.

Kitahara Hakushū, lyricist. "Hawaii no taikaisen." Tokyo: Yomiuri Shinbunsha, 1942.

———. "Risu, risu, korisu." *Akai tori* 1 (1918): 2–3.

Kitahara Megumi, ed. *Ajia no josei shintai wa ikani egakareta ka: shikaku hyōzō to sensō no kioku*. Tokyo: Seikyūsha, 2013.

———, ed. *Nijūseki no josei bijutsuka to shikaku hyōzō no chōsa kenkyū: Ajia ni okeru sensō to diasupora no kioku*. Osaka: Osaka Daigaku kenkyūka, 2011.

Kiyose Ichirō. *Nijūgo hikoku no hyōjō*. Tokyo: Rōdō bunkasha, 1949.

Kleeman, Faye. *In Transit: The Formation of the Colonial East Asian Cultural Sphere*. Honolulu: University of Hawai'i Press, 2014.

———. *Under an Imperial Sun: Japanese Colonial Literature of Taiwan and the South*. Honolulu: University of Hawai'i Press, 2003.

Kokatsu Reiko, ed. *Hashiru onnatachi: Josei gaka no senzen, sengo, 1930–1950 nendai*. Tochigi: Tochigi Prefectural Museum of Fine Arts, 2001.

———. "Senjika no Nihon no josei gaka wa nani wo egaitaka." In Kitahara Megumi, ed., *Ajia no josei shintai wa ikani egakareta ka: shikaku hyōzō to sensō no kioku*, 25–72. Tokyo: Seikyūsha, 2013.

"Kokubō to kenkō tenrankai." *Asahi Shinbun*, March 5, 1941, evening edition, 2, column 3.

Kōno Wakana. "Ehon to puropaganda: 1920–1930 nendai Soren no sensō ehon shiron." *Sekai bungaku* 100 (Dec. 2004): 20–30.

Kōsaka Jirō, Fukutomi Tarō, Kawada Akihisa, and Tan'o Yasunori. *Gakatachi no sensō*. Tokyo: Shinchōsha, 2010.

Koshizaki Sōichi. *Ainu-e*. Sapporo: Hokkaidō shuppan kikaku sentā, 1945 (reprint 1976).

Kozawa Setsuko. *Aban gyarudo no sensō taiken: Matsumoto Shunsuke, Takiguchi Shūzō soshite gagakuseitachi*. Tokyo: Aoki shoten, 2004.

———. *'Genbaku no zu:' Egakareta 'kioku,' katarareta 'ega.'* Tokyo: Iwanami shoten, 2002.

———. "Jūgonen sensōki no bijutsu o megutte." *Rekishi hyōron* 520 (Aug. 1993): 66–78.

———. Kubo Takashi. *Nan'yō ryokō*. Tokyo: Kin no hoshisha, 1931.

Kubo Zaiku. "Kubo Zaiku nikki." http://www.aya.or.jp/~marukimsn/event
 /others/041103yoshida_houkoku.htm. Accessed October 4, 2017.

Kubota Fumio. *Nan'yō no tenchi*. Tokyo: Kodansha, 1943.

Kujū Fumihiro. "Sensō sanbi to 'tennōsei' no raisan." *Shinseki* [The communist]
 194 (Sept. 2001): 6–29.

Kunimoto, Namiko. *The Stakes of Exposure: Anxious Bodies in Postwar Japanese
 Art*. Minneapolis: University of Minnesota Press, 2017.

Kurahara Korehito. *Puroretaria bungaku no tame ni*. Tokyo: Senkisha, 1930.

Kwon, Nayoung Aimee. *Intimate Empire: Collaboration and Colonial
 Modernity in Korea and Japan*. Durham, NC: Duke University Press,
 2015.

"Kyōdo joryū gaka ga teito ni sukecchi ten: zaiRo ichinen amari no Akamatsu-
 san." *Asahikawa shinbun*, March 14, 1939, 7.

Linenthal, Edward T. *Preserving Memory: The Struggle to Create America's
 Holocaust Museum*. New York: Columbia University Press, 1995.

Lowe, Lisa. *The Intimacies of Four Continents*. Durham, NC: Duke University
 Press, 2015.

Magnússon, Sigurður Gylfi, and István M. Szijártó. *What Is Microhistory? Theory
 and Practice*. London: Taylor and Francis, 2013.

Makimoto Kusurō. *Chiisai dōshi*. Tokyo: Jiyusha, 1931.

———. *Puroretaria dōyō kōwa*. Tokyo: Kōshudō, 1930.

———. *Puroretaria Jidō bungaku no shomondai*. Tokyo: Sekaisha, 1930.

Mark, Ethan. "Resituating Modern Japan in Empire, Fascism, and Defeat: A
 Review Essay." *Journal of Asian Studies* 76:4 (Nov. 2017): 1104–1112.

Marotti, William. *Money, Trains, and Guillotines: Art and Revolution in 1960s
 Japan*. Durham, NC: Duke University Press, 2013.

"M'Arthur Seizing 40 for War Crimes." *New York Times*, Sept. 12, 1945. http://
 uvallsc.s3.amazonaws.com/imtfe/s3fs-public/51336.jpg?null. Accessed
 July 13, 2017.

Maruki Bijutsukan, ed. *Genbaku no zu: Kyōdō seisaku, Maruki Iri, Maruki Toshi*.
 Higashimatsuyama: Maruki Bijutsukan, 2004.

Maruki Bijutsukan nyūsu. Higashimatsuyama: Maruki Bijutsukan.

Maruki Iri. "Kokoro ga kurau." *Geibi nichinichi shinbun*, April 12, 1926, n.p.

———. "Koi." *Geibi nichinichi shinbun*, Jan. 25, 1926, n.p.

———, au. and illus. "Ressha kanseki." *Chūgoku shinbun*, Oct. 5, 1950, n.p.

———. "Sanjūsan no aki." *Taichi* 101 (1933): 17–21.

———. "Sumi, kami, gamen, inshō." *Binokuni* 17:6 (June 1941): 76–77.

———. *Ruru henreki*. Tokyo: Iwanami shoten, 1988.

———. "Zai-Hiro Nihon gadan ni yosu." *Taichi* 102 (1933): 20–22.

Mason, Michelle. *Dominant Narratives of Colonial Hokkaidō and Imperial
 Japan: Envisioning the Periphery and the Modern Nation-State*. New York:
 Palgrave, 2012.

Mason, Michelle, and Helen J. S. Lee. *Reading Colonial Japan: Text, Context, and Critique*. Stanford, CA: Stanford University Press, 2012.

Matsumoto Shunsuke. "Ikiteiru gaka" (*Mizue* 437, April 1941), reprinted in Matsumoto Shunsuke, *Ningen Fūkei* (Tokyo: Chūō Kōronsha, 1982): 236–247.

Matsumoto Takeshi, ed. *Iwasaki Chihiro no seishun*. Tokyo: Subaru shobō, 1976.

Medick, Hans. "Mikro-Historie." In W. Schulze, ed., *Sozialgeschichte, Alltagsgeschichte, Mikro-Historie. Eine Diskussion*, 40–53. Gottingen: Vandenhoeck & Ruprecht, 1994.

Michiba Chikanobu. *Shimomaruko bunka shūdan to sono jidai: 1950 nendai sākuru bunka undo no kōbō*. Tokyo: Mizuzu shoba, 2016.

Migishi Setsuko. "Geijutsu no fukkatsu: Kitai sareru hitobito: Akamatsu Toshiko-san no koto." *Fujin gaho* 507 (Nov. 1946): inside front cover.

Minami no kuni meguri. Tokyo: Ie no hikari [n.d. ca. 1940–1945].

Minear, Richard. "Review: The Atomic-Bomb Paintings." *Bulletin of Concerned Asian Scholars* 19:4 (October–December 1987): 58–63.

Mita, Maki. *Palauan Children under Japanese Rule: Their Oral Histories*. Senri Ethnological Reports 87. Osaka: National Museum of Ethnology, 2009.

Mitchell, W. J. T. *What Do Pictures Want? The Lives and Loves of Images*. Chicago: University of Chicago Press, 2005.

Mitter, Partha. "Decentering Modernism: Art History and Avant-Garde Art from the Periphery." *The Art Bulletin* 90:4 (Dec. 2008): 531–548.

Miyamoto, Yuki. *Beyond the Mushroom Cloud: Commemoration, Religion, and Responsibility after Hiroshima*. New York: Fordham University Press, 2012.

———. "Sacred Pariahs: Hagiographies of Alterity, Sexuality, and Salvation in Atomic Bomb Literature." *Japan Studies Review* 13 (2009): 149–168.

Miyata Hiroshi. "Senzen no Hokkaidō: Seikatsu zuga kyōiku jiken to wa?" *Akahata*, May 10, 2008. https://www.jcp.or.jp/akahata/aik07/2008–05 –10/20080510faq12_01_0.html. Accessed June 22, 2018.

Miyata Shigeo. "Bijutsuka no sessō." *Asahi shinbun*, October 14, 1945, evening edition, p. 2, row 8, column 1.

Mizoguchi Ikuo. *Enogu to sensō: Jūgun gakatachi to sensōga no kiseki*. Tokyho: Kokusho kankōkai, 2011.

Motohashi Sei'ichi. *Futari no gaka: Maruki Iri/Maruki Toshi no sekai*. Tokyo: Ofisu emu, 2005.

Moxey, Keith. *Visual Time: The Image in History*. Durham, NC: Duke University Press, 2013.

Murayama Masao. *Thought and Behavior in Modern Japanese Politics*. London: Oxford University Press, 1963.

Murayama Shirō. *Seikatsu tsuzurikata jissen ron*. Tokyo: Aoki shoten, 1985.

"Namida de katarenu Akamatsu-san: Genbaku sanbusaku kansei kinenkai." *Fujin minshu shinbun*, Aug. 26, 1950, n.p.

Nagaoka Hiroyoshi. *"Genbaku no zu* o kakitsuzukeru: jūsanbu no kansei ni yosete, Maruki fūfu ni kiku." *Shimin* 4 (Sept. 1971): 108–114.

Nagoya-shi Bijutsukan, ed. *Sengo Nihon no riarizumu 1945–1960.* Nagoya: Sengo Nihon no riarizumuten bijutsu kōi'inkai, 1998.

Nakagawa Ichirō. *Daitōa sensō myōgashū.* Tokyo: Noberu shobō, 1967.

Nan'yō guntō yōran. Koror, Palau: Nan'yōchō, 1932.

Nan'yō guntō yōran. Koror, Palau: Nan'yōchō, 1940.

"Nan'yō shokumin keikaku." *Asahi shinbun,* March 31, 1891, morning edition, 1.

"Nan'yō shōnen jūgungan, nesshin ni kangeki." *Asahi shinbun,* Oct. 26, 1938, evening edition, 2.

Narita Ryūichi. *"Rekishi" wa ikani katarareta ka? 1930 nendai 'Kokumin no monogatari' hihan.* NHK books no. 913. Tokyo: Nihon hōsō shuppan kyōkai, 2001.

National Diet Library. "Portraits of Modern Japanese Historical Figures: Satō Naotake." http://www.ndl.go.jp/portrait/e/datas/413.html?cat=99. Accessed July 26, 2016.

Nelson, John K. *Experimental Buddhism: Innovation and Activism in Contemporary Japan.* Honolulu: University of Hawai'i Press, 2013.

"Nihon kankō no Nan'yō shochō." *Asahi shinbun,* July 14, 1915, morning edition, 5.

Nika gashū 29. Tokyo: Asahi shinbunsha, 1942.

Nishi Haruhiko. *Kaisō no Nihon gaikō* (9th ed.). Tokyo: Iwanami shoten, 1973.

———. *Watashi no gaikō hakusho.* Tokyo: Bungei shunju shinsha, 1963.

Nishino Motoaki. *Umi no seimeisen: Waga Nan'yō no sugata.* Tokyo: Futabaya gofukuten, 1935.

Niwa Fumio. *Kaisen.* Tokyo: Chūō kōronsha, 1943.

Noenoe, K. Silva. *Aloha Betrayed: Native Hawaiian Resistance to American Colonialism.* Durham, NC: Duke University Press, 2004.

Noguchi Masaaki. "Nan'yō guntō ni okeru bunka no binkon." *Umi wo koete* 3:3 (March 1940): 65–67.

Ōashi Shin'ichi, ed. *Nobiru shōkokumin no shi.* Tokyo: Hakubunkan, 1942.

Obata Tetsuo. *Senryōka no 'genbakuten:' Heiwa o oimotometa seishun.* Kyoto: Kamogawa shuppan, 1995.

O'Brien, Susie. "Resilience Stories: Narratives of Adaptation, Refusal, and Compromise." *Resilience: A Journal of the Environmental Humanities* 4:2–3 (Fall 2017): 43–65.

Ōda Yōko. *Shikabane no machi.* Tokyo: Chūō kōronsha, 1948.

Ōe Kenzaburō. *Hiroshima nōto.* Tokyo: Iwanami shoten, 1965.

Ōfuji Mikio. "Senchūki no jidōbungaku hyōron: seikatsu dōwa kara shōkokumin bungaku e no nagare o otte." *Gakudai Kokubun* 29 (1986): 153–169.

Ogawa Mimei. *Atarashiki jidō bungaku no michi.* Tokyo: Futaba shoin seikōkan, 1942.

Ōishi Matashichi. *Kore dake wa tsutaeteokitai: Bikini jiken no omote to ura.* Tokyo: Kamogawa, 2007.

Okamura Yukinori. *A Brief Guide to the Maruki Gallery for the Hiroshima Panels/'Genbaku no zu' Maruki bijutsukan minigaidobukku.* Higashimatsuyama-shi: Maruki Gallery for the Hiroshima Murals, 2015.

———. *Gakugei'in nisshi.* http://fine.ap.teacup.com/maruki-g/.

———. "'Genbaku no zu' futatsu aru no ka?" http://www.aya.or .jp/~marukimsn/kikaku/2016/2016hiroshima.html. Accessed Aug. 9, 2017.

———. *'Genbaku no zu' no aru bijutsukan: Maruki Iri, Maruki Toshi no sekai o tsutaeru.* Iwanami bukkuretto no. 964. Tokyo: Iwanami shoten, 2017.

———. *'Genbaku no zu' zenkoku junkai.* Tokyo: Shinjuku shobō, 2015.

———. "Gentōban 'Genbaku no zu' *Pikadon* hakkutsu!" http://fine.ap.teacup .com/maruki-g/1767.html. Accessed Aug. 2, 2017.

———. "Gentōban 'Genbaku no zu' 'Pikadon' to 50 nendai 'Genbaku no zu' no media hyōgen." Unpublished conference paper. Delivered on Jan. 21, 2012, at Waseda University.

———. *Hikaku geijutsu annai: Kaku wa dō egakaretaka?* Iwanami bukkuretto no. 887. Tokyo: Iwanami shoten, 2013.

———, ed. *Maruki Bijutsukan bukkuretto 2: 'Genbaku no zu' o ronzu: Yoshida Yoshie, Yoshitome Yō, Kozawa Setsuko.* Higashimatsuyama: Maruki Bijutsukan, 2000.

———, ed. *Maruki Bijutsukan bukkuretto 3: Maruki Toshi-san o omobukai zenkiroku.* Hagashimatsuyama: Maruki Bijutsukan, 2005.

———. *Shiryō yō nenpu: Maruki Iri, Maruki Toshi, to nijū seiki: Dai'ichibu 1901–1950.* Higashimatsuyama: Maruki Bijutsukan, 2010.

———. Unpublished remarks, delivered at the opening of the Maruki show at Boston University Art Gallery, Fall 2015.

Okawa Takei. "Genshukuna jikō hihan: Sengo no bijutsukai." *Bijutsu* 2:5 (Nov. 1945): 25.

Okaya Kōji. *Nankai hyōtō: Mikuroneshia ni mīserareta Hijikata Hisakatsu, Sugiura Sasuke, Nakajima Atsushi.* Tokyo: Fuzanbō, 2007.

——— and Aoki Shigeru. *Bijutsukatachi no Nan'yō guntō: The South Sea Islands and Japanese Artists, 1910–1941.* Tokyo: Tokyo Shinbun, 2008.

Ōkuma Nobuyuki. *Kokka'aku: Sensō sekinin wa dare no mono ka?* Tokyo: Chūō kōronsha, 1957.

Okumura Shigeko, au., Iwasaki Chihiro, illus. *Atatakai kyōshitsu: kami shibai gohonshū.* Tokyo: Nihon kyōsantō shuppanbu, 1948.

Olick, Jeffrey. *The Politics of Regret: On Collective Memory and Historical Responsibility.* New York: Routledge, 2007.

Omuka Toshiharu. "Modanizumu no hon'yaku: Taishōki shinkō bijutsu undō no jissen." *Kokubungaku* 49:10 (Sept. 2004): 14–20.

————. "'Shin Roshia den' to Taishōki no shinkō bijutsu." *Suravu kenkyū* 35 (1988): 79–107.

————, ed. *'Teikoku' to bijutsu: 1930 nendai Nihon no taigai bijutsu senryaku.* Tokyo: Kokusho kankōkai, 2010.

Ono Hōjirō. "Maruki Bijutsukan o mijika ni." *Shin Nihon bungaku* 52:6 (August 1997): 108–112.

op de Beeck, Nathalie. *Suspended Animation: Children's Picture Books and the Fairy Tale of Modernity.* Minneapolis: University of Minnesota Press, 2010.

Orbaugh, Sharalyn. *Propaganda Performed: Kamishibai in Japan's Fifteen Year War.* Leiden: Brill, 2007.

Orr, James J. *The Victim as Hero: Ideologies of Peace and National Identity in Postwar Japan.* Honolulu: University of Hawai'i Press, 2001.

Park, Sunyoung. *The Proletarian Wave: Literature and Leftist Culture in Colonial Korea, 1910–1945.* Cambridge, MA: Harvard University Press, 2015.

Peacock, Margaret. *Innocent Weapons: The Soviet and American Politics of Childhood in the Cold War.* Chapel Hill: University of North Carolina Press, 2014.

Peattie, Mark R. *Nan'yō: The Rise and Fall of the Japanese in Micronesia, 1885–1945.* Honolulu: University of Hawai'i Press, 1988.

Perry, Samuel. *Recasting Red Culture in Proletarian Japan: Childhood, Korea, and the Historical Avant-Garde.* Honolulu: University of Hawai'i Press, 2014.

Povinelli, Elizabeth. *Economies of Abandonment: Social Belonging and Endurance in Late Liberalism.* Durham, NC: Duke University Press, 2011.

Richter, Giles. "Entrepreneurship and Culture: The Hakubunkan Publishing Empire in Meiji Japan," in Helen Hardacre with Adam L. Kern, ed. *New Directions in the Study of Meiji Japan,* 590–602. Leiden: Brill, 1997.

Robert, Jean-Noël. "Reflections on a Buddhist Scene in *The Tale of Genji*." *Cipango—French Journal of Japanese Studies* 3 (2014). http://cjs.revues .org/634. Accessed July 14, 2017.

Rosenfeld, Alla. "Between East and West: The Search for National Identity in Russian Illustrated Children's Books, 1800–1917." In Rosalind P. Blakesley and Margaret Samu, eds., *From Realism to the Silver Age: New Studies in Russian Artistic Culture,* 168–188. DeKalb: Northern Illinois University Press, 2014.

Ruoff, Kenneth J. *Imperial Japan at its Zenith: The Wartime Celebration of the Empire's 2,600th Anniversary.* Ithaca, NY: Cornell University Press, 2010.

Saeki Ikurō. "Jidō bunka ni kansuru kakusho." In Nitan'osa Nakaba, ed., *Shōkokumin bungakuron,* 18–30. Tokyo: Shōrinsha, 1942.

————. *Shōkokumin bunka o megutte.* Tokyo: Nihon shuppansha, 1943.

Saito, Fred. "Artist Portrays Hiroshima Blast: Japanese Say Sight Beautiful, Dreadful." *Pacific Stars and Stripes,* July 7, 1952, n.p.

Sakamoto, Rumi. "Pan-Pan Girls: Humiliating Liberation in Postwar Japan." *Portal: Journal of Multidisciplinary International Studies* 7:2 (2010): 1–15.

Sakima Michio. *Āto de heiwa o tsukuru: Okinawa/ Sakima bijutsukan no kiseki.* Iwanami bukkuretto no. 904. Tokyo: Iwanami shoten, 2014.

Sakuramoto Tomio. *Shōkokumin wa wasurenai: kūseki tsūshin yori.* Tokyo: Marujusha, 1982.

Sand, Jordan. "Imperial Japan and Colonial Sensibility: Affect, Object, Embodiment." *positions: east asia cultures critique* 21:1 (Winter 2013): 1–10.

Sandler, Mark H. "A Painter of the 'Holy War:' Fujita Tsuguji and the Japanese Military." In Marlene J. Mayo and J. Thomas Rimer with H. Eleanor Kerkham, eds., *War, Occupation, and Creativity: Japan and East Asia 1920–1960*, 188–211. Honolulu: University of Hawai'i Press, 2001.

———. "The Living Artist: Matsumoto Shunsuke's Reply to the State." *Art Journal* 55:3 (Autumn 1996): 74–82.

Saranillo, Dean Itsuji. "Why Asian Settler Colonialism Matters: A Thought Piece on Critiques, Debates, and Indigenous Difference." *Settler Colonial Studies* 3:3–4 (2013): 280–294.

Satō Yoshimi, au., Imamura Toshio, illus. *Yashi no mi donburiko.* Tokyo: Seikadō, 1943.

Sawachi Hisae. "Jiji baba no hitokoto: kataritsugubeki koto." *Sekai* 507 (November 1987): 242–263.

SCAPIN-33. "Press Code for Japan." http://dl.ndl.go.jp/info:ndljp/pid/9885095. Accessed Aug. 1, 2017.

SCAPIN-550. "Memorandum for: Imperial Japanese Government. Through: Central Liaison Office, Tokyo. Subject: Removal and Exclusion of Undesirable Personnel from Public Office." http://www.ndl.go.jp/modern/e/img_t/M006/M006–001tx.html. Accessed July 12, 2017.

Schenking, J. Charles. *Making Waves: Politics, Propaganda, and the Emergence of the Imperial Japanese Navy, 1868–1922.* Honolulu: University of Hawai'i Press, 2005.

Schmidt, Gary D. *Making Americans: Children's Literature from 1930 to 1960.* Iowa City: University of Iowa Press, 2013.

Seaton, Philip. *Japan's Contested War Memories: The 'Memory Rifts' in Historical Consciousness of World War II.* London: Routledge, 2007.

Segi Shin'ichi. *Nihon no zen'ei: 1945–1999.* Tokyo: Seikatsu no tomosha, 2000.

"Sekai no wadai: Atomic Bomb." *Kakushin* (April 1946): 52–55.

"Seisen bijutsu no aki: Nika-ten nyūsen happyō." *Hokkaidō shinbun*, August 30, 1938, n.p.

Semyonova, Natalya, and Nicolas V. Iljine, eds. *Selling Russia's Treasures: The Soviet Trade in Nationalized Art, 1917–1938.* New York: Abbeville Press Publishers, 2013.

Seraphim, Franziska. *War Memory and Social Politics in Japan.* Cambridge, MA: Harvard East Asian Center, 2006.

Sharp, Jane Ashton. *Russian Modernism between East and West: Natal'ia Goncharova and the Moscow Avant-Garde.* Cambridge: Cambridge University Press, 2006.

Shepherdson-Scott, Kari. "A Legacy of Persuasion: Japanese Photography and the Artful Politics of Remembering Manchuria." *Journal of Decorative and Propaganda Arts* 27 (2015): 124–147.

———. "Art Photography, Industry, and Empire: Japanese Soft Power in America, 1933–34." *Art History* (2018): 710–741.

Sherif, Ann. "Cold War Era Cultural Alliances and Gendered Nationalism in Japan." Unpublished conference paper. Delivered on March 24, 2018. Association for Asian Studies Conference.

———. "Hot War/Cold War: Commemorating World War II on its Sixtieth Anniversary." *Japan Focus* 3:5 (2005): 1–2.

———. *Japan's Cold War: Literature, Media, and the Law.* New York: Columbia University Press, 2009.

Shimada Kōsei. *Māsharu no kodomotachi: Suibaku no shima.* Tokyo: Fukuinkan shoten, 1996.

Shimizu Ikutarō. "Bijutsu to shintaisei." *Atoriye* 17:10 (October 1940): 1–4.

Shinshū Kōshōha Zenshōji kaiki hyakunen kinenshi: Shizen tokufū. Chippubetsu: Zenshōji, 2002.

"Shuppan bunkyō suisen gasho." *Asahi shinbun,* Feb. 12, 1943, morning edition, 4.

Silverberg, Miriam. "Constructing a New Cultural History of Prewar Japan." *boundary 2* 18:3 (Autumn 1991): 61–89.

Slaymaker, Douglas. *The Body in Postwar Japanese Fiction.* New York: Routledge Courzon, 2004.

Snelgrove, Corey, Rita Dhamoon, and Jeff Corntassel. "Unsettling Settler Colonialism: The Discourse and Politics of Settlers, and Solidary with Indigenous Nations." *Decolonization: Indigeneity, Education, & Society* 3:2 (2014): 8, 11–12.

Steiner, Evgeny. "A Battle for the 'People's Cause' or for the Market Case: Kramskoi and the Itinerants." *Cahiers du Monde Russe* 50:4 (Oct.–Dec. 2009): 627–646.

Stoler, Ann Laura, ed. *Imperial Debris: On Ruins and Ruination.* Durham, NC: Duke University Press, 2013.

Sugimura Mitsuko. "Nanyō guntō kara naichi no mina-sama e: shinpai shinaidekudasai." *Asahi Shinbun,* Sept. 5, 1941, morning edition, 6.

Sugiyama Shōko, ed. *Maruki Toshi ten: Onna egaki ga yuku Mosukuwa, Parao, soshite Genbaku no zu.* Ichinomiya-shi: Ichinomiya-shi Migishi Setsuko Kinen Bijutsukan, 2012.

Suzuki, Erin. "And the View from the Ship: Setting Asian American Studies Asail." *Verge: Studies in Global Asias* 4:2 (Fall 2018): 44–53.

Suzuki Osamu. "Sensō bijutsu no kōzai: Bijutsu ni okeru kōteki seikaku to shiteki seikaku." *Bijutsu* 3:1 (Jan. 1946): 2–8, 13–14.

Tajika Kenzō, ed. *Garyū: Maruki Iri sumigashū/Lying Dragon: A Collection of Drawings by Maruki Iri, Chiaroscurist*. Tokyo: Zōkeisha, 1970.

Takaguchi Shūzō, trans., and André Breton, au. *Gendai no geijutsu to hihyō sōsho.* Vol. 17: *Chōgenjitsushugi to ega.* Tokyo: Kōseisha, 1930.

Takao Tokiwa and Shimomura Hikoichi. *Kōkoku shin chiri.* Osaka: Nihon shuppansha, 1937 (revised reprint 1938).

Takasaki gakusei kodankai, ed. *1952nen natsu: Genbakuten no kiroku.* Takasaki-shi: Takasaki gakusei kondankai, 1952.

Takeda Yukio, au., Fuseishi Shigeo, illus. "Isamu-san no sensuitei." In Aiga Hidetsugu, ed., *Tsuyoi ko yoi ko.* Tokyo: Shōgakkan, 1943.

Takenaka, Akiko. "Collecting for Peace: Memories and Objects of the Asia-Pacific War." *Verge: Studies in Global Asia* 1:2 (Fall 2015): 136–157.

———. "Mobilizing Death in Imperial Japan: War and the Origins of the Myth of Yasukuni." *Japan Focus* 38:1 (Fall 2015): 1–15.

———. *Yasukuni Shrine: History, Memory, and Japan's Unending Postwar.* Honolulu: University of Hawaiʻi Press, 2015.

Takizawa Kyōji. "Nanshin seisaku to bijutsu: Nan'yō bijutsu kyōkai o megutte." In Tokyo bunkazai kenkyūjo, eds. *Shōwaki bijutsu tenrankai no kenkyū: senzenhen.* Tokyo: Tokyo bunkazai kenkyūjo, 2009.

———. "Nan'yō guntō to Nihon kindai bijutsu: Bijutsuka, sakuhin, bijutsushi keisei e no kan'yo." *Kagoshima bijutsu kenkyū* 26 (November 2009): 173–182.

Tanaka Hisao. *Nihon sensōga keifu to tokushitsu.* Tokyo: Perikan, 1985.

Tan'o Yasunori and Kawada Akihisa. *Imēji no naka no sensō: Nisshin Nichiro kara reisen made.* Tokyo: Iwanami shoten, 1996.

Tansman, Alan, ed. *The Culture of Japanese Fascism.* Durham, NC: Duke University Press, 2009.

Templado, Louis. "The Maruki Legacy." *Japan Quarterly* 42:3 (July–Sept. 1995): 281–289.

Te Punga Somerville, Alice. "Searching for the Trans-Indigenous." *Verge: Studies in Global Asia* 4:2 (Fall 2018): 96–105.

Thornber, Karen. "Responsibility and Japanese Literature of the Atomic Bomb." In David Stalh and Mark Williams, eds., *Imag(in)ing the War in Japan: Representing and Responding to Trauma in Postwar Literature and Film.* Leiden: Brill, 2010.

Tiampo, Ming. *Gutai: Decentering Modernism.* Chicago: University of Chicago Press, 2010.

———, Alexandra Munroe, Yoshihara Jirō, and Hirai Shōichi. *Gutai: Splendid Playground.* New York: Guggenheim Museum, 2013.

Tokuda Kyūichi. "Tō kakudai kyōka no keika to tō no kōzenka ni tsuite." *Akahata* 1:2 (Nov. 7, 1945): 4–5.

Tokunaga Sunao, ed. *Hatarakumono no bungaku dokuhon.* Tokyo: Shinkōsha, 1948.

Tomii, Reiko. *Radicalism in the Wilderness: International Contemporaneity and 1960s Art in Japan.* Boston: MIT Press, 2018.

Tomizawa Sa'ichi. "Hiroshima hyōgen no kiseki dainibu: Maruki fusai to kokuhatsu." *Chūnichi shinbun,* Aug. 6, 1987, n.p.

Torigoe Shin. *Jidō zasshi 'shōkokumin' kaidai to saimoku.* Tokyo: Kūkansho, 2001.

Toshima-ku rekishiteki kenzōbutsu chōsasho 1: jūtakuhen. Tokyo: Toshima-ku kyōikui'inkai, 2001.

Treat, John Whittier. "Choosing to Collaborate: Yi Kwang-su and the Moral Subject in Colonial Korea." *Journal of Asian Studies* 71:1 (Feb. 2012): 81–102.

———. *Writing Ground Zero: Japanese Literature and the Atomic Bomb.* Chicago: University of Chicago Press, 1995.

Tsuruta Gorō. "Gaka no tachiba." *Asahi shinbun,* Oct. 25, 1945, evening edition p. 2, row 7, column 1.

Tsuruya Mayu. "Sensō Sakusen Kirokuga: Seeing Japan's War Documentary Painting as a Public Monument." In Thomas Rimer, ed., *Since Meiji: Perspectives on the Japanese Visual Arts, 1868–2000,* 99–123. Honolulu: University of Hawai'i Press, 2012.

Turner, Victor. *The Anthropology of Performance.* New York: PAJ Publications, 1988.

Uchiyama, Benjamin. "The Munitions Worker as Trickster in Wartime Japan." *Journal of Asian Studies* 76:3 (August 2017): 655–674.

Uemura Takachiyo. "Bijutsu saiken no senketsu mondai." *Bijutsu* 2:5 (Nov. 1945): 8.

Usami Shō. *'Genbaku no zu' monogatari.* Tokyo: Komine shoten, 1985.

———. *Ikebukuro Monparunassu.* Tokyo: Shūeisha, 1990.

Victoria, Brian Daizen. *Zen at War* (2nd ed.). New York: Rowman & Littlefield, 2006.

Volk, Alicia. "Authority, Autonomy, and the Early Taishō 'Avant-Garde.'" *positions: east asia cultures critique* 21:2 (Spring 2013): 451–473.

———. *In Pursuit of Universalism: Yorozu Tetsugorō and Japanese Modern Art.* Berkeley: University of California Press, 2010.

Walker, Brett. *Toxic Archipelago: A History of Industrial Disease in Japan.* Seattle: University of Washington Press, 2011.

Ware wa nani o nasubeki ka? Tokyo: Nihon Kyoiku Gageki [n.d., ca. 1944].

Ware ware ga mita Sovēto Rosshia. Osaka: Sodōmei kikansha seikatsu suijō dōmei, 1949.

Watanabe Shōichi. "Teikoku kenpō 'senpan' ron." *Kakushin* 192 (Aug. 1986): 15–19.

Weisenfeld, Gennifer. "The Expanding Arts of the Interwar Period." In Thomas Rimer, ed., *Since Meiji: Perspectives on the Japanese Visual Arts, 1868–2000,* 66–98. Honolulu: University of Hawai'i Press, 2012.

Williams, Robert C. "The Nationalization of Early Soviet Culture." *Russian History* 9:2/3 (1982): 157–172.

Wilson, Rob. "Postcolonial Pacific Poetries: Becoming Oceania." In Jahan Ramazani, ed., *The Cambridge Companion to Postcolonial Poetry*, 58–71. Cambridge: Cambridge University Press, 2017.

Winther-Tamaki, Bert. "Embodiment/Disembodiment: Japanese Painting during the Fifteen-Year War." *Monumenta Nipponica* 52:2 (1997): 145–180.

———. "From Resplendent Signs to Heavy Hands: Japanese Painting in War and Defeat, 1937–1952." In J. Thomas Rimer, ed., *Since Meiji: Perspectives on the Japanese Visual Arts, 1868–2000*, 124–142. Honolulu: University of Hawai'i Press, 2012.

Wittner, Lawrence S. Unpublished letter to the Nobel Committee nominating Maruki Iri and Maruki Toshi for the Nobel Peace Prize. Dated November 19, 1995.

Wolfe, Alan. "Toward a Japanese-American Nuclear Criticism: The Art of Iri and Toshi Maruki in Text and Film." *Bulletin of Concerned Asian Scholars* 19:4 (Oct.–Dec. 1987): 55–57.

Wu, Chinghsing. "Japan Encounters the Avant-Garde: The Art and Thought of Koga Harue, 1895–1933." PhD diss, University of California–Los Angeles, 2010. UMI number 3446789.

Yamanaka Hisashi. *Senji jidō bungaku ron: Ogawa Mimei, Hamada Hirosuke, Tsubota Jōji*. Tokyo: Ōtsuki shoten, 2010.

———. *Shōkokumin sensō bunka shi*. Tokyo: Keisō shobō, 2013.

Yamanashi, Emiko. "Western-Style Painting: Four Stages of Acceptance." In J. Thomas Rimer, ed., *Since Meiji: Perspectives on the Japanese Visual Arts, 1868–2000*, 19–33. Honolulu: University of Hawai'i Press, 2012.

Yanagi Ryō. "Rearuizumu to minshu shugi." *Bijutsu* 3:6 (June 1946): 1–14.

Yanagishita Sōichi, Ōhashi Isamu, Suzuki Shigeru, and Sasai Masao. *Ajia shitsurakuen: Tokyo saiban hōkoku, dai 2 gō (Sabakareru Nippon zokugō)*. Tokyo: Tokyo shinbunsha, 1947.

———. *Sabakareru Nippon: Tokyo saiban hōkoku dai'ichigō*. Tokyo: Tokyo shinbunsha, 1946.

Yazawa Kōichirō. "'Genbaku no zu' tenshikai no shashin." *Adachi shidan* 381 (Nov. 11, 1999): 4.

Yazawa Masaru and Kozawa Setsuko. *Ongaku/bijutsu no sensō sekinin*. Tokyo: Kinohanasha, 1995.

Yi, Christina. *Colonizing Language: Cultural Production and Language Politics in Modern Japan and Korea*. New York: Columbia University Press, 2018.

Yoneyama, Lisa. *Cold War Ruins: Transpacific Critique of American Justice and Japanese War Crimes*. Durham, NC: Duke University, 2016.

Yoshida Mizuho. *Asa no inekoki: Shōkokumin shishū*. Tokyo: Chūō kōronsha, 1942.

Yoshida Yoshie. *Kaitaigeki no maku orite: Rokujū nendai zen'ei bijutsu.* Tokyo: Zōkeisha, 1982.

———. *Maruki Iri Toshi no jikū: ega to shite no 'Genbaku no zu.'* Tokyo: Aoki shoten, 1996.

———. "Sensōga to iu ijōsa o chokushi suru koto kara: tokushū: heiwa o tsukuru." *Manabu* 532 (Aug. 2002): 18–21.

———. *Yoshida Yoshie zenshigoto.* Tokyo: Geijutsu shoin, 2005.

Yoshimi Yoshiaki. *Grassroots Fascism: The War Experience of the Japanese People.* Translated by Mark Ethan. New York: Columbia University Press, 2016.

Young, Louise. *Japan's Total Empire: Manchuria and the Culture of Wartime Imperialism.* Berkeley: University of California Press, 1998.

Yuhashi Shigetō. *Senji Nisso kōshō shōshi: 1941nen - 1945nen.* Tokyo: Kasumigaseki shuppan, 1974.

"Zentondenhei meibo." http://www.asahi-net.or.jp/~xj6t-tkd/tonden/meibo/meibo_all.pdf. Accessed June 8, 2016.

Zwigenberg, Ran. *Hiroshima: The Origins of Global Memory Culture.* Cambridge: Cambridge University Press, 2014.

Index

Page numbers in boldface type refer to illustrations

aesthetics: and critique of colonialism, 35–40; of deformation, 175–179; direct action, 134–135, 207–210; downstairs, **91**, **93**–102; imperial, and Micronesia, 51–55; leftist feminist, 130–133; and primitivism, 146–148; as revolutionary weapon, 141–143. *See also* "bare naked aesthetics"; fascist aesthetics; Proletarian Eastern aesthetics

Ainu, 12–16, 48, 234n22. *See also* Hokkaidō; colonialism

Akahata, 2, 205, 271nn44–45; Toshi's work for, 170–**171**. *See also* International Military Tribunal for the Far East (IMTFE)

Akai tori, 56–58, 60–61. *See also* "culture for little countrymen"; publications, imperialist

Akamatsu family: as settler-colonials, 15–16; Toshi's oil paintings, of 18–19. *See also* settler-colonialism; Hokkaidō

Akamatsu Toshiko. *See* Maruki, Toshi

anachrony: and heterochrony, 228–229. *See also* heterochrony

antinuclear movement: and alternate media, 214–218, 276n98; and children, 226–227; and direct action, 218–220; and Marukis, 2–4, 7–8, 194–195, 276n93; and

Nuclear Panels, 202–204, 210–212; poster, 226–228

Anybody Can Make Art (*E wa dare demo kakeru*), 146, 149–154. *See also* "bare naked aesthetics"; manifesto

artist: and colonization of women, 149–152; criticism of based on gender, 122, 127–130, 261n5; *dessin* 24; female artist as child, 164–165; and imperial formation, 27–**28**; Japanese use of, 28–30, 78–79, 84, 162–163, 179–180; and nationalism, 107–111; persecution of, 29, 72, 86 (*see also* censorship); as potential war criminal, 159–161; and responsibility, 85, 263n34; Soviet Russian, 94–99, 112–114; Western-style training of, 17–18, 97–98; as "whore" (*shōgi, shōfu*) and "puppet," 163–165. *See also* avant-garde; Modernism; oil painting; realism; sketching

artistic wartime responsibility: and arts establishment (*gadan*), 187, 190; in *Asahi News*, 159–161, 163; in *Bijutsu*, 161–163, 262n26; and critical self-reflection, 161, 162–167; debate, 157–158, 159–163, 182–189, 261n9, 263n34; and Nihon Bijutsukai (Japan Art Association), 164–169, 262n30, 263n31, 269n24; and oil paintings, 159,

ABOUT THE AUTHOR

Charlotte Eubanks is associate professor of comparative literature, Japanese, and Asian studies at the Pennsylvania State University. She studies the material culture of books and word/image relations, with a focus on Japanese literature from the medieval period to the present. Her articles have appeared in *Ars Orientalis, Book History, Harvard Journal of Asiatic Studies, Japanese Journal of Religious Studies, PMLA, Symposium, Word & Image,* and a range of other venues. She is associate editor at the journal *Verge: Studies in Global Asias.*